*Master Drawings from the National Gallery of Canada*

# Master Drawings from the
# National Gallery of Canada

National Gallery of Art, Washington

The exhibition is made possible by
the Belzberg Family.

*Exhibition dates*
Vancouver Art Gallery
13 September—20 November 1988

National Gallery of Canada, Ottawa
9 December 1988—12 February 1989

National Gallery of Art, Washington
5 March—21 May 1989

The catalogue was produced by the Editors
Office, National Gallery of Art, Washington,
under the supervision of Melanie B. Ness,
managing editor
Edited by Brenda Gilchrist, New York
Designed by Susan Lehmann, Washington

Printed by Schneidereith and Sons, Baltimore,
Maryland, on eighty-pound Warren's lustro
offset enamel
The typeface is Palatino, set by BG
Composition, Inc., Baltimore, Maryland

Printed in the United States

Library of Congress Cataloging-in-Publication
Data
Master drawings from the National Gallery of
Canada.
Exhibition catalogue.
Bibliography: p.
Includes index.
1. Drawing, European—Exhibitions.
  2. National Gallery of Canada—Exhibitions.
  I. National Gallery of Canada.   II. National
Gallery of Art (U.S.)
NC225.M37   1988    741.94'074'0153    88-19651
ISBN 0-89468-120-6

Cover illustration: Samuel Palmer, *Oak Trees,
Lullingstone Park,* detail, cat. 85
Frontispiece: detail, cat. 81

# Contents

6    Directors' foreword
J. CARTER BROWN and SHIRLEY THOMSON

7    Acknowledgments

9    Introduction   MIMI CAZORT

13    Catalogue

14    Note to the reader

15    *Italian*

87    *Netherlandish and German*

153    *French and Spanish*

225    *English*

293    References cited

311    Index of artists

## Directors' foreword

*Master Drawings from the National Gallery of Canada* is the first collaborative exhibition between the National Gallery of Art, Washington, and the National Gallery of Canada, Ottawa. For this achievement we want to thank Allan Gotlieb who, as Canada's Ambassador to the United States, conceived the idea of an exhibition of masterpieces from the National Gallery in Ottawa to be shown in Washington and whose powers of gentle persuasion brought the project into existence. This exhibition of master drawings celebrates the completion of two major Canadian architectural projects: the new National Gallery of Canada in Ottawa and the Canadian Chancery in Washington.

The drawings in the exhibition date from the fifteenth to the nineteenth century; they were created by major European artists and reflect the most important artistic movements of their time. Very few have been shown in the United States. The selection of drawings was worked out in agreeable collaboration between our two institutions by Mimi Cazort, curator of European prints and drawings, Douglas Schoenherr, associate curator of European prints and drawings, Rosemarie Tovell, associate curator of Canadian prints and drawings (National Gallery of Canada), and Diane De Grazia, curator of Italian drawings (National Gallery of Art). The exhibition was coordinated in Ottawa by Mr. Schoenherr and in Washington by Miss De Grazia. In addition, we would like to thank the other Canadian scholars who contributed entries to the catalogue: Marie-Nicole Boisclair, Howard Collinson, W. McAllister Johnson, Catherine Johnston, George Knox, Laurier Lacroix, Katharine Lochnan, David McTavish, Roger Mesley, Kim Sloan, Joaneath Spicer, and Douglas Stewart. Sydney Freedberg and Andrew Robison (National Gallery of Art) also contributed advice and aid in the early planning of the exhibition.

We are particularly grateful to the Belzberg Family for its generous support of the exhibition.

J. CARTER BROWN
Director
National Gallery of Art

SHIRLEY THOMSON
Director
National Gallery of Canada

## Acknowledgments

The organizing and coordinating curators at the National Gallery of Canada and the National Gallery of Art in Washington would like to take this opportunity to thank all the staff members of their respective institutions who contributed their energetic support to this exhibition. A collaborative enterprise of this nature is always a complex process, and the departments of exhibitions, publications, conservation, technical services, and public relations in both institutions have been involved in varying degrees. Thanks on an individual basis must be sacrificed to the exigencies of brevity, but the gratitude is nonetheless sincere. That the National Gallery of Canada was able to embark on the show at all, in the middle of its move to new quarters, is a testimony to staff solidarity. Special mention must, however, be made of the contribution of Jennifer Trant at the National Gallery of Canada who coordinated the text for the catalogue.

We would also like to thank the team of authors from Vancouver to Quebec City who readily agreed to write catalogue entries. They, in turn, register their gratitude to colleagues who have provided advice in specialized areas: Egbert Haverkamp-Begemann, Alice Binyon, Jaap Bolten, William Bradford, Judith Bronkhurst, Paul Chaffe, René Chartrand, A. Condliffe, Howard Coutts, A.C.W. Crane, Bernice Davidson, Erica Davis, Elizabeth Einberg, Cyril Fry, John Gere, Carol Gibson-Wood, Tom Girtin, John Glover, Francis W. Hawcroft, Christian von Heusinger, Thomas Da-Costa Kaufmann, Marianne Küffner, Willy Laureyssens, Raymond Lister, Anne W. Lowenthal, Stephanie Maison, Corinne Mandel, Oliver Millar, Agnes Mongan, Jennifer Montagu, Susan Morris, Edgar Munhall, Evelyn Newby, Konrad Oberhuber, Richard Ormond, Ann Percy, Edmund P. Pillsbury, Cecilia Powell, Jeremy Rex-Parkes, Jane Roberts, William W. Robinson, Renato Roli, Eleanor Sayre, Stuart B. Schimmel, Douglas Smith, Timothy Standring, Julian Steele, John Thorp, and Lawrence Turčić.

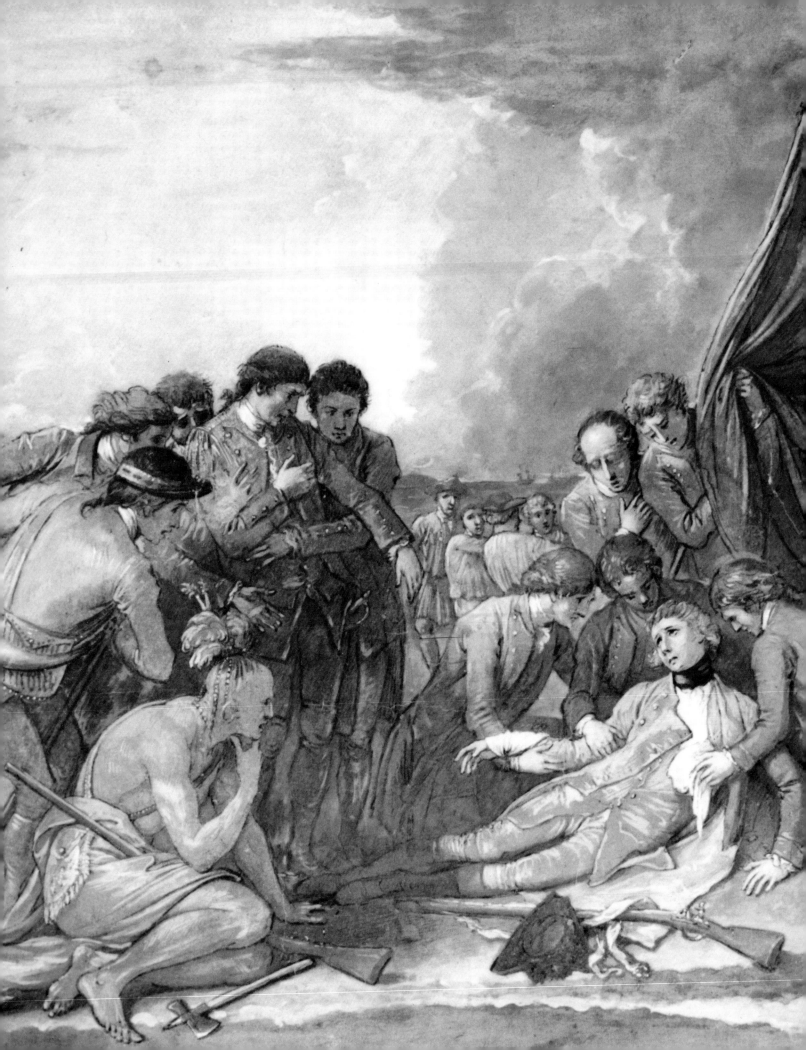

# Introduction

The kind invitation of the National Gallery of Art in Washington to the National Gallery of Canada in Ottawa to mount an exhibition from its collection of drawings has provided welcome opportunities on a number of fronts. One of the chief pleasures of putting together such an exhibition is that it gives the curators an excuse to poke about in the solander boxes, meditate on the nature of drawings, and ponder which sheets one wants to send out as public emissaries. The exhibition also furnishes a gratifying occasion to review the history of the National Gallery of Canada's collections.

The National Gallery of Canada owes its genesis in the nineteenth century not, as was so often the situation in the United States, to the philanthropic impulses of the new industrialists, but rather to the strong Victorian belief in state responsibility for cultural matters propounded, in this case, by a son-in-law of the Queen herself, the Marquis of Lorne. The husband of Victoria's artist-daughter Princess Louise, he proposed the idea of a national Canadian institution devoted to the visual arts in March 1880, during his tenure as Governor General (1878–1883). Ottawa had been established as the capital only a little over twenty years earlier, and the Marquis had worked out the terms of the foundation with a group of contemporary Canadian artists who, in an amazingly short time, had established themselves as official representatives of this newly recognized young cultural entity. Thus, in that year the National Gallery was established jointly with the Royal Canadian Academy, the diploma works of which were to be placed on deposit in the Gallery, forming the nucleus of the collections.

The original identification with England and English cultural attitudes was naturally reflected in the painting collection in the early years. Prompted by the example of the Canadian artist-donors, a number of fellow English academicians were inspired to aid the struggling young colonial enterprise by donation as well. In 1883 Frederic Lord Leighton gave his painting *Sansone* and in 1884 Sir John Everett Millais contributed his *Portrait of the Marquis of Lorne*. George Frederic Watts followed in 1887 with the gift of his well-known painting *Time, Death, and Judgement*. The drawing collection was also English in its original orientation. After several years of hesitant and sporadic addition of the odd single sheet, in 1909 the collection was enriched by an important group of drawings by the fin-de-siècle artist Walter Crane, including those for his *Faerie Queen*, thus establishing a precedent for the acquisition of prints and drawings related to book illustration.

With the appointment of the Advisory Arts Council in 1907, the development of the prints and drawings collections gained considerable momentum, and in 1911 a group of seventeen "old master drawings" of exceptional quality from the Duke of Rutland's collection was bought for the now unimaginably low price of $1,850. Informed English taste still prevailed, but in 1913 the narrow base of English and Canadian content was abruptly expanded. On the eve of its incorporation as The National Gallery of Canada, the government made an even more lavish expenditure of $5,000 that procured for the institution a group of drawings that reflected a powerful current in contemporary Canadian taste for mid-nineteenth-century French art, with a strong predilection for the bucolic delights of the Barbizon school. For a society in which most city dwellers retained clear memories of a recent rural past, this was not unexpected.

The next significant surge of activity in the area of prints and drawings at the Gallery occurred in 1921, when a young Canadian named H. P. Rossiter was appointed to establish a department of prints and drawings. After graduating from the University of Toronto, Rossiter had worked in the print room of the Boston Museum of Fine Arts (to which he returned in 1923 to form, over the succeeding decades, one of the most prestigious collections of master prints in North America). Although Rossiter's emphasis

was on the collecting of prints and the building of an awareness of prints in the local consciousness, a number of significant drawings were added to the collection during his short tenure, including the four splendid late Goyas, two of which are included in the present exhibition (see cats. 59–60). Rossiter's influence on the collection persisted long after his departure, as he continued until the 1960s to advise on print purchases.

An important factor during the early decades of the century was the personality of the director, Eric Brown, who arrived on the scene in 1910. Brown has long been respected as the man who labored unceasingly to gain acceptance for the young avant-garde Canadian painters known as the Group of Seven. Less well known was his dedication to the principle of a country's cultural orientation extending beyond the parochial and the narrowly nationalistic. He acted on his belief that a critical component for the Gallery's continued well-being must be self-examination in the light of its own historical past, and that its capacity for renewal lies in the vitality of its ties with the world beyond itself in space and time. Brown's enlightened point of view allowed him to support the development of Canadian art while simultaneously cultivating a respect for the art of the past out of which it had grown.

In 1928 the Gallery made, almost by chance, an important acquisition in terms of human resources when Brown invited a young Englishwoman, Kathleen Fenwick, to spend a year in Ottawa as curator of prints and drawings. She accepted, stayed for forty years, and was working on the still uncompleted catalogue of the English drawings at the time of her death in 1972. Miss Fenwick brought a high degree of professionalism to the Gallery. She instituted cataloguing records of the collection based on British Museum standards, built up an excellent print and drawing research library, and, although she was not allowed to buy drawings for many years (that privilege, and that budget, being reserved for the English advisors), she engineered a consistent program of print purchases at a time when fine impressions of Dürers and Rembrandts were to be had for a few pounds.

Miss Fenwick's informed enthusiasm, her eagerness to share the collection through a series of in-house exhibitions, which persisted uninterrupted until 1983, and her contribution to the Gallery's national traveling exhibitions, which had been inaugurated in 1918, constituted a major contribution to the fortunes of the Gallery for several decades. Visitors who had been granted access to the inner storage areas recall the passionate interest with which she discussed prints and drawings, books in general, the newly formed Film Institute or the Design Center (in both of which she was involved). She brought a level of wit and intelligence to a small museum in what was then a small provincial capital city.

In the 1940s collections development naturally fell off, but by then a growth pattern had been set, which was to persist and which was different from that of major museums in the United States. South of the forty-ninth parallel, in the larger and more prosperous cities from the nineteenth century onward, the beneficiaries of the new wealth had discovered that the collecting of art was a gratifying occupation, and the donation of their collections to public institutions a natural culmination and memorial. This pattern did not develop in Canada. One reason was certainly that much of Canadian industrial expansion (the railroads, for instance) was financed by foreign capital, the profits of which promptly returned home. As for the concentrations of wealth that did remain in the country, they were not conspicuously consumed, for the most part. The flamboyant combination of risk and aggrandizement that lent color and glamour to the American scene was simply not evident in Canada.

Added to these factors was Canada's continuing cultural orientation toward Europe, where the support of the central cultural institutions was the responsibility of the state, a situation deemed appropriate for Canada as well. Thus, the acquisition budgets of the national museums were provided solely by the federal government, and, given the slim base of the existing collections, this made for a tenuous condition. The museums felt little need to cultivate private collecting, and the potential collectors, without the cooperation and support of the curators to guide them through the intricacies of quality and attribution and the mazes of the art market, found other things to do with their money. The mutually benefi-

cial interdependence between public collecting institutions and private collectors, of crucial importance for the development of the major public collections in Europe and the United States, did not evolve in Canada.

This simplistic description of what was naturally a more complex situation is relevant, however, to our discussion of the character of the national collection of drawings. The collection is small (only about 1,200 sheets) because it contains no lot purchases or donations. In fact, there have been very few donations of any kind. Two remarkable exceptions, which are included in the present exhibition, are the Albrecht Dürer *Nude Woman with a Staff* (see cat. 28) given by Joseph H. Hirshhorn and a group of his friends and associates in 1956 and the Giovanni Domenico Tiepolo (*Encounter During a Country Walk* (see cat. 25) from a group of twenty-seven drawings donated by Mrs. Samuel Bronfman in 1974. Partly because of its small size, however, the collection also has a very specific character, since each object was chosen with individual care and attention due to a finite but mercifully predictable budget. Consequently, the collecting standards set very early on emphasized quality without ostentation, the drawing itself rather than the name attached to it. This approach had advantages and disadvantages. The advantages were that during the decades when drawing scholarship was in its infancy and many new buyers were easily hoodwinked by the tag of a "Michelangelo," or a "Guido Reni," the Gallery fell into no such traps. A major disadvantage of this modest approach was that, during decades in which it was still possible to acquire sheets by the major masters, we did not. Granted we have no false Michelangelo; we have no Michelangelo at all.

The sophistication and skill of the English advisors appointed by the successive directors were by and large enormously beneficial to the Gallery. A glance at the provenance of a number of drawings in this exhibition will show that many of the first-rate sheets were acquired on the basis of their recommendations. In the 1920s the Gallery sought the occasional advice of Charles Ricketts; from 1937 to 1968 its European drawing purchases were recommended successively by Paul Oppé and A. E. Popham, whose taste, knowledge, and discretion stood us in good stead. Popham, with the collaboration of Miss Fenwick, produced what is still the only catalogue of the permanent collection, which, although it appeared in 1964 and the collection has more than doubled since, continues to serve as the basic published document on the collection. It is also to these scholars that the National Gallery owes, respectively, the foundations of the present English and Italian collections.

For Canada 1967 was a "Jubilee" year, marking the country's centennial, an event noted by most of the outside world as the year of Expo '67 in Montreal. Less conspicuous but of greater importance for the Gallery was the appointment that same year of Jean Sutherland Boggs as director. Miss Boggs swept away the last vestiges of colonial mentality by asserting a firm policy of autonomy, whereby all acquisitions were controlled internally. She added several new appointees to the staff in both the Canadian and non-Canadian subject areas in all fields of drawings and prints, paintings, and sculpture. In that year this writer assumed the post of assistant curator of prints and drawings. Since our accession numbers do not bear a year indication, it might be of interest to anyone desiring to plot the development of the collection that the advent of this new era of independence for the drawing collection was signaled by the acquisition of the Vincent van Gogh *Swamp* (see cat. 46; actually purchased by Miss Boggs), and that the responsibility of all subsequent acquisitions (that is, all post–15461 numbers) can be laid at the feet of the current staff, for better or for worse.

With the Gallery's assumption of full responsibility for its collections development, a somewhat broader approach to the acquisition of prints and drawings was adopted. This entailed a methodical assessment of the collections and a consistent attempt to develop the existing strengths by the addition of works by major draftsmen, along with a policy of expanding in new directions. At this time a fresh eye was focused on Canadian drawings, from the eighteenth century to the present. The National Gallery's function as a teaching as well as an exhibition center called for a breadth of range in terms of artist, country, and period represented, and in terms of the variety of

purposes for which drawings have historically been made. A conscious effort was made to acquire sheets that show the artist's first jottings of an idea, others showing the exploration of details, working drawings and finished presentation sheets; studies from life and from nature, as well as from fantasy and the imagination; private drawings such as caricatures and portraits of friends, as well as public exhibition pieces; and drawings as records of places or events.

Finally, thoughtful consideration was given to acquiring sheets that demonstrate the historical sources of Canadian art, the traditions from which Canadian artists had learned and continue to learn. Looking for drawings that would fill in this picture provided a challenge that in the end proved to be a creative one. There was, for example, the tradition of English topographical watercolors, the direct ancestor of the Canadian landscape tradition by way of the itinerant military artists who set about to record the wilderness in their neat and measured way. The present exhibition contains two examples of such work: the watercolors by Thomas Davies (see cat. 75) and James Heriot (see cat. 81). Then there were the French mid- to late-nineteenth-century *paysagistes* whose hardy confrontations with the rougher aspects of landscape furnished worthwhile lessons for the Canadian artist, armed only with

charcoal, pastel, or watercolor, attempting to deal with vast expanses of land, rocks, and water. The drafting style and subject matter of the French Symbolists, although known only in reproduction to the artists unable to make the coveted journey to Europe, was a clear stimulus to the more melancholy Quebec draftsmen of the late nineteenth and early twentieth century.

A word about the selection of drawings for the exhibition is in order. European and Canadian artists only are represented. The cut-off point was set at c. 1900, which means that the twentieth century (encompassing a few of the Gallery's finest sheets; for example, some splendid German Expressionist drawings) is excluded. Included, on the other hand, is a substantial group of English works that are perhaps less often seen in an exhibition of this kind. The selection reflects the patterns of collecting described above and has, at the same time, tried to maintain the standard of quality that has always been the paramount consideration in choosing acquisitions for the National Gallery of Canada.

In closing, we would like to dedicate this catalogue and this exhibition to the memory of Miss Kathleen Fenwick.

MIMI CAZORT
Curator of Prints and Drawings
National Gallery of Canada

Catalogue

## Note to the reader

The drawings are catalogued according to national school: Italian (cats. 1–26); Netherlandish and German (cats. 27–46); French and Spanish (cats. 47–71); and English and Canadian (cats. 72–90). Measurements are given in millimeters, height preceding width, followed by inches within parentheses. Shortened references are fully explained in the list of references cited, which is divided into books and articles, cited by author and date, and exhibition catalogues, cited by city and date.

### Contributors

| | |
|---|---|
| M–NB | Marie-Nicole Boisclair |
| MC | Mimi Cazort |
| HC | Howard Collinson |
| WMcAJ | W. McAllister Johnson |
| CJ | Catherine Johnston |
| GK | George Knox |
| LL | Laurier Lacroix |
| KL | Katharine Lochnan |
| DMcT | David McTavish |
| RJM | Roger J. Mesley |
| DES | Douglas E. Schoenherr |
| KS | Kim Sloan |
| JS | Joaneath Spicer |
| JDS | J. Douglas Stewart |
| RT | Rosemarie Tovell |

Italian

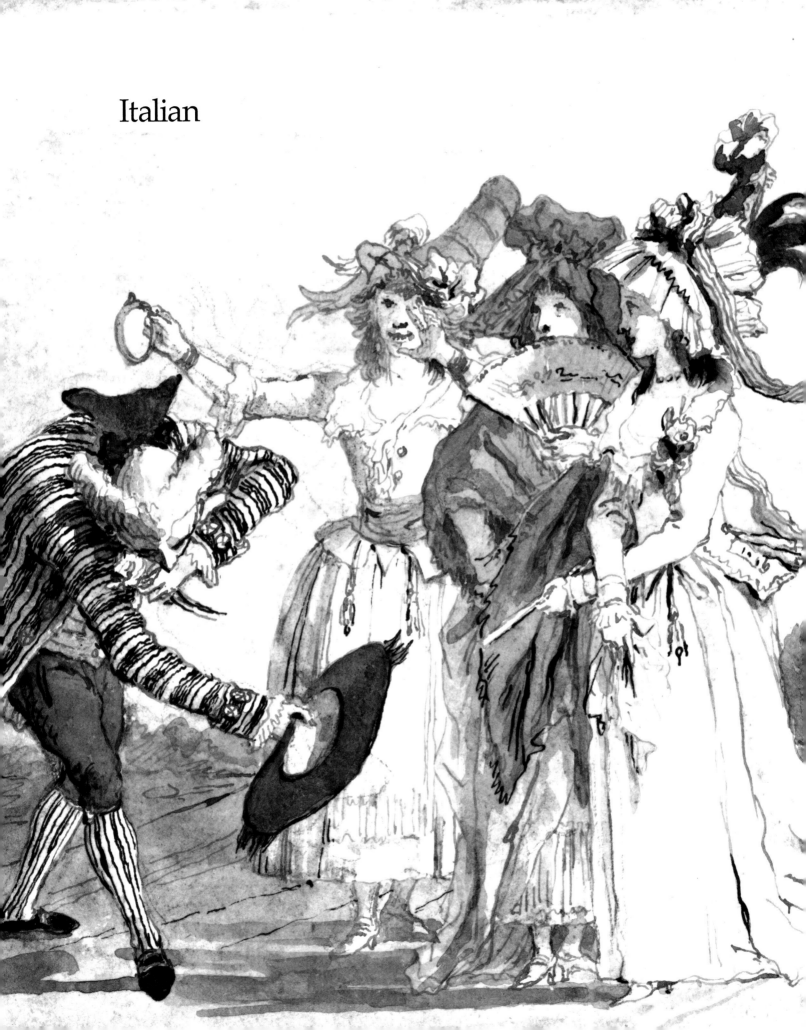

**1**

## *Nine Famous Men: Elisha, Lycurgus, Azariah, Sardanapalus, Amos, Hosea, Joel, Obadiah, and Jonah*, c. 1450 (?)

**Unknown Artist**
Italian or French, fifteenth century

Pen and brown ink and watercolor, heightened with white (oxidized), on vellum

316 x 201 (12⁷/₁₆ x 7¹⁵/₁₆)

Inscriptions: Each figure is identified by an inscription in pen and brown (iron gall) ink in Latin, some also by inscriptions in a later hand in French. Below each figure, except Azariah, is written *fuit hoc tempore* contracted in various ways, and after the name of each of the six prophets is written the Latin abbreviation *pp̄hā* (for prophet). From the top left the inscriptions are as follows: *Elisas* (barely legible); on scroll: *vocavit dn̄s fame et vesnt(?) super terras* (2 Kings 8:1); *Licurgus*; in a later hand: *Licurgue Roi de thrace*; *Azarias*; in a later hand: *Aza . . .* ; below feet: *fuit anno m̄cxxviii(?)*; *Sardanapalus*; in a later hand: *Sardanapale*; *Amos*; on scroll: *qui edificat in celos ascersionē suam* (Amos 9:6); *Osee*; in a later hand: *osee*; on scroll: *O mors ero mors tua morsus tuus ero in inferno* (Hosea 8:14); *iohel*; on scroll: *efundam spūm* [spiritum] *meum super om̄m̄ carnem* (Joel 2:28); *abadias*; on scroll: *In montem sion erit salvatio et erit sc̄tus* (Obadiah 1:17); *ioanas*; on scroll: *abissus vallavit me et pelagus opruit capud meum* (Jonah 2:6)

Provenance: French collection(?); Quaritch, London; William Morris, London, 1894; Charles Fairfax Murray; sale, Sotheby's, London, 18 July 1919, lot 50; Sir Sydney Cockerell; anonymous sale, Sotheby's, London, 2 July 1958, lot 18; Dr. and Mrs. Francis Springell; their sale, Sotheby's, London, 28 June 1962, lot 5; purchased at the sale, through A. E. Popham

Literature: Hoff 1937–1938, 292–294; Berenson 1938, 2:17, no. 164ᶜ (3rd ed. 1961, 2: 35, no. 164ᶜ); Toesca 1952, 16–20, fig. 11; Longhi 1952, 56–57; Saxl and Meier 1953, 1: 279–281, 2: pl. 21, fig. 5; Grassi 1956, 86; Milan 1958, 64, under no. 202; van Regteren Altena 1959, 83; Scheller 1962, 56–67; Virch 1962, 11–12; Scheller 1963, 206; Fenwick 1964, 2, 4, fig. 2; Popham and Fenwick 1965, 3, no. 1; Fenwick 1966, 24; Simpson 1966, 135–159; Laclotte 1967, 34–41; Degenhart and Schmitt 1968, I–2: 592, 619, n. 14; New York 1968, under no. 19; Boggs 1969, 153, 155, fig. 1; Vertova 1969, 42–43, fig. 1; Toesca 1970, 62–66, pl. 60 and color pl.; Boggs 1971, 58, pl. 156; Mode 1972, 370; Berlin 1973, 21–25; New York 1975a, under no. 33; Northampton 1978, under no. 101; Degenhart and Schmitt 1980, 2: 380–382, under no. 714; Amsterdam 1981a, 9–10; Bean and Turčić 1982, 284; Malibu 1983, 18; Vienna 1986, 168–171; Madrid 1986, under no. 86; London 1987d, 201

Exhibitions: London 1896; London 1959, no. 4; Toronto 1968, no. 2; London 1969, no. 1; Florence 1969, no. 1; Paris 1969–1970, no. 1

Acc. no. 9896

This drawing is a page from a book of illustrations of famous personages, or *uomini famosi*, mostly from classical and biblical times. Altogether, nine pages of the picture chronicle are known today. Eight of the pages, including sheets in the Rijksprentenkabinet, Amsterdam, the National Gallery of Victoria, Melbourne, the Metropolitan Museum of Art (two pages), and the Ian Woodner Collection, New York, were acquired unbound in 1894 by William Morris and later belonged to his disciple, Sir Sydney Cockerell.[1] A ninth sheet, also discovered in England, is now in the Kupferstichkabinett, Berlin-Dahlem.[2]

The verso of the present page bears traces of figures on the sheet in Amsterdam, while indications of the figures on the Ottawa page appear on the verso of one of the two sheets in the Metropolitan Museum.

The individual figures on the surviving pages are identified by inscriptions in Latin, and in many cases in French by a

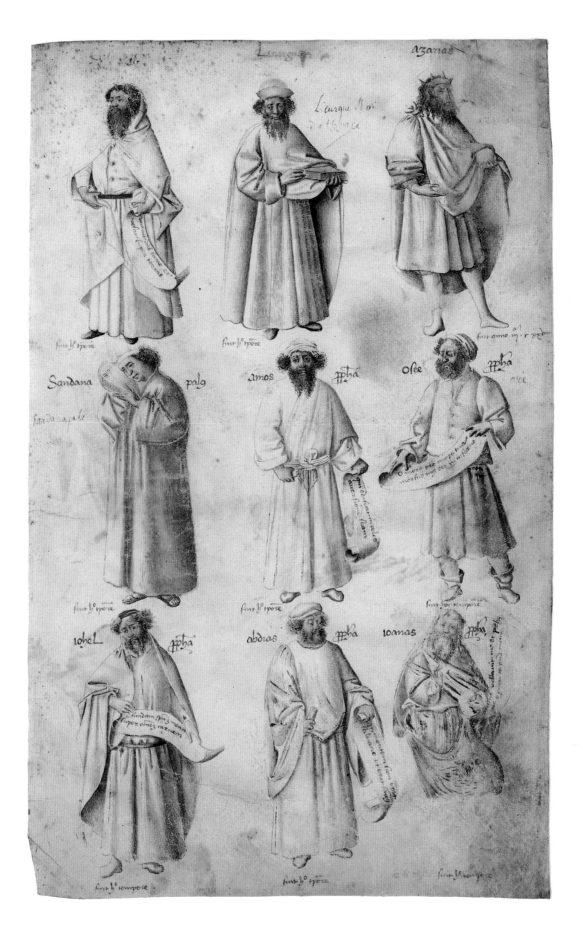

Fig. 1. Leonardo da Besozzo, *Uomini famosi* (folio 6, verso), Crespi Collection, Milan

later hand. The present sheet includes six prophets: Elisha, Amos, Hosea, Joel, Obadiah, and Jonah, each carrying a scroll inscribed with a text from the respective prophet as recorded in the Old Testament; King Azariah of Judah; and two nonbiblical figures: Sardanapalus, the legendary Assyrian, and Lycurgus, the Greek. The arrangement and identification of the nine figures are identical with a page (folio 6, verso) in an intact picture chronicle in the Crespi Collection, Milan (fig. 1). But where the figures in the sheets from the Cockerell chronicle are isolated one from another against the neutral background of the vellum, the figures in the Crespi chronicle share a continuous space defined by a flat platform at the bottom of each register and a solid blue background. The Crespi chronicle is signed by Leonardo da Besozzo, an artist from Lombardy. It has long been recognized that Leonardo da Besozzo was not the originator of this series of *uomini famosi,* and that because his figures are interrupted by architectural features, such as windows, he must have been copying a series of wall paintings.[3] These paintings have now been identified as the lost frescoes attributed to Masolino in the *sala teatri* of the palace be-

longing to Cardinal Giordano Orsini on Monte Giordano in Rome.[4] The frescoes were completed before 1432 and were probably destroyed in the 1480s.[5] Leonardo da Besozzo could have made his copies after the Monte Giordano frescoes on his way to or from Naples, where he undertook paintings in the choir of S. Giovanni a Carbonara shortly after 1433.[6] Altogether, the frescoes in the Palazzo Orsini represented over three hundred full-length personages beginning with Adam and Eve and proceeding through the Eusebian six ages to Tamerlane who died in 1405. The fame of the *uomini famosi* in the Palazzo Orsini was considerable: apart from the Cockerell and Crespi chronicles, three other sets of illustrations and two early verbal descriptions of the frescoes are known today.[7]

The page from Ottawa represents personages from the Fourth Age, which commences with David and ends with Peisistratus. King Azariah on the present sheet is inscribed with a date that is partly defaced but which can be determined from the other sources as 3129.[8] The dates throughout the Monte Giordano series are reckoned from the creation of the world, with the birth of Christ fixed at 3963.[9]

In many instances the artist of the Cockerell chronicle has simplified the figures of the Crespi chronicle. Thus the figures around Elisha's feet and the sea around Jonah's whale are eliminated altogether and King Azariah has abandoned the scepter he is shown holding in his right hand in the Crespi chronicle. In the case of Sardanapalus the situation is more complicated and may imply a misunderstanding of the model: the musical instruments around his feet have been dispensed with in the Ottawa sheet and the ruler now listens to a stringed instrument pressed next to his cheek, instead of resting his head on a pillow as is shown in the Crespi chronicle and described in one of the two verbal records of the Palazzo Orsini frescoes (*Sardanapalus super pulinari dormiens*).[10]

The figures in the sheets from the Cockerell chronicle display a delicacy of color (rose, blue, olive green, and lavender) and a refined assurance of draftsmanship absent in the Crespi chronicle. The faces possess an animated individuality, and the volumetric drapery is modeled with light coming from a single

source. Yet the identity of the artist who made these copies has not been conclusively established. Berenson, who did not mention the connection with the Crespi chronicle, listed the drawings generically as by the school of Fra Angelico, an artist similar to Pesellino or Domenico Veneziano.[11] Fedja Anzelewsky in discussing the sheet in Berlin suggested a Lombard artist working 1440–1450.[12] More widely accepted has been Ilaria Toesca's proposal that the artist may have been French, and an artist influenced by Piero della Francesca such as Jean Fouquet (c. 1420–1477/1481), who was in Rome as a painter to Pope Eugenius IV.[13] The latter died in 1447. Toesca considered the Ottawa sheet to be the finest of the surviving pages.

DMCT

1. The eight pages were dispersed in 1958: Sotheby's, London, 2 July 1958, lots 15–22, all illustrated.
2. Berlin 1973, 21–25, no. 27.
3. The chronicle was first published by Brockhaus 1885, 42–64. Fiocco 1935, 385–404, and Ragghianti 1937 associated the figures with Paolo Uccello's monochromatic *giganti,* painted in the Casa Vitaliani, Padua, in the 1440s.
4. Scheller 1962, 61; Simpson 1966, 135–159.
5. Simpson 1966, 140, 158; Mode 1972, 369, n. 2.
6. Scheller 1962, 67, n. 30; Mode 1972, 370, n. 12.
7. The illustrated chronicles are the *Libro di Giusto,* Gabinetto Nazionale delle Stampe, Rome; a manuscript (ms. 102) in the Biblioteca Reale, Turin; and another recently on the New York market (Kraus 1985, no. 1); the two descriptions were published by Simpson 1966, 150–159.
8. Simpson 1966, 152–153.
9. One of the two manuscript descriptions gives the date as 3663 (Simpson 1966, 156).
10. Simpson 1966, 153.
11. Berenson 1938, 2:17, no. 164c.
12. Berlin 1973, 21–25, no. 27.
13. Toesca 1952, 16–20; Toesca 1970, 62–66. See also Longhi 1952, 56–57; van Regteren Altena 1959, 82–83; Lombardi 1973, 71–73, 79, 81–83.

## 2
## *Sheet of Studies*

**Perino del Vaga**

Florence 1501–1547 Rome

Pen and black ink on laid paper

Verso: *Sheet of Studies*

Pen and black ink and red chalk (for decorative design)

172 x 178 (6¾ x 7)

Inscribed by the artist, verso lower right, in pen and the same ink as that of the drawing, *perino*

Provenance: Unidentified mark (Lugt 2683); purchased from P. & D. Colnaghi, London, 1963, through A. E. Popham

Literature: Popham and Fenwick 1965, 15, no. 18; Gibbons 1967, fig. 3 (recto); Gibbons 1977, 1:212

Exhibition: Providence 1973, no. 67

Acc. no. 9974

The verso of this drawing includes what is probably a signature, and the old blue laid-paper mount (now detached) is inscribed *Perino del Vaga del* and *N.° 9.* There is no reason to doubt this attribution, even though a direct connection with a finished work by Perino del Vaga has never been established.

On both the recto and verso the drawings contain a variety of studies that may well have been undertaken for more than one project, or else were executed at random. On the recto's upper part a group of slender male nudes advances toward a landscape with a large tree; on the lower part are details of an arm and of feet and a seated nude. Below the middle, the sheet has been folded horizontally and a scale numbered *5 10 5* inscribed along this line. The verso also shows male nudes, which are evidently part of two separate scenes: one on the left with numerous figures clambering out of a body of water; and one at the upper right with a group of four seated nudes, at least two of which seem to be wearing hats or crowns. There are also vessels *all'antica* at the lower right and grotesques drawn in red chalk at the upper left. From the evidence of the verso in particular, it is clear that the sheet has been cropped on all

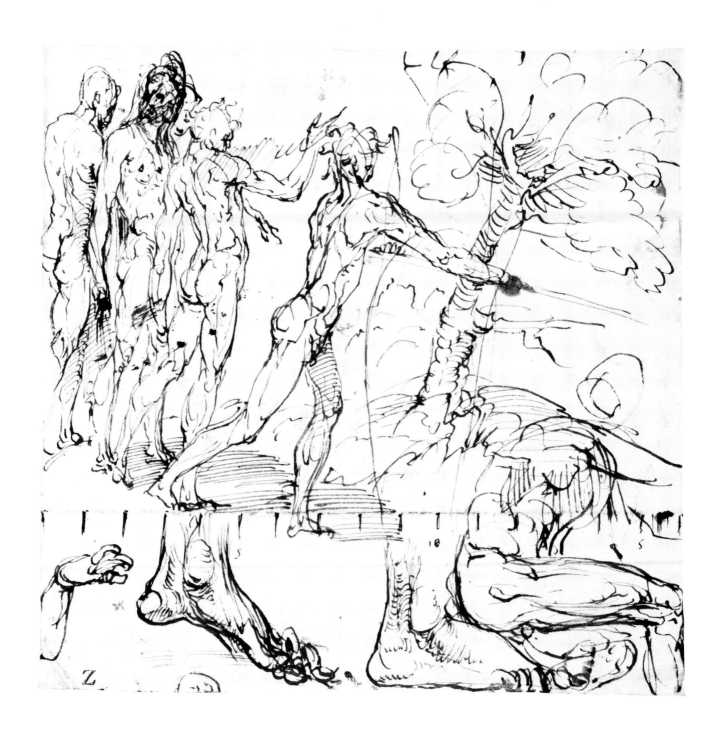

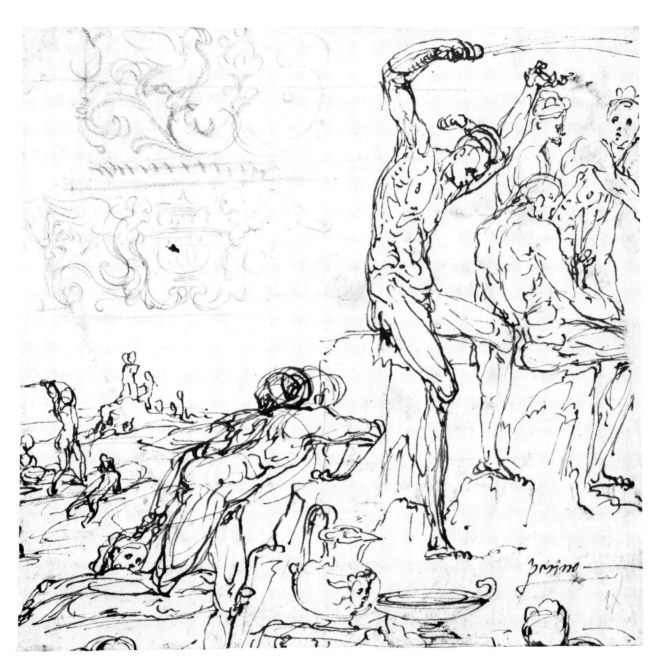

Cat. 2, verso

sides; yet the numbered scale starts logically from the left-hand side of the page in its present dimensions.

A precise identification of these studies has not been ascertained, but Popham remarked that the scene on the left of the verso appears to be for a composition of the Deluge.[1] Subjects involving violent incidents at sea seem to have fascinated Perino: in 1522–1523 in Florence he himself picked the theme of the Crossing of the Red Sea for a monochromatic canvas now in the Uffizi; and during his sojourn in Genoa in 1528–1538 he did a ceiling painting in the Palazzo Doria of Neptune calming the storm after the shipwreck of Aeneas.[2] This painting is now lost but a composition drawing for it has been identified in the Louvre.[3] While the drawing in Ottawa does not correspond in any specific detail with either of these works, it is not impossible that it was executed with such a commission in mind.

The drawing has been compared to several other sheets of figure studies that can be dated to Perino's Genoese sojourn or to his visits to Pisa during the same years. These include a sheet in the Art Institute of Chicago and one in the Art Museum, Princeton University.[4]

It might be noted that in the present sheet the linear treatment of the musculature is so emphatic as to give the impression that the figures are almost *écorchés*.

DMCT

1. Popham and Fenwick 1965, 15.
2. Vasari 1878–1885, 5: 603, 615; Parma Armani 1986, 53, 99–101, 338–340, fig. 45.
3. Inv. no. 636. Florence 1966, 24–25, no. 17, fig. 16; and Paris 1983a, 79–80, no. 90.
4. Leonora Hall Gurley Memorial Collection, Chicago, inv. no. 22.477: Providence 1973, 59–60, no. 65; Joachim and McCullagh 1979, 25–26, no. 10, pls. 15–16. Princeton 47-16: Gibbons 1977, 1:212, no. 692.

## 3

a. *Design for an Interior Wall Decoration with a Lion and Figures*

b. *Design for an Interior Wall Decoration with Three Figures*

**Lelio Orsi**
Novellara c. 1511–1587 Novellara

Pen and brown ink with brown wash over traces of black lead (or graphite?) on buff laid paper, laid down on heavy laid paper

a. 188 x 91 (7⁷/₁₆ x 3⁹/₁₆); b. 187 x 92 (7³/₈ x 3⁵/₈)

Inscribed in an unknown hand, verso of secondary support (a.), center top, in red chalk, partially obscured, *K206* (?); verso of secondary support (b.), center top, in red chalk, partially obscured, *K20* (?)

Provenance: A. D. Bérard (Lugt 7); G. Vallardi (Lugt 1223); purchased from H. M. Calmann, London, 1956, through Paul Oppé

Literature: Popham and Fenwick 1965, 23–24, no. 28; Vitzthum 1969, 10–11, figs. 1–2; Romani 1984, 64–65, 67, fig. 42 (a)

Exhibition: Paris 1969–1970, no. 5

Acc. nos. 6844.1 and 6844.2

These drawings are typical studies by Lelio Orsi, who worked for more than forty years for the Gonzaga counts at Novellara, north of Reggio Emilia, but whose life remains obscure, in part because he was not discussed by Giorgio Vasari. Evidently Orsi occupied himself with doing decorations on the facades and interiors of local houses, although in this endeavor he was clearly supported by the taste of the ruling counts. In 1563 Count Alfonso Gonzaga ordered all houses in Novellara to be decorated with facade frescoes.

The present drawings were probably not undertaken for facades but for the walls of an interior room. The rectangular area left blank at the top center of each drawing was no doubt intended to correspond to the space occupied by a transverse ceiling beam. Otherwise, the drawings comprise a rich mélange of popular mannerist motifs, such as harpies, garlands, and decorative consoles, interspersed with human figures entwined with animals—a common feature of Or-si's work. Two additional drawings, similar in format and style to the sheets exhibited here, are located in the Louvre (fig. 1).[1] The drawings in Ottawa and Paris have been dated by Romani to the first half of the 1560s.[2]

Among the various objects in the present drawings, the lion and sphere emblazoned with an eagle in cat. 3a assume special significance, and appear again in a drawing by Orsi most likely for a book illustration.[3] In fact, the lion and eagle had been used together as heraldic devices of the Gonzaga family since the fifteenth century;[4] their appearance in drawings by Orsi suggests connections with a Gonzaga commission. During the 1560s Orsi was engaged in doing wall decorations for the Gonzaga family in a new residence at Bagnolo and in the Casino di Sotto, the Casino di Sopra, and the Rocca in Novellara, but since little or no visual evidence remains of these commissions, it has been impossible to establish any exact relationship with these drawings.[5]

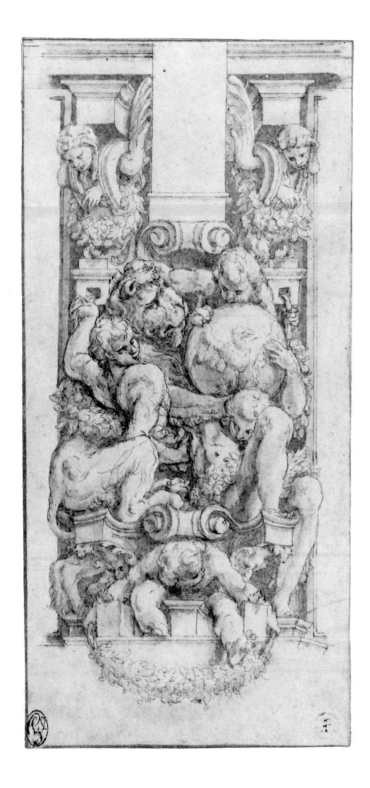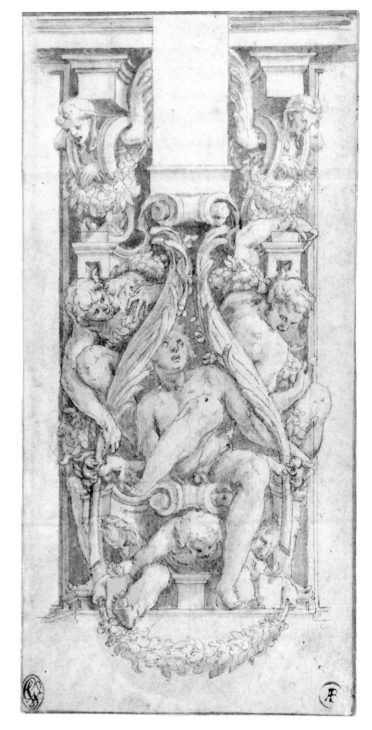

Fig. 1. Lelio Orsi, *Design for a Wall Decoration*, Musée du Louvre, Paris, Cabinet des Dessins (Cliché des Musées Nationaux)

Pierre-Jean Mariette, the eighteenth-century French connoisseur, remarked that "les desseins [*sic*] de ce peintre [Orsi] sont fort recherchés. Il a une assez belle plume, et joint au goût terrible de Michel-Ange les graces aimables du Corrège sous qui il a étudié."[6] While it cannot be proved that Orsi studied in nearby Parma with Correggio, the influence of the older artist is widespread in Orsi's work. Michelangelo's influence may well have increased after Orsi went to Rome in 1554–1555, but it is likely that it began sometime before.[7] That Orsi had closely studied the ceiling decorations of both Correggio and Michelangelo is suggested by the figures in the Ottawa drawings, even if they do not disclose direct appropriations from either master.

Popham proposed that these drawings may have been owned by John Talman (1677–1726), an amateur artist and son of William Talman the architect.[8] Talman collected architectural and ornamental drawings in particular and surrounded them with gold tooling, as is found around these sheets.

DMCT

1. Inv. nos. 6689 and 6690 (fig. 1). Villani 1955, 71, pl. 3; Romani 1984, 64–65, fig. 41 (inv. no. 6689).
2. Romani 1984, 84.
3. Albertina, inv. no. 2729; Romani 1984, 67, fig. 46.
4. Litta 1819–1911, 4, fasc. 48, pl. 1.
5. For the commissions, see Romani 1984, 7–9, 53–57.
6. Mariette 1851–1860, 4:63.
7. Romani 1982, 41–61; Romani 1984, 28–37, has proposed an earlier trip by Orsi to Rome, during the second half of the 1540s.
8. Popham and Fenwick 1965, 24.

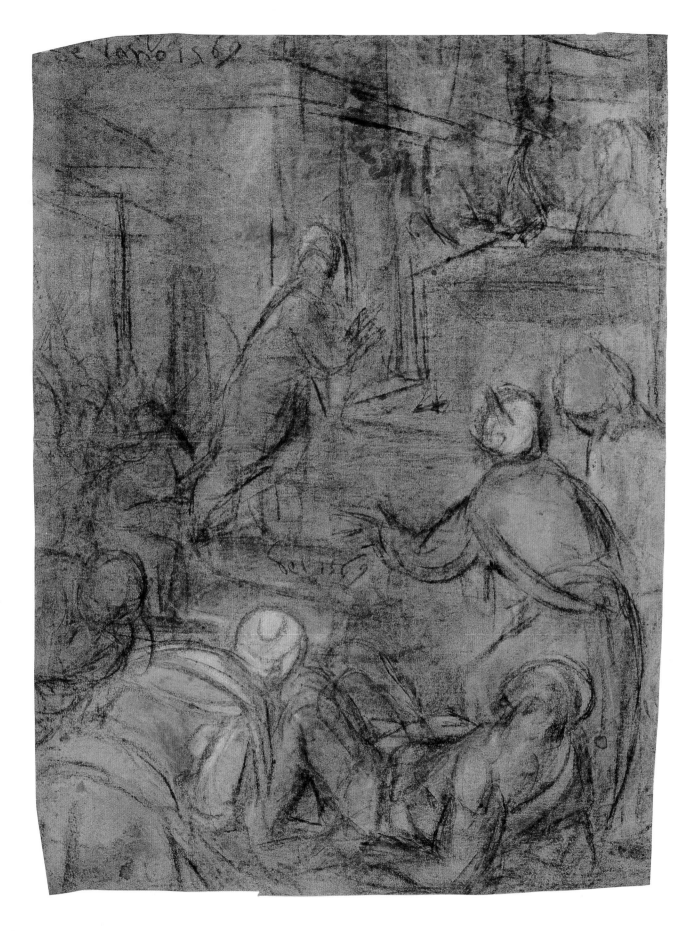

**4**

*The Presentation of the Virgin, 1569*

**Jacopo da Ponte,
called Jacopo Bassano**

Bassano del Grappa 1510/1515–1592
Bassano del Grappa

Black, white, and colored chalks, on blue-gray laid paper, mounted on laid paper

520 x 397 (20¹/₂ x 15⁵/₈), irregular

Inscribed by the artist, upper left, in black chalk, *de lano 1569*; at center on the steps, in black chalk, *del 1569*; in an unknown hand, lower right of secondary support, in pen and brown ink, *B.B. n° 23*; in an unknown hand, verso, in pen and brown ink, *B.B. n° 88*; lower left, in pen and brown ink, *di Jacopo Bassan*

Provenance: Collection formerly thought to be that of the Borghese; M. Marignane (Lugt 1872); A. de Hevesy(?); purchased from H. M. Calmann, London, 1938, through Paul Oppé

Literature: Mongan and Sachs 1940, 1:52, under no. 64; Oppé 1941, 55; Tietze and Tietze-Conrat 1944, 52, no. 177, pl. 143; Muraro 1954, 54; Muraro 1957, 296; Venice 1958, 22, under no. 2; Zampetti 1958, 44 and pl. 83; Arslan 1960, 113, 170, 173, 177, pl. 153; Rearick 1962, 529, fig. 12; Zampetti 1964; fig. 3; Fenwick 1964, 1; Popham and Fenwick 1965, 19, no. 25; Vitzthum 1969, 12, fig. 5; Vertova 1969, 45; Boggs 1971, 33 and pl. 159; Ballarin 1973, 122 and n. 1; Pallucchini 1982, no. 83; Scarpa 1987, 395

Exhibitions: Indianapolis 1954, no. 52; Venice 1957a, no. 11; New York 1961, no. 6; Toronto 1968, no. 4; London 1969, 15, no. 5; Florence 1969, no. 2; Paris 1969–1970, no. 4

Acc. no. 4431

This large drawing from Jacopo Bassano's full maturity is an early example of colored chalks used to realize a composition. Even earlier instances of this use of several colored chalks are his drawings of the *Scourging of Christ*, formerly in the collection of H. M. Calmann and now in the National Gallery of Art, Washington, and of the *Arrest of Christ*, now in the Musée du Louvre, both of which are dated 1568.[1] All three drawings were once part of an album that was formerly thought to have belonged to the Borghese family.

Whereas black or red chalk applied singly or with white heightening had long been a popular medium in Venice, the use of a combination of several colored chalks was very rare. In Lombardy, Leonardo and some of his followers had occasionally employed colored chalks for individual figure or portrait studies, but it was Jacopo Bassano who during the third quarter of the century made a practice of using colored chalks for figure studies and for entire compositions. At about the same time, and perhaps independently, Federico Barocci began extensively to employ colored chalks on blue paper for similar purposes.[2]

Of the three composition drawings from 1568–1569, the sheet in Ottawa is the most summary: only slight attention has been paid to modeling, and details such as features are ignored entirely. However, the black outlines are emphatic and abrupt, and as Rearick observed they "splinter with a ferocious vitality unique in the sixteenth century."[3] The outlines also contain many changes or correc-

tions, such as those to the position of the arms of the figure to the left of the steps or of the legs of the reclining man at the bottom right. These pentimenti suggest something of Bassano's restless and dynamic creativity, of his enduring quest for new pictorial solutions. It is revealing that on another drawing dated 1569, Jacopo Bassano wrote ''Nil mihi placet'' (Nothing pleases me).[4]

While Rearick related the drawing in Washington to a painting of the *Scourging of Christ* by Jacopo Bassano in the Accademia, Venice,[5] neither the drawing in Paris of the *Arrest of Christ* nor the sheet in Ottawa has been connected with a finished work of art. Yet it is almost certain that both were undertaken in preparation of specific paintings.[6]

Oppé, followed by Tietze and Tietze-Conrat, pointed out the compositional similarity between the Ottawa drawing and a painting of the *Circumcision* in the Museo Civico, Bassano, which is signed by Jacopo Bassano and his son Francesco, and dated 1577.[7] At the same time Oppé and Tietze-Conrat both acknowledged that the drawing most likely represents the Presentation of the Virgin in the Temple. In fact in his maturity Jacopo Bassano often favored compositions with protagonists mounting diagonal flights of stairs. Figures such as the reclining man supported on his elbows at the lower right are also frequently found in contemporary compositions by Bassano. Another, even larger drawing in Warsaw of the *Presentation of the Virgin in the Temple* by Bassano was published by Mrozinska; she noted its similarity in style and composition to the Ottawa drawing, though the composition is reversed and the architectural setting is more spacious.[8] The composition is also horizontal. Despite these differences Popham believed that the two drawings were probably studies for the same picture. Rearick dated the Warsaw drawing to about 1575, a proposal supported by Ballarin.[9]

Whatever the exact purpose of these drawings of the Presentation of the Virgin in the Temple, they constitute significant representations of a subject, summarized by Jacobus de Voragine in the *Golden Legend,* that had engaged such major Venetian painters as Carpaccio, Cima, Lotto, Titian, and Tintoretto.

DMCT

1. Rearick 1962, 525–526; Paris 1984, 14, no. 10.
2. For a recent discussion of Barocci's relationship with Jacopo Bassano, see Washington 1984, 37.
3. Rearick 1962, 529.
4. *The Visitation,* Uffizi, inv. no. 13953F; Tietze and Tietze-Conrat 1944, 51, no. 146, pl. 145; and Muraro 1957, 292; Rearick 1962, 530; Florence 1976, 162–164, no. 118, fig. 92.
5. Rearick 1962, 525–526, fig. 10.
6. On 25 May 1581 Francesco Bassano wrote to the Florentine collector Niccolò Gaddi: ''. . . perchè noi non avemo disegnato molto, nè avemo mai fatto professione tale, ma ben avemo messo ogni studio in cercar di far le opere, che abbiano a riuscir al miglior modo che sia possibile,'' Bottari and Ticozzi 1822–1825, 3: 265–266.
7. Oppé 1941, 55; Tietze and Tietze-Conrat 1944, 52, no. 177.
8. Venice 1958, 21–22, no. 2; London 1980, no. 2, pl. 8.
9. Rearick 1962, 529, n. 16; Ballarin 1969, 96, 111, n. 29.

## 5

## *Temperance*, c. 1561–1562

**Federico Barocci**
Urbino c. 1535–1612 Urbino

Pen and brown ink with brown wash, heightened with opaque white, on blue laid paper, laid down on card backing

226 x 101 (8¹⁵/₁₆ x 4)

Inscribed in an unknown hand, lower left, in pen and brown ink, *Barocci;* in an unknown hand, verso of secondary support, top edge, in blue pencil, *286;* lower edge, in graphite, *A 21990 (10-27)*

Provenance: Unidentified mark (not in Lugt); purchased from P. & D. Colnaghi, London, 1957, through Paul Oppé

Literature: Popham and Fenwick 1965, 31–32, no. 40; Gere 1969, 182, no. 153; Smith 1970, 108–110, fig. 55; Smith 1973, 88, fig. 8; Smith 1977, 65–66; Smith 1978, 333; Emiliani 1985, 1:23

Exhibition: Cleveland 1978, no. 7

Acc. no. 6896

Fig. 1. Attributed to Federico Barocci, *Temperance,* Casino of Pius IV, Vatican Gardens, Rome

Despite the old attribution to Federico Barocci at the lower left, this drawing of one of the four cardinal virtues has been published by Popham, Gere, and Smith as by Taddeo Zuccaro.[1] Popham noted that at one stage in his career Barocci produced drawings resembling those of his slightly older compatriot Taddeo Zuccaro. A lively pen line, ample applications of brown wash and white heightening, and the use of blue paper characterize the technique of such drawings. Smith pointed out that the drawing is related, though with many differences, to a *Temperance* fresco (fig. 1) in one corner of the coved ceiling of an upper room in the Casino of Pius IV, a small villa in the Vatican Gardens, Rome.[2] Designed by Pirro Ligorio, the Casino was lavishly decorated between 1561 and late 1562 by a number of artists, including Santi di Tito, Orazio Sammacchini, Barocci, and Federico Zuccaro. Although there has been confusion over the specific contributions of the various artists involved, Taddeo Zuccaro's name has not entered into the discussion; and in fact he is never mentioned in the payments for the work in the Casino. The room with the figure of

Temperance has in the past been ascribed to the Florentine artist Santi di Tito. Smith instead reattributed the *Temperance* fresco to Federico Zuccaro (who is known to have worked in the Casino), and explained that Federico used the drawing by his elder brother, Taddeo, as a model. This was a practice followed by Federico on a number of occasions.

More recently Edmund P. Pillsbury challenged this interpretation. Pillsbury endorsed the association of the drawing with the fresco in the Casino of Pius IV, but he reverted to the traditional attribution of the sheet. He convincingly argued that the drawing displays Barocci's pictorial use of light and shade to realize form, in contrast to Taddeo's more systematic, plastic approach. The way in which the figure is conceived is also characteristic of Barocci: ''first as a sketch of a naked torso—one, in fact, reminiscent of Michelangelo's *Risen Christ* in the Minerva—executed to establish the pose and subsequently as a study of the drapery covering the figure to fix its final form.''[3] Independently Gere also came to the conclusion that the drawing is by Barocci.[4]

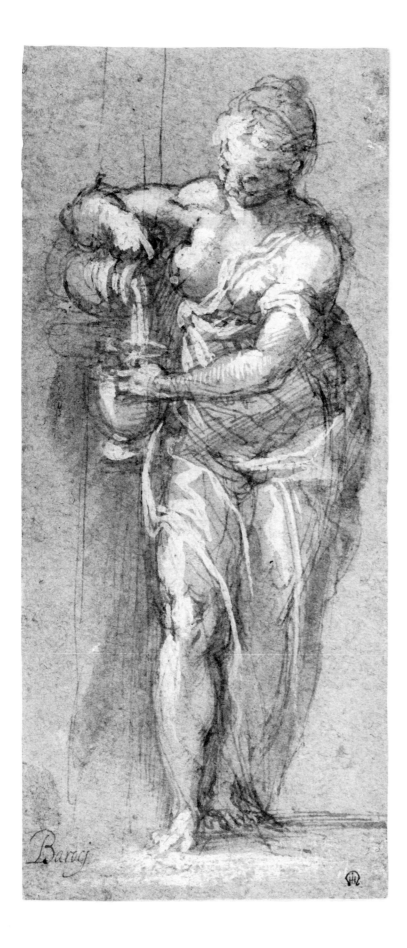

Pillsbury further observed that the frescoes of the virtues on the cove of the second floor room appear to be by several hands, and that of all the figures Temperance has perhaps the most distinctive stylistic traits. In the use of rich color suffused with a brilliant light, Temperance is comparable to Barocci's figures in the large room on the ground floor of the Casino. The pose of the figure also bears comparison with one in Barocci's *Martyrdom of Saint Sebastian,* an altarpiece from 1557–1558 in the Duomo of Urbino. Pillsbury thus concluded that the fresco of *Temperance* must also have been painted by Barocci.

At Windsor there is an old copy of this drawing. Although Tietze and Tietze-Conrat attributed the Windsor drawing to Giuseppe (Porta) Salviati, the correct relationship to the Ottawa drawing was noted by Gere.[5]

DMCT

1. See Literature above.
2. Smith 1970.
3. Cleveland 1978, 34.
4. On an annotation on the drawing's mount. Smith 1978, 333, also seemed now to accept the attribution of the drawing to Barocci.
5. Tietze and Tietze-Conrat 1944, 245, no. 1396; Popham and Fenwick 1965, 32; Schilling and Blunt 1971 (?), 128, no. 523.

## 6

## *Trinity Surrounded by Angels*

**Federico Zuccaro**
Sant'Angelo in Vado c. 1540–1609 Ancona

Pen and brown (iron gall) ink and wash, with some yellow pigment above the upper figures, on off-white laid paper, laid down on laid paper

341 x 252 (13⅞ x 9⅞), corners cut diagonally

Inscribed in an unknown hand, lower left edge, in pen and brown (iron gall) ink, *tadeus Succarus*

Provenance: Purchased from W. R. Jeudwine, London, 1963, through A. E. Popham

Literature: Popham and Fenwick 1965, 33–34, no. 44; Macandrew 1980, 83

Exhibition: London 1963b, no. 3, pl. 11

Acc. no. 9975

Although the drawing bears an old inscription to Taddeo Zuccaro at the lower left, Philip Pouncey recognized the sheet as a preliminary study by Taddeo's younger brother, Federico.[1] Pouncey related the drawing to Federico's fresco in the cupola of the Chapel of Angels (Cappella degli Angeli), the third chapel on the right in the mother church of the Jesuits, the Gesù in Rome (fig. 1).

Federico's paintings in the chapel—including an altarpiece, *The Archangels Adoring the Trinity,* and frescoes with scenes of Hell and Purgatory and of angelic intercession—form part of a major Counter-Reformation program of decorations undertaken throughout the newly constructed church from the 1580s onward. The iconographic unity of the decorations as a whole was explicated by the late Howard Hibbard.[2] He showed that the subject matter of the nave chapels moves from historical scenes with human beings, at the entrance of the church, to theological concepts with heavenly beings, next to the transepts and the crossing with the "dome of heaven." The Chapel of Angels is thematically paired with the Chapel of the Trinity, directly across the nave from it. Founded in 1588 by Gaspare Garzonio, who then lost his fortune, the Chapel of Angels subsequently came under the patronage of

Curzio Vittorio and his wife. Their arms appear on the altar tabernacle. While the exact date of Federico's decorations has never been established, it is usually given as the mid-1590s.

Significant differences appear between the Ottawa drawing and the finished fresco. Most notably, the scale and action of several of the major figures have altered. In the drawing, the Trinity in the

Fig. 1. Federico Zuccaro, *Assumption, Coronation, and Trinity,* Cappella degli Angeli, Il Gesù, Rome

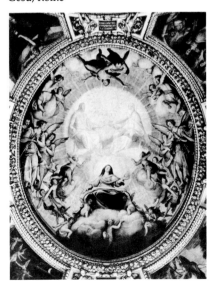

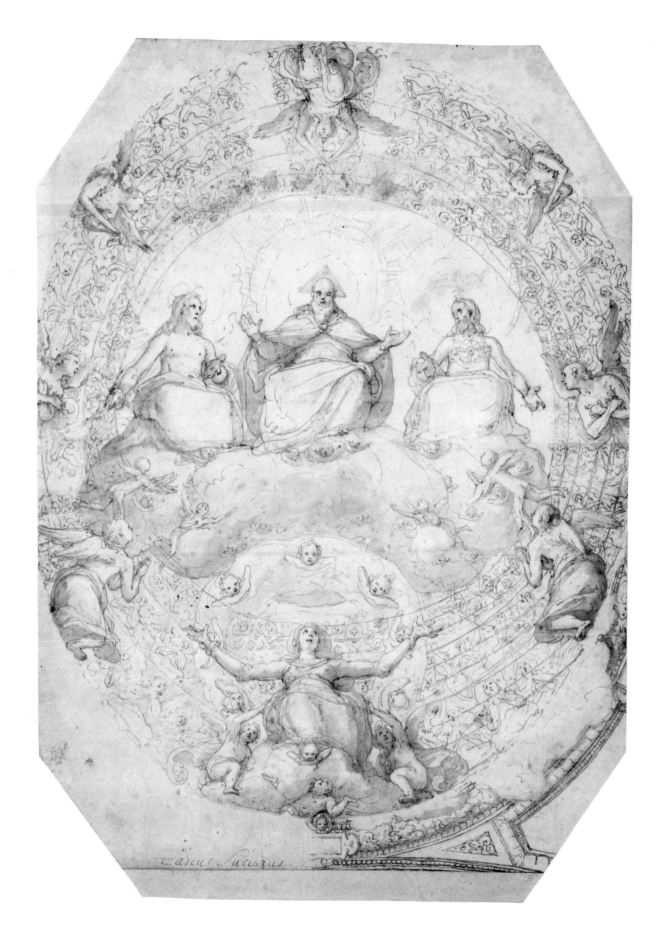

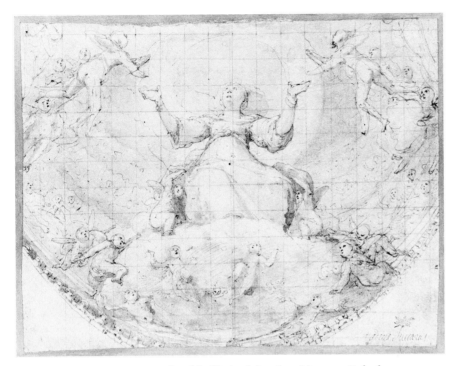

Fig. 2. Federico Zuccaro, *Assumption of the Virgin,* Ashmolean Museum, Oxford

center is the predominant feature. God the Father is shown in the middle, his arms extended from an encompassing mantle, and his bald head superimposed on a triangular nimbus; he is flanked by God the Son, Jesus Christ, at the left, and on the right by the Holy Ghost, shown as another seated male figure—a relatively unusual interpretation. The dove of the Holy Ghost faintly hovers above this figure and appears again against his chest. Below, the Virgin Mary is seated with widely outstretched arms and an upward gaze directed toward the central group.[3] She is encircled in an aureole of light and cherubim, and the entire ceiling is enclosed in concentric rings of other angels, which is appropriate to the chapel's dedication. In the fresco Mary is given greater prominence and is shown closer to the Trinity. God the Son and God the Father, now seated opposite each other, are about to crown her Queen of Heaven, while above on the same axis the more conventional dove as symbol of the Holy Ghost emits radiance in all directions. The cupola thus includes the Coronation of the Virgin, not present in

the drawing, and a more traditional representation of the Trinity. The interpretation of the Trinity is in fact analogous to that in the altarpiece by Francesco Bassano in the opposite Chapel of the Trinity.

In both the drawing (at the bottom) and the fresco, the oval decoration is framed by a garland. But whereas in the chapel the fresco is discretely contained within the stucco molding of pomegranates and grapes, in the drawing the clouds supporting the angels spill over the frame. This is a feature of no little interest in view of Giovanni Battista Gaulli's much more conspicuous adoption of the same illusionistic device in his ceiling fresco of the nave of the Gesù from 1676–1679.[4]

A second drawing by Federico Zuccaro for the cupola of the Chapel of Angels, now in the Ashmolean Museum, Oxford (fig. 2), must have been done subsequent to the Ottawa sheet.[5] Showing only the lower half of the oval decoration, the Oxford drawing is squared for transfer and includes a hinged flap of paper with a corrected study of the Virgin, whose

pose comes closer to that in the completed fresco. Since both the Oxford and Ottawa drawings are similarly inscribed *tadeus Succarus,* it is probable that at one time they were in the same collection. The Oxford drawing was owned by Richard Boyle, 1st Earl of Burlington (1612–1697), and Jonathan Richardson, Sr. (1665–1745), who correctly attributed the drawing to Federico Zuccaro.

DMCT

1. London 1963b, under no. 3.
2. Hibbard 1972, 29–49.
3. This is a variation on the pose of the Virgin in the *Assumption* in the Pucci Chapel, S. Trinità dei Monti, completed by Federico Zuccaro in 1589. For the chapel, see Gere 1966, 284–293.
4. Compare with Enggass 1964, 50: ''. . . [Gaulli's] major innovation consists in breaking clearly, broadly and dramatically over the three-dimensional frame. . . .'' Enggass 1964, 44, remarks that the subject of the ceiling is the same as that of Federico Zuccaro's altarpiece in the Chapel of the Angels. This is not quite true: the altarpiece represents the adoration of the Trinity, the ceiling the name of Jesus.
5. Macandrew 1980, 82–83.

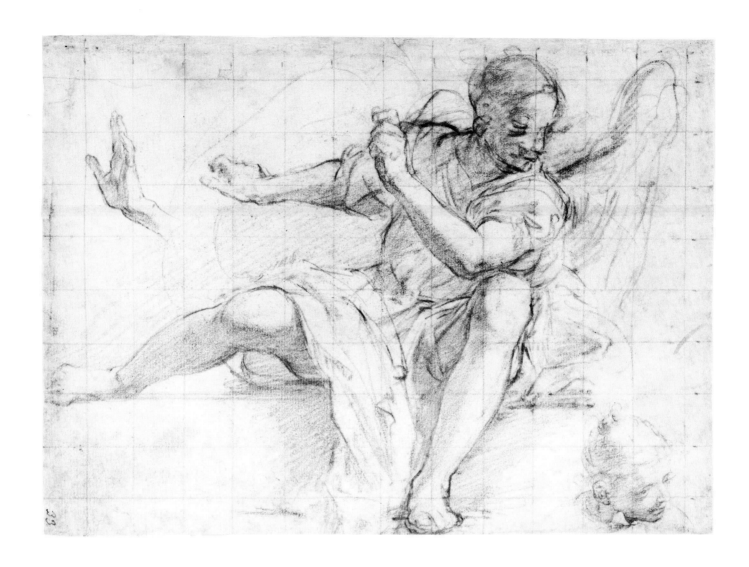

7

*Seated Angel*

**Attributed to
Bernardino Poccetti**

San Marino 1548–1612 Florence

Red chalk on laid paper, squared for transfer

219 x 306 (8⅝ x 12¹/₁₆)

Watermark: Crown surmounted by star

Provenance: Purchased from Faerber and Maison,
London, 1969

Acc. no. 15899

This drawing of a seated, gesticulating angel viewed *sotto in su* bore at the time of its purchase an attribution to the Florentine artist Baldassare Franceschini, called Il Volterrano. The source of this attribution is not known. Although the drawing is clearly seventeenth-century Florentine, the attribution to Volterrano is not convincing. In 1981 Lawrence Turčić suggested an attribution to Bernar-

dino Poccetti. Jacob Bean had made the same observation earlier and independently.[1] Bean subsequently suggested a comparison with two other drawings attributed to Poccetti of actively gesticulating angels seen from below, also in red chalk and squared for transfer: *Study for an Angel* (private collection, New York) and *Study of an Angel* (Yale University Art Gallery, New Haven).[2] The Yale drawing, which was purchased from the same source as the Ottawa sheet, bears an old inscription on the verso giving it to Poccetti.

To these drawings might be added several others that are similar in style, all relating to various of Poccetti's commissions in the church of SS. Annunziata in Florence. Hermann Voss recognized a study in the Kupferstichkabinett, Berlin, as being by Poccetti for one of the angels in his lunette fresco in the church of the SS. Annunziata in Florence.[3] There are also several sheets from the Uffizi Gallery's extensive collection of Poccetti drawings that were identified by Walter Vitzthum as being preparatory studies by the artist for his frescoes in the Cappella di San Sebastiano in the SS. Annunziata.[4] Aside from their generic similarities in terms of subject, these drawings show a number of similar characteristics in the dynamic pose and vigorous gestures of the figures, the artist's frequent habit of developing details in the odd corner of the sheet, and the combinations of subtle modeling and crisp line, smoothly curving contours and angular accents.

The evidence for a Poccetti attribution for the Ottawa drawing is still circumstantial, however, as it has not been possible to link the study directly to a finished work. Poccetti's work both in the SS. Annunziata and in S. Maria Maddalena dei Pazzi contains numerous depictions of angels perched precariously on shelves, demonstrating by their gestures the action in the central scene. Turčić noted that the pose of the Ottawa angel is almost identical, in reverse, to that of an angel in the half lunette fresco above and to the right of the *Last Supper* in a chapel in the Florentine church of S. Appollonia.[5] The fresco is signed and dated 1611.

M C

1. Turčić, verbal communication, 1983. Turčić subsequently found that Bean had annotated a photograph of the drawing with the same suggested attribution.
2. Haverkamp-Begemann and Logan 1970, 1: no. 274, 2: pl. 147, as "attr. Bernardino Poccetti."
3. Voss 1920, 2:371.
4. Florence 1980, no. 81. These are: *A Seated Angel* (8748 F, fig. 99), *An Angel* (8607 F), *A Putto and Two Studies for a Seated Woman* (847 F v), and *Two Putti* (847 F r). Another study, again *Two Putti* (340 F), is cited there as having been identified by Anna Maria Petrioli Tofani and Anna Forlani Tempesti for the Annunziata frescoes.
5. Turčić, verbal communication, 1987. The fresco is reproduced in Vertova 1965, 90, fig. 39.

## 8

## *Virgin and Child*

**Ludovico Carracci**
Bologna 1555–1619 Bologna

Red chalk, heightened with white chalk, on faded greenish-blue laid paper

Verso: *Head of a Young Man Looking Up, a Hand, and a Fragment of Drapery*

Red and black chalk

282 x 245 (11⅛ x 9¹¹/₁₆)

Provenance: Count Bianconi; Sir Thomas Lawrence (Lugt 2445); Lord Francis Egerton, 1st Earl of Elles-mere (Lugt suppl. 2710b); 6th Duke of Sutherland; his sale, Sotheby's, London, 11 July 1972, lot 10; John Gaines, New York; purchased from Richard Day, London, 1976

Literature: Popham 1938, 14; Bodmer 1939, 150, pl. 125; Schilling and Blunt 1971(?), under no. 98; Bohn 1984, 424, no. 7

Exhibitions: London 1836, no. 1; London 1898, no. 57; London 1938, no. 390; Leicester 1954, no. 10; London 1955a, no. 4; Bologna 1956, no. 29, pl. 17; Newcastle upon Tyne 1961, no. 13; Ottawa 1982, no. 20

Acc. no. 18457

This study of the Virgin and Child, beautifully drawn in red chalk on contrasting greenish-blue paper, has been recently connected with Ludovico Carracci's painting of the *Martyrdom of Saints Ursula and Leonardo* from 1590.[1] Plausible though this association may be, it is not conclusive; the poses of both the Virgin and Child in the drawing are considerably different from those in the painting: the figures are represented high in the sky, with the Virgin's drapery only schematically indicated. In the drawing the artist looks down on his model, carefully rendering the folds in her sleeve and skirt, emphasizing shadows with a buildup of red chalk and catching the effects of light with touches of white chalk. The study is obviously one made from life, a practice advocated by the Carracci in the school they set up in Bologna in the 1580s. Were it not for the halo indicating its religious purpose, the drawing might otherwise be considered an end in itself. The intensity of detail, however, is unusual with Lu-dovico except when a study can be seen to have been directly transposed into paint. That the drawing was highly re-garded is evident from a copy made after it by a pupil in the Carracci academy, Giacomo Cavedone.[2]

The facial type of the Virgin, with hair pulled tightly back from a high, promi-nent forehead, pronounced cheekbones, and small tapering chin, owes much to Federico Barocci, a formative influence on the young Carracci family along with Correggio and the Venetians. The same physiognomy of the Virgin is evident in a further life drawing now given to Lu-dovico[3] and in one by another Carracci pupil, Pietro Faccini.[4] It is conceivable that there was a model or a member of the artists' immediate entourage who had these features, for she recurs as one of the martyrs in the picture of Saint Ur-sula mentioned above and in a later vari-ant of it in the town of Imola,[5] as well as

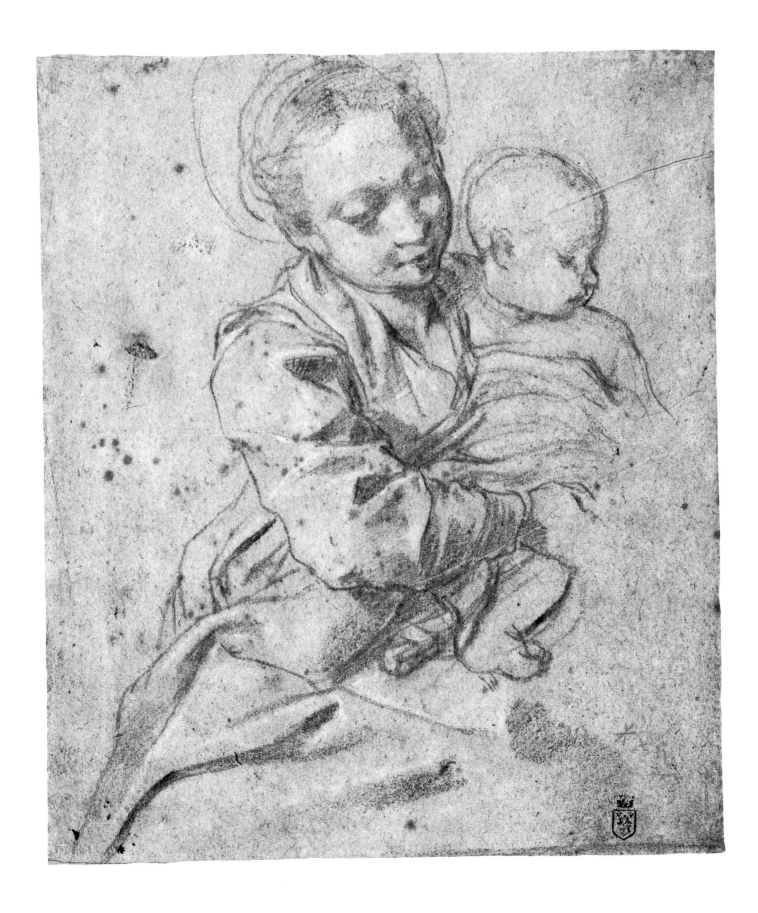

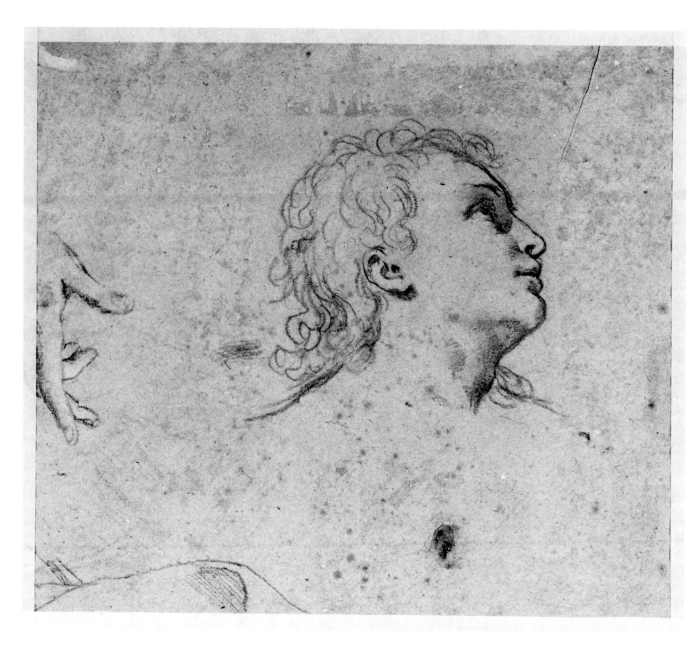

Cat. 8, verso

in a more generic, idealized form in other representations of the Virgin.[6]

Although the Virgin's hands and the babe's left arm have been left incomplete in this drawing, the sheet has been cut at the top, truncating the halo, and at the bottom, since on its reverse at this point occur the fingers of a study of a hand that has been clearly cut. Unrelated to the missing hand of the Virgin on the recto, the fingers on the verso are nevertheless typical of Ludovico's hands as seen in other drawings.[7]

The head of the young man in profile, his upward-turned eye cast in shadow, also on the verso, is similar to the youth bearing the bier at the left of the painting of the *Body of the Virgin Being Taken for Burial*.[8] Nevertheless, it is difficult to reconcile the monumental figure type characteristic of this later painting with the early date of the drawing on the recto, which is clearly from the 1580s.

CJ

1. Bohn 1984, 424, no. 7; see her fig. 9 and Bodmer 1939, pl. 16 for the painting.
2. Uffizi, inv. no. 9111, Santarelli Collection.
3. Uffizi, inv. no. 9108, Santarelli Collection; see Bohn 1984, 423, no. 6, pl. 6, where she quotes Leonore Street's attribution of this drawing to Ludovico despite the old inscription to Cavedone. The handling of this black chalk drawing is livelier, however, than the copy by Cavedone cited above and its identification with Ludovico is probably correct.
4. Metropolitan Museum of Art, Harry G. Sperling Fund and Rogers Fund 1975. Reproduced in Bean 1979, no. 160; also Ottawa 1982, no. 34.
5. Bodmer 1939, pl. 28.
6. Bodmer 1939, pls. 1, 21, 31.
7. Witt Collection, inv. no. 4198, reproduced in Bologna 1956, no. 25, pl. 9; Uffizi, inv. no. 1548 Orn, reproduced in Turner 1985, fig. 92.
8. Dated to c. 1608–1609; Galleria Nazionale, Parma, inv. no. 154, but painted for the cathedral at Piacenza; see Bodmer 1939, 133, no. 62, pl. 71.

## 9
## Vision of Saint Francis

**Annibale Carracci**
Bologna 1560–1609 Rome

Pen and brown (iron gall) ink and wash over black chalk on laid paper, formerly laid down on laid paper, overlaid with a decorative border similar to that used by Jonathan Richardson

Verso: *Study for a Doorframe with the Bust of a Cardinal in the Pediment*

Pen and brown (iron gall) ink

209 x 227 (8³/₁₆ x 8¹⁵/₁₆)

Inscribed in an unknown hand, verso of secondary support, lower left, in pen and brown (iron gall) ink, *Guercino*

Provenance: Thomas Hudson (Lugt 2432); Shickman Gallery, New York; purchased from David E. Rust, Washington, D.C., 1981

Literature: Posner 1971, 86, 163, no. 72, 166, no. 56, under no. 99; Malafarina 1976, under no. 92

Exhibitions: New York 1966a, no. 18; Ottawa 1982, no. 30

Acc. no. 26531

The drawing bears an old attribution to Guercino, which it evidently retained until modern times. It is so designated on a loose sheet numbered 59 with the reference "see no. 89" from an unidentified dealer's catalogue in the photographic archives of the National Gallery of Art, Washington. The present attribution to Annibale Carracci is due to Sir Denis Mahon.[1]

Mahon rightly connected the drawing with a painting by Annibale (fig. 1), formerly in the collections of the Duc d'Orléans and of the Duke of Bridgewater and his descendants, the Earls of Ellesmere. The preparatory drawing and picture were reunited through their recent acquisition by the National Gallery of Canada.[2] The scene of the Vision of Saint Francis was a favorite post-Tridentine subject[3] and was also depicted by Ludovico Carracci, Annibale's older cousin, on more than one occasion. The exquisite candor of Annibale's painting and the fact that it is on a small copper panel suggest that it was meant as a private devo-

Cat. 9, verso

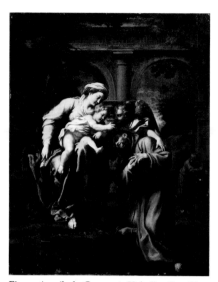

Fig. 1. Annibale Carracci, *Holy Family with Saint Francis*, National Gallery of Canada, Ottawa

Fig. 2. Annibale Carracci, *Portrait of Cardinal Odoardo Farnese*, Musée du Louvre, Paris, Cabinet des Dessins (Cliché des Musées Nationaux)

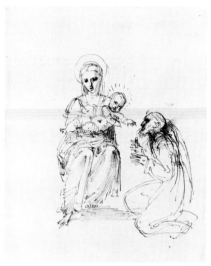

Fig. 3. Annibale Carracci, *Study for The Vision of Saint Francis*, Royal Library, Windsor Castle (Reproduced by Gracious Permission of Her Majesty The Queen; copyright Her Majesty The Queen)

tional work, although no record of its original owner exists. It was first cited by the Roman biographer Giovan Pietro Bellori[4] as belonging to Monsignor Lorenzo Salviati.

The painting has been dated to Annibale's early Roman years.[5] Following commissions in Parma and Reggio Emilia, Annibale transferred to Rome the summer of 1595 to paint frescoes in the Palazzo Farnese in the Campo dei Fiori. There, over a period of ten years, he produced a work of supreme classicism that is one of the great achievements in seventeenth-century painting. The complexity of the decoration left Annibale with little time to contract other major commissions, but he did execute several altarpieces and a number of smaller religious pictures for private patrons. The fact that the architectural background of this painting refers to the arcade in the courtyard of the Palazzo Farnese may indicate that it was originally intended for the young Cardinal Odoardo Farnese in whose palace he was living at that time. No architectural setting is indicated in this drawing, which is preparatory to the composition, but a close examination of

the picture reveals pentimenti for some form of structure at the right. These were painted out when the classical arcade was introduced, necessitating the extension of the copper panel at the sides. It is not clear whether this change was one that was imposed upon the artist or whether he arrived at this solution independently, having determined that the figure group in the foreground required a setting of greater monumentality and finding it in the architecture of the Farnese courtyard.

The verso of this sheet, while unrelated to the scene of the *Vision of Saint Francis*, again brings us back to a possible connection with Cardinal Odoardo. Since he was at this date still Annibale's primary patron, there is every likelihood that the portrait of a cardinal surmounting the sketch of a door is meant to be his. Schematic though this is, the indication of a long narrow face bears comparison with known portraits of Cardinal Odoardo (fig. 2).[6]

A more rudimentary pen sketch of the *Virgin and Child with Saint Francis* belonging to the Royal Library in Windsor Castle must anticipate the one on the recto of

this sheet (fig. 3).[7] Dry and emphatic in handling, it is typical of the abbreviated form of annotation Annibale developed to organize the complex scheme of narrative scenes and fictive stucco decoration in the Farnese ceiling fresco. The sketch shows the Virgin seated frontally and Saint Francis kneeling in profile, his hands outstretched as if to receive the Christ Child. The composition is more fully developed in the drawing under discussion, where the Virgin's head now turns in the direction of the saint and her knees point away to balance the thrust of the Christ Child toward the saint, a feature that remains essentially unchanged. An angel has been introduced at the right, supporting from behind Saint Francis, whose hands are now crossed over his breast. The use of wash in the drawing adds a sense of volume to the group. In the painting, aside from the introduction of the architecture and the figure of Saint Joseph tethering the donkey in the background, subtle changes occur in the positions of and in the rapport between the main figures. Saint Francis now swoons (''languishes with divine love,'' in Bellori's words) before his vi-

sion, and the Christ Child and Virgin turn more deliberately toward him. A third drawing, a chalk study for a hand holding a book, previously connected with this painting can be disregarded since the hand is considerably larger than the hand of the Virgin in the painting where the book is at a different angle.[8] Moreover it does not appear to be by Annibale. A pen drawing in the British Museum[9] shows two angels supporting Saint Francis who holds a crucifix. This drawing relates to a picture of *Saint Francis in a Swoon* given tentatively to Annibale[10] but likely from his studio. Annibale also made a now lost picture of the *Death of Saint Francis,* known through an engraving made after it and a preparatory drawing at Windsor.[11]

CJ

1. Letter to David E. Rust, 23 June 1966; mistakenly transcribed as Ludovico Carracci in the Shickman Gallery catalogue in October of the same year.
2. Inv. no. 18905; Laskin and Pantazzi 1987, 60–61.
3. Askew 1969, 280–306.
4. Bellori 1672, 95.
5. Posner 1971, 43, suggests "around 1597."
6. He is shown in profile in the painting *Christ in Glory with Saints* in the Uffizi (Posner 1971, no. 103) where his long nose, Hapsburg jaw, and prominent lower lip are to be noted; an engraved frontal portrait is reproduced by Zapperi (1987, 63, fig. 1), whose promised book on Annibale and Cardinal Odoardo may throw light on the question of the commission of the *Vision of Saint Francis* and the intended destination of the projected doorframe. Finally, a small portrait drawing in the Louvre (inv. no. 7394; pen and ink; 79 x 55 mm; inscribed *A. Carracci*), shown here (fig. 3), of a youthful cardinal with curls protruding from beneath his biretta must surely be Odoardo since it exhibits the same features evident in the two portraits mentioned above. It is also seen from the same angle as the small portrait medallion in the doorframe on the verso of this sheet.
7. Inv. no. 2133; Wittkower 1952, no. 415, fig. 63.
8. Meder 1922–1925, 2, pl. 9.
9. British Museum, inv. no. 1895-9-15.
10. Byam Shaw 1967, no. 184, who cites other versions of this composition at the Sheffield City Museums and Art Gallery and the Staatliche Kunstsammlungen Dresden, this last attributed to Schedoni.
11. Wittkower 1952, fig. 43, no. 341, pl. 54.

## 10

### *Souls in Purgatory Supplicating the Madonna of Loreto*

**Giovanni Francesco Barbieri, called Il Guercino**
Cento 1591–1666 Bologna

Pen and brown ink with brown wash, heightened with white wash (center and left clouds), over traces of graphite, on laid paper; lower center figure reworked with graphite

320 x 223 (12⅝ x 8¹³⁄₁₆)

Provenance: Lionel Lucas (Lugt suppl. 1733a); Claude Lucas; his sale, Christie's, London, 2 December 1949, lot 78; purchased from H. M. Calmann, London, 1956, through Paul Oppé

Literature: Popham and Fenwick 1965, no. 79; Vitzthum 1969, 12

Exhibitions: Florence 1969, no. 6; Paris 1969–1970, no. 13; Ottawa 1982, no. 53

Acc. no. 6837

In 1618 Guercino painted an altarpiece for the Church of S. Pietro in his native Cento, a town lying in the plain between Bologna and Ferrara. In this picture Saints Bernard of Siena and Francis of Assisi kneel at an altar, seen from an angle, on which stands the Madonna of Loreto.[1] This wooden image of the Virgin and Child, draped in richly embroidered mantle and adorned with necklaces and crowned with the papal tiara, has surmounted the altar of the Santa Casa in the sanctuary at Loreto since time immemorial. Guercino is known to have represented this image in another painting with a bishop and different saints, recorded in the eighteenth century in the Palazzo Hercolani, Bologna.[2] Furthermore, an engraving by G. B. Pasqualini published in 1628[3] that is based on a drawing by Guercino shows the Madonna of Loreto viewed frontally, as in the drawing under discussion. In this drawing two winged angels intercede for souls in purgatory, represented in the

foreground of the composition. A nearly identical drawing of similar dimensions but with differences in the number and character of the supplicating souls exists in the Albertina in Vienna (fig. 1).[4]

No painting of the Souls in Purgatory Supplicating the Madonna of Loreto is known to have existed but the style of the two drawings, with their use of wash to suggest strongly contrasting light effects, suggests an early date in the artist's career. Though his initial training in Cento was based on local and Ferrarese masters, Guercino was influenced by the chiaroscuro of Ludovico Carracci's famous altarpiece in the Capuchin church in Cento. In Bologna working for Cardinal Ludovisi (1617–1618) and afterward in Ferrara for Cardinal Serra (1619–1620), Guercino developed and exploited dramatic light effects in his paintings. In his drawings he used wash to achieve effects similar to those of Ludovico before him. After a period in Rome whence he was called to serve Gregory XV Ludovisi,

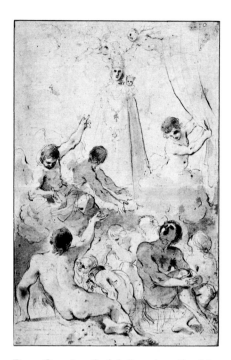

Fig. 1. Guercino, *Souls in Purgatory*, Graphische Sammlung Albertina, Vienna (Fonds Albertina)

who had been elected pope, this aspect of Guercino's art was tempered by his response to Renaissance painting and classical sculpture. To interpret these two drawings as earlier, rejected compositions for the painting in the Church of S. Pietro in Cento would be pure speculation, impossible to demonstrate without consulting the terms of the original commission. If the artist were simply exploring in pen and ink the possibility of using an image of the Madonna of Loreto stimulated by his painting for Cento, however, it is unlikely he would have executed two such elaborate drawings with only minor variations. They must represent, then, a specific purpose, as yet undefined.

True to the character of seventeenth-century Bolognese artists, Guercino was a prolific draftsman. Though many drawings were included in the memorable exhibition devoted to the artist in Bologna in 1968, a catalogue of the vast collection of his drawings at Windsor Castle is long awaited.

CJ

1. Now in the local Pinacoteca; Bologna 1968, no. 26.
2. Istituto per i beni culturali naturali della regione Emilia Romagna, Documenti/22 (1984): *Marcello Oretti e il patrimonio artistico privato bolognese*, 118.
3. See Bertelà and Ferrara 1973, no. 829.
4. Stix and Spitzmuller 1941, no. 219.

**11**

*The Sacrifice of Noah*

**Giovanni Benedetto Castiglione**

Genoa 1609–1631 Mantua

Brush and red-brown and dark brown oil paint, over monotype (?) on laid paper, laid down on two sheets of laid paper

259 x 394 (10⅛ x 15⁹/₁₆)

Provenance: Purchased from Baskett and Day, London, 1972

Acc. no. 16990

Because he has always been better known for his drawings than for his paintings, the Genoese artist Giovanni Benedetto Castiglione occupies a special place in the history of the Italian baroque. His drawings and their close relatives the monotypes are, in fact, considered among the most forceful and distinctive works in their medium from the period. His etchings also, like those of his contemporary Pietro Testa, possess a signal authority of their own apart from his painting oeuvre. It was perhaps through these media that Castiglione expressed

his particular genius to the fullest. Scholarship has, in fact, focused more on his drawings than on his paintings, as witness the absence of a current published monograph on his paintings and the presence of an excellent and definitive one on his drawings.[1]

Original and innovative in his iconographic interpretations, Castiglione delighted in any subject that allowed him to depict motley groups of animals, domestic and exotic. Among his favorite subjects were the two episodes from the Noah story with the greatest opportunities for animal representation: the Entry into the Ark and Noah's subsequent grateful sacrifice after his safe delivery from the Flood. Versions of these two compositions, both in painting and in drawing, and detailed studies for figures and animals are too numerous to list here.

The present drawing has not been related specifically to a finished painting or an etching of the Noah subject. It is sometimes difficult to tell in a sketchy sheet such as this which of the two episodes the artist is representing, without the clear delineation of either the Ark or the smoke of the Sacrifice. In the Entry scenes, the animals are usually clearly paired. Here many of them are accompanied by their mates, except the two most conspicuous, the ostrich and the ram, who seem to have lost theirs. This suggests a moment of relaxation after the Flood, with the Sacrifice represented faintly in the background. Timothy Standring suggests a date of the mid-1640s.

The drawing is interesting technically, since it seems to have been done on the basis of a monotype or counterproof, which, though faint, was then finished and touched up with the brush. The pale and rather flat impression of the monotype is most visible on the left, while the sharp delineation and accents plainly added with the brush are evident in those on the right.[2]

The frequency of compositions calling for animals in Castiglione's oeuvre is difficult to explain apart from the predilections of his patrons and his own personal interest. Subjects that he did repeatedly and that required animals include a number of Old Testament patriarchal journey scenes, classical subjects such as Circe and her enchanted victims, and sacrifices to Pan or Priapus. That such subjects found favor with his patrons is well documented. At least two Noah scenes are recorded as being in the collection of his major patron, the Duke of Mantua, after the artist died: a Noah's Ark with animals and birds, and a painting of Noah sending the animals into the Ark.[3]

It has been suggested that in his painted dramas of men and beasts in harmony, Castiglione was trying to reconstruct a Golden Age of biblical or classical times. On a more literal level, he seems to have been influenced during his early and formative Genoese years by the Flemish artist Jan Roos, who frequently included animals in his compositions and who was in Genoa from 1616 onward. It is also likely that Castiglione's interest in animals and his skill in depicting them was due to Sinibaldo Scorza, the animal and bird aficionado who is mentioned in the biographies as one of Castiglione's masters. The artist is known also to have maintained contacts with Genoese literary figures who exploited themes of the bucolic and the pastoral. A more mundane suggestion might simply be that exotic creatures such as the ostrich and the camel were available for study in the port cities of Genoa and Venice (Castiglione spent time there later), where they were brought by cargo ship to enhance the private zoological gardens of the wealthy and curious. The familiarity that the artist shows with his animals not only in form but in gesture is surely based on careful and direct observation.

M C

1. Philadelphia 1971. The most definitive work on the paintings is the unpublished doctoral dissertation by Standring 1982.

2. Examination of the sheet by the research and conservation laboratory of the National Gallery of Canada confirms this hypothesis. The conservator, Anne Maheux, noted that under microscopic examination, the edges of the lines of the monotype areas show the typical "halo" of spreading oil. She also noted that, again under the microscope, a faint edge like a plate mark could be seen around all four sides of the image.

3. Castiglione 1971: "quadro di altezza braccia 4, longhezza braccia 5, rappresentante l'arca di Noe con quantita d'animali e uccelami" (109); and "quadro di palmi dodeci in longhezza e sei in altezza con Noe che manda li animali nell' Arca . . ." (69–70).

**12**

## *The Mystic Marriage of Saint Catharine*, c. 1650

**Giulio Carpioni**
Venice 1613–1678 Vicenza

Recto: red chalk brushed with water to create red wash on buff laid paper; verso: a very slight sketch of the Virgin and Saint Catharine, in faint red chalk

348 x 247 (13¹¹/₁₆ x 9³/₄)

Inscribed possibly by the artist, lower right corner, in graphite, *Carpioni F.*

Watermark, at center: Anchor (Heawood 1)

Provenance: Sigmund Nauheim, Frankfurt; Alberto Sichel Morales; sale, Christie's, London, 26 March 1974, lot 11; purchased from Yvonne Tan Bunzl, London, 1979

Exhibition: London 1975c, no. 8

Acc. no. 23230

Giulio Carpioni was a leading history painter in the classical manner in Vicenza in the middle decades of the seventeenth century. Art historians still find it quite hard to explain how it came about that a painter who was born in Venice came to abandon the colorism for which that city is so celebrated, and to adopt a cool and clearly structured style that really has no parallel in northern Italy. Even a comparison with Poussin helps very little. Orlandi in 1719 told us that he emerged from the school of Padovanino,[1] but nothing certain is known of him until he settled in Vicenza in 1638, at the age of twenty-five. This remained his home until the end of his life. His career was fully described by Pilo,[2] and the dates of his birth and death were subsequently adjusted by Zorzi.[3]

The present drawing is evidently a compositional study for an altarpiece not otherwise known apart from a closely related, but apparently weaker, drawing in the Ashmolean Museum at Oxford.[4] An extant altarpiece on very similar lines is in the church of S. Lorenzo in Vicenza, *The Holy Family with Saint Anthony of Padua* (fig. 1).[5] There the Virgin stands, facing right, with the Christ Child before her, standing on a book, also facing right. Saint Anthony kneels, facing left, and Saint Joseph stands, also facing left; two

Fig. 1. Giulio Carpioni, *The Holy Family with Saint Anthony of Padua*, S. Lorenzo, Vicenza

putti fly overhead. Pilo suggested a date c. 1650 for this painting, which is adopted here for our drawing.

There is a possibility that the Ottawa drawing may be associated with the church of S. Caterina in Verona, for which Carpioni painted "a second altarpiece" in 1651.[6] The drawing also displays important links with an altarpiece in SS. Felice e Fortunato in Verona, of controversial date, depicting *Four Female Martyrs.*[7]

Julien Stock has pointed out that copies of drawings by Carpioni are not unknown, creating problems that find a parallel to the situation here between this drawing and the version in the Ashmolean, mentioned above. He cited the case of the drawing in the collection of Roberto Ferretti di Castelferretto,[8] of which a second weaker version is recorded in the collection of Felton Gibbons.[9] This is a mythological subject and therefore comparable with a drawing at the Hessiches Landesmuseum Darmstadt depicting *Neptune and Chronos,* and an engraving by François Godefroy after a drawing by Jean-Baptiste Joseph Wicar, recording a lost painting of the same subject by Carpioni, with some variations.[10]

GK

1. Orlandi 1719, 311.
2. Pilo 1961.
3. Zorzi 1961, 219–222.
4. Parker 1956, 422, no. 805.
5. Pilo 1961, 119, pl. 47.
6. Pilo 1961, pl. 32.
7. Pilo 1961, pl. 141.
8. Exhibited Venice 1980, no. 61; Toronto 1985–1986, no. 48.
9. Exhibited Washington 1974, 24, no. 42.
10. Recorded in photographs in the Witt Library, London, neg. no. 992/16 (19a).

# 13
# *Calling of Saint Matthew*

## Simone Cantarini
### Pesaro 1612–1648 Verona

Pen and brown ink and gray wash with traces of red and black chalk on laid paper

Verso: *Truncated Study for a Virgin with Saints, and a Separate Study of Saint John the Baptist*

Red chalk, heightened with pen and brown ink

193 x 274 (7⅝ x 10³/₁₆)

Inscribed in an unknown hand, lower left, in pen and brown ink, *cassa;* by A. M. Zanetti, verso of old mat, in pen and black ink, *Primo Sublime Abbozzo/di Guido Reni/di Singolare Composizione/di figure*

Provenance: A. M. Zanetti (Lugt 2992f); Baron Dominique Vivant-Denon (Lugt 779); Sir Bruce Ingram (Lugt 1405a); Carl Winter (bears his mark, *CW*); sale, Sotheby's, London, 5 December 1977, lot 6 (ascribed to Guido Reni); purchased from C. G. Boerner, Düsseldorf, 1978

Literature: Johnston 1979, under no. 27

Exhibitions: Cambridge 1959, no. 62; Ottawa 1982, no. 58

Acc. no. 23212

Simone Cantarini was an ardent draftsman, remembered more for his spirited red chalk compositions than for his paintings. Less well known are his lively pen drawings such as this one, which hid until recently behind an attribution to Guido Reni, Cantarini's teacher for three or four years in Bologna.

In fact, the composition connects with three other drawings that can all be seen as preparations for a supposed painting of the *Calling of Saint Matthew* unknown today and not cited in the obvious sources. These comprise one in pen attributed to Cantarini at the Louvre[1] and two in red chalk, one bearing an old inscription attributing it to Cantarini, part of a large collection of drawings by the artist in the Brera,[2] and the other attributed to Reni in Rotterdam.[3]

The eighteenth-century Venetian collector Anton Maria Zanetti mistakenly classified this drawing as by the hand of Reni, but no doubt correctly defined it as the artist's first sketch ("primo sublime abbozzo"). With its strong horizontal

emphasis and rapidly receding diagonal arrangement of the table and figures grouped around it, the composition is highly reminiscent of Tintoretto's scenes painted for the chancels of Venetian churches. Cantarini could have seen these on the visit that his Bolognese biographer Carlo Cesare Malvasia ascribed to the early years of the artist's career. On the other hand, the intense light from the left indicated in the application of wash

recalls Caravaggio's paintings in the Contarelli Chapel in Rome. This source of inspriation is further exploited in the arrangement of the figures in the two red chalk drawings mentioned above where the receding diagonal is reduced and the protagonists are brought forward to the picture plane (figs. 1–2). The company around the table is smaller in number and the attention is more obviously concentrated on the central action. Openly

indebted to Caravaggio's *Calling of Saint Matthew,* Cantarini has moved Christ to the extreme right of the composition and deliberately quoted the gesture of his raised arm in beckoning the tax collector. At the left, Matthew is seen from behind half rising from his stool and leaning inward toward Christ, a partial transposition of the youth at the center of Caravaggio's composition. The figure with plumed hat, moved from his central

Cat. 13, verso

position in the Rotterdam drawing to the extreme left in the Brera drawing, is also a stock figure in Caravaggio's cast of characters. The evolution of this composition clearly progresses from the loosely defined pen sketch toward the more fully developed figures of the Brera drawing.[4] Unlike Reni, who was trained in the Carracci academy and hence reflected their drawing practices, Cantarini was already a formed artist when he arrived at Reni's studio and did not as a rule execute elaborate chalk studies for individual figures. Rather, he seems to have moved from the pen sketch to a more precise rendering of the whole composition in chalk. The vitality and authority of handling in the Brera drawing has something also of the quality of Agostino and Annibale Carracci's pen drawings of the 1590s, particularly in the convoluted lines of Christ's drapery. All these factors tend to suggest a dating in the 1640s, after Cantarini left Reni's studio and was more receptive to other influences.

Cantarini is reputed to have gone to Rome about 1640 following his break with Reni and his return to his native Pesaro. Returning to Bologna only after Reni's death in 1642, he seems to have set up his studio there until 1648 when he went to Mantua to work for Carlo II Gonzaga di Nevers. He died later that same year in

Fig. 1. Simone Cantarini, *Study for The Calling of Saint Matthew,* verso, Pinacoteca di Brera, Milan

Fig. 2. Simone Cantarini, *Study for The Calling of Saint Matthew,* Museum Boymans–van Beuningen, Rotterdam (Copyright Frequin-Photos)

Verona. Unfortunately, so few documents exist recording his commissions that a solid chronological assessment of his output is still lacking and no painting of a *Calling of Saint Matthew* is known to have been made.

The reverse of the sheet in Ottawa bears a truncated portion of a drawing that does, however, connect with a known painting—the *Immaculate Virgin with Saints John the Evangelist, Nicolas of Tolentino and Euphemia* now in the Pinacoteca in Bologna.[5] This drawing represents an early stage in the development of the composition when the Virgin is envisaged as standing on a crescent moon in a manner close to Ludovico Carracci's famous *Madonna degli Scalzi,*[6] but with the saints below represented only in half figure. We find further evidence of this earlier stage in two chalk studies by Cantarini, one in the Louvre[7] and the other in the Albertina.[8] In the picture, the Virgin has been telescoped into a seated position with her foot on the crescent moon, now inverted, whereas the saints are increased to full figure. Given its size and shape, this work must have been con-

ceived as an altarpiece, but there is no trace of such a work in the early guides of Bolognese churches. The painting was first recorded in a private collection in Bologna in the eighteenth century. Andrea Emiliani assigned it an early date (1635),[9] but there is no external evidence to support this, and it is worth noting that he placed the Brera version of the *Calling of Saint Matthew* composition late in the artist's career. It should be remembered that the artist is buried in the church of Saint Euphemia in Verona. Could there be a connection between this institution and the prominence awarded the saint in the painting in Bologna? From early on Cantarini was protected by the Veronese writer and painter Claudio Ridolfi. Could Ridolfi have negotiated commissions with Verona for Cantarini, which were only partially realized late in the artist's career? It is curious, too, that on the recto of the sheet in Rotterdam there is again a fully developed study for a Presentation of the Virgin in vertical format that similarly has no known corresponding painting.

CJ

1. Louvre inv. no. 14647.

2. Brera inv. no. 100, verso; Milan 1959, no. 64.

3. Rotterdam inv. no. 1-416, verso.

4. Contrary to my earlier interpretation, see Ottawa 1982, no. 58.

5. Mancigotti 1975, color pl. 7.

6. Bodmer 1939, pl. 22.

7. Louvre inv. no. 9826; mistakenly attributed to Massimo Stanzione by Mariette and exhibited as such in Paris 1967, no. 24.

8. Benesch 1964, no. 53.

9. Bologna 1959, no. 49.

## 14

## *Head of a Man in Three-quarters Profile to the Left,* c. 1674–1679

**Carlo Maratta**

Camerano (Marches) 1625–1713 Rome

Red chalk, heightened with white chalk, on blue laid paper, mounted on cream laid paper

264 x 247 (10⅜ x 9¹¹/₁₆)

Inscribed in an unknown hand, on mount, in pen and brown ink, *di Carlo Maratti*

Provenance: Purchased from R. E. A. Wilson, London, 1937

Literature: Popham and Fenwick 1965, 61–62, no. 89

Acc. no. 4360

Carlo Maratta arrived in Rome from his native Marches around 1636 and soon entered the studio of Andrea Sacchi, where he spent several years. He adopted the classical style of his master, but gave it a more marked academic character. Extremely productive, he became the leader of the Roman school of painting after the deaths of the great artists of the preceding generation.

Popham and Fenwick tentatively connected the present drawing with the head of an apostle in Maratta's *Death of the Virgin* in the Villa Albani, Rome,[1] but Catherine Johnston correctly recognized it as a study for the head of the figure standing at the left in *The Death of Saint Francis Xavier* (1674–1679) in the church of the Gesù in Rome (fig. 1).[2] The position and expression of the heads in the painting and drawing are identical. The figure in the painting represents one of the Portuguese merchants who abandoned Saint Francis Xavier on the island of Shangchwan. His gaze into the distance indicates that he remembers the episode of the missionary saint's death with mixed feelings of regret and indifference; no real grief distorts his handsome face.

The drawing is careful and finished; all the details of the head are noted with a superb mastery and with only a few pentimenti. The plasticity of the white highlights and some smoother shading in red chalk soften the more incisive lines, such as those on the tip of the nose and on the

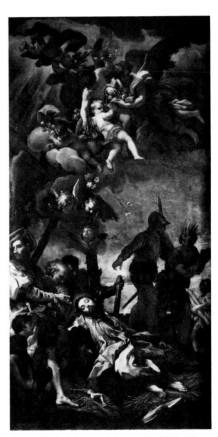

Fig. 1. Carlo Maratta, *The Death of Saint Francis Xavier,* Il Gesù, Rome

Fig. 2. Carlo Maratta, *Self-Portrait*, c. 1675, Musées Royaux des Beaux-Arts de Belgique, Brussels (Copyright A.C.L. Brussels)

ear. The curly strokes of the beard, lightly sketched, balance the rather dry cross-hatching on the head, and their unfinished character relieves the academic rigor of the drawing. These quick strokes also give the impression of a living face, whose fixed expression and arrested half-smile might otherwise border on the frozen.

Masterfully drawn, this study of a head has a similar character to the *Self-Portrait* in Brussels of c. 1675 (fig. 2). The two heads are refined and elegant; but we also perceive in them an affectation, a lack of naturalness, which transforms the merchant-sailor, accustomed to a rugged existence, into a court fop. As in the *Self-Portrait*, Maratta idealized the physiognomy of his model in the drawing, but gave him an expression that reveals more of his true character.

The *Self-Portrait* drawing in the Louvre[3] conveys a more sympathetic image of the painter than does the Brussels *Self-Portrait*, whose artificiality and affectedness may give the viewer a sense of unease. A similar feeling may be aroused by the Ottawa drawing, which perhaps explains why Mâle found all the figures in the Gesù painting rather cold, with the exception of Saint Francis Xavier himself.[4]

Several other preparatory drawings for the picture were listed by Harris and Schaar[5] and by Alcaide.[6] All these draw-ings illustrate how the final painting was worked out. While the figure whose head is studied in the Ottawa drawing does not appear in the first compositional studies in Madrid, it does appear in the study in Düsseldorf.[7] Since it establishes the final expression of the head, the Ottawa drawing is probably the last the artist made for this figure.

M-NB

1. Mezzetti 1955, fig. 36.
2. Oral communication.
3. Mezzetti 1955, fig. 55.
4. Mâle 1951, 439.
5. Harris and Schaar 1967, 113–116, nos. 285–292.
6. Alcaide 1965, 14–15, nos. 26–27.
7. Harris and Schaar 1967, 114, no. 285, pl. 63.

**15**

*Saint Michael Vanquishing Lucifer,* c. 1660

## Guillaume Courtois
## Guglielmo Cortese,
## called Il Borgognone

Saint-Hippolyte (Burgundy) 1628–1679
Rome

Two shades of red chalk, heightened with opaque
white and gray, on buff laid paper, lined with tissue;
the verso of the support rubbed with red chalk, per-
haps for transfer

378 x 266 (14⅞ x 10⁷/₁₆)

Inscribed, in an unknown hand, lower right, in pen
and brown ink, *P.C. N⁰ 10*

Provenance: Purchased from Yvonne Tan Bunzl,
London, 1976

Literature: Rome 1979–1980, under no. 176

Acc. no. 18727

Guillaume Courtois arrived in Italy with
his brothers Jacques and Jean-François
about 1636, settling in Rome c. 1639,
where he was henceforth known as Gu-
glielmo Cortese. Introduced to the art of
painting by his elder brother Jacques, he
furthered his education in the studio of
Pietro da Cortona with whom he collabo-
rated on several large projects. One of
Cortona's most gifted pupils, Courtois
always showed the influence of his mas-
ter, but finally achieved a personal style
that borrowed elements in turn from Pier
Francesco Mola and Giovanni Lanfranco,
and after 1660 from Carlo Maratta,
Giovanni Battista Gaulli, and Bernini.
The latter made him one of his principal
collaborators after the deaths of Fran-
cesco Allegrini and Guido Ubaldo Ab-
batini. Courtois' grand official commis-
sions are becoming better known, but
few easel pictures have as yet been given
to him. The two main repositories of his
drawings are the cabinets in Düsseldorf
and Rome.

The present drawing elaborates the
composition of the two protagonists in
the battle between the Archangel Michael
and Lucifer, which Courtois had previ-
ously sketched in a sheet in the Ga-
binetto Nazionale delle Stampe in Rome
(fig. 1).[1] In 1973 Graf suggested that a
*Study of Legs* in Düsseldorf (fig. 2) might
be related to the figure of Lucifer.[2] If this

Fig. 1. Guillaume Courtois, *Saint Michael
Vanquishing the Devil,* Gabinetto Nazionale
delle Stampe, Farnesina, Rome, FC 127089

is so, we must suppose that Courtois
made at least one earlier compositional
study different from the ones that are
known. Indeed it would be surprising if,
after he had established the positions of

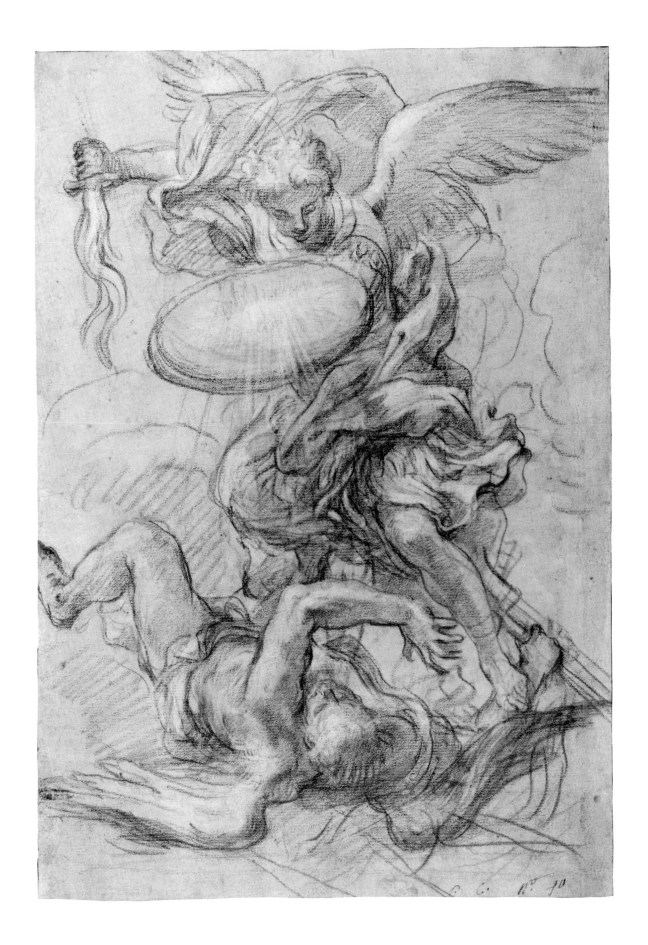

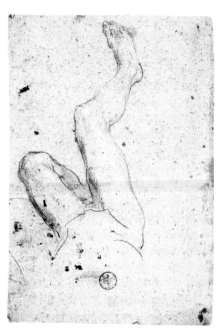

Fig. 2. Guillaume Courtois, *Study of Legs*, Kunstmuseum Düsseldorf, inv. no. FP 13646

the two figures in the Ottawa sheet, the artist had executed a study of Lucifer's legs in a different and reversed position. It is also possible that the Düsseldorf drawing is a detail of a figure in another as yet unidentified painting by Courtois.

The old attribution of the Rome drawing to Ludovico Gimignani underlines the Cortonesque character of the Ottawa sheet, which could be dated c. 1660. The facial type, the curly hair, and the sweet expression of the Archangel are all reminiscent of Cortona, as are the magnificent suppleness of his body and the dynamism that sweeps the two figures up into the same concentric movement. This flexibility of body and movement was softened by the influence of Maratta after 1660. Similarly Cortonesque is the pictorial quality of the drawing, accentuated by the nervous and rapid line of varying intensities, which first runs lightly and then returns thicker and darker to refine, accent, and correct the details. The numerous pentimenti indicate a certain hesitancy on the part of the artist.

The attributes of the figures, though not entirely new, were rather unusual in the seventeenth century. Saint Michael's sword of fire symbolizes the spiritual

evolution of souls from the infernal cycle of the passions. The radiant shield of crystal symbolizes Divine Love, which protects the Archangel as well as all souls living in harmony with God. But crystal was also long known for its curative properties. Oriental medicine still makes use of it, while in the West, holistic medicine is beginning to recognize its energizing power. Moreover, as the ancients said, a healthy body is a sign of a healthy mind and spirit. The crystal shield therefore symbolizes both spiritual and physical healing. The bursts of light from the crystal blind the devil, who raises his left arm across his face to ward them off, a gesture that weakens him in the struggle. Saint Michael places his foot on Lucifer's right arm, which holds the usual pitchfork. But Satan's weapon is ineffectual against the Divine Fire, which strikes him before he can wound his adversary. This signifies that souls strengthened by the light can triumph over the weapons and tricks of the devil.

A symbol of liberty, peace, and Divine Love, Saint Michael is also a symbol of health: the love of Christ healing the body also cures the sins of the soul. As Mâle explained, the Archangel Michael was part of the Franciscan cult, and paintings on this theme are often found in Franciscan churches.[3] That is the case with Guido Reni's famous painting in the church of the Capuchins of Capo le Case, Rome,[4] of which several other Franciscan churches in Rome owned copies.

Courtois' drawing reflects the spirit of Saint Francis of Assisi, who was concerned above all with the health of the soul and who was fasting for several days in honor of Saint Michael when he received the stigmata. We wonder who suggested this particular iconography to Courtois. Perhaps it was his younger brother Jean-François, who took his perpetual vows with the Capuchins at the beginning of 1660, assuming the religious name of Jean-Antoine. A minor painter, Jean-François probably executed paintings for the monasteries of his order both in Rome and in the provinces.

No painting corresponding to the Ottawa drawing has as yet been discovered, but one might exist in a Franciscan church in Rome. Could the picture have been commissioned from Courtois through his Capuchin brother for the monastery of Capo le Case or for San Pietro in Montorio, which belonged to the Franciscans in the seventeenth century? In order to answer this question, it would be necessary to consult the archives of these two institutions.

The graphic style of the initials at the lower right of the drawing might indicate a French collector. It could perhaps be that of Pierre Collin, a Parisian amateur whose modest collection of drawings "seems to have been sold on the market around 1890–1895."[5]

M-NB

1. Inv. no. F.C. 127089.
2. Graf 1976, 1:65, no. 153; 2: pl. 202.
3. Mâle 1951, 491.
4. Garboli and Baccheschi 1971, no. 163, color pl. 44.
5. See Lugt 453.

## 16

## *The Assumption of the Virgin*

**Paolo Pagani**
Castello Valsolda c. 1661–1716 Milan

Recto: pen and brown (iron gall) ink, with yellow (possibly bistre) wash over graphite, on laid paper; verso: a slight tracing of two of the apostles on the recto, in pen and brown ink and graphite

549 x 293 (21⅝ x 11⁹⁄₁₆)

Inscribed by the artist, on the tomb, in pen and brown ink, *Paulus Paganus Inv!.*; lower left, in pen and brown ink, partially obscured with opaque white, *E P* (for Dr. Edward Peart, Lugt 891)

Watermark at center, not identified

Provenance: Dr. Edward Peart (Lugt 891); purchased from P. & D. Colnaghi, London, 1954, through Paul Oppé

Literature: Vitzthum 1964, pl. 39; Popham and Fenwick 1965, no. 100

Acc. no. 6219

Paolo Pagani is an important and interesting figure in the history painting of Venice and Bohemia in the decades before and after 1700. Sadly, many of his most ambitious works are lost, and little of monumental character remains save the frescoed ceiling of 1696 in the parish church of his native village of Castello Valsolda, high on the hill above Lake Lugano. He is most frequently known simply as the master of Antonio Pellegrini. The most recent summary of his position as a draftsman is that of Bean,[1] and a recent survey of his work as a painter was published by Burri.[2]

The present drawing, a study for an altarpiece not otherwise recorded, is a key work of the greatest importance, on account of both its monumental size and its signature. The Virgin is born aloft on a mushroom-shaped cloud, a reference to the passage in Ecclesiasticus 24:4, where Wisdom declares: ''I dwell in high places, and my throne is a cloudy pillar.'' In this respect it foreshadows the great treatments of this subject in eighteenth-century Venice by Sebastiano Ricci and Giovanni Battista Piazzetta.

GK

1. Bean 1976, 64–66.
2. Burri 1982, 47–72.

Cat. 16, verso

**17**

*Samson Slaying the Philistines*

**Aureliano Milani**
Bologna 1675–1749 Bologna

Black chalk, heightened with white chalk, on laid paper mounted on wove paper

392 x 518 (15⁷/₁₆ x 20³/₈)

Watermark: Fleur-de-lis in circle (similar to Heawood 1567)

Provenance: Purchased from Yvonne Tan Bunzl, London, 1979

Exhibition: Ottawa 1982, no. 91, pl. 91

Acc. no. 23348

The drawing by Aureliano Milani is directly related to a large painting by him now in the Banco Populare in Modena, one of a series of four in the bank's collection that deals with incidents from the life of Samson. The artist's biographer, Zanotti, did not specifically mention this series in his rather lackadaisical discussion of the artist's works.[1] Roli suggested that these four are part of the larger series of nine paintings identified by Zanotti only as "storie tutte sacre," which the biographer described as begun for the Duke of Parma in 1711 and finished after Milani's permanent move to Rome in 1718.[2] In the same breath, however, Zanotti mentioned that Milani "pinse ancora un Sansone per il senator Magnani."[3] The fact that the "Sansone" paintings are part of a series of nine (the notion of nine paintings dealing with the exploits of Samson would seem a phenomenon to have jogged even Zanotti's mind into recollection), or that Milani did not one but four for his good patron the Senator Magnani, is not ultimately important, since the dating of the paintings to the latter years of Milani's Bolognese period seems appropriate on stylistic grounds.

The major evidence for such a date is provided by another painting, destroyed during World War II, which was documented to the period just before Milani left for Rome, and which is close in style to the Samson series: the *Martyrdom of Saint Stephen* formerly in the church of S. Maria della Mascarella in Bologna.[4] There is a related drawing for this painting, also in black and white chalk on brownish paper, that has large-scale figures operating primarily on the front plane, and that is stylistically identical to the present sheet. This drawing, whose present location is unknown, was until recently in a private collection in Bologna. It has always been assumed that the drawings are preparatory studies for the paintings. The watermark resembles several others, all of which are found on eighteenth-century Roman papers. It is thus conceivable that the artist did the drawing later in Rome as a *ricordo* of his ambitious composition.

The drawing can be seen as a visual summary of the most conspicuous characteristics of late baroque Bolognese art: the unabashed quotations from Annibale and Ludovico Carracci (the drawing was once attributed to Ludovico), the melodramatic and exaggerated gestures of the protagonists, the careful attention to accurate depiction of muscular bodies, and the cavalier disregard of detail and topographical logic in the landscape. Milani was considered by his contemporaries to be an ideal exponent of these characteristics: Zanotti approvingly described the artist's compositions as "subjects that demand nude men, muscular and ferocious."[5]

MC

1. Zanotti 1739, 2:159–167.
2. Roli 1977, 277, figs. 207a–b, 208a–b. The other sub-
jects are *Samson Carrying the Gates of the City, Samson
and Delilah,* and *Samson Blinded.*
3. Zanotti 1739, 2:162.
4. Roli 1960, 190, pl. 61a.
5. ''argomenti che vogliono uomini nudi, muscolosi
e terribili,'' Zanotti 1739, 2:162.

18

*A Classical Landscape with Ruins*

**Marco Ricci**
Belluno 1676–1730 Venice

Gouache on vellum with tack-over edges, formerly mounted on a wood panel

299 x 438 (11¾ x 17¼), image

Inscribed in an unknown hand, verso of wood panel, in pen and brown ink, *No. 10 Mrs* (two names effaced); a label was also formerly attached to the verso, reading: *By Marco Ricci/Left by Pss. Sophia Matilda/of Gloucester to Henry/Duke of Grafton 1844 D*

Provenance: Joseph Smith(?); King George III(?); Princess Sophia Matilda of Gloucester; Duke of Grafton; Mrs —— ——; sale, Sotheby's, New York, 16 June 1976, lot 55; purchased at the sale

Acc. no. 18692

Marco Ricci, nephew of Sebastiano Ricci, began his recorded career as a landscape painter and scenographer at about age thirty, when he sold twenty small paintings to Lord Invine in Venice. His earliest works have often been attributed to Salvator Rosa, but these stormy seascapes, landscapes, and battle pieces by Ricci, which are still at Temple Newsam, offer evidence of some direct contact with Alessandro Magnasco.[1] Ricci's early contact with an English patron no doubt led

Fig. 1. Marco Ricci, *Mountain Landscape,* present location unknown (Courtesy Sotheby's, New York)

to the invitation to come to England with Antonio Pellegrini, extended by the Earl of Manchester, then British Ambassador in Venice, in 1708. In England Marco worked as a scene-painter at the Haymarket Theatre, recently built by John Vanbrugh as a center for Italian opera, and at Castle Howard and Kimbolton, two houses in which Vanbrugh was also involved as architect. Before leaving Venice, he appears to have collaborated with Pellegrini on the large canvas *The Brazen Serpent,* in the choir of S. Moisé, and in England this collaboration continued on the canvases from Burlington House that are now at Narford. In later years he collaborated in a similar fashion with his uncle, Sebastiano Ricci.

The present drawing is a very typical example of a classical landscape with ruins by his hand belonging to a later phase of his career. There are a number of similar examples among the material sold by Consul Smith to King George III,[2] now at Windsor Castle: these are also painted in gouache on leather. The present example, together with the companion piece with which it appeared in the sale in New York (fig. 1), is painted on vellum.

Princess Sophia Matilda (1773–1844), who is mentioned in the inscription, was a spinster daughter of the 1st Duke of Gloucester and Edinburgh (1743–1805), brother of George III, and the third son of Frederick, Prince of Wales (1707–1751), eldest son of George II and Caroline of Anspach. William Henry Fitzroy, 4th Duke of Grafton (1760–1844), a descendant of Charles II and Barbara Villiers, was a brother-in-law to Sophia Matilda, since he married her half-sister, Charlotte Maria, daughter of the 2nd Earl of Waldegrave. After the latter's death, his widow Maria married the Duke of Gloucester and Edinburgh. The label quoted above may refer to Henry Fitzroy, the 5th Duke (1790–1863), who succeeded at his father's death on 28 September 1844.

This provenance might indicate that our drawing also came from the collection of Consul Smith, through George III, but Sir Oliver Millar feels that this is unlikely, and suggests that it was perhaps bought by Princess Sophia Matilda's father, the Duke of Gloucester, or his brother, the Duke of York, who both had resided in Italy.

The lion placed prominently in the left foreground is very reminiscent of those standing in front of the Arsenale in Venice.

GK

1. For a full account of Marco Ricci, see Pilo 1964.
2. Levey 1964, 28–35.

**19**

*Studies for ''The Four Seasons''*

**Vittorio Maria Bigari**
Bologna 1692–1776 Bologna

Red chalk on laid paper. The drawing appears to have been removed from a sketchbook: the left margin is torn, all others cut

190 x 147 (7½ x 5¾)

Provenance: Purchased from Lorna Lowe, London, 1975 (as ''anonymous Venetian, eighteenth century'')

Acc. no. 18242

The attribution of this drawing to the Bolognese decorative artist Vittorio Maria Bigari is based on the existence of an etching bearing an inscription in the plate, *Vit. Ma. Bigari inv. . . . . F. Rosaspina fe./Dal Landini in Bologna*. It has been impossible to identify the print further since there is no catalogue of Rosaspina's etchings, and the only known impression exists as a loose sheet in the Biblioteca Sassi in Forli. In the etching, four of the heads are reproduced in medallions in reverse: *Primavera* (the girl with flowers at the top); *Estate* (with some floral additions, the girl on the left); *Autunno* (the man in the lower right); and *Inverno* (the man in the lower left). The other two studies of the girl with her head bound in scarves were evidently rejected studies for *Winter.*

   The drawing is interesting since it reveals an unfamiliar aspect of Bigari's technique as a draftsman: his use of the finely sharpened red chalk with no supplementary sanguine wash. It also demonstrates the extraordinary continuity of style in the Bolognese drawing tradition. Without the identification provided by the print, the sheet could easily be taken for a drawing by Donato Creti (1671–1749) a generation earlier. For this reason, it seems plausible to date the drawing fairly early in Bigari's career, and because his later work is almost entirely composed of large decorative projects for palazzi and churches in Bologna.

MC

**20**

*Fantastic Head of a Young Man, in Profile to the Left,*
c. 1742–1757

**Giovanni Battista Tiepolo**
Venice 1696–1770 Madrid

Pen and brown ink and wash, over graphite, on laid
paper, mounted on laid paper

250 x 207 (9⁷/₈ x 8¹/₈)

Watermark: Escutcheon

Provenance: Library of the Sommasco convent
at Santa Maria della Salute, Venice; Leopoldo
Cicognara; Antonio Canova; Monsignor Canova;
Francesco Pesaro; Edward Cheney, Badger Hall,
Shropshire; Cheney sale, Sotheby's, London, 29
April 1885, lot 1024; E. Parsons and Sons, London;
Earl of Ranfurly; P. & D. Colnaghi, London; Richard
Owen, Paris; purchased from P. & D. Colnaghi, Lon-
don, 1952, through Paul Oppé

Literature: Popham and Fenwick 1965, no. 107

Exhibitions: London 1952, no. 35; Victoria 1961, no. 39;
Toronto 1968, no. 45 and cover; London 1969, no. 15;
Florence 1969, no. 12, and Paris 1969–1970, no. 15

Acc. no. 6056

Giovanni Battista Tiepolo dominates the
history painting of eighteenth-century
Venice. For more than half a century, he
decorated churches, palaces, and villas
throughout northern Italy from Venice to
Milan. From the age of forty onward he
enjoyed an international reputation,
working for the courts of Saint Peters-
burg and Madrid, and his most sublime
achievement was the group of frescoes
painted in 1751–1753 for the Prince-Bishop
Karl-Philipp von Greiffenklau at Würz-
burg. He was a prolific draftsman, mak-
ing drawings in black and red chalk on
blue paper, and in pen and wash on
white paper. The former are careful stud-
ies for his paintings, while the latter are
virtuoso performances, often made for
their own sake. His drawings survive in
large numbers, mainly because they were
carefully preserved in albums, which en-
abled them to survive the century of ne-
glect his reputation suffered following
his death. The present drawing, one of a
group of drawings from the estate of
Richard Owen, was purchased from

Messrs. Colnaghi in 1952, through the
good offices of Paul Oppé. It is part of a
series of fantastic heads, of which the
earliest record is the catalogue of an exhi-
bition at the Savile Gallery in 1928.[1]
About ten of the series were shown
there, in association with thirty drawings
on the theme of the Holy Family. This
catalogue also includes a photograph of
the bookplate of Edward Cheney, who
purchased the album that contained the
drawings in 1842, recording its prove-
nance from Tiepolo himself through
Leopoldo Cicognara, Antonio Canova,
and Francesco Pesaro.[2]

Mark Oliver, a cofounder of the Savile
Gallery, has noted that the album ap-
peared in a sale of Ranfurly property in
Dublin and was bought for a small sum
by a young woman. It was sold to Col-
naghi for £800, and thence passed to
Richard Owen, a *marchand-amateur* who
lived on the quai Voltaire in Paris. The
Savile Gallery bought forty drawings
from Owen, and about fifteen of these
went to Alessandro Contini-Bonacossi; it

does not appear that the present drawing was among them.

In the photographic archive of the Fogg Art Museum, a set of photographs, originating with Richard Owen, records the appearance of ninety-three drawings in the series of fantastic heads. The present drawing is included among them.[3]

As for the date of these drawings, one rather atypical specimen in the Antoine Seilern collection at the Courtauld Institute of Art[4] is datable to c. 1742, and two were used by Domenico Tiepolo as models for etchings of 1757.[5] The series as a whole probably falls between these dates.

The drawings appear to have been made for their own sake, and cannot be associated directly with paintings.

G K

1. London 1928.
2. The photograph is also reproduced and discussed in Knox 1960, 6.
3. Fogg Photographic Collection, no. 372d/T442/50(KK).
4. Seilern 1959, 154–155, no. 169, pls. 130, 131.
5. Knox 1970, *Teste* I.10 and I.30. For some further discussion, see Knox 1975, 151, and Byam Shaw and Knox 1987, nos. 78–80. Popham and Fenwick 1965 refer to a drawing in the Lehmann Collection as "very similar": see Szabo 1981, no. 96; Byam Shaw and Knox 1987, no. 80.

## 21

## *A Woman Begging*, 1734

**Anton Kern**
Tetschen 1709/1710–1747 Dresden

**after Giovanni Battista Pittoni**
Venice 1687–1767 Venice

Red crayon and graphite over red chalk, on laid paper, laid down on laid paper

420 x 300 (16⁹/₁₆ x 11¹³/₁₆)

Inscribed in an unknown hand, verso of secondary support, lower center, in pen and ink(?), *Giovan. Marco Pitteri 1703–1786* (partly erased)

Provenance: Unidentified collector's mark, top center, crowned shield with lion rampant (not in Lugt); Matthias Komar, New York (Lugt 1882a); purchased from Lorna Lowe, London, 1982

Exhibition: London 1981, no. 32, pl. 12

Acc. no. 28018

Giovanni Battista Pittoni was a leading history painter in eighteenth-century Venice, a solid, middle-of-the-road craftsman. In terms of age, he falls between Piazzetta and Tiepolo, and on one occasion at least, the three of them were involved in a joint project, to provide altarpieces for the church of the Maddalena at Parma. The present drawing has been identified as a finished study for the figure of the beggar woman in the lower right corner of the altarpiece in the Schlosskirche at Bad Mergentheim, *The Alms of Saint Elizabeth of Hungary* (fig. 1) of 1734.[1] The profile, legs, and drapery of the woman are identical in drawing and painting; her right hand, holding the bowl, and the child are different. A less elaborated drawing of the same subject, omitting the staff and vase in the foreground, was noted by Pallucchini.[2]

However, this last drawing, in the Fondazione Giorgio Cini in Venice,[3] was rejected by Binion, and indeed all the drawings illustrated by Pallucchini that come close in style to the present sheet[4] were assigned by Binion to the Bohemian painter Anton Kern, who resided in Venice as an apprentice and assistant in the Pittoni studio for some nine years, from 1725 to 1734.[5] Binion also noted a copy by Kern of *The Alms of Saint Elizabeth of Hungary* at Prague.

Fig. 1. Giovanni Battista Pittoni, *The Alms of Saint Elizabeth of Hungary*, 1734, Schloss-kirche, Bad Mergentheim (Württemberg)

The realization that Kern was responsible for some of the material from the Pittoni studio has been developing for some time, starting in 1966 when Alessandro Bettagno first doubted a drawing in the Louvre, *The Martyrdom of Saint Thomas*.[6] This again makes a valuable comparison with the present drawing.

The inscription on the verso presumably refers to the engraver Marco Alvise Pitteri (1702–1786), for reasons that are not at all clear.[7]

GK

1. Zava Bocazzi 1979, no. 4, pl. 351.
2. Pallucchini 1945, pl. 114. Neither this nor the present drawing are listed by Binion 1983.
3. Inv. 30,207.
4. Pallucchini 1945, nos. 119, 121–128, 135, 136.
5. Binion 1983, 25–29, figs. 394–397.
6. Venice 1966, no. 35; Binion 1983, fig. 396.
7. I am grateful to Alice Binion for confirming the conclusions of this entry.

**22**

## *An Architectural Capriccio*

**Francesco Guardi**
Venice 1712–1793 Venice

Recto: pen and brown (iron gall) ink and wash on laid paper; verso: slight sketch in black chalk of the hull and rigging of a ship

255 x 397 (10¹/₁₆ x 15⁵/₈)

Watermark: Fleur-de-lis over letter *W* (similar to Heawood 1531)

Provenance: J. P. Heseltine; his sale, Frederick Muller, Amsterdam, 27–28 May 1913, lot 305; purchased from Edouard Jonas, Paris, 1956

Literature: Seilern 1959, 68; Popham and Fenwick 1965, 76–77, no. 113; Morassi 1975, no. 634

Exhibitions: Toronto 1968, no. 30; London 1969, no. 12; Florence 1969, no. 10

Acc. no. 6573

Francesco Guardi seems to have started his career in the studio of his brother-in-law, Giovanni Battista Tiepolo, who was married to his sister, Cecilia.[1] He appears later to have collaborated with his older brother, Antonio, as a history painter, and only turned to *vedute* painting—on which his fame principally rests—in middle life, possibly as late as c. 1760, when he is mentioned as a ''good pupil of Canaletto.''[2] He was a prolific draftsman, and the present drawing is linked in various ways with a considerable number of

Fig. 1. Francesco Guardi, *Capriccio with Arch and Temple,* formerly Talleyrand Collection, present location unknown

Fig. 2. Francesco Guardi, *An Architectural Capriccio,* Collection of Mrs. Murray S. Danforth, Providence, Rhode Island

other drawings and paintings. In his book on the Guardi drawings, Morassi identified it as a study for a painting once with Thomas Agnew and Sons,[3] which has a pendant, for which there is a drawing in the Antoine Seilern collection of the Courtauld Institute of Art.[4] Morassi also noted a related drawing at Verona.[5]

The problem here is to establish the correct relationship between this drawing and another (fig. 1) formerly in the Talleyrand collection,[6] and a painting (fig. 2) in Providence.[7] The Ottawa drawing is a more careful performance than the Talleyrand drawing, using the wash in an unusually precise and dramatic way. In this respect, it faithfully reflects the tonal balance of the painting in Provi-

Cat. 22, verso

dence. The Talleyrand drawing is more summary and more agitated in penmanship, though the compositional differences are minimal. The horseman on the extreme left is replaced by a standing figure in the Talleyrand drawing. In the Providence painting, the trees below this figure are omitted; the sticks in the water beneath the arch are likewise omitted, though these appear in a slightly larger version in the Museo Cagnola at Gazzada.[8] The present design is also repeated in several paintings of vertical format, such as that in the Seilern collection,[9] and at least four other examples may be noted.[10] Thus it is clear that this was one of Guardi's favorite compositions.

The drawing on the verso evidently relates to one of Francesco's paintings of storms at sea, essays in the manner of Marco Ricci. A similar vessel may be noted in two of these canvases, one in a private collection in Zurich and one in the Assheton-Bennett collection in London.[11]

GK

1. For some evidence of Francesco Guardi as an apprentice in the Tiepolo studio, see Knox 1976.
2. The whole question of Francesco's role in the Guardi studio prior to the death of Antonio in 1760 is extremely problematic. For Francesco's link with Canaletto prior to the latter's death in 1766, see Livan 1942, under the date 25 April 1764, and Knox 1980, 204.
3. Morassi 1975, 187. For the painting with Agnew, see Morassi 1973, no. 952 (not illustrated); also London 1968, 12, no. 16.
4. For the pendant, see Morassi 1973, no. 970, pl. 851. For the Seilern drawing, see Morassi 1975, no. 628, pl. 611.
5. Museo del Castelvecchio; Morassi 1975, no. 635, pl. 618.
6. Morassi 1958, no. 66; Morassi 1975, no. 633, pl. 609.
7. Mrs. Murray S. Danforth Collection; Bortolatti 1974, no. 464.
8. Morassi 1973, no. 944, pl. 841.
9. Seilern 1959, no. 113, pl. 73.
10. Morassi 1973, nos. 942, 945, 945a, 946, pls. 832–836.
11. Bortolatti 1974, nos. 123 and 431.

## 23

## *A Fantastic Interior*, c. 1750

**Giovanni Battista Piranesi**
Mogliano 1720–1778 Rome

Pen and brown ink and wash over red chalk, on off-white laid paper, laid down on heavy laid paper with a drawn border

124 x 180 (4⁷/₈ x 7¹/₁₆)

Inscribed by the artist, bottom right, in pen and brown ink, *Piranesi*

Provenance: Prince Argoutinsky-Dolgoroukoff (Lugt 2602d); Armand Rateau; purchased from H. M. Calmann, London, 1948, through Paul Oppé

Literature: Thomas 1954, pl. 40; Thomas 1957, 11; Fenwick 1964, fig. 4; Popham and Fenwick 1965, no. 114; Fenwick 1966, 22, 24 (repr.); Rey 1969, 10–11; Boggs 1971, fig. 166

Exhibitions: Toronto 1968, no. 42; London 1969, no. 11; Florence 1969, no. 9; Paris 1969–1970, no. 17; Venice 1978a, no. 22

Acc. no. 4993

Giovanni Battista Piranesi, a celebrated engraver and publisher and sometime architect, was a Venetian by birth and upbringing. However, in 1740, at the age of twenty, he seized an opportunity to go to Rome in the train of a Venetian ambassador to the Holy See. By this time he may have already received a basic training in stage design, and on arrival in Rome he continued to study stage design with Domenico and Giuseppe Valeriani, and etching with Giuseppe Vasi. By 1742 his independent career was under way: he had begun to explore the antiquities of Rome, and he appears to have abandoned any ambitions as a stage designer

and to hope for a career as an architect. By 1747 he was settled definitely in Rome, and his relatively brief career as an enormously successful and prolific print-maker began.

This drawing, which obviously relates to his background in stage design, seems to have been one of a group, possibly the contents of a small sketchbook, which belonged to Prince Argoutinsky-Dolgo-roukoff (1875–1941) in 1932. Some of the drawings in this group are recorded on the London art market in 1948, and with H. M. Calmann in 1954. Two of these, of the same size, 122 x 180 mm, appeared in a Sotheby's sale in 1980.[1] However, not all the Piranesi drawings from this source are so small.[2]

The purpose of these drawings, which are carefully executed and often bear the same signature, is not at all clear, unless they are indeed visionary ideas for the theater, which ultimately blossomed into that fantastic dreamlike series of etchings, the *Invenzioni Capric di Carceri all Acqua Forte*. They are quite small, far smaller than Piranesi's graphic work in general, though they are about the same size as the series of the *Vedute di Roma* of 1745.[3] One of them, in the Kunsthalle at Hamburg, was identified by Wilton-Ely as a study for the eighth plate of the *Carceri* of 1749–1750.[4] The present design displays some broad affinities with the third plate of the *Carceri*.[5] The date of c. 1750 is due to Hylton Thomas.[6]

GK

1. Sotheby's, London, 11 December 1980, lots 44 and 45. Of these, the latter is described as follows: "A preliminary study, in the same direction, for a print added to the *Opere varie,* published after 1757." They are also reproduced by Focillon 1918, pls. 128, 123.
2. For example, the specimens in the E. Powis Jones collection, New York (154 x 213 mm), and in the Ashmolean Museum (257 x 187 mm). These are reproduced by Bettagno in Venice 1978a, nos. 6, 11.
3. See the exhibition catalogue, Venice 1978b, 11–12, pls. 7–17.
4. Wilton-Ely 1978, fig. 147, measuring 183 x 133 mm; see also Robison 1986, fig. 46, where it is dated 1748–1749.
5. For a full recent discussion, see Robison 1986, 148–151.
6. Thomas 1954.

## 24

## *Two Figure Studies*

**Giovanni Battista Piranesi**
Mogliano 1720–1778 Rome

Pen and brown (iron gall) ink on off-white laid paper

227 x 323 (8$^{15}$/$_{16}$ x 12$^{11}$/$_{16}$)

Inscription: Ascribed to Piranesi by John Skippe in pencil on the mount

Provenance: John Skippe, Ledbury; Mrs. A. C. Rayner Wood; Skippe sale, Christie's, London, 20–21 November 1958, lot 157; Baron Robert von Hirsch; F. A. Drey, London; Charles Slatkin Galleries, New York; gift of Mrs. Samuel Bronfman, O.B.E., in honor of her late husband, Samuel Bronfman, C.C., LL.D., 1973

Exhibitions: London 1953, no. 201; London 1958, no. 157, pl. 27; New York 1966b, no. 17, pl. 14; Ottawa 1974, no. 9; Venice 1978b, no. 55

Acc. no. 17576

The drawings of Giovanni Battista Piranesi fall broadly into three categories: first, the visionary designs of his youth, culminating in the etchings known as the *Carceri* and the *Grotteschi*; second, the large topographical drawings, studies for the great monumental series of etchings of Rome and Pompeii; and third, a small number of studies of trees and figures, which relate less directly to the etchings and were no doubt made in Piranesi's rare moments of relaxation. This sheet clearly belongs to the third category.[1]

Since John Skippe (1742–1811) is re-

## An Encounter During a Country Walk, c. 1791

### Giovanni Domenico Tiepolo
Venice 1727–1804 Venice

Pen and brown ink, with gray and brown wash, over black chalk on off-white laid paper

288 x 417 (11⅜ x 16⁷/₁₆)

Inscribed by the artist, bottom left, in pen and brown ink, *domo Tiepolo f*

Watermark: A large escutcheon with the letters *C S C*

Provenance: Henri de Chennevières, Paris; sale, Sotheby's, London, 6 July 1967, lot 67; Charles Slatkin Galleries, New York; gift of Mrs. Samuel Bronfman, O.B.E., in honor of her late husband, Samuel Bronfman, C.C., LL.D., 1973

Exhibitions: New York (n.d.), pl. 16; Ottawa 1974, no. 19

Acc. no. 17582

corded as having bought drawings in Italy in the period 1773–1778,[2] it is not unlikely that he purchased this sheet from the artist's studio in the last phase of Piranesi's career. It may be compared with other similar sheets by Piranesi, such as those in the Ecole des Beaux-Arts in Paris,[3] and in the collection of Janos Scholz in New York.[4] Figures such as these, on a much smaller scale, are a familiar element in many of Piranesi's prints.

G K

1. The drawings of Piranesi have been studied by many scholars; see particularly Thomas 1954.
2. Lugt 1956, suppl. 1520a,b.
3. Thomas 1954, no. 74.
4. Thomas 1954, no. 70; exhibited Washington 1974, no. 94.

Domenico Tiepolo, the eldest son of Giovanni Battista Tiepolo, was a very considerable artist in his own right. His independent career started when he was about twenty years old, and he quickly established his reputation as a painter of serious and original religious works. In the early years he was a productive etcher, and throughout his life he was a prolific draftsman. At a comparatively early age, in his middle fifties, he virtually retired from painting and devoted himself to the creation of those innumerable and characteristic drawings in pen and wash by which he is best known. In his early sixties he undertook a large and ambitious series of elaborate scenes of contemporary life, several of which bear the date 1791. These drawings have a broad relationship with the frescoed decorations that Domenico painted in the same year for the Tiepolo family villa on the country road that leads from Mirano to Zianigo.[1] The series, which was discussed by Byam Shaw,[2] includes many country scenes with peasants, some urban scenes, and a few, as here, showing fashionable people enjoying their *villeggiatura* in the countryside. It is sometimes

thought that Domenico was responsible for introducing such themes from everyday life into the Tiepolo studio, but it now seems that he must share the credit for this with his father.[3] From time to time in these drawings he makes use of the landscape drawings and the caricatures of Giovanni Battista.

The exact purpose of these drawings is unclear: it appears that they were not made for sale, and it is possible that they were intended for the engraver. Certainly the Venetian printmakers at this time were issuing a certain amount of comparable material, mostly after designs by Francesco Maggiotto, the son of Domenico Maggiotto, a close follower of Giovanni Battista Piazzetta. Nothing is known of the history of these drawings prior to the late nineteenth century, when a number of them are recorded in the collection of Henri de Chennevières, an official of the Louvre and the author of a small but valuable book, the first monograph on Tiepolo, published in 1898. He may have acquired his drawings from Camille Rogier, another Tiepolo enthusiast, who was resident for a period in Venice.[4] Some sixty drawings of The Scenes of Contemporary Life can now be counted, and the series may originally have comprised as many as one hundred sheets. Nothing very comparable can be found in the earlier work of Domenico,

but these drawings do lead to the celebrated series of scenes from the life of Punchinello, the *Divertimenti per li regazzi*, which followed some ten years later. It has been sugested that, just as the last mentioned drawings echo the theater of Carlo Gozzi, the scenes of contemporary life reflect the theater of Carlo Goldoni.[5] This particular drawing exhibits an unusual technical touch: after he had finished the drawing, Domenico decided to strengthen the figure of the bowing fop on the left by working over it entirely with the pen.

G K

1. These are now housed in Ca'Rezzonico in Venice: see Pignatti 1960, 330–379, and Mariuz 1971, pls. 348–383. Pl. 368 has some relationship with the present drawing.
2. Byam Shaw 1962, 45–51.
3. Thus it can now be shown that it was Giambattista who established the special Tiepolo form of Punchinello (Knox 1984), and it was he who executed nearly all the landscape drawings in the Tiepolo studio (Knox 1974).
4. For a brief notice of Rogier and de Chennevières, see Knox 1960, 8–9.
5. These links are touched upon by Byam Shaw 1962, 46–51, and Knox 1983, 146. For the Punchinello drawings, see Bloomington 1979 and Gealt 1986.

## 26

## *Sheet of Eight Heads*, after 1805

**Mauro Gandolfi**

Bologna 1764–1834 Bologna

Pen and brown (iron gall) ink on laid paper, lined with tissue, mounted on wove paper with a ruled border (upper right corner repaired)

250 x 196 (9¹³/₁₆ x 7¹¹/₁₆), irregular

Watermark: Voorn 165

Provenance: Purchased from Armando Neerman, London, 1980

Acc. no. 23749

Both Mauro Gandolfi and his father, Gaetano (1734–1802), produced a number of these little *Studi di teste* and it is often difficult to distinguish their hands. They repeated many of the same types (pretty girls and boys, old men, Turks) and their pen styles reflect their work as printmakers: Gaetano as etcher, Mauro as engraver. It is principally the system of crosshatching and dots, which Mauro executed with greater control and precision than his father, that identifies Mauro's sheets. Mauro, in fact, in his autobiography wrote that he decided in 1801 to spend some time in Paris learning the art of engraving.[1] He had begun to despair of getting commissions for paintings after the dislocations of local patronage that occurred with the advent of Napoleon in 1796 (an event he enthusiastically supported). For the rest of his life, after his return to Italy in 1805, he supported himself primarily by the practice of reproductive engravings, the sale of some highly finished watercolors, and a sporadic trade in semiprecious gems.

MC

1. Zanotti 1925.

Netherlandish and
German

## 27

## *Virgin and Child with Four Angels*

**Unknown Artist**
Netherlandish, late fifteenth century

**after Hans Memling**
Seligenstadt n.d.–1494 Bruges

Metalpoint over black chalk or leadpoint on prepared cream-colored laid paper

254 x 190 (9 x 7½)

Provenance: Richard Philipps, Baron Milford (1744–1823); Sir John Philipps; *L'Art Ancien,* Auction 98, Zurich, 16 June 1960; H. M. Calmann; purchased from P. & D. Colnaghi, London, 1961

Literature: Popham and Fenwick 1965, 87, no. 125; Fenwick 1966, 26; Friedländer 1971, 6: pt. 2, 131 n. 73, pl. 128

Exhibitions: London 1953, no. 258; London 1961, no. 11; Toronto 1968, no. 3; London 1969, no. 18; Florence 1969, no. 15; Paris 1969–1970, no. 21

Acc. no. 9677

Although the drawing has been attributed, with reservations, to Hans Memling, it would seem to be a copy of the left panel of a diptych in the Alte Pinakothek in Munich (fig. 1).[1] The left panel shows this composition of the Madonna and Child with four angels, and the right panel, Saint George and a kneeling donor. Because the surface of the diptych is damaged, it is impossible to determine whether it was painted by Memling himself, but the composition is certainly typical of his work. It was apparently much admired, for three painted copies of the composition are known, all from the late fifteenth or early sixteenth centuries. Two are probably Netherlandish, the third was attributed by Friedländer to the Master of Kappenberg, a Westphalian artist of the early sixteenth century.[2]

The attribution of the drawing to Memling rested on the assumption that it is a preparatory study for the painting. Even so, it would be difficult to establish whether the drawing was by Memling or by the assistant who may have painted the work, for no drawings survive that can be attributed to Memling. In any case, it is unlikely the drawing is a preparatory study for the Munich painting.

The use of highly finished preparatory studies does not seem to have been normal studio practice in fifteenth-century Flanders. There are virtually no fifteenth-century Flemish drawings that can be shown to be specific studies for paintings. To the contrary, such metalpoint drawings were routinely used for the opposite purpose—by other artists to record elements of paintings or entire compositions for future reference.[3]

These fifteenth-century Netherlandish drawings do not ordinarily provide a complete copy of a composition, but record a selection of interesting passages. The artist of the Ottawa drawing, however, has recorded the entire figural grouping from Memling's painting, although his interest was limited to the figures—they alone are outlined in black chalk or leadpoint as a preliminary guide for the detailed metalpoint drawing.[4] The background landscape and buildings are summarily sketched in; the tree and rose bushes immediately behind the Virgin are not indicated at all.[5] The musical instruments and the faces and hands of the angels are all left in outline form relative to the detailed depiction given the Virgin and Child and the angels' draperies.

Compared to the painting, the drawing

Fig. 1. Workshop of Hans Memling, *Virgin and Child with Four Angels* (left panel of a diptych), Alte Pinakothek, Munich

is rather two-dimensional. The draftsman was concerned to record the arrangement of the forms on the picture plane as a guide for a future painting, not to show their placement in space or how their spatial existence was indicated. Clearly the reduction of the background diminishes the spatial content of the composition, but even within the figural group there is a flattening of forms; the three-dimensional quality of the folds of the garments is considerably lessened.

The hatching technique indicates where there should be shading, rather than modeling the forms. The solid stereometric forms of the musical instruments, quite impressively depicted in the painting, are lost in the summary representation in the drawing. The two-dimensional outlines of the instruments are clearly marked, but not the interior details, which would give them spatial reality. Finally, details such as the Christ Child's head have lost plasticity.

There are several noticeable differences between the drawing and the Munich panel. The contour of the angel's robe at the lower center in the drawing was at first drawn somewhat too low and corrected. The angels' faces, as far as can be judged from the outlines, are rather broader than in the Memling. The two rear angels are much higher in the composition of the drawing than of the painting. In the painting, the heads of both angels are below that of the Virgin, while in the drawing the angels extend above her, interrupting the coherent, graceful flow of the original composition. Interestingly, this alteration is not seen in the painted copies of the panel.

The drawing also contains several clues about its later use. First, lines have been drawn with a straightedge between one and two centimeters in from the left, right, and lower edges. This might have been a guide for a somewhat reduced version of the composition in a copy. Second, the drawing bears a number of small traces of black paint or ink, as well as red and blue paint. It clearly was used in a painter's workshop and may have fulfilled its purpose as a guide for a painted copy of Memling's panel.

HC

1. Friedländer 1971, 6: pt. 2, no. 104. As "Memling workshop(?)."
2. The Netherlandish copies are Friedländer 1971, 6: pt. 2, no. 104a and b. For the attribution to the Master of Kappenberg, see Friedländer 1971, 6: pt. 2, 131 n. 73 and pl. 129A.
3. The National Gallery of Canada's drawing by Gerard David of four heads from the Ghent Altarpiece is an excellent example. Popham and Fenwick 1965, no. 126.
4. Although leadpoint was often used to sketch in a composition to be completed in another medium, the combination of the two metalpoint media is somewhat unusual. See Ames-Lewis 1981, 35–43, for the most recent discussion of silverpoint technique. Relating specifically to fifteenth-century Netherlandish technique, see Sonkes 1969, 269–275.
5. Interestingly, the tree and rose bushes are also omitted in the copy now in the Rutgers Art Museum (Friedländer 1971, 6: pt. 2, 104b). However, the painting does not show the other changes to Memling's composition seen in the Ottawa drawing.

## 28

## *Nude Woman with a Staff*, 1500–1501

**Albrecht Dürer**

Nuremberg 1471–1528 Nuremberg

Pen and brown ink with brown wash on laid paper

235 x 96 (9¼ x 3¾)

Inscribed, in an unknown hand, upper center, in pen and brown ink, *1508 AD* (in monogram)

Provenance: Prince Georg Lubomirski (formerly on deposit in the museum at Lemberg); P. & D. Colnaghi, London; presented by Joseph H. Hirshhorn and a group of his friends and associates, 1956

Literature: Reitlinger 1927, 155; Flechsig 1931, 2:183; Grebarowicz and Tietze 1929, no. 12; Lippmann 1929, 7: no. 751; Winkler 1936–1939, 1: no. 265; Panofsky 1945, 2: no. 1185; Tietze and Tietze-Conrat 1937, 2:17, no. 251a; Musper 1952, 118; Fenwick 1956, 331; Colnaghi 1960, no. 71; Benesch 1962, 2: no. 342; Popham and Fenwick 1965, no. 183; Emory 1965, 40; Fenwick 1966, 21, 26; Rupprich 1966, 2:37; Boggs 1969, 155; Vitzhum 1969, 10–17; Vertova 1969, 46, 48; Boggs 1971, 49; Strauss 1974, 2: no. 1500/33; Edwards 1979, 110

Exhibitions: London 1955, no. 28; Vancouver 1964, no. 11; Toronto 1968, no. 9; London 1969, no. 20; Florence 1969, no. 17; Paris 1969–1970, no. 23; Washington 1971a, no. VIII

Acc. no. 6652

Despite the ''studio-prop'' appearance that the staff the woman holds imparts, this study is not a drawing from nature but one of Albrecht Dürer's earliest proportional studies of the nude human body. The basic form of the figure was determined with a pair of dividers used to measure the distances between significant aspects of the figure. The drawing shows numerous holes left by Dürer's compass or dividers' point, which all fall at intersections of the main axis with the major horizontal divisions of the body or at significant points along the contour of the figure.

Describing the system by which the figure is created is complicated and Dürer's own instructions for the construction of such a figure are long and difficult to follow. The structure of the woman's body is made from a geometric scheme for the ideal human form, an idea that began to fascinate Dürer about 1500, perhaps as a result of seeing similar studies in the possession of Jacopo de' Barbari, an Italian artist working in Nuremberg from 1500 to 1503.[1]

The drawing is based on several units, such as the side of the equilateral triangle defined by the sternum and the breasts, or the sides of the square that surrounds the chest. Dürer has coordinated this use of geometric shapes with the division of the figure into fractions of its central axis. For example, the length of the legs is three times the length of the side of the square defining the chest. After this geometric structure was drawn, the contours of the figure were added freehand, followed by the modeling and the brown wash background.

The dating of many of Dürer's nude studies from the first decade of the sixteenth century, especially the proportional studies, has been the cause of much scholarly discussion. The place of any particular undated drawing within the evolution of his figure types and

method of construction is usually determined by its relationship to the engraving of *The Fall of Man*, dated 1504. The drawings are basically classed as early studies (around 1500), studies immediately preceding the engraving (thus from 1504), and studies following the engraving.

This drawing bears the date 1508 and a monogram, but scholars have been virtually unanimous in denying the authenticity or accuracy of the inscription.[2] It is clear that the fashion in which the figure is constructed is typical of his first phase of such experiments. In his constructed figures before his second trip to Italy in 1505–1507, Dürer attempted to build up the human form by the use of geometric shapes as well as to divide the various elements of the body as fractions of the total length.[3] In his later figure studies, Dürer tried only to determine the length of sections of the body along the central axis, using an arithmetical system rather than a geometric one.

Rupprich and Levenson both assigned the Ottawa drawing a date of 1501–1503. Levenson suggested that the placement of the legs, with a clear differentiation between the free left leg and engaged right leg, was a development that is seen only in the drawings immediately before *The Fall of Man*, thus placing the Ottawa drawing in 1503. However, this stance is seen in drawings datable to 1500 such as the *Nude Woman with a Foreshortened Circle* in the British Museum.[4] Interestingly, the position of the right foot is hard to determine in the Ottawa drawing, because Dürer seems to have corrected it. His change of heart would perhaps indicate that he was still not following a set pattern in the positioning of the legs. Levenson pointed out that the figure in the Ottawa drawing has an anatomy similar to that of the *Reclining Nude* of 1501 in the Albertina.[5]

Strauss was justified in placing the Ottawa drawing among Dürer's first efforts at constructing figures, a group of studies done in 1500. He provided telling evidence of the date of the entire group by pointing out that they are on similar paper with the same watermark[6] (although the paper of the Ottawa drawing does not contain a watermark). All utilize a similar method of construction and show female nudes of the same body type. A final indication of the drawing's place in

Dürer's earliest proportional studies is the location of the lowest reference point on the central axis well below the feet. This appears in only the earliest attempts.[7] The figure's head would seem to match the schema shown in a drawing in the British Museum that has been dated alternatively to 1500 and 1504.[8]

Dürer's attention was concentrated on the method of the construction and not on meticulous draftsmanship and, as a result, some parts of the freehand drawing are rather weak. The shading of the right leg is too heavy and radiates too markedly from a central point, thus flattening rather than modeling the form. The twist of the neck is awkwardly achieved and the right arm is unconvincingly joined to the torso. Indeed, it is only in these relatively early proportional studies that he even bothered to provide any shading over lines of construction. He quickly decided that it was more effective to trace the outline onto the verso or onto another sheet in order to work up a fair copy.

This may help explain one purpose of the addition of the heavy brown wash after completion of the drawing. Although he did not trace this drawing on the verso, during this period Dürer often made a constructed drawing on one side of the sheet and traced the lines on the verso to make a version without the lines of construction. The heavy outline may have aided in that process. It also adds a spatial quality to the drawing by creating a ground for the figure. Finally, the wash helps to smooth out the contours of the figure, which were uneven due to the "connect-the-dots" method of construction.

H C

1. A more complete discussion of the nature and origin of Dürer's theories is in Panofsky 1945, 1: 261–284, and is briefly stated in Rupprich 1966, 2:9–10.

2. See Popham and Fenwick 1965, no. 183. Strauss 1974, 2: no. 1504/18, correctly points out that the drawing *Head of a Woman* in Compiègne also has a monogram and the year 1508 added by the same hand. The penwork seems too weak to be Dürer's.

3. This division is pointed out by Rupprich 1966, 2:19. The most notable example of Dürer's use of geometric shapes for the construction of a figure in 1500 is the famous painted *Self-Portrait* in the Alte Pinakothek, Munich.

4. The date of 1500 is accepted for this drawing and that of the *Nude Woman Constructed* on the verso of the sheet (Winkler 1936–1939, 2: nos. 411–412, Strauss

1974, 2: nos. 1500/29–30) by Panofsky 1915, 86, and Rupprich 1966, 2:42–44.

5. Winkler 1936–1939, 1: no. 260; Washington 1971a, no. VIII.

6. Strauss 1974, 2: no. 1500/24. The watermark is a bull's head with caduceus. This group, Strauss 1974, 2: nos. 1501/24–36, forms the bulk of Dürer's proportional studies of female figures constructed in the "geometric" manner.

7. As noted by Strauss 1974, 2: no. 1500/33.

8. British Museum, Sloan 5230 fol. 10r. Rupprich 1966, 2:46, dated the drawing to 1500. Strauss 1974, 5: HP 1504/1, tentatively suggested 1504.

## 29

## *The Christ Child Disputing with the Elders*

**Aert Ortkens (Pseudo)**

Brussels, early sixteenth century

Pen and brown ink over traces of black chalk on laid paper

220 (8⅝), diameter

Inscribed by the artist, center left, in pen and brown ink, . . . *IANCRER* (?)

Watermark: Gothic P (similar to Briquet 8535–8540)

Provenance: A. Grahl (Lugt 1199); Henry Oppenheimer; C. R. Rudolf; his sale, Sotheby's, Amsterdam, 6 June 1977, lot 7; purchased at the sale

Literature: Parker 1938, under no. 64 (as A. Ortkens); Wayment 1969, 267 (as B. van Orley); Wayment 1969a, 367; Boon 1978, under no. 384 (as "Pseudo A. Ortkens," unknown Brussels master)

Exhibitions: London 1953, no. 252 (as A. Ortkens); London 1953–1954, no. 496; London 1962, no. 115

Acc. no. 18866

Although the design (*vidimus*) for glass painting constituted a significant category of drawing in the Netherlands in the late fifteenth and sixteenth centuries, there are big gaps in our understanding of the artists involved, especially in the southern Netherlands. Drawings for glass painting are generally not signed, and much of the glass painting itself has been lost.

*The Christ Child Disputing with the Elders* is one of several generically related designs for decorative glass roundels that were probably done from c. 1505 to 1520 in Brussels, or, in any case, the southern Netherlands, for which no persuasive attribution has been put forth.[1] The annotation on an allegedly related drawing led to an attribution early in this century[2] to Aert Ortkens from Nijmegen, who was known as a glass painter in Mecheln. The annotation is ambiguous at best and there are no proven connections between any of the drawings and extant glass paintings. The present drawing is unusual in the fluid, light touch of the contour lines combined with great assurance in the analysis of forms. The fishhook hatching strokes may run across the tops of folds for general shading. The *Circum-*

Fig. 1. Pseudo Aert Ortkens, *The Circumcision of Christ,* Rijksprentenkabinet, Amsterdam (Copyright Rijksmuseum-Stichting, Amsterdam)

*cision of Christ* in Amsterdam (fig. 1)[3] is the only drawing from the larger group of drawings considered in the past to be by the same hand or shop that exhibits an identical use of line and form and comparable sense of composition. Certainly the *Adoration of the Magi,* also for-

merly in the Rudolf Collection,[4] previously described as by the same hand, bears little relationship. The attribution of these and other drawings to the young Bernard van Orley by Wayment[5] is not convincing, as Boon[6] indicated. The grouping of hands must be rethought. The continued attribution of such drawings to Aert Ortkens (Pseudo or so-called, and so forth) is simply an omnibus abstraction retained until plausible identifications are proposed.

The episode of the twelve-year-old Christ who slipped away from his parents in Jerusalem and returned to the temple in order to dispute the interpretation of the law with the elders (Luke 4:41–52) is the only story of Christ's childhood in the canonical gospels. To convey pictorially the respect accorded him, the artist shows Christ expounding from the position of authority at the lectern under a canopy bearing an indecipherable, apparently meaningless inscription meant to suggest Latin. The ellipse of attentive elders complements the curve of the roundel, while the inexplicably kneeling elder who twists around to look back at Christ offers an opportunity for a profusion of splaying folds, a decorative foreground artifice used in other roundels possibly from the same shop. Instead of Mary and Joseph entering from the left, as is customary, an elder climbs the steps from what is evidently the book room, bearing another tome for consultation. Mary and Joseph look in through the arched doorway in the right rear, creating a secondary vignette paralleling the Flight into Egypt to the rear of the *Circumcision*.

This *Christ Child Disputing with the Elders* and the related *Circumcision* (with the Flight into Egypt) must be from a series of the Seven Sorrows of Mary. That this is not simply a Life of Christ or the Virgin is indicated by the symbolic treatment of Mary in the Ottawa drawing. Next to Mary, who holds her hands in a gesture of prayer or homage and is the only figure with a halo, is suspended a sword. This is the sword metaphorically referred to by Simeon (Luke 2:35), to whom the mission and future suffering of Christ were revealed when Christ's parents presented him to the temple. The ''com-passion'' or future suffering of the Virgin in sympathy with her son was also prophesied with the metaphor ''a sword will pierce through your own soul also'' (see cat. 42). Her distress at Christ's disappearance and his confrontation with the elders provided an event from Christ's childhood that rounds out the incidents of the Sorrows or Passion of Mary to the mystical number seven: Circumcision, Flight into Egypt, Dispute with the Elders, Carrying of the Cross, Crucifixion, Lamentation, Entombment. The devotion of the *Mater Dolorosa* reached its peak in the late fifteenth century in the Netherlands.[7] In 1423 the synod at Cologne instituted a feast celebrating her Seven Sorrows, and in the 1490s in Flanders the first confraternity devoted to their contemplation was founded. By 1500 altars and chapels were being dedicated to the Seven Sorrows and the Ottawa *vidimus* was surely executed for the windows of such a chapel.

JAS

1. Beside those cited by Wayment 1967 and 1969, Boon 1978, under nos. 12 and 384–386, and in the Sotheby's, London, sales catalogue, 6 June 1977, under lot 7, there are three episodes from the story of Susanna in the Fogg Art Museum, Harvard University.
2. Friedländer 1917 and successive writers as discussed by Wayment 1967, 177–179, and Boon 1978, 137–138.
3. Rijksprentenkabinet, inv. no. 21:482, pen and brown ink, and gray wash (original?), 220 mm in diam.; Boon 1978, no. 384, ill.
4. London 1972, no. 114, ''pen and brush in brown and grey, heightened with white, on brown paper,'' 219 mm in diam.; Wayment 1969b, fig. 11.
5. Wayment 1967, 266–269.
6. Boon 1978, under no. 384, considers the three drawings to be by the same hand, though he rejects the attribution to van Orley.
7. For the Seven Sorrows, see Gerdts 1954, Kirschbaum 1972, and Vandenbroeck 1985, under nos. 383–389, Master of Hoogstraten, *The Seven Sorrows of Mary*. For the Circumcision alone, see Schiller 1971, 88–90.

## 30

## *A Landsknecht Running*

**Jörg Breu the Younger**

Augsburg c. 1510–1547 Augsburg

Pen and black ink with gray wash on cream laid paper

130 x 130 (5¹/₈ x 5¹/₈)

Inscribed, in an unknown hand, upper left, in pen and brown ink, *N33;* in another hand, lower left, in graphite, *10;* verso of secondary support, in graphite, *H. Holbein*

Watermark: Lower right, five-pointed star

Provenance: William Young Ottley; Sir Thomas Lawrence (Lugt 2445); John Malcolm; The Hon. A. E. Gathorne-Hardy; Geoffrey Gathorne-Hardy; The Hon. Richard Gathrone-Hardy; purchased from Richard Day, London, 1977

Literature: Gathorne-Hardy 1902, no. 65

Exhibitions: London 1971, no. 2

Acc. no. 18892

The attribution to Jörg Breu the Younger cannot be completely affirmed because such freely drawn pen and wash designs were done by many artists in southern Germany or Switzerland during the middle decades of the sixteenth century. However, there appears to be some basis for associating the work with Breu based on comparison to other drawings attributed to him, such as the *Party in the Open Air with an Architectural Setting* in the collection at Chatsworth[1] or a drawing of a similar subject in Darmstadt.[2] The Chatsworth drawing, whose composition is quite close to several of Breu's woodcuts, shows the same freedom in handling the pen and a similar daring in adding large areas of wash without relating them precisely to the forms to be modeled. The use of single pen strokes in the garments to denote three-dimensional forms is also characteristic of all three drawings.

In his more finished drawings, such as the dated and monogrammed chiaroscuro drawing of 1543 in the Pierpont Morgan Library,[3] Breu depicts dramatic movement, but his want of spontaneity in execution gives a stilted and exaggerated appearance to the figures, who

lack the lively grace of those in the Chatsworth and Darmstadt drawings. At the other extreme is the impressive rendition of a figure in motion in the Ottawa drawing, which has been quickly and boldy drawn, with contours suggested more than actually shown.

The man is identifiable from his clothing and sword as a *Landsknecht,* or mercenary soldier. These soldiers are ubiquitous in German art of the first half of the sixteenth century. Not least among the reasons for their frequent depiction was their colorful, outlandish attire. The broad feathered hat, wide slashed sleeves, narrow knee-length trousers, leather thigh protection, and broad flat-toed shoes of this figure are similar to many depictions of *Landsknechte* from the period between about 1510 and 1540. As of the middle of the century, *Landsknechte* are shown with looser leggings. The clothing of this figure is virtually identical to several in a series of *Landsknechte* of 1538 by Niklas Stoer printed in Nuremberg.[4] His weapon is a *Katzbalger,* or *Landsknecht* sword, in general use for most of the first half of the sixteenth century.

The subject matter of the drawing can-

not be fully understood since the draw-
ing has obviously been excised from a
larger sheet. The man appears to hold
another figure by the hair(?) and pre-
pares to attack with his sword. The cor-
ner of a building and possibly half a
doorway are visible at the right, and so
the missing figure may have been trying
to escape to safety. Such a combination
would be no rarity in any of the many
large woodcuts or paintings of battle
scenes done in southern Germany dur-
ing the 1530s and 1540s, although the fig-
ure cannot be found in Breu's surviving
woodcuts.[5] However, the subject matter
of his lost wall paintings is largely un-
known. Breu and his workshop provided
illuminations for a large number of man-
uscripts that contain historic scenes or
scenes of contemporary battles.[6] This fig-
ure may prove to be a study for such a
project.

If the attribution to Breu proves not to
be correct, the drawing could possibly
have been cut from a design for a stained
glass panel of either German or Swiss or-
igin. These drawings, which exist in large
numbers, are usually in a similar pen and
wash technique and are occasionally as
freely executed as this work.

HC

## 31

### a. *Bird Catchers with Nets,* 1582

### b. *Bird Catchers with an Owl Decoy,* 1582

**Hans Bol**

Mecheln 1534–1593 Amsterdam

Pen and brown (iron gall) ink with brown wash, incised with stylus for transfer, on laid paper, mounted on laid paper

Each 69 x 219 (2¹¹/₁₆ x 8⁵/₈)

Inscribed by the artist, lower center (a.), lower right (b.), in pen and brown ink, *Hans Bol/1582*

Provenance: W. Esdaile(?); John Viscount Hampden; his sale, London, 27 June 1827, lot 21 (with two others); Lord Ranfurly; sold from his collection at Christie's, London, 26 March 1928, lot 34; purchased at the sale by Savile Gallery, London; purchased from H. M. Calmann, London, 1940, through Paul Oppé

Literature: Oppé 1941, 55; Mongan 1949, 66; Popham and Fenwick 1965, nos. 128, 129; Boggs 1971, fig. 160(a.)

Exhibitions: Montreal 1953, nos. 114, 115; London 1969, no. 22; Paris 1969–1970, no. 25

Acc. nos. 4554 and 4555

Hans Bol joined the guild in Antwerp in 1574, and so would have executed these drawings in that city before emigrating to the United Provinces in 1584. The extant work from these years consists chiefly of small paintings in tempera and vast numbers of washed pen and brown ink designs for prints, mostly in series.[1] The Ottawa compositions are clearly incised and were engraved in reverse as plates 28 and 27 in *Venationis, Piscationis et Aucupii Typi* (Types of Hunting, Fishing and Bird Catching)/*Joes Bol depingebat Philip Galleus excud. Antwerp 1582.*[2] Of this fifty-four-plate series, two more preliminary designs also depicting the hunting of birds are found in Cambridge, Massachusetts;[3] two in London[4] depict the hunting of rabbits; and two formerly in the collection of Dr. A. von Wurzbach depict the hunting of mountain goats (fig. 1)[5] and rabbits (fig. 2).[6]

The impetus for Bol's series was most likely the success of the engravings after

1. Washington 1969–1970, 46, no. 106. The suggestion was made that the drawing is a preparatory study for a large woodcut.
2. Stuttgart 1979–1980, no. A11, where it was suggested that the Darmstadt drawing, because it has been squared, may relate to wall paintings done by Breu for Pfalzgraf Ottheinrich in Neuburg a.d. Donau in 1536–1537 or 1545.
3. Augsburg 1980, 233–234, no. 612.
4. Geisberg 1930, nos. 1363, 1370.
5. Geisberg 1930, nos. 390–408.
6. For example, the book from Eton College described in Dodgson 1934. A listing of manuscripts from Breu's workshop is in Thieme-Becker, 4:596–597.

Cat. 31a

Cat. 31b

the hunt scenes of Jan van der Straet (Stradanus) published in Antwerp beginning in 1570; a series of forty engravings without a title page was published in 1578[7] by Philip Galle who then commissioned the series by Bol. Stradanus' hunts began as designs for tapestries for the Medici and perhaps in consequence they feature more exotic game, though the more ordinary, less "heroic" scenes of European local practices as represented in the Ottawa sheets are also included.[8] Ludovico Guicciardini, in his *Descrittione . . . di tutti i Paesi Bassi* (Antwerp 1567),[9] noted that in addition to the hunting preserves reserved for the nobility, great tracts of woodlands in Flanders were open to hunting by everyone. The engravings in both series are accompanied by brief descriptive captions of no use to a hunter[10] but sufficient for a pic-

ture series in the encyclopedic spirit of the time, intended to delight and engage the attention of the upper- or middle-class viewer. The variety of animals is matched by human ingenuity in hunting them. Most of the hunts are set in a sunny, neatly domestic, rolling countryside. The oblong format encourages the eye to wander, seeking out the agile hunters or leisured bystanders in every part of the composition.

If episodes such as the enthusiastic pointblank killing of rabbits are not intrinsically interesting to the modern sensibility, hunting subjects were widely popular in the sixteenth century. Hunting was not only a noble recreation, which in its most challenging aspects prepared men for war, but a natural and necessary part of life for all classes. Here was the basic evidence of the hierarchies

of creation, of God's promise of his bounty in all its wondrous variety placed under the dominion of Adam and Eve's descendants.

This is explicit in the opening pages of the important hunting manual published in the same year, 1582, by J. Feyerabendt in Frankfurt with illustrations by Jost Amman, *Neuw Jag unnd Weydwerck Buch, das ist ein grundtliche Beschreibung vom Anfang der Jagten, auch vom Jäger. . . .*[11] The pages and pages devoted to the raising of good hunting dogs accompanied by illustrations such as a man feeding a sick dog through a funnel (f. 17) throw into relief the recreational character of Bol's drawings.

JAS

Fig. 1. Hans Bol, *Hunting Mountain Goats*, formerly Collection of Dr. A. von Wurzbach, present location unknown (Courtesy Christie, Manson & Woods, Ltd., London)

Fig. 2. Hans Bol, *Hunting Rabbits*, formerly Collection of Dr. A. von Wurzbach, present location unknown (Courtesy Sotheby's, London)

1. For a general survey of Bol's work, see Franz 1965 and 1969.

2. Hollstein: Bol 110–163; P. Galle 568–622.

3. Fogg Art Museum, Harvard University, also from the collection of Lord Ranfurly, both 69 x 219 mm, signed and dated 1582; Mongan 1949; Franz 1965, 53, figs. 136, 137.

4. Victoria & Albert Museum, both 69 x 222 mm, signed and dated 1583(?); published by Franz 1965, 53, figs. 138, 139.

5. Christie's, London, 26 March 1968, lot 78, pen and brown ink and wash, 563 x 199 mm, signed and dated 1582.

6. Sotheby's, London, 23 March 1972, lot 30, pen and brown ink and wash over black chalk, 67 x 220 mm, signed and dated 1582.

7. Series of 1570, Hollstein: H. J. Muller 117–122; series of 1578, Hollstein: P. Galle 528–567. A title page was added in the expanded edition of 104 plates published c. 1596 as *Venationes, Ferarum, Avium, Piscium, Pugnae Bestiariorum* (Hollstein: P. Galle 424–527), by which name the engravings are normally known. The series is briefly summarized in Boon 1978, under no. 437.

8. For example, *Catching Birds with Nets*, pl. 79 in *Venationes . . .* , is of similar nature to one of the Fogg drawings.

9. See Vinckeboons, *Title Page for Ludovico Guicciardini's "Description de touts les Pays-Bas . . ."* (cat. 35).

10. It has been suggested (London 1969, no. 22) that Bol's series was a "descriptive manual."

11. The wooducts alone are found in Bartsch, 20: nos. 9.1–9.40.

## 32

## *Design with a Halberdier,* 1583

**Christoph Murer**
Zurich 1558–1614 Winterthur

Pen and black ink with gray wash on cream-colored laid paper

Verso: *Sketch for a Halberdier*

Pen and black ink

405 x 286 (15⅞ x 11¼)

Inscribed by the artist, center, in pen and black ink, *FLOE/O lih bring hoffnung*(?) not fully legible; in panel at bottom, *1583 Andreas Gassmann, Burger zu Thann* (*Basel* erased); upper right, partially legible, *auch gestut zu hoffnung*(?); verso, lower center, *Martin Minman der ehren* (fest)

Watermark: Top half, center, Basel staff, similar to Briquet, no. 1292

Provenance: Lt.-Col. William Stirling of Keir; his sale, Sotheby's, Amsterdam, 6 June 1977, lot 3 (repr.); Sotheby's, London, 21 October 1963, lot 4; C. R. Rudolf; purchased from P. & D. Colnaghi, London, 1977

Literature: Ganz 1966, 87

Acc. no. 18867

The composition of this drawing, a standing figure with a coat of arms beneath an architectural framework that incorporates subsidiary scenes, is a formula standard to the design of heraldic glass panels from the late fifteenth through the seventeenth centuries. During that period *Kabinettscheiben,* or stained glass panels, usually with a heraldic subject, were produced in great quantity in southern Germany and particularly Switzerland. The heraldic panels were customarily presented as gifts to prominent citizens or guilds by other prominent citizens, guilds, or city and cantonal governments. The panels normally bear the coat of arms of the donor and when displayed by the recipient indicated the homage paid them by the donors.[1]

This drawing has an elaborate architectural framework in the form of an open portico, in which stands a man wearing slashed trousers and a wide-sleeved jacket, armed with halberd and sword— all in the fashion of the later sixteenth century. To the left is the coat of arms of Andreas Gassmann, inscribed as the commissioner of the glass in the

strapwork panel at the bottom of the drawing, which also contains the date 1583. Two unidentified scenes are shown in the panels at the upper left and right; between them is a strapwork shield behind which sits a putto holding foliate garlands that disappear into the architectural framework.

The scenes in the top compartments cannot be precisely identified, but the activities represented (feasting and courtship) are typical of the subjects of such designs. In the right compartment, a man and a woman are on horseback, with the man turning around to speak to his companion. In the compartment at the left, a group of men are at table. The two figures in the foreground—the man at the right standing to pour wine into the cup of the seated man to the left—are in a pose exactly like that of a pair of men in a glass design by Murer dated 1588, now in Karlsruhe, albeit seen from a different angle.[2]

The inscriptions on the drawing were quickly and rather carelessly written and hence are not fully legible. Clearly they give a motto, undoubtedly Gassmann's,

Cat. 32, verso

which includes a reference to "hope." The letters *FLOE* at the left may also be an abbreviated version of a personal motto,[3] but their significance is no longer apparent. The name on the back, "Martin Minman the Honorable" (*ehren* is presumably an abbreviation for *ehrenfest* or *ehrenwert,* standard phrases of address), is in a different hand and need not be related to the drawing's creation or original purpose.[4]

Murer, from a family of glass painters in Zurich, is known to have been in Basel from 1579 and to have left in 1583 to go to Strasbourg.[5] This commission from a citizen of the Alsatian town of Thann would seem to have come before he left Basel. While Thann lies between Basel and Strasbourg it was influenced more in the sixteenth century by Basel than by Strasbourg. Murer also mistakenly identified Gassmann as a citizen of Basel (he is not recorded as a citizen of Basel). During 1583, Murer did at least one other commission for a patron from the area between Basel and Strasbourg.[6] With the Rhine providing an easy mode of transportation between the cities, it is quite possible that he traveled back and forth comparatively often.

The attribution of this unsigned drawing to Murer is confirmed by comparison to other works by him from the early 1580s. The freedom of the penwork and the robust application of the wash are especially characteristic of his work of the period. Although the ornate strapwork, festoons of rather amorphous fruits and flowers, and putti are typical of the work of several Swiss glass designers of the period, their use here is identifiably Murer's. Among the closest comparisons is his design for a glass panel of *The Adoration of the Magi* (fig. 1) in the Schweizerisches Landesmuseum in Zurich, dated 1583.[7] The draftsmanship is identical to that of the Ottawa drawing, with its rapidly drawn garlands, the formulaic faces of the putti, and the confident use of wash. Although the drawing has a more complex narrative subject, the decorative framework demonstrates his ability to provide infinite variations using the same basic components.

The lively arch in the pose and freshness of observation in the face of the halberdier on the verso may indicate a study from life,[8] although this would be highly unusual in the tradition of glass designs,

Fig. 1. Christoph Murer, *Design for a Glass Panel with the Adoration of the Magi,* 1583, Schweizerisches Landesmuseum, Zurich

and the face reappears in a number of Murer's drawings. However, even the reworking of this sketch in the finished figure on the recto retains a more concentrated gaze and more specifically described features than the normally generic appearance of such heraldic figures. A portrait or not, the halberdier guards the Gassmann coat of arms, the embodiment of the power and confidence attributed to the family.[9]

H C

1. See the excellent recent summary of the subject by E. Landolt in Basel 1984, 392–412.
2. *Group at Table,* Staatliche Kunsthalle, Karlsruhe, inv. no. XI 355. Karlsruhe 1978–1979, no. 51, ill. 11.
3. As in the well-known example of Niklaus Manuel Deutsch's use of the letters *NKAW* to replace his personal motto, *Niemand kann alles wissen,* in similar drawings such as *The Flute-Player,* Kunstmuseum Basel, Kupferstichkabinett, inv. no. UX5. See Berne 1979, no. 174.
4. For his deciphering of the inscriptions to the extent possible, and for information pertaining to Andreas Gassmann, I am very grateful to Dr. Ulrich Barth of the Staatsarchiv Basel.
5. For Murer's biography see Vignau-Wilberg 1982, 10–52, and Basel 1984, 483–488.
6. The panel with the arms of Bishop Laurentius Gutjahr, Abbot of Altdorf and Ettenheimmünster. See Heidelberg 1986, E31, where it is suggested the design was made in Strasbourg.
7. Inv. no. 11904. With the collector's mark of Heinrich Nüscheler (Lugt 1345), a glass painter in Zurich, 1550–1611.
8. As suggested by Ganz 1966, 87.
9. The figures that accompany the coats of arms in these panels are usually intended not as portraits, but as heraldic motifs, such as wild men, *Landsknechte* and *Reislaüfer* (mercenary soldiers), or seductive women. See the examples in Basel 1984, nos. 280–293.

## 33
## *Allegory of the Plundering of the Netherlands*

**Joachim Wtewael**
Utrecht c. 1566–1638 Utrecht

Pen and black ink with gray wash over traces of black chalk, heightened with opaque white, on laid paper

193 x 245 (7$^1$/$_2$ x 9$^{11}$/$_{16}$)

Inscribed by the artist, lower left, in pen and gray ink, *Jo Wte Wael;* in pen and black ink, *6;* in a later hand, verso top, in graphite, *2 / 130788*

Watermark: Crowned shield with rampant lion (indistinct; similar to Heawood 3135)

Provenance: E. Perman; his sale, Sotheby's, Amsterdam, 27 June 1974, lot 166; purchased at the sale

Literature: McGrath 1975, 183, 195–197; Lowenthal forthcoming (see n. 17 below)

Exhibition: Stockholm 1953, no. 84

Acc. no. 18104

Though not an immigrant from the Spanish Netherlands like David Vinckeboons (cat. 35), Joachim Wtewael[1] was among those Dutch artists of the early seventeenth century most caught up in the political issues surrounding relations with Spain.

The Ottawa drawing is part of a series of at least ten scenes depicting the *Subjugation and Salvation of the Netherlands:* the subjugation of the Netherlands by the Hapsburgs and her salvation by Prince Maurice of Orange. The series was first pieced together and extensively discussed by McGrath.[2] Wtewael did a series of designs for prints in 1605 but his compositional drawings otherwise appear to be models for paintings. McGrath thought the series was probably for prints, but it may be for proposed paintings, especially since, as Lowenthal observed, right and left are not reversed.[3] Such a series would in fact find an exactly contemporary parallel in Otto van Veen's twelve paintings of the *Rebellion of the Batavians under Claudius Civilis,*[4] completed in 1612 for the assembly hall of the Staten General in The Hague, surely commissioned at the latest not long after the twelve-year truce signed in 1609 with Spain. In commemorating the successful rebellion from Roman rule in 69–70 A.D. of the Batavians, living in what is now Holland, van Veen's series celebrates Prince William of Orange's role as leader of the rebellion from Spain of what became the United Provinces. Wtewael's series signals William's role but proclaims that of his son. Did Wtewael hope for an equivalent commission?

Wtewael's history of Hapsburg domination of the Netherlands and the eventually successful rebellion is played out through the interaction of a few representative figures—one of them always a female personification of the Netherlands, easily identifiable by comparison with the maidenly figure labeled *Belgica* in contemporary allegories. Beyond these ten scenes, which are signed and numbered,[5] there are three more that are comparable but neither signed nor numbered. The story leading up to the Ottawa drawing—which is the sixth and shows Belgica at the nadir of her fortunes—unfolds with (1) the noble but diffident Belgica courted by a Spaniard of the Order of the Golden Fleece (Prince Philip on his grand tour of 1549?)[6] (in Vienna, fig. 1[7]), as a representation of the protective, munificent Spanish overlordship in the 1550s and early 1560s; (2) the

Fig. 1. Joachim Wtewael, *Belgica Courted by Spain (Prince Philip?)*, Graphische Sammlung Albertina, Vienna (Fonds Albertina)

Netherlands plagued by the Church and the growing military presence;[8] (3) the pivotal events of 1566; (4) the 1567 arrival and tyranny of the Duke of Alva; (5) the arrival on the scene of William of Orange, who cannot bring decisive help; and (6) the exploitation and devastation of the 1570s and 1580s (Ottawa). As McGrath pointed out, Wtewael made use here of the contemporary image of the virtue Patience as a bereaved woman devastated, if not personally humiliated, by the destruction of war but who yet maintains her faith in divine assistance, as shown in G. de Jode's engraving dated 1587 (fig. 2).[9] Of course, Wtewael's traditional, erotic interpretation of the battered Netherlands as a supplicating young woman, with one breast accidentally bared and her beautiful young body miraculously unscarred by her ordeal, is clearly intended to increase the appeal for protection from the male viewer. The cycle continues with (7) the divine appointment of William of Orange as the savior; (8) his murder in 1584 and the dedication of his son Maurice to the cause; (9) the latter's military successes;

and (10) Maurice's coming triumph, which he wishes to share with Belgica. This would bring us up to the period of the truce negotiations beginning in 1607. The meeting and joining of right hands[10] between the personifications of the Netherlands and Spain—the pledging of the truce in 1609 witnessed by a reluctant Maurice—is known only in a copy[11] that is not numbered. Two further autograph but unsigned and unnumbered scenes show Maurice, leading Belgica, accepting the keys of a city, and Belgica enthroned and prosperous accepting the riches of the Indies. McGrath posited that the first of these two may be a rejected scene initially designed to follow no. 9[12] and the second may have been planned originally as the final scene.[13]

Slightly modified conclusions might be drawn from this excellent argument, namely, that the series as first conceived and numbered ended without a depiction either of the truce or of a complete triumph of Maurice simply because the truce had not yet been signed and, moreover, Maurice and the interests allied to him were adamantly against it, wanting

to fight on. As an adherent of the alliance of Anti-Remonstrants and Orangeists, Wtewael may have designed this series before the truce was signed, then addended it when the course of events became clearer.

On stylistic grounds the drawings fit well, as McGrath suggested,[14] with those datable to c. 1609–1610 on the basis of their preparatory relationship to dated paintings or prints. Only two drawings from 1603 (or 1608) and 1622 are actually dated.[15] Belgica is a graceful, swaying figure with a small head. Her body when nude reflects natural, if idealized proportions, sensuously interpreted. The dancelike movements of these figures include few of the contortions of the earliest drawings. On the other hand, these are not the full-bodied figures with larger heads and heavier movements of compositions datable to c. 1622.[16] The firm, swinging pen line is beautifully complemented by strong washes for depth and silhouetting of forms. The shading is characteristically augmented by spaced, regular single hatchings both for shadows and for highlighting with

Fig. 2. G. de Jode, *Patience*, Victoria & Albert Museum, London (Courtesy of the Trustees of the Victoria & Albert Museum)

opaque white. While the questions of dating and interpretation are certainly not closed,[17] among Wtewael's datable drawings, works of c. 1609–1610 or earlier, such as his *Wedding of Peleus and Thetis* (Amsterdam)[18] for a painting in Providence[19] dated 1610, provide what for the time being seem to be the most suitable comparisons.

JAS

1. For this involvement, as well as his career as a painter, see Lowenthal 1986, McGrath 1975, 209–211, and cat. 34, attributed to Joachim Wtewael.

2. McGrath 1975. Boon 1978, under no. 503, offers a somewhat different argument on the intrepretation and connoisseurship.

3. In a letter of 30 September 1987.

4. Rijksmuseum, Amsterdam; Van de Waal 1952, especially 210–215.

5. The signatures and certainly the numbers may have been added after the artist made his selection. Number 3 is known only in a copy, but which is also signed and dated.

6. McGrath 1975 followed Lindeman 1929 in suggesting Charles V but recognized this solution as unsatisfactory. The homage paid by the peasants at the left and the processionlike movement of the figures through varied terrain suggest a "progress." Could this refer to Prince Philip's successful grand tour of the Netherlands in 1549 as heir apparent? The good feelings generated then would be dissipated.

7. Albertina, inv. no. 8.161, pen and black ink with gray wash and white heightening, 189 x 242 mm; McGrath 1975, 182. Compare Vinckeboons cat. 35 for a parallel use of a bifurcated view into the distance of the twin sources of prosperity: shipping and agriculture. See also, attributed to Joachim Wtewael cat. 34 for a proposal as to Belgica's body language.

8. The drawings are all illustrated and described by McGrath 1975, 183–184.

9. The comparison is discussed by McGrath 1975, 186–187.

10. See the discussion under Vinckeboons cat. 35.

11. McGrath 1975, 205–208.

12. McGrath 1975, 204–205.

13. McGrath 1975, 212–213.

14. McGrath 1975, 214 n. 122.

15. Lindeman 1929, T.2, and Lowenthal 1986, fig. 114.

16. As the drawing *Christ Blessing the Children* (Detroit; Lowenthal 1986, fig. 118) for the painting dated 1622 in Leningrad (Lowenthal 1986, A-85).

17. In a forthcoming article in *Nederlands Kunsthistorisch Jaarboek*, Anne Lowenthal will propose another interpretation of the three extra scenes in connection with her assignment of the drawings, on stylistic grounds, to the years after the end of the twelve-year truce in 1621. The author has most kindly communicated to me the main thesis of her article; however, without access to the text, its arguments could not be fairly represented in the current entry. Clearly she will throw light on points that have remained problematic.

18. Rijksprentenkabinet; Boon 1978, no. 409; Lowenthal 1986, under no. A-53.

19. Museum of Art, Rhode Island School of Design; Lowenthal 1986, no. A-53.

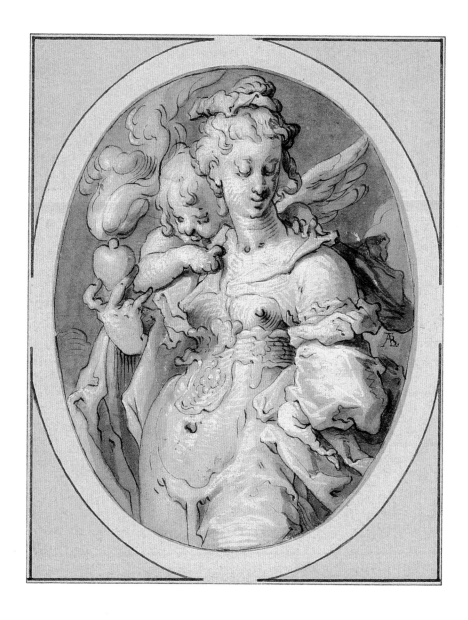

### 34
### *Venus and Cupid*

**Attributed to Joachim Wtewael**
Utrecht c. 1566–1638 Utrecht

Pen and brown ink with brown wash, heightened with opaque white, on laid paper

127 x 98 (5¹/₁₆ x 4), oval

Inscribed in a later hand, center right, in pen and brown ink, *AB,* in monogram; in a later hand, verso below center, in graphite, *Goltius*

Provenance: Purchased from Cythera Fine Arts, Saint Albans Bay, Vermont, 1982 (as A. Bloemaert)

Acc. no. 26993

Though previously attributed to Abraham Bloemaert (1564–1651), the present study is here provisionally reattributed to his fellow Utrecht artist Joachim Wtewael. Bloemaert was one of the most prolific, influential, and inventive draftsmen[1] of the late sixteenth and early seventeenth centuries. His drawings served

Fig. 1. Joachim Wtewael, *Venus and Cupid*, Museum Boymans–van Beuningen, Rotterdam (Copyright Frequin-Photos)

Fig. 2. Abraham Bloemaert, *Diana*, Nelson-Atkins Museum of Art, Kansas City, Missouri, Bequest of Mr. Milton McGreevy (Copyright William Rockhill Nelson Trust)

a range of purposes: as studies and compositions for paintings or prints, or as ends in themselves. In contrast, Wtewael's far fewer drawings are chiefly compositional studies for paintings,[2] whose execution was limited by his involvement in the flax trade and city government. Wtewael worked in a style closely associated with Bloemaert's and their drawings have proved hard to separate.

Amatory depictions of goddesses and gods in an oval format were very popular in these decades, the curving frame complementing the graceful gestures and torsos favored by the Dutch mannerists. Wtewael made delicately sensuous paintings on copper with the same dimensions and format as the Ottawa drawing; another drawing of *Venus and Cupid*, again an oval of the same dimensions (Rotterdam, fig. 1)[3] and presumably for such a

painting, has been attributed to him and dated c. 1608/1610. A connection with a comparable depiction of *Diana*, once more of the same format and size but certainly by Bloemaert (Kansas City, fig. 2),[4] was recently put forth by Bolten.[5]

The Ottawa *Venus* could be a copy of the lost companion to the *Diana*, as has been proposed;[6] certainly the parallels in the characterization of the figures suggest a relationship in some form. Nevertheless, if one sets aside the false monogram, the slight but distinct differences in interpretation—angular, linear shading and exaggeration of artifice, as in the hands—do not necessarily indicate lack of skill on the part of a slavish copyist in conveying Bloemaert's more modulated manner. This could also point to the complementary approach of a somewhat more independent hand, possibly Wtewael's. Here one might compare draw-

Fig. 3. Joachim Wtewael, *Annunciation to the Shepherds,* Kunstmuseum Düsseldorf, inv. no. FP 5031 (Photo Landesbildstelle Rheinland)

ings attributed to him at the beginning of the century, for example, the shepherds in the Düsseldorf study of the *Annunciation to the Shepherds* (fig. 3).[7]

Venus is embraced by Cupid and holds up a burning heart, an emblem since Horapollo of human passion. Though the connotations of the burning heart could vary,[8] the passion of earthly or physical love is probably intended here as it is in the contemporary engraving after Goltzius of *Venus*, which forms with prints of *Bacchus* and *Ceres* a series celebrating the popular proverb "Sine Cenere et Baccho friget Venus" (Without nourishment and wine love grows cold).[9] In other contexts it may represent Celestial Love or an aspect of the societal bonds of good faith. As the latter, it appears as a central image in David Vinckeboons design for the title page for Ludovico Guicciardini's *Description de touts les Pays-Bas . . .* (cat. 35). That this is not a Celestial Venus is further indicated by her body language. Venus has her hand on her hip with the elbow turned out toward the viewer. This is a common male gesture of assertion, found throughout Dutch art, especially in portraits and historical authority figures. It is, however, rarely found in contemporary depictions of women, except in royal portraits or personifications, where it signifies sovereign composure (as in Wtewael's *Belgica*, cat. 33, fig. 1, to be contrasted with her impending humiliation), or in representations of "loose" women: including those in a jaunty "merry company," or a saucy farm girl.[10]

JAS

1. Until the anticipated publication of Jaap Bolten's monograph on Bloemaert's drawings, questions of authenticity and chronology will remain difficult to resolve.

2. Lowenthal's 1986 monograph on Wtewael's paintings provides very useful clarifications on compositional drawings for (and after) dated paintings. As the author readily indicated, many problems concerning the drawings must still be addressed.

3. Museum Boymans-van Beuningen, inv. Goltzius no. 8, pen and brown ink with gray wash and opaque white, 130 x 110 mm; Lowenthal 1986, under no. A-32.

4. Nelson-Atkins Museum of Art, inv. no. 81-30/5, pen and brown ink, red and brown washes (over black chalk?), 140 x 108 mm; Kansas City 1965, no. 33.

5. Letter of 10 August 1987. No date for the *Diana* was proposed.

6. As suggested by Bolten in his letter of 10 August 1987.

7. Kunstmuseum, Kupferstichkabinett, inv. no. FP5031, pen and brown ink with gray wash, 192 x 328 mm; Lowenthal 1986, under no. A-9.

8. The best demonstration of this variety is found in emblems from Gabriel Rollenhagen's influential *Nucleus emblematum,* vol. 1 (Arnheim, 1611), nos. 39, 65, 72, 79, 87, and vol. 2 (Arnheim and Utrecht, 1613), nos. 44, 54, 72, 79.

9. *Venus,* Strauss 1977, no. 337 (B. 66 Saenredam); *Bacchus,* no. 336 (B. 65 Saenredam); *Ceres,* no. 338 (B. 67 Saenredam).

10. A few examples could be cited from the work of Willem Buytewech: *Merry Company on a Terrace* (Rotterdam, Museum Boymans-van Beuningen; Paris 1975, no. 30; Haverkamp-Begemann 1959, no. 48) and *Peasant Girl from De Zijpe* (New York, Pierpont Morgan Library; Paris 1975, no. 86). Such body language will be taken up in a future study.

## 35

## Title Page for Ludovico Guicciardini's "Description de touts les Pays-Bas," 1609

**David Vinckeboons**

Mecheln 1576–1629 Amsterdam

Pen and brown ink with gray and brown wash, corrected with opaque white, on laid paper, laid down on laid paper

303 X 207 (12⅜ X 8¹¹/₁₆)

Inscribed by a later hand, lower center, in pen and brown ink, *D. Vinckenboon*

Provenance: G. Hofstede de Groot (Lugt suppl. 561); his sale C. G. Boerner, 4 November 1931, lot 268; D. Schweisguth (Lugt suppl. 2351b); H. S. Reitlinger (Lugt suppl. 2272a); Sotheby's, London, 22–23 June 1954, lot 798; purchased from K. E. Maison Gallery, London, 1955, through Paul Oppé

Literature: Simon 1958, 38; Popham and Fenwick 1965, no. 138; Wegner and Pée 1980, 44, no. 43, under no. 45

Acc. no. 6317

Like many artists in Amsterdam in the decades around 1600, David Vinckeboons had immigrated to the United Provinces from the Spanish Netherlands. Thus the commission to design the title page (fig. 1)[1] for a French edition of Ludovico Guicciardini's famous *Descrittione . . . di tutti i Paesi Bassi* (Description of All the Lowlands), published in Amsterdam in 1609 by Cornelius Nicolas, would have had special meaning for him, especially since it was the year the twelve-year truce with Spain was signed in Antwerp, bringing to a halt the bitter fighting between the now separated northern and southern Netherlands. Vinckeboons' largest drawing is an allegory (Paris, fig. 2)[2] on this truce, engraved by Hessel Gerritsz. in the same year.

Ludovico Guicciardini (1521–1589),[3] nephew of the more famous Florentine writer Francisco Guicciardini, adopted Antwerp as his permanent residence after he became involved in the flourishing commercial relations between that city and Italy. The original Italian text of this sympathetic survey, the first comprehensive study of the Netherlands in any language, was published in Antwerp in

1567; a French edition appeared shortly after, in the same year. In 1581 a revised edition appeared, followed in 1582 by a companion French edition, upon which the 1609 Amsterdam edition was based. A Dutch translation was published in 1612. That there was no contemporary Spanish edition of this knowledgeable guide could be taken as indicative of Madrid's attitudes toward the Netherlands.

Guicciardini offered a spirited survey of the Netherlands. He described the terrain, the region's resources, the physical appearance of the cities, the differing structures of government, the character and wealth of the people, and their cultural achievements, livelihoods, and professions. "Parcette cy," he wrote in the preface to this French edition, "tu pourras voir sans sortir de ta maison, en petit espace, en peu de temps, la situation, la grandeur, la beauté, la puissance & noblesse de cestant excellents & admirables pays." The text addresses the same thirst for delightful detail found in the series of fifty-four hunting scenes by Hans Bol (see cat. 31), also published in Antwerp in 1582. Guicciardini gave most of his attention to Antwerp and Brabant,

Fig. 1. *Title page of Ludovico Guicciardini, "Description de touts les Pays-Bas . . ."* (Cornelius Nicolas, Amsterdam, 1609), The British Library, London (Copyright The British Library)

Fig. 2. David Vinckeboons, *Allegory on the Truce of 1609,* Ecole Nationale Supérieure des Beaux-Arts, Paris

but he traveled widely and was impressed, for example, by the general prosperity found in the province of Holland.

Vinckeboons' title page generally reflects the tenor of the text. Beyond the architectural tableau within which the actual title is displayed, one sees the plowed fields and ship-filled harbor so vital to the Netherlands' economic well-being.[4] Gathered in symmetical groupings within this tableau are representatives of various occupations and classes. In front, aristocrats, men of letters, and merchants carry on animated discussions; behind, peasant onlookers are identified by the burdens of their occupations. No military figures are present. For all Guicciardini's homage to the admirable commercial abilities and physical sturdiness of Netherlandish women, his only female representatives are two diminutive personifications as shield protectors, whose counterparts in the engraved version of Vinckeboons' *Truce* are entitled *Moderation* and *Love of Country.*

The shield itself introduces an important new note to the ensemble. A frequent motif in contemporary Dutch imagery, the flaming heart may represent human passion of the most spiritual as well as the most profane type, as in the Ottawa *Venus and Cupid,* attributed here to Joachim Wtewael (cat. 34). Combined with clasped hands, usually right hands (as in the engraving reversed from Vinckeboons' design), the image of the heart is expanded to represent the faith or bonds of friendship.[5] Related emblems are found in Gabriel Rollenhagen's well-known *Nucleus emblematum* (Arnheim and Utrecht, 1611–1613), as "Bona Fide" (vol. 2, no. 79) or "En Dextra Fidesque" (vol. 2, no. 72) (fig. 3). While Guicciardini's text implies the importance of unity to the provinces, the selection and prominence of this emblem may more specifically be a response to the highly charged political debates going on in Amsterdam from 1607 to 1609. In many ways the twelve-year truce allowed the United Provinces a breathing period in which to

Fig. 3. Crispin van de Passe, engraver, "En Dextra Fidesque" (The Right Hand of Faith), in Gabriel Rollenhagen, *Nucleus Emblematum–Centuria Secunda* (Arnheim and Utrecht, 1611–1613)

establish its economic might, but there was also considerable opposition, of which Prince Maurice of Orange was one of the leaders.[6] Amsterdam was an important center of this opposition, which focused first of all on the commercial restrictions that would be imposed as part of a cease-fire agreement and on the deeply emotional desire of many of those who had fled from the south to fight on for the liberation of the south and the reuniting of the divided provinces.

In consequence, the very publication in 1609 in Amsterdam of Guicciardini's text could be construed as an antitruce, prowar statement. A different and entirely overt form of support for Prince Maurice is found in Joachim Wtewael's contemporaneous series of the *Subjugation and Salvation of the Netherlands* (see cat. 33). Vinckeboons' design for the *Allegory on the Truce of 1609* (fig. 2) seems to pay rather conventional homage to the cessation of the fighting, including an acknowledgment of the desire for peace by the Archdukes, who lead Truce's triumphal car before the enthroned personifications of *Belgica Archducis Substita* (The Netherlands under the Archdukes) and *Belgica Libera*. Of course it is naive to anticipate consistency at all times between the artist's own values and the intent of commissions accepted.

In these drawings from 1608 and 1609 Vinckeboons is at the height of his powers as a draftsman. The complete assurance with which he wields his pen in rhythmically rounded lines and lightly applied decorative washes complements the sprightly, elastic character of the figures. While he has moved away from the elongated proportions of a few years previous, there is still no evidence that Vinckeboons drew figures from life (*naer het leven*) as did growing numbers of his contemporaries, for example, Hendrick Avercamp and Roelandt Savery; rather these are shrewdly observed types. Indeed the head of the man on the right edge of the podium is reused from that of the elder brother in his 1608 *Departure of the Prodigal Son* (London).[7]

JAS

1. The drawing is incised for transfer. That the title-page design was for the Amsterdam 1609 edition of Guicciardini's text was first noted in the study of Vinckeboons' drawings by Wegner and Pée 1980. The engraving plate was used again for the Amsterdam 1625 edition.

2. Ecole des Beaux-Arts, inv. no. M2110, 52421, pen and brown ink with gray and blue washes, two sheets together 400 x 915 mm; Paris 1985, no. 123, where it is compared with the engraving by Hessel Gerritsz. (Muller 1863–1881, 1: no. 1267), which is briefly introduced in McGrath 1975, 206.

3. For biographical data on Guicciardini and a listing of the major editions see Ciselet and Delcourt 1943, Touwaide 1979, Zwager 1968.

4. See also fig. 2 where the port is probably Antwerp as Brugerolle (Paris 1985) suggested. This same dual background is found in Wtewael's allegory of *Belgica Courted by Spain* (cat. 33, fig. 1).

5. The image of clasped right hands, the *dextrarum iunctio*, under a burning heart as an emblem of a good Christian marriage is briefly discussed by E. de Jongh, *Portretten van echt en trouw, Huwelijk en gezin in de Nederlandse kunst van de zeventiende eeuw* (Haarlem 1986), 51, 54, figs. 55–57. See further, Karel van Mander, *Van de Wtbeeldinghen der Figueren* in *Het Schilderboeck* (Haarlem 1604), fol. 132v ''De Handt'' and ''T'Herte.'' The rarity of such faith is captured on Adrian van de Venne's title page of his satyric *Tafereel van de belachende Werelt* (1635): against the background of a knockdown dragout fight between the sexes, a cupid wearing a fool's cap balances on a glass globe within which one sees once more the clasped hands below the burning heart.

6. An excellent survey of this opposition is found in Israel 1982, especially 28–42. See also McGrath 1975 and Chapman 1986 who takes up the issue of national versus local feeling.

7. British Museum, Department of Prints and Drawings; Wegner and Pée 1980, no. 39a.

## 36

### *Houses Behind the Schwarzenberg Palace in Prague, 1604–1605*

**Roelandt Savery**
Kortrijk 1576–1639 Utrecht

Pen and brown ink on laid paper

248 x 224 (9¹¹/₁₆ x 8¹³/₁₆)

Inscribed in a later hand, verso lower right, in graphite, *A 15903;* in red chalk (trimmed and illegible)

Provenance: Purchased from P. & D. Colnaghi, London, 1949, through Paul Oppé. (The proposal made by Kaufmann: "Feitama collection [?]; sale P. de Haan, Amsterdam, 16 October 1758, Kunstboek F, lot 69 or 70" [Princeton 1982] is not viable due to the size of the drawings.)

Literature: Boon 1961, 146; Popham and Fenwick 1965, no. 137; Gerszi 1977, 122; Spicer 1979, 95, C66

Exhibitions: London 1949, no. 36; Ghent 1954, no. 145; Florence 1969, no. 20; Princeton 1982, no. 60

Acc. no. 5524

In 1603 after the death in Amsterdam of Jacob Savery, Roelandt's elder brother and teacher, with whom Roelandt had earlier traveled north to escape the turbulence of their native Kortrijk, Roelandt left for Prague. There at the court of the emperor Rudolf II he became "court landscape painter," returning to Amsterdam only in 1613. These ten years were remarkably fertile for Savery: of the c. 250 drawings extant today, all but perhaps twenty were done at that time.[1] His official status as a painter influenced his drawings, of which the great majority were made with the preparation of paintings in mind. Bohemian peasants, animals from the imperial menageries, landscape views of the alps and the Bohemian wilderness, and scenes of Prague itself were all drawn from life (*naer het leven,* as he frequently inscribed them). On the other hand, some of the small, finished compositions were made as designs for execution by the court engraver Egidius Sadeler.

Savery's views of Prague range from majestic panoramas to casual back streets.[2] Only Rome had received such attention in the sixteenth century, while in Amsterdam a growing sense of the city as a historical entity was just beginning to foster an interest in her walls and gates. Savery's close-up views of Prague are not, however, of the facades of the great churches or of the streets around the imperial palace on the hill above the city, the Hradcany. Rather it was the back alleys and crumbling edges of the city that attracted his attention. In the Ottawa sketch we ascend the Hradcany with the towers of the Strahow Monastery visible in the distance off to the left.[3] The gables of the furthermost edifice on the hill are easily identifiable as belonging to the Schwarzenberg Palace. Built in 1545–1563 for Jan Lobkovic, its facade on the square across from the entrance to the imperial palace remains most impressive today (now the Museum of Czechoslovakian Military History). Nevertheless it is the houses *behind* the Schwarzenberg Palace that attracted Savery. The jumbled visual patterns of broken masonry, wattled fences, and bedding being aired are facets of city life that constitute a kind of parallel to the peasants'[4] patched and common garments Savery so extensively recorded in the markets and byways of the area.

*Houses* is a fine example of the freely sketched pen studies from Savery's first years in Prague. These studies would at-

Fig. 1. Roelandt Savery, *Shacks in a Yard*, The Pierpont Morgan Library, New York, 1980.22

tain more rigor within a few years. None of these related studies are dated but they can be confidently assigned to the years 1603–1605 on the basis of external factors touching other drawings. The most famous of these is the *Charles Bridge from the Island Kampa* (Prague).[5] A comparison with the deftly drawn and slightly later *Shacks in a Yard* (New York, fig. 1)[6] involves what is clearly a rural motif, but the approach to the muddy puddles and rough walls and the sense of the accidental in the viewing angle reflect the same interest in picturesque irregularities, motifs that could lend variety and interest to a larger composition.

Pieter Stevens, a Flemish landscapist working in Prague at the same time, made a nearly identical, though wider drawing, which is lost but of which a later copy exists (Prague).[7] The inscription on the verso implies that the original was made in 1605; Stevens did not normally date his drawings but 1605 is certainly plausible for Savery's version and it cannot be excluded that the drawings were made at the same time.[8]

JAS

1. The only complete study of the drawings is Spicer 1979; this will be fundamentally reassessed in my forthcoming monograph on the artist as a whole.
2. Savery's dramatic use of a drawing of a Prague street as the basis for a painting is treated in Spicer 1982.
3. Compare the magnificent panorama *Prague from the Strahow Monastery* in the Rijksprentenkabinet, Amsterdam. Spicer 1979, C93; Boon 1961, ill.
4. Treated in Spicer 1970 and 1979, ch. 4; Raupp 1985; and in a forthcoming essay by Thomas Kaufmann.
5. Národni Galerie; Spicer 1979, C64; Fuciková 1986, pl. 50.
6. Pierpont Morgan Library, inv. no. 1984.17, pen and brown and black ink, coral, brown, pale blue, and gray washes, on light brown paper; Spicer 1979, C71.
7. Copy by R. Burde (Národni Galerie), Prague 1978, no. 39.
8. The interrelationship of artists working at court has been widely debated; for the landscapists, see particularly Gerszi 1977.

## 37
## Study of a Young Man's Head

**Peter Paul Rubens**
Siegen 1577–1640 Antwerp

Black chalk heightened with white chalk on buff laid paper

313 x 280 (12⁵/₁₆ x 11)

Inscribed in a later hand, lower left on an added corner, in pen and brown ink, *Rubens;* lower right, in pen and brown ink, (*q* or *g* ?) *60*

Provenance: The Hon. Mrs. Fitzroy-Newdegate; sale, Christie's, London, 14 March 1952, lot 249; purchased from P. & D. Colnaghi, London, 1953, through Paul Oppé

Literature: Burchard and d'Hulst 1963, no. 121; Müller Hofstede 1966, 435; Fenwick 1964, 8; Popham and Fenwick 1965, no. 141; Fenwick 1966, 24; Jaffé 1970, 22; Boggs 1971, 44; Martin 1971, 277–278; Martin 1972, 3, 7, 21, 148–149

Exhibitions: London 1952, no. 13; Toronto 1968, no. 32; Florence 1969, no. 26; London 1969, no. 27; Paris 1969–1970, no. 29; Antwerp 1977, no. 141

Acc. no. 6159

Although the inscribed letter-and-number combination on the Ottawa sheet resembles that on drawings formerly in the Resta-Somers Collection (Lugt 2981), it cannot be matched with the manuscripts that list that collection.[1]

It was not until 1963 that the Ottawa studies were connected by Burchard and d'Hulst with Rubens' composition *Cupid Supplicating Jupiter's Consent to his Marriage with Psyche,* which was then known by a drawn copy in Copenhagen.[2] Rubens' canvas has since been discovered; it is now in the FORBES Magazine Collection, New York (fig. 1), and is dated by Martin to c. 1612–1615.[3]

The Ottawa sheet is one of a series of large-scale studies from the model that Rubens began to make during his sojourn in Italy, where this type of drawing, which had originated in the High Renaissance, had recently been revived by the Carracci. Such studies were especially characteristic of Rubens' practice after he returned to Antwerp in 1608 and organized a large studio to deal with the commissions that flowed in.[4]

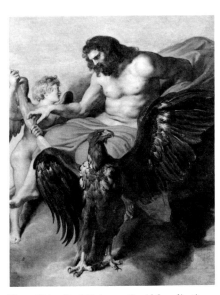

Fig. 1. Peter Paul Rubens, *Cupid Supplicating Jupiter's Consent to his Marriage with Psyche,* The FORBES Magazine Collection, New York (Photograph Otto E. Nelson)

With its economy of forms, curving strokes in the hair, and gentle, luminous shadows, the Ottawa drawing is close in style to chalk studies like the Pierpont Morgan Library *Study of Daniel,* which was drawn c. 1615 for the large picture *Daniel in the Lions' Den* now in the National Gallery of Art, Washington.[5]

The Ottawa sheet includes studies of Cupid's head and his right arm, with just a suggestion of Jupiter's thunderbolt, which the cheeky youth has wrested from the Thunderer (*Amor omnia vincit*).[6] At the bottom right is a study of Jupiter's right hand, which reaches out to retrieve the thunderbolt. The latter hand is, in outline, curiously reminiscent of the languid, impotent left hand of Adam in Michelangelo's fresco, *The Creation of Adam,* on the Sistine Ceiling. It may be that Rubens, by this ''inverted'' reference, is suggesting that Cupid, not Jupiter, is in power, the equivalent of God the Father.

Studies like the Ottawa drawing of details from the model were made by Rubens only after the whole composition had been worked out in drawings or oil sketches. Yet the process was not mechanical; usually there are slight changes between the drawing and the painting. In this case, Jupiter's hand in the painting is moved up closer to Cupid's head, increasing the tension of the struggle between the two deities. With characteristic economy, as Martin noted, Rubens seems to have used the passages of Cupid's throat and chin from the Ottawa drawing (suppressed in the FORBES painting) for those of Ganymede in a picture now in the Schwarzenberg Collection, Vienna.[7]

JDS

1. London 1969, no. 27.
2. Burchard and d'Hulst 1963, no. 121.
3. Martin 1972, 3. (''In the firm, sculptural modeling, in the luminous colours enriched by strong reflections in the shadows, and in the pressure of the powerful forms against the frame . . . [it is] typical of the works produced by Rubens in Antwerp during the years 1612 to 1615.'' Martin 1972, 21.)
4. Held 1959, 1: 26–30, 72–74.
5. Paris 1979–1980, no. 12.
6. For the iconography and the classical literary sources, which include the *Metamorphoses* of Appuleius (6.22), see Martin 1972, 4–17.
7. Martin 1972, 21.

Fig. 1. Otto van Veen, *The High Priest Refus-
ing Joachim's Offering*, Maagdenhuis, Ant-
werp (Copyright A.C.L. Brussels)

rounding the Ottawa drawing is also
found in a drawing of the same period by
Jordaens, *The Holy Family with Saint John,
His Parents and Angels* in the Louvre.[11]

JDS

1. London 1963b, no. 6.
2. Popham and Fenwick 1965, 101.
3. Popham and Fenwick 1965, 101; Held 1959, 1:
fig. 50, and no. 28.
4. D'Hulst 1974, 1: 129.
5. D'Hulst 1974, 1: 128–129. For reproductions of the
Metsys and the de Clerck, see Brussels 1984, 186, 57.
6. For comments on the iconography of this theme in
the late sixteenth and early seventeenth centuries,
see Knipping 1974, 2: 282.
7. Brussels 1984, 219, 338.

8. For a reproduction of this work, and several Neth-
erlandish drawings of this theme, see D.I.A.L.
1958–, 73 A21.
9. Baudouin 1977, 60.
10. Jaffé 1969, 22.
11. D'Hulst 1974, 1: no. A38. The Louvre drawing
(which is a study for a painting in the Warsaw mu-
seum) is stylistically similar to the Ottawa sheet in its
use of line and wash, and in its schematic faces. Two
other drawings, d'Hulst 1974, 1: nos. A25 and A26
(also studies for a painting), may be cited as equally
typical of this period of Jordaens' activity as a
draftsman.

## 38

## *The High Priest Refusing Joachim's Offering*

**Jacob Jordaens**
Antwerp 1593–1678 Antwerp

Pen and brown ink with brown wash over charcoal on laid paper, with a brown wash border

244 x 146 (9⅝ x 5¾)

Provenance: Purchased from W. R. Jeudwine, London, 1963, through A. E. Popham

Literature: Popham and Fenwick 1965, no. 145; d'Hulst 1969, 385; Jaffé 1969, 22; d'Hulst 1974, 1: no. A36

Exhibitions: London 1963b, no. 6; Antwerp 1966, no. 13; Ottawa 1968, no. 127; Toronto 1968, no. 26

Acc. no. 9983

At the time of purchase, the drawing was described as ''School of Barocci.''[1] First attributed to Jacob Jordaens by Christopher White,[2] that attribution has never been questioned. Popham thought it was an early work, when the artist was influenced by Rubens, and noted affinities between the Ottawa drawing and a 1611 sheet of studies by Rubens (now divided between the Courtauld Institute [ex-Count Seilern] and the Metropolitan Museum of Art)[3] for the Antwerp Cathedral *Presentation in the Temple*, one of the wings of the *Descent from the Cross* triptych. D'Hulst (who dated the Ottawa drawing c. 1617) noted that the kneeling figure in the foreground of the Rubens drawing is almost identical to that in the Jordaens sheet.[4]

The painting for which the Ottawa sheet is a study has not been identified. D'Hulst wrote: ''The subject (for which see the apocryphal *Protevangelium Jacobi*) is somewhat rare in Flemish art. The composition bears some resemblance to . . . the outer side of the right panel of Quinten Metsys's *St. Anne*, 1590 triptych, now in the Brussels museum. . . . It is, however, still more like the right outside panel of Hendrick de Clerck's triptych of *The Kindred of St. Anne*, 1590 [also in the Brussels Museum]. . . . The direct relationship between [the Jordens and de Clerck] . . . is confirmed by the fact

that both show, in similar pose, a shepherd with a ram at his side, a figure which does not appear in the Metsys painting.''[5]

Actually, the depiction of *The High Priest Refusing Joachim's Offering* is not that rare in Flemish art, at least not in the sixteenth century.[6] In the Musées Royaux des Beaux-Arts, Brussels, two additional altarpieces include this subject, one from the workshop of Bernard van Orley, 1528, and the other the *Triptych of the Legend of Saint Anne*, by Jan II van Coninxloo, 1546.[7] A painting of the Joachim subject by Michiel Coxcie is also in the Escorial.[8]

Still another example of the Joachim theme appears on one of the wings of the chapel of the Saint Anne triptych, painted about 1600 by Otto van Veen, and now in the Maagdenhuis, Antwerp (fig. 1).[9] Joachim's bulk, the posture of his legs, and the step in van Veen's composition suggest that it may have had some influence on Jordaens' Ottawa design. However, the latter is clearly more baroque in its fluidity of light and shade and its curving forms.

Presumably Jordaens' Ottawa drawing was part of a design for a triptych, since the theme appears traditionally on altarpiece wings, and because of the drawing's unusually tall, narrow format.

Jaffé[10] seems to have been the first to notice that the wide border of wash sur-

## 39
### *The Expulsion from Paradise*

**Anthony van Dyck**
Antwerp 1599–1641 London

Oil on laid paper, laid down on buff laid paper

191 x 172 (7¹/₂ x 6³/₄)

Inscribed in an unknown hand, verso of secondary support, at upper edge, in pen and brown (iron gall) ink, *E.*; upper center, in graphite, *No. 2*

Provenance: Jonathan Richardson, Sr. (Lugt 2184); Thomas Hudson (Lugt 2432); Sir Joshua Reynolds (Lugt 2364); J.B.S. Morritt, Rokeby Park, Yorkshire, and his descendants; private collection, London; purchased from Baskett and Day, London, 1975

Literature: Nicolson 1974, 53; Cazort 1975; Stewart 1979, 467; Larsen 1980, no. A68

Exhibitions: London 1973a, no. 7; Paris 1974, no. 22; Princeton 1979, no. 23; Ottawa 1980, no. 47

Acc. no. 18490

When this work by Anthony van Dyck was discovered only a few years ago, it was recognized as connected with a double-sided drawing by him in Antwerp (figs. 1–2)[1] and given the same very early dating.[2] But Nicolson[3] thought that the Ottawa sheet was "amazingly advanced for its time" and dated it later, "c. 1621," that is, at the end of the artist's first Antwerp period; Martin and Feigenbaum argued for the same later dating for the Antwerp sheet.[4] McNairn saw the Ottawa sketch as deriving "in style from the young artist's close study of Rubens' oil sketches."[5]

In 1979 I wrote: " . . . the angel in the Ottawa *Expulsion from Paradise* is very close (reversed) to Cupid in the Royal Collection *Cupid and Psyche* painting of c. 1639–1640,[6] at the end of van Dyck's English period (fig. 3). Perhaps the Ottawa picture, too, is late. It has the cool palette and the elongated figures of the late period, and the spread-out composition."[7]

While superficially van Dyck's Expulsions are similar to his dramatic themes of the first Antwerp period, that is, the Minneapolis Institute of Arts *Betrayal of Christ*[8] and the Musée du Louvre *Saint Sebastian*,[9] on closer analysis they prove

to be fundamentally different. The Expulsions lack the complexity, the plunging diagonals, and in general the more baroque character of the first Antwerp period, but have a classical-baroque, relieflike structure. The smaller scale of the figures and the grand tree forms allow an openness not seen in early compositions. The drama of the Expulsions relates them to late compositions such as the 1634 Munich *Lamentation* or late portraits such as the *Mrs. Endymion Porter* (Duke of Northumberland) and the Wilton *Lady Castlemaine.*[10]

For Martin and Feigenbaum the Antwerp sheet was "compatible with a number of drawings made towards the close of the first Antwerp period, as for example those for the *Betrayal of Christ* [in Berlin and the Louvre]."[11] Yet these display great complexity and detailed linearity, unlike the simplicity, pictorial grandeur, and abstraction of the Antwerp drawing. A small but telling comparison may be made: in the Berlin and Paris drawings, the feet are carefully depicted, as is usual in van Dyck's early period, but on both sides of the Antwerp sheet (and in the Ottawa oil sketch), the feet are virtually ignored.[12]

Van Dyck's treatment of the subject

Fig. 1. Anthony van Dyck, *Expulsion from Paradise*, recto, Museum Plantin-Moretus en Prenten-kabinet, Antwerp (Courtesy of the Museum Plantin-Moretus)

owes little to Rubens.[13] What seems to be Rubens' only *Expulsion* is an oil sketch of c. 1620, planned (but not used) for the Antwerp Jesuit church ceiling. Instead, van Dyck's composition may derive from an engraving by R. Sadler after Marten de Vos (fig. 4).[14] Yet as Cazort noted, unlike traditional treatments of the theme, van Dyck's treatment "tends to strengthen the position of the Original Sinners against the inevitable winner, the Agent of the Wrath of God."[15]

With its grand proportions, and its pronounced *cuirasse esthétique*, the figure of Adam in both the Ottawa sketch and the recto of the Antwerp sheet has an antique air. The pose recalls one of the Dioscuri on the Monte Cavallo at Rome. The poses of Adam on the verso of the Antwerp drawing suggest the influence of another antique sculpture, the *Borghese Warrior*.[16]

The right-hand Adam on the verso of the Antwerp sheet is also close in proportions and pose (reversed) to the Cupid in the *Cupid and Psyche*. Even the schematic line for Adam's hip muscle reappears in Cupid's.

Detailed connections between the *Expulsion* oil sketch and the *Cupid and Psyche* include the highlighting of the edge of the angel's and Cupid's wings, and the scalloped cloud forms around the angel in the *Expulsion* and behind the dead tree in the *Cupid and Psyche*. But the strongest connection is the similarity of the angel and the Cupid. The Ottawa *Expulsion* and the *Cupid and Psyche* are both roughly square and the figures are the same scale. In each the action takes place on a shallow stage in a landscape with a great central tree.

There is also a meaningful connection between the themes of the two works. In 1637 Shakerly Marmion published a lengthy "Morall" poem, *Cupid and Psyche,* and dedicated it to Prince Charles Louis of the Palatinate, who was visiting his uncle, King Charles I.[17] The publication included commendatory verses from poet and playwright friends, including Thomas Heywood, whose masque *Love's Mistress,* also based on the Cupid and Psyche story, had been presented at court in 1636.[18] Like the masque, Marmion's poem is neo-Platonic, allegorizing

the story as the gradual ascent of the "Soul" (Psyche) to final union with "Divine Love" (Cupid) in heaven. Marmion wrote a "Mitheology" at the beginning explaining the allegory. Much of this section derives from the early Christian mythographer Fulgentius, who saw Cupid's falling in love with Psyche and being burned by the oil of her lamp (when she, against his orders, "discovered" him) as a parallel to the Fall of Man.[19] Marmion took the parallel further, and saw Psyche's loss of her home, after disobeying Cupid, "like Eve . . . made naked through desire, [being] cast out of all happinesse, exhil'd from her house, and tost with many dangers. . . ."[20]

Thus in the late 1630s at the court of Charles I, the Old Testament story of Adam and Eve expelled from paradise was read as analogous to part of the pagan tale of Cupid and Psyche. In light of this and of the visual evidence, it seems possible that van Dyck's compositions of these themes were created as pendants. Since the *Cupid and Psyche* is thought to have been painted c. 1639–1640 for the Queen's House at Greenwich,[21] the *Ex-*

Fig. 2. Anthony van Dyck, *Expulsion from Paradise*, verso, Museum Plantin-Moretus en Prenten-kabinet, Antwerp (Courtesy of the Museum Plantin-Moretus)

Fig. 3. Anthony van Dyck, *Cupid and Psyche*, Kensington Palace, Royal Collection, London (Reproduced by Gracious Permission of Her Majesty The Queen; copyright reserved to Her Majesty Queen Elizabeth II)

Fig. 4. R. Sadler, after Marten de Vos, *Expulsion from Paradise*, 1583, Rijksprentenkabinet, Amsterdam (Copyright Rijksmuseum-Stichting, Amsterdam)

*pulsion* may also have been designed for that location. The scheme may never have been fully realized because of the collapse of the royal finances and the civil wars. On the eve of the latter, in December 1641, van Dyck himself died.

The brilliance of the handling, the exquisite, "almost irridescent colour,"[22] and the bold grandeur of the forms and composition of the Ottawa sketch show that even at a late date van Dyck could rise to a (possibly) royal occasion. These qualities, and the individual treatment of the subject, are reminders that in the death of the artist, aged only forty-two, the world lost not only a great portrait painter, but a brilliant history painter as well.

JDS

1. Vey 1962, no. 1.
2. Paris 1974, 35.
3. Nicolson 1974, 53.
4. Princeton 1979, 94.
5. Ottawa 1980, 113. Larsen (1980, A68) is the only critic to reject the Ottawa sketch as a work of van Dyck.
6. Millar 1963, no. 166.

7. Stewart 1979, 467.

8. Princeton 1979, no. 24.

9. Ottawa 1980, no. 14.

10. Glück 1931, 365; London 1982b, no. 36; Waterhouse 1978, fig. 54. Both ladies have elegant ovoid faces like Eve in the Ottawa *Expulsion*.

11. Princeton 1979, 94; the drawings are nos. 25–26.

12. Similar, schematic feet are seen in a late composition drawing *The Rape of the Daughters of Leucippus* (Chatsworth; Held 1964, fig. 1; for further comment on this drawing see below n. 16) and in a related composition drawing of the same theme in the Louvre (Lugt 1949, no. 643), which is catalogued (rightly) as ''Ecole de Van Dijck,'' but which may well be a copy of a lost original by van Dyck himself.

13. Martin 1968, no. 40; Princeton 1979, 96.

14. Zweite 1980, 276, and pl. 185.

15. Cazort 1975, 5.

16. Haskell and Penny 1981, nos. 137, 43. The prominent *cuirasse esthétique* is seen also in the Louvre drawing discussed above in n. 12. (For the schematization of the torso known as the *cuirasse esthétique*, see Clark 1956, 40.)

17. Nearing 1944.

18. Heywood 1874, 5: 81–160. There were sets designed by Inigo Jones, including one for the Prologue with ''Cupid descending in a cloude,'' but these are lost. See Orgel and Strong 1973, 2: 826.

19. Whitbread 1971, 89: ''Adam, although possessing sight, does not see himself as naked until he eats of the tree of covetousness.''

20. Nearing 1944, 105. Although Marmion takes most of his narrative from Appuleius' *Golden Asse*, he does invent some episodes. One is that Cupid, when first sent by Venus to ''shoot'' Psyche, is instead overcome with love for her, ''And as in this distraction he did stand, / He let his arrowes fall out of his hand'' (Nearing 1944, 109; lines 169–170). Van Dyck's *Cupid and Psyche* depicts a much later event in the story: Cupid finding Psyche after she has opened Proserpina's box of beauty. However, there may be an allusion in the picture to that earlier episode in the quiver of arrows that has fallen at Cupid's feet.

21. Millar 1963, 104. As pendants, and with the light coming (exceptionally) from the right, van Dyck's two compositions must have been planned for specific locations—perhaps, considering their squarish shapes, for overmantels. Viewing the Queen's House today, it is very difficult to say for where they might have been destined.

22. Cazort 1975, 3.

## 40

## *The Baptism of the Ethiopian Chamberlain*, early 1650s

### Rembrandt van Rijn
Leiden 1606–1669 Amsterdam

Verso: *Study of a Man's Head and Left Arm Seen from the Rear*

Reed pen and brown ink, on laid paper

182 x 211 (7$^1$/$_8$ x 8$^1$/$_4$), irregular

Inscribed by a later hand, verso lower left, in pen and brown ink, *Rembrandt f*; upper right, in graphite, C; lower left, in graphite, *2* / [illegible] / *5*

Provenance: Ignace-Joseph de Claussin, Paris; Pierre Defer, Paris; Henri Dumesnil, Paris (Lugt 739); W. R. Wilhelm Valentiner, Berlin; his sale, Mensing, Amsterdam, 25 October 1932, lot 7; purchased from P. & D. Colnaghi, London, 1977; purchased 1977

Literature: De Claussin 1824–1828, suppl., 159, no. 71; Swarzenski and Schilling 1914, no. 46; Valentiner 1934, no. 539; Benesch 1935, 50; Benesch 1957, no. 909; Rotermund 1963, no. 249

Acc. no. 18909

Rembrandt first treated the subject of the Baptism of the Ethiopian Chamberlain in paintings of 1626 (Utrecht)[1] and another of c. 1631, which, though lost, is reflected in a 1631 etching by J. G. van Vliet,[2] an engraving by Claes Jansz. Visscher,[3] and in painted copies. A rather confused black chalk composition in Munich[4] is related, though probably not directly preparatory. Rembrandt returned to the subject in an etching of 1641 (fig. 1)[5] before executing the Ottawa drawing at some point in the early 1650s. The Ottawa drawing has received surprisingly little attention in the literature on Rembrandt's treatment of the subject.[6]

This important early conversion and baptism is recounted in the Acts of the Apostles 8: 36–39. In response to angelic direction, the disciple Philip traveled south from Jerusalem on the desert road to Gaza. On the way he sought out an encounter with the chamberlain of the Candace (Queen) of Ethiopia, a eunuch, who had been to Jerusalem to worship (thus a proselyte if not actually a Jew). Returning south in his chariot the cham-

Cat. 40, verso

Fig. 1. Rembrandt van Rijn, *Baptism of the Ethiopian Chamberlain,* Rijksprentenkabinet, Amsterdam (Copyright Rijksmuseum-Stichting, Amsterdam)

berlain studied the book of Isaiah but was puzzled by the prophesies. Philip's offer of interpretation was gladly accepted. Grasping the messianic prophesy of Christ's mission, the chamberlain wished to be baptized. As they were passing a body of water, Philip accommodated him and they both went ''down into the water.''

Rembrandt's general adherence to previous pictorial traditions (even where they differ from the text) has been clearly established by Tümpel in his writings on other aspects of Rembrandt's biblical representations.[7] In all Rembrandt's earlier compositions, in the great majority of the numerous representations in the oeuvre of contemporary artists such as Pieter Lastman, and in sixteenth-century Dutch imagery we find a richly and exotically garbed black African kneeling at water's edge, his chariot and entourage waiting close by on a wilderness road, while Philip sprinkles water on his head. Less frequently, as in Simon Frisius' famous engraving of *Christian Faith,*[9] the chamberlain is stripped to a loin cloth. To

show him kneeling beside the water updated the story to conform with contemporary practice: most Protestant sects in the Netherlands did not immerse.

In the Ottawa drawing the man being baptized is racially unspecified—and therefore seemingly Caucasian—given the neutral use of the cream paper and the (unprecedented?) rear view, which shields any distinctive features. This is curious as his race is, after all, intrinsic to the story and to its importance for Christians. The representation has other odd features as well. As noted, though water is just being sprinkled on his head, he is stripped to a loin cloth rather than richly dressed. The composition is odd in other ways. The traditional characterization of desert or wilderness, though it may vary, does not include these massive walls and tower of a city or fortress. At the right edge armed men wait beside horses but there is no chariot. The disciple resembles Rembrandt's representations of Peter far more than those of Philip. The departures from tradition are so many, and Rembrandt's other extant treatments

are so consistent in all these particulars, that we must wonder if another baptism is intended; nevertheless, no alternative is convincing. Very few baptisms of individuals are noted, much less described, in the New Testament. Paul was baptized in Damascus after his miraculous conversion but perhaps because of the succinctness of the reference in Acts 9: 18, it is rarely represented in art. Cornelius, a Roman centurion, was baptized by Peter (Acts 10: 44–48) but so was his whole household, and so this cannot be he.

Dutch Calvinists[9] acknowledged only baptism and communion as sacraments. The story of the Ethiopian was attractive to them because it supported Reformed emphasis on (1) reception of the word of God and the primacy of faith in relation to baptism and (2) the unknowableness of God's Grace, that God will bestow it where he wishes without regard to past works or merit, or, for that matter, race or state of physical wholeness. In regard to the last point, it is worth remembering that the chamberlain was a eunuch, and therefore according to Jewish law

"maimed" (and therefore subject to proscription).

This muting of richly anecdotal detail and gesture in favor of a restricted body language of great humility—typified by this slightly hunched figure who faces away from us—focuses our attention on the act itself and is an aspect of the increasingly subdued, deindividualized, austerely characterized imagery of the 1650s and 1660s. Of Rembrandt's late works, we are particularly reminded of the deeply moving *Prodigal Son* in Leningrad.[10] Rembrandt's preference in these decades for the reed pen, its relative inflexibility exploited for abstraction, is consistent with this. A similar use of a drier, breaking, angular line, strikingly different from the earlier flowing, swelling lines of the quill pen, can be found in the large number of drawings assigned to the early 1650s, for example, *The Leave-taking of Tobias, Sarah and the Angel from Raguel and Anna* in Amsterdam[11] or *Christ Healing a Leper* in Berlin-Dahlem.[12]

The small study of a *Man's Head and Left Arm* on the verso, possibly another view of the disciple, is unpublished. The partial tracing of the recto composition with a stylus was apparently done by M. Pool in 1828 when he etched this drawing for De Claussin.[13]

JAS

1. Rijksmuseum Het Catharijneconvent; Rembrandt Research Project 1982, no. A5; Defoer 1977.
2. See Defoer 1977, fig. 15, or Bruyn 1982, fig. 3.
3. Bruyn 1982, fig. 5, with discussion.
4. Munich Graphische Sammlung; Benesch 1957, no. 13; Wegner 1973, no. 1110. Two further pen drawings in Munich were attributed to Rembrandt from the 1650s by Benesch 1957, nos. 967, 968, but are not now accepted (Wegner 1973, nos. 1378, 1379).
5. Hollstein: Rembrandt 96. The drawing in the Musée du Louvre, Benesch 1957, no. 488 (as a preliminary study for the etching), has been justly doubted, as by Tümpel 1970, under no. 122. The painting of the *Landscape with the Baptism of the Ethiopian Chamberlain* dated 1636 in Hannover (Niedersächsisches Landesmuseum [on loan]; Gerson 1968, no. 195), traditionally assumed to be by Rembrandt, has been rejected by the Rembrandt Research Project.
6. The discussion in Defoer 1977 is the most extensive; see also Tümpel 1970 and the Rembrandt Research Project 1982, under A5. See Rotermund 1963 for the only mention of the Ottawa drawing.
7. See particularly Tümpel 1969.
8. Hollstein: Frisius 3; Defoer 1977, fig. 18.
9. The main points of the position are outlined by Defoer 1977. For an approach to the manifestation of divine Grace in Rembrandt's work, see Spicer 1985.
10. The Hermitage; Gerson 1968, no. 355.
11. Rijksprentenkabinet; Benesch 1957, no. 871; Schatborn 1985, no. 41.
12. Kupferstichkabinett; Benesch 1957, no. 900.
13. De Claussin 1824–1828, suppl., 159, no. 71.

## 41

## *Woodland Interior,* c. 1655–1665

**Jan Lievens**
Leiden 1607–1674 Amsterdam

Pen and brown (iron gall) ink on Japan paper

228 x 378 (8¹⁵/₁₆ x 14⁷/₈)

Provenance: G. Leembruggen; his sale, Amsterdam, 5 March 1866, lot 357(?); Victor Koch; his sale, Sotheby's, London, 29 June 1949, lot 87; purchased at the sale, through Paul Oppé

Literature: Schneider 1932, no. Z.428 (rev. ed. 1973, 390, no. SZ.428 [with brown wash]); Popham and Fenwick 1965, no. 155 (on parchment); New York 1977–1978, under no. 66; Ekkart 1979, 31; Jacob 1979, 22, 24; Sumowski 1980, 372, n. 2; Sumowski 1979–(1983), 7: no. 1672ˣ-3 (on vellum); New York 1986, under no. 50

Exhibitions: Vancouver 1957, unnumbered; Braunschweig 1979, no. 73 (on Japan paper)

Acc. no. 5063

Jan Lievens' fame rests first of all on his fruitful early fellowship with Rembrandt in Leiden before 1631, but his most distinctive achievements are his later portrait and landscape drawings.[1] An analysis of these landscape drawings is difficult because none of them are related to known paintings or prints and none are dated, much less signed. After leaving Leiden in 1632 and a two-year sojourn in England, Lievens spent the years from 1635 to early 1644 in Antwerp, at which time he apparently became interested in landscape. Clumps of trees and woods appear in portrait paintings and prints from these years while his initial essays in independent landscape painting (none are signed or dated) are thought to have been inspired by those of Adrian Brouwer. Whether or not the assignment of landscape drawings to this period is justified, the great majority were made after 1644 when Lievens settled in Amsterdam. In fact, the first landscapes to offer evidence for dating are associated with the years spent in The Hague, 1654–1658.

The drawings encompass topographically identified sites near Arnhem and The Hague—distant views over rolling hills and woodland interiors—of which the Ottawa drawing is one of the finest. As in a similar drawing in London (fig. 1),[2] these sunlit glades or clearings are frequently viewed from the perspective of the artist-viewer seated at the base of a nearby tree. The straight, sturdy tree trunks, some hollow or splaying, shoot cleanly out of the ground without any sign of the voluptuous root systems favored by Neyts (see cat. 43) or earlier by Roelandt Savery.[3] The atmosphere of classical calm engendered in the even light draws us into the quietude of the scene. The lowest boughs extend over our heads, furthering the sense of intimacy. These woodlands are domesticated, suburban or rural, the dead wood picked up, the ground trodden; there is none of the matted underbrush of Savery's central European forests. Some are enlivened by men out walking with their dogs[4] or by Titianesque idyls with milkmaids and cows or herders with flocks and flutes.[5]

Time spent in the famous wood near The Hague—the Haagsche Bos—during his residence there from 1654 to 1658 must have influenced Lievens' perception of nature. His *Creamery in the Haagsche Bos*

in Paris,[6] a site depicted by other artists, serves as a focus for associating a number of related drawings, including that in Ottawa. Sumowski[7] suggested that drawings on Japan paper, such as the *Creamery,* were most likely not drawn directly from nature but executed in the studio; therefore only the sketches from nature can be securely dated in connection with an identified site. Nevertheless, it is legitimate to suppose that the more finished compositions were made not much later, unless there is evidence to the contrary, which there is not. Of course, after 1658 Lievens may have continued to seek out or to reconstruct a type of environment to which he had become sensitized. Thus a more precise dating than from 1655 to perhaps 1665 cannot be proposed.

His portrayal of woodlands becomes more distinctive when one considers con-temporary views around Amsterdam such as those by Rembrandt, for example, the *Wooded Road,* usually dated c. 1650 and now at Malibu (fig. 2).[8] Amsterdam did not enjoy a public wood like the Haagsche Bos, but a cultivated countryside dotted with clumps of trees. Moreover, Rembrandt's interest in nature is from the human perspective: trees are clustered around a cottage, arch over a rutted road, or shade a saint.

Lievens worked primarily with a reed pen and brown ink,[9] whose bold vertical strokes reinforce the formal strengths of the trees and remind the viewer of the Venetian landscapes that influenced his more idyllic subjects. The effect is very different from the austere, dry strokes of Rembrandt's roughly contemporary *Baptism* (cat. 40). Few of Lievens' drawings include any wash; he again eschewed the emotive potential of dramatic shifts in light and shade.

*Woodland Interior* is on Japan paper, like many of Lievens' finest landscapes.[10] The surface of the paper is characterized by an extreme smoothness and by a rich tone ranging from golden to a buff or tan.[11] The paper is absorbent but holds ink on the surface, creating a soft effect. According to Reed 1969, westbound shipments of Japan paper are documented only for 1643 and 1644. Rembrandt was evidently the first artist to recognize the potential of this paper, which he exploited in remarkably sensuous impressions pulled from a wide range of his plates.

JAS

Fig. 1. Jan Lievens, *Interior of a Wood*, The British Museum, London (Courtesy of the Trustees of The British Museum)

Fig. 2. Rembrandt van Rijn, *A Wooded Road*, c. 1650, The J. Paul Getty Museum, Malibu

1. The Braunschweig 1979 catalogue (by R. Ekkart, S. Jacob, and R. Klessman), aptly entitled *Jan Lievens, ein Maler im Schatten Rembrandts*, relied in part on Ekkart's 1973 revision of Schneider's 1932 monograph. In an article of 1980 and a new corpus in 1983, Sumowski has raised further issues.

2. British Museum, Department of Prints and Drawings, inv. no. 1895-15-1197, pen and brown ink on Japan paper, 232 x 374 mm; Sumowski 1979–(1983), 7: no. 1696[x].

3. For example *Bulbous Roots,* Amsterdam, heirs of Prof. J. Q. van Regteren Altena; Spicer 1979, C60; Paris 1977, no. 120.

4. Museum Boymans-van Beuningen, Rotterdam; Sumowski 1979–(1983), 7: no. 1694[x], fig. 95.

5. British Museum, Department of Prints and Drawings; Sumowski 1979–(1983), 7: no. 1682[x]; Metropolitan Museum of Art; Sumowski 1979–(1983), 7: no. 1673[x].

6. Institut Néerlandais, Fondation Custodia; Sumowski 1979–(1983), 7: no. 1670[x] with the intriguing title *Roomhuis in the Haagsche Bos* (Wooded Landscape with Rooming House). The *roomhuis* (creamhouse or creamery) was apparently considered a picturesque site as C. van Hasselt has shown (Brussels 1968–1969, under nos. 15, 96, 95); he further emphasized the import of site identification for dating.

7. In his 1980 article Sumowski correctly raised the issue of the relation of sketches from nature to finished compositions, but his rejection of Ekkart's provisional chronology was hasty.

8. J. Paul Getty Museum, inv. no. 85-GA.95, pen and brown ink with wash, 156 x 200 mm; Benesch 1957, no. 1253.

9. By exception, the rather casual *Peasant Dwelling* in the Seger Collection, Toronto (Sumowski 1979–(1983), 7: no. 1686a[x]), includes passages sketched lightly in graphite (not black chalk); the *ductus* of the line suggests originality. The support is very thin Japan paper.

10. There are scattered, very brief discussions of Japan paper, especially as used by Rembrandt, by White 1969, 16–17; Reed 1969; Robison 1977, 13–14. White cited various etchings bearing dates in the 1630s printed on Japan paper. On the basis of the first importation in 1643 given in Reed's essay, this would mean that Rembrandt was at least printing, if not still modifying, etchings begun and dated years before.

11. Lievens' landscape drawings have not always been examined with this aspect in mind. The lack of reference to a support in recent literature does not necessarily mean that the drawing is on laid paper (see n. 9). As descriptions become precise, previous assertions that Lievens worked on vellum, as in the case of the Ottawa drawing, must be reexamined. The tone inherent in the paper may also have caused some drawings on Japan paper to have been described as washed when there is no sign of this: Sumowski 1979–(1983), 7: no. 1678[x] (Metropolitan Museum of Art), no. 1685[x] (British Museum, Department of Prints and Drawings), or no. 1679[x], n. 10 (British Museum, Department of Prints and Drawings, also on Japan paper). As a complement to a study of watermarks, an investigation of Lievens' use of Japan paper could have chronological implications, at least for sheets heretofore assigned to the Antwerp period.

## 42

## *Simeon Holding the Christ Child*

**Philips Koninck**
Amsterdam 1619–1688 Amsterdam

Pen and brown ink on laid paper (ledger sheet), mounted on laid paper

220 x 154 (8⅝ x 6¼)

Inscribed in a later hand, verso, in graphite, *998 / 157;* on secondary support, in graphite, *192;* verso of secondary support, in graphite, *Lievens*(?) / [illegible] / *Lastman*(?) [deleted] / *Ecole de Rembrandt*

Provenance: Prince W. Argoutinsky-Dolgoroukoff (Lugt 2602d); his sale, R.W. P. de Vries, Amsterdam, 27 March 1925, lot 192 (as Lievens); purchased at sale by Tobias Christ; his sale, Sotheby's, London, 9 April 1981, lot 30; purchased from C. G. Boerner, Düsseldorf, 1982

Literature: Schneider 1932, no. Z.42 (as P. Koninck); Gerson 1936, 152, no. Z.142; Lugt suppl., 376 under no. 2602d (as Jan Lievens); Schneider 1973 (rev. ed.), no. Z.42 (as P. Koninck); Gerson 1980 (rev. ed.), 79–80, 152, no. Z.142; Sumowski 1979–(1982), 6: no. 1451[x]

Acc. no. 28103

As a draftsman, Philips Koninck is best known for his evocative depictions of the spreading Dutch landscape, but his biblical drawings, made in Amsterdam under the influence of Rembrandt, include some of his most expressive individual works. There are well over one hundred biblical drawings, all done in quill or reed pen with brown ink, sometimes with passages brushed in wash. The majority are compositional studies, but a number of single figures without settings exist, of which only a few relate to the development of the larger compositions. None appear to be preparatory to the surprisingly few extant history paintings. Drawings of biblical subjects bear dates from 1658 to 1679 but the dating of many sheets is problematic.

The present figure is easily identified as Simeon, whose miraculous recognition of Jesus as the "Christ," that is, the anointed one or Messiah, is told in Luke 2:22–38. At the time Mary and Joseph brought Jesus to the temple, it was revealed to Simeon, a "devout and righteous" old man, that the baby was the "Lord's Christ." "He took him up in his arms and blessed God . . . [saying] mine eyes have seen thy salvation. . . ." He then prophesied that Mary as well as Jesus would suffer, using the metaphor "and a sword will pierce through your own soul also." Though the prophecy of Mary's "com-passion" was virtually ignored in Dutch seventeenth-century art, the literal interpretation of this passage was popular in pre-Reformation imagery, as in the rear of Pseudo Ortkens' *Christ Child Disputing with the Elders* (cat. 29).

Simeon is a majestic figure, his stature and dignity consistent with the gravity of his blessing. A second version in Dresden (fig. 1)[1] expresses instead the tenderness of his initial response. The two studies were dated by Sumowski to c. 1679 in comparison with a *Lamentation* signed and dated 1679 in Braunschweig.[2] However, the vigor and control of the Ottawa *Simeon* are far removed from the progressive breakdown of lines and forms characteristic of drawings from the 1670s, and well advanced in the *Lamentation*. In addition, the Ottawa *Simeon* is clearly a

Fig. 1. Philips Koninck, *Simeon Holding the Christ Child,* Staatliche Kunstsammlungen Dresden, Kupferstich-Kabinett

Fig. 2. Philips Koninck, *Presentation in the Temple,* Herzog Anton Ulrich-Museum, Braunschweig

workup of the same figure in the sketch of the *Presentation in the Temple* in Braunschweig (fig. 2),[3] assigned by Sumowski to c. 1671. This is still too late. If a comparison is made, on the one hand, with drawings more securely datable to 1671—such as the *Presentation* in Copenhagen[4] or the *Lamentation* dated 1671 in Braunschweig[5]—and, on the other hand, with drawings dated or assigned to the period from 1658 to 1664—such as the double-sided *Mocking of Christ* (Paris),[6] the *Three Orientals* (New York),[7] or *Solomon's Idolatry* dated 1664 (Braunschweig)[8]—it is clear that Gerson's dating of the Dresden and Ottawa drawings to the early 1660s was justified. Parallels are found especially in the Paris and New York sheets for stylistic features: the long, continuous strokes of greatly varying width and pressure by the reed pen to suggest shade or weight, sometimes the splayed nib running dry in an idiosyncratic flourish. The shading may be accentuated by patches of short, thick, parallel strokes. The dexterous shorthand of Simeon's upturned face returns in those of Solomon's queen and her priest.

JAS

1. Kupferstich-Kabinett, inv. no. C1376, 212 x 165 mm, the only other drawing clearly on ledger paper; Sumowski 1979–(1982), 6: no. 1450[x]. Gerson 1936 was the first to call attention to the connection.

2. Herzog Anton Ulrich-Museum; Sumowski 1979–(1982), 6: no. 1355[x].

3. Herzog Anton Ulrich-Museum, inv. no. 372, 180 x 225 mm; Sumowski 1979–(1982), 6: no. 1448[x].

4. Den Kongelige Kobberstiksamling; Sumowski 1979–(1982), 6: no. 1447[x].

5. Herzog Anton Ulrich-Museum; Sumowski 1979–(1982), 6: no. 1353[x].

6. Institut Néerlandais, Fondation Custodia; Sumowski 1979–(1982), 6: nos. 1399[x]–1400[x].

7. Pierpont Morgan Library; Sumowski 1979–(1982), 6: no. 1401[x].

8. Herzog Anton Ulrich-Museum; Sumowski 1979–(1982), 6: no. 1346[x].

## 43

### Recto: *Landscape with Large Tree*

### Verso: *Study of a Large Tree*

**Gillis Neyts**

Ghent 1623?–1687 Antwerp

Pen and brown ink on laid paper

263 x 212 (10⅜ x 8⅜)

Inscribed by the artist, lower left, in pen and brown ink, *AE* (in monogram) *Neyts fecit;* in a later hand, upper left, in pen and brown ink, *Dessin Double*

Provenance: Dr. August Straeter (1810–1897), Aachen (Lugt 787); Dimitri Alexandrovitsch Rovinski (1826–1895); J. Rosenberg (1845–1900), Copenhagen (Lugt 1519); purchased from Schaeffer Galleries, New York, 1968

Acc. no. 15761

Gillis Neyts is recognized chiefly for his many landscape drawings and etchings. Little is known about his artistic development other than that he became a master in Antwerp in 1647 and probably traveled to Italy at some point. Since only a handful of dated drawings and paintings have been identified, the chronology proposed here is based on the grouping of clusters of drawings along a stylistic continuum.

The Ottawa studies of fantastic trees, virtuoso plays of whirling branches penned in loosely flowing, wiry lines, are characteristic of several such studies of single or clumps of trees. Their exuberant convolution of branches is matched in Neyts' *Rustic Lovers Beneath a Fantastic Tree* (Amsterdam, Heirs of Prof. J. Q. van Regteren Altena).[1] The nervous, endlessly circling thin line creates a striking contrast to the calm, broad vertical strokes of Jan Lievens' *Woodland Interior* (cat. 41).

Neyts' tree studies are stylistically contiguous with a number of his Italianate, or, occasionally his Netherlandish, landscapes. The latter are drawn with a similarly moving line but contain only passages of wildly growing greenery, as in *Mountain Landscape* in Leiden[2] or *Italianate Landscape with a City Gate in Ruins* in Antwerp.[3] These more fluid drawings do not

appear to be dated. As in the tree studies, the first name of the signature is monogrammed *AE* for Aegidius rather than *gillis* or *g;* the form *AE* seems to be found only on very late paintings such as *Mountain Landscape with Travelers* in Cologne[4] dated 1681. It has gone unnoticed that figure studies in London,[5] signed the same way and analogous in manner, were used for this painting.

Next come various relaxed but realistic snatches of rural Flemish countryside delicately outlined in pen and ink with a generous use of watercolor, such as *Mill in a Valley* (Munich).[6] There are similarities here to the work of Lucas van Uden, with whom Delen suggested Neyts might have studied.

The most numerous are his finely stippled, precise landscapes, frequently on parchment, which are far removed from the Ottawa *Trees*. The subjects may be realistic, as in *Views of Antwerp* in Antwerp[7] or idealized, perhaps with ruins or a castle, as in London[8] or Darmstadt.[9] Some bear dates from 1650 to the mid-1660s.[10] These two groups are signed *g* or *gillis neyts,* as are the stylistically comparable (but undated) etchings illustrated in Hollstein. If the continuum is progressive, all this suggests that the most precise drawings would be among the earliest, even-

Cat. 43, verso

tually evolving into the flamboyance
of the Ottawa *Trees* for which a dating to
the 1670s or 1680s can be tentatively
proposed.

JAS

1. Bernt 1958, no. 438; also British Museum, Department of Prints and Drawings, Gernsheim no. 25583, and Fogg Art Museum, Harvard University, Gernsheim no. 92978.
2. Rijksuniversiteit, Prentenkabinet; Gernsheim no. 44496. Or Rijksprentenkabinet, Amsterdam, inv. no. 1919:26.
3. Stedelijk Prentenkabinet; Delen 1938, no. 435, ill.
4. Wallraf-Richartz Museum, inv. no. 2505; Vey and Kesting 1967, 78, fig. 111.
5. British Museum, Department of Prints and Drawings, Hind 1923, Neyts nos. 6–7, pl. 62.
6. Graphische Sammlung; Wegner 1973, no. 808, ill.; Bernt 1958, no. 437. There are several fine examples in Rijksprentenkabinet, Amsterdam, such as *Bridge* (inv. no. A4299) or *Castle Ruins* (inv. no. A4498), also 1910:54, inv. nos. A1930, 1931, 4298, 4498.
7. Stedelijk Prentenkabinet; Delen 1938, nos. 438–440, ill.; see also Van Hasselt in London 1972, nos. 59–61, and Thièry 1953.
8. British Museum, Department of Prints and Drawings, Hind 1923, Neyts no. 24, pl. 63. The collection contains a large number of similarly finished and signed landscapes.
9. Hessisches Landesmuseum, dated 1650; Gernsheim no. 24254.
10. As Rijksprentenkabinet, Amsterdam, views of Brussels (dated 1662, inv. no. 1919:28), and Harlebeeck (dated 166[3], inv. no. 1919:27).

## Lambert Doomer
Amsterdam 1624–1700 Amsterdam

## 44
## *The Hermitage at Nantes*, 1645

Black chalk with brown, gray, and rose wash on laid paper

192 x 309 (7$^{1}/_{2}$ x 12$^{1}/_{8}$)

Inscribed by the artist, lower left, in pen and brown ink, *Doomer f.*; lower right, in pen and brown ink, *8*; verso bottom center, in pen and brown ink, *de Heremita[g]i te Nantes; Doomer f. A 1645.*; in a modern hand, verso upper center, in graphite, *587.1940 / Ausgestellt: | Alte Malerei aus Köln., Privatbesitz | 4 Nov.–15 Dez. 1922 | im Kolnischen Kunst [?], Köln*

Provenance: Private collection, Germany, 1922; C. Jose; sale, Amsterdam, 20 April 1950, lot 29, (repr.); purchased from P. & D. Colnaghi, London, 1950, through Paul Oppé

Literature: Popham and Fenwick 1965, no. 171; Schulz 1972, no. 104; Schulz 1974, no. 77; Sciolla 1974, 37, under no. 36; Schatborn 1977, 50; Sumowski 1979–, 2: no. 383-3

Exhibitions: Cologne 1922, unnumbered; Vancouver 1957, no. 20; London 1969, no. 32

Acc. no. 5818

At some point in 1645, probably after a time spent in Rembrandt's studio, the twenty-one-year-old Lambert Doomer traveled to Nantes where two of his brothers were members of the Dutch merchant community. In May of the following year the artist Willem Schellincks joined him. In July 1646 they left Nantes and traveled together in France for two months, but returned separately to the Netherlands. Doomer made an extensive series of drawings bearing the dates 1645 and 1646 that record this trip.[1] Some fifteen drawings of Nantes remain, many identified by the artist on the verso and dated 1645 (the date seemingly added all at one time years later).[2] Sixteen more views of Nantes are known only from the later replicas the artist made in the years after 1665. A replica of the Ottawa drawing was last seen in a 1976 auction.[3] Schellincks' less numerous studies are complemented by a diary (Copenhagen),[4] in which he noted their movements and his impressions of the country.

The Nantes drawings depict representative sites or vistas, leavened with anecdotal figures. Doomer recorded public buildings, such as *Church of Saint Peter in Nantes* (Musées Royaux des Beaux-Arts, Brussels),[5] and more loosely conceived, picturesque rural farmyards.[6] In contrast, his *Nantes Seen from Across the Loire from the Capuchin Hermitage* (Metropolitan Museum of Art, fig. 1)[7] is an effective panoramic profile of the city. The Capuchin hermitage on the rocky banks of the Loire outside the city must have been a notable site, at least for its excellent van-

tage point. Indeed it was described by Schellincks who visited the site while in Nantes, as "seer schilderachtigh"[8] ("paintinglike" or picturesque). This quality comes out in the Ottawa study: the rising rocks at the right, played off against the sweep of the river bank, and accented by the staccato rhythms of the pollards, are captured with an emphasis on the formal abstractions of nature more than on topographical idiosyncracies. *Loire Landscape in the Vicinity of the Hermitage at Nantes* (Berlin-Dahlem)[9] is similar. Doomer himself grouped these three

views since they are serially numbered: Ottawa *8,* Berlin *9,* and New York *10* in the same ink as the detailing in the New York drawing. None of the other extant Nantes views are so numbered.

The Nantes drawings are Doomer's earliest dated works. Only a few of his French drawings are related to paintings; their consistently complete character suggests they were intended as ends in themselves. The majority demonstrate considerable control and skill, though most follow the descriptive conventions of earlier travel drawings. Doomer began

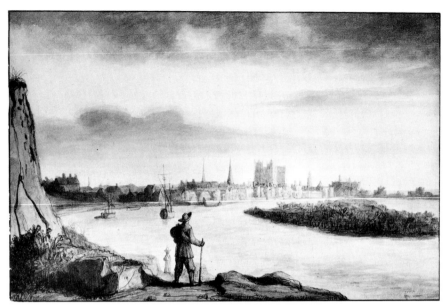

Fig. 1. Lambert Doomer, *Nantes Seen from Across the Loire from the Capuchin Hermitage,* The Metropolitan Museum of Art, New York, Rogers Fund

by fully working out the views in black chalk. In the Ottawa drawing a confident, looping stroke applied with shifting pressure is especially effective in bringing out the sensuous depressions in the rocky hill. The whole was then washed in brown and gray, and a rose tone, which lends great warmth. In some of the views (fig. 1), details in the foreground are rendered in brown ink.

Although there is no documentary evidence for the artist's prior training, these drawings are not the work of a beginner but of a formed artist working in a manner not inconsistent with a period of recent study with Rembrandt. Sumowski's conclusion[10] on this question may well be correct: while this tutelage cannot be stated as fact, as Schulz has done, neither does Schatborn's[11] reassignment of all the Rembrantesque studies to after Doomer's acquisition of albums of Rembrandt's drawings in 1658 seem justified. Unfortunately, Sumowski's identification of similarities in the ''handwriting'' between pen drawings by Doomer assigned to the period c. 1644 and Rembrandt's drawings of the early 1640s, on the one hand, and Doomer's French drawings, on the other, is not argued in a sustained

fashion. However, taking another tack, it may be observed that Doomer's use of chalk for preliminary studies, for example, on the verso of *Cowes Castle on the Isle of Wight,*[12] is closer to Rembrandt's chalk landscape drawings of the early 1640s[13] than to those of anyone else.

Another study made by Doomer on this French trip, *Cave in the Vicinity of Tours,*[14] is also in the collection.

<div style="text-align: right">J A S</div>

1. See Schulz 1974, 15–17; Schatborn 1977; and Sumowski 1979–, 2: under no. 383.
2. The present text follows Schatborn 1977 and Sumowski 1979–, 2: under no. 383, in assuming that the drawings were made in 1645, as inscribed, and not 1646 as Schulz asserted. Schulz supposed that Doomer traveled to Nantes with Schellincks in the spring of 1646. As Schatborn suggested, it is unlikely that Doomer mistook the year. Thus Schulz' dating of the Ottawa drawing to 1646 is not accepted.
3. Schulz 1974, no. 77A; Sumowski 1979–, 2: no. 816. Kornfeld & Klipstein, Berne, 11 June 1976, lot 51, pen and brown washes on ledger paper, 234 x 414 mm, ill. in the sales catalogue of Mak van Waay, Amsterdam, 15 January 1974, lot 1126f.
4. Royal Library, NyKgl.p.370. See Van den Berg 1942.
5. Schulz 1974, no. 60, ill.; Sumowski 1979–, 2: no. 469[x], ill.
6. As that in Rijksprentenkabinet, Amsterdam; Schulz

1974, no. 66, ill.; Sumowski 1979–, 2: no. 384, ill.
7. Metropolitan Museum of Art, inv. no. 1965:48, black chalk, pen and brown ink, and brown, gray, and olive washes, 235 x 370 mm; Schulz 1974, no. 50; Sumowski 1979–, 2: no. 470[x].
8. Van den Berg 1942, 12.
9. Staatliche Museen, Kupferstichkabinett; Schulz 1974, no. 79; Sumowski 1979–, 2: no. 385.
10. Sumowski 1979–, 2: no. 783, under nos. 370, 449[x], 465[x]. His redating of no. 467[x] to c. 1645 makes sense, but Schatborn's 1985, no. 26, reattribution of Sumowski no. 368 to Rembrandt is also convincing.
11. In support of his position, Schatborn cited Schulz' conclusion that there is no connection between the French drawings and the Rembrantesque drawings Schulz dated to c. 1644. Schatborn did not address the question of an alternative formation.
12. Amsterdam, with B. Houthakker; Schatborn 1977, fig. 5; Sumowski 1979–, 2: no. 393.
13. Albertina, *Near the Heiligewegspoort,* Benesch 1957, no. 805, or Surrmondt-Ludwig Museum, Aachen, *Nieuwezijde Voorbugwal in Amsterdam,* Benesch 1957, no. 820.
14. Inv. no. 6303; Popham and Fenwick 1965, no. 172; Schulz 1974, no. 123; Sumowski 1979–, 2: no. 383.

## 45
## *Life Study of a Female Nude, 1825–1826*

**Julius Schnorr von Carolsfeld**
Leipzig 1794–1872 Dresden

Graphite with brush and brown ink and brown wash on wove paper

379 x 209 (15 x 9¹/₂)

Inscribed in an unknown hand, lower right corner, in graphite, *Flinsch Z 8*

Watermark: Upper left corner, countermark, *PM*

Provenance: Alexander Flinsch, Berlin; sale C. G. Boerner, Leipzig, Auction 111, 29–30 November 1912, no. 533; Heinrich Stinnes, Cologne; purchased from C. G. Boerner, Düsseldorf, 1977

Exhibitions: Düsseldorf 1976, 164, no. 104; Downsview 1981

Acc. no. 18769

Julius Schnorr von Carolsfeld was one of the leading members of the group of German artists active in Rome in the 1810s and 1820s known as the Nazarenes. The drawing is a study for the woman leaning out of the loggia at the right edge of Schnorr's fresco *The Army of Charlemagne Defending Paris,* in his cycle illustrating Ariosto's *Orlando Furioso* in the Casino Massimo in Rome.[1] The plan to decorate four rooms in the Casino Massimo with scenes from the works of four great Italian writers—Petrarch, Tasso, Dante, and Ariosto—originated in 1817. In the end, the room honoring Petrarch was not executed. Tasso's room was largely decorated by Friedrich Overbeck, Dante's primarily by Peter Cornelius.

Between 1822 and 1827, Schnorr was periodically engaged in creating his frescoes for the Ariosto room, which was the only room entirely completed by one artist and which was considered at the time to be the most successful of the three. Schnorr was commissioned to paint the Ariosto room in 1818, and by 1819 he had established the scenes to be painted and their location in the room and had made detailed cartoons for the ceiling paintings. Although his planning for the wall paintings did not begin until 1822, by January of 1823 he had planned the entire

room in rough outline. The main wall was to show the battle for Paris (*Orlando Furioso,* canto 15, strophes 8 and 9). To the left side of the main wall, Schnorr depicted the Saracen Agramont before the city walls of Paris; on the right side, the scene of Charlemagne and his army within the city.

The Ottawa drawing is a study for a figure on the extreme right side of the composition, where a group of Parisians look upon the scene in alarm. The grouping seems to have been especially problematic for him, because he continued to develop its composition after the rest of the scene was completed. In his first sketch, he placed this group behind a wall at the lower right.[2] This was altered in the second design to show a man, two women, and a child in an open loggia with a woman and child climbing a small set of stairs in front of them.[3]

Close analysis of the details of these drawings and the other surviving studies for the wall provides not only a more precise dating than has heretofore been suggested for the Ottawa drawing, but an interesting insight into Schnorr's working method. In the series of studies for the group in the loggia, the figure of the woman leaning out over the wall becomes progressively more like the pose

Fig. 1. Julius Schnorr von Carolsfeld, *Life Study of a Nude Woman Ascending Stairs*, 1825–1826, Staatliche Kunstsammlungen Dresden, Kupferstich-Kabinett

seen in our drawing.[4] The positions of the entire group are roughly fixed in the sketch for the complete composition in Leipzig (Museum der bildende Künste).[5] This compositional drawing can be dated to 1825, because it must postdate a sketch inscribed in pencil *d. 4 Febr. 1825*[6] that shows an earlier version of the pose of the woman climbing the stairs.

However, both the Ottawa drawing and a similar drawing, apparently of the same model, posed as the woman on the stairs, in the Kupferstich-Kabinett in Dresden (fig. 1)[7] were done after the large compositional sketch, for they represent changes made after the Leipzig drawing and before the final cartoon for the fresco.[8] The large drawing in Leipzig shows the woman climbing the stairs with her hand on the side of the bundle on top of her head. In the final cartoon, her hand is quite clearly on the top of the bundle, as it is in the life drawing for the figure in Dresden. Thus, the Dresden study must have been made after the drawing in Leipzig and before the cartoon.

A similar change is made in the figure shown in the Ottawa drawing. In the large Leipzig sketch, her hand is on the shoulder of the small boy in front of her; in the Ottawa drawing and in the final cartoon, it is resting on the ledge. Again, it would seem that the life drawing was done after the Leipzig sketch and before the cartoon.[9]

Thus, the life studies were done after the composition was fixed in the Leipzig sketch and before the cartoon for the painting was drawn. In both cases, it would seem that Schnorr worked out the basic pose in the sketches, perhaps without reference to a live model. He then did nude studies from life of a model assuming the pose of those figures. Since Schnorr was already painting the main wall with the scene in February 1826 (and had finished by June 1826), he had clearly finished the cartoon by early 1826.[10] The Ottawa drawing and its mate in Dresden can be dated to the period between February 1825 and the beginning of 1826.

Questions of use and dating aside, the drawing must be classed among the major achievements of nineteenth-century draftsmanship. The Ottawa drawing, one of Schnorr's best figure studies from his Italian period, is an outstanding example of his combination of the precise rendering of form typical of Nazarene drawings with his own meditative quality, achieved through supple contours and quiet rhythmic flow across the sheet.[11] Schnorr's drawings from the years in Italy have long been valued for their economy and purity of expression. Many writers have acclaimed them as a highlight of nineteenth-century German art, paying Schnorr the compliment of comparing him to Ingres. Keith Andrews appropriately turned the comparison the other way. "The only draughtsman of equal rank in early nineteenth-century Europe was Ingres, and if his lines seem less hard and more sinuous, Schnorr's reveal a deeper expressiveness. The best of his drawings reach beyond mere observation and become visions."[12]

Schnorr's own comment on draftsmanship applies perfectly. In a letter to his friend the art dealer Johann Gottlob Quandt, he wrote: "Only this one thing should not be desired from me—that I acknowledge an outer regularity, a superficial beauty, as true beauty. I want to see beauty as the stamp of the soul and will not take pleasing forms as beauty; and to me, if one wants to paint, he shouldn't paint well-proportioned lay figures and pass them off as people, rather he should form bodies and faces which witness to an inner spirit."[13]

HC

1. The basic study of the Casino Massimo and of Schnorr's contribution to its decoration is Gerstenberg and Rave 1934, especially 119–168. On page 40, they provide a summarized chronology of Schnorr's work on the wall paintings. For Schnorr and his contribution to the Casino, also see Andrews 1964, 43–54.
2. Gerstenberg and Rave 1934, no. 60, pl. 146. Museum der bildende Künste, Leipzig, inv. no. 930, 8.
3. As in Gerstenberg and Rave 1934, no. 62, pl. 150.
4. Gerstenberg and Rave 1934, no. 63, pl. 152, and no. 64, pl. 153.
5. Gerstenberg and Rave 1934, no. 59, pl. 149.
6. Gerstenberg and Rave 1934, no. 66, pl. 154, at left. It shows the woman turning around to look behind her, a pose not used in the larger compositional sketch.
7. The drawing is pen and wash over pencil, measuring 473 x 350 mm; Andrews 1964, 120, pl. 55c. Neither the Ottawa drawing nor the Dresden drawing were known to Gerstenberg and Rave.
8. In the Staatliche Kunsthalle, Karlsruhe. Gerstenberg and Rave 1934, no. 55, pl. 106.
9. One final difference should be mentioned. The Leipzig sketch shows both women with their hair completely covered in scarves or turbans. Both life studies include careful renditions of the braided coiffure that are almost exactly repeated in the cartoon. The omission of the coiffure from the Leipzig sketch could be due to the lack of necessity to show all details of the composition. This is rather different from the change of pose.
10. In fact, he wrote to his father on 15 August 1826 that the last of the large cartoons was finished. Schnorr 1886, 306.
11. On Schnorr's drawings in general, see Berlin 1974.
12. Andrews 1964, 46.
13. Schnorr 1886, 426, letter of 30 January 1823.

## 46

## *The Swamp*, 1881

### Vincent van Gogh
Groot-Zundert 1853–1890 Auvers-sur-Oise

Pen and black ink over graphite on cream laid paper

468 x 593 (18⅜ x 25⁵/₁₆)

Watermarks: Center left, *ED & Cie* within cartouche; center right, *PLBA*

Provenance: Oldenzeel Art Gallery, Rotterdam; H. Tutein Nolthenius, Delft; d'Autretsch Art Gallery, The Hague; M. Frank, New York; Mrs. Martin Nachmann, New York; M. Frank, New York; purchased from Marianne Feilchenfeldt, Zurich, 1967

Literature: Faille 1928, 3: no. 846, 4: pl. 5, fig. 846; Vanbeselaere 1937, 52, 59, 124, 126, 407; Evans 1968, 7, 9; Boggs 1969, 155; Vitzthum 1969, 12, 14; Faille 1970, no. 846; Boggs 1971, no. 173; Mettra 1972, 4; Feilchenfeldt 1973, n.p.; Amsterdam 1974, 33; Hulsker 1977, no. 8; Hulsker 1980, no. 8; Lochnan 1980, 2

Exhibitions: Rotterdam 1903, no. 81; Rotterdam 1904, no. 52; New York 1955, no. 79; Zurich 1967, no. 93 (*hors catalogue*); London 1969, no. 35; Florence 1969, no. 57; Paris 1969–1970, no. 37

Acc. no. 15461

When van Gogh decided, after several career failures, to be an artist, he moved in October 1880 to Brussels to pursue his artistic self-education, mainly through copying and contact with artists. Upon his brother Theo's suggestion, he soon visited the young painter Anthon van Rappard (1858–1892).[1] After Vincent returned to his parents' home in Etten in April 1881, the two artists kept in touch. Indeed, van Rappard visited van Gogh at Etten for twelve days in June 1881. In a June 1881 letter to Theo, Vincent wrote of plein-air sketching expeditions with van Rappard: "We have taken many long walks together—have been, for instance, several times to the heath, near Seppe, to the so-called Passievaart, a big swamp. . . . While he was painting, I made a drawing in pen and ink of another part of the swamp, where all the water lilies grow (near the road to Roozendaal)."[2]

The drawing referred to is *Marsh with Water Lilies* (F845), which is quite similar to *The Swamp*, albeit smaller.[3] Van Rappard did a pen drawing of the van Gogh

vicarage while he was at Etten, and, during their earlier contact in Brussels, he and van Gogh produced ink drawings of similar subjects.[4] Van Gogh admired van Rappard's ink drawings, rendered by quick, short strokes applied mainly in vertical-horizontal and diagonal crosshatching—characteristics that van Gogh emulated in *The Swamp* but with a greater profusion of strokes and concentration on atmospheric effects.

*The Swamp* also denotes van Gogh's admiration for The Hague school, a group of artists who came into prominence in the 1870s and who were often viewed as the Dutch equivalents to the Barbizon school of realist landscape painters in France. Van Gogh knew Hague school works well, having seen them as a former employee of Goupil and Company art galleries in The Hague, London, and Paris.[5] As late as May 1883, van Gogh would write to van Rappard: "Well, I for my part am also trying to find the path I think best, let's say the path of Israëls, Mauve, Maris . . ."[6]—all leading Hague

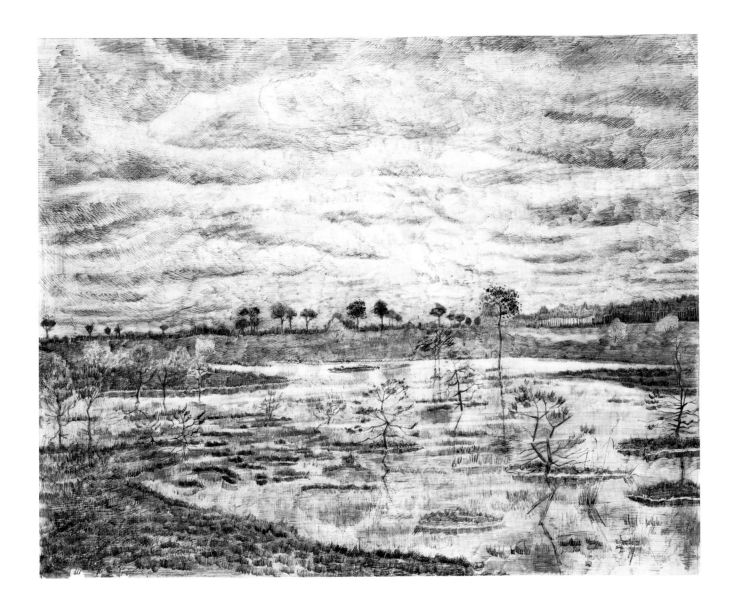

school artists. Typical Hague school works depict the uneventful Dutch polder landscape, often with much attention paid in equal measure to sky and water, and little central incident or bracketing—all qualities found in *The Swamp*.[7]

Although *The Swamp* is a derivative work, with overworking symptomatic of a novice, and is damaged and has been restored, it is significant in several ways.[8] Produced when most of his efforts were still copies, this is an early instance of

van Gogh shifting from self-education to a moderately original, personal response to a valued environment. The combination and frequent alternation of soft graphite and ink strokes give a shimmering atmospheric quality comparable to the "gray period" of Hague school landscape painting. Although *The Swamp*'s panoramic openness recalls such sources and its staccato ink strokes parallel van Rappard's ink drawings, these characteristics also anticipate the expansive vital-

ism of such late and thoroughly personal works as *Field Under Thunderclouds* of 1890 (F778), of which van Gogh wrote: "I did not need to go out of my way to express sadness and extreme loneliness."[9] This seems a belated echo of a comment Vincent made in 1879: "I still can find no better definition of the word *art* than this, 'L'art c'est l'homme ajouté à la nature' [art is man added to nature]—nature, reality, truth, but with a significance, a conception, a character, which the artist

brings out in it, and to which he gives expression, 'qu'il dégage,' which he disentangles, sets free and interprets. A picture by Mauve or Maris or Israëls says more, and says it more clearly, than nature itself.''[10] Hence the beginnings of van Gogh's mature style and aesthetic are adumbrated in this very early drawing and in his thoughts regarding the influences that shaped it.

RJM

1. For the van Gogh–van Rappard interaction, see Amsterdam 1974, especially Jaap Brouwer's essay ''Van Rappard and van Gogh,'' 29-39, to which the present commentary is indebted.

2. Van Gogh 1959, letter 146, 1: 234.

3. *Marsh with Water Lilies* measures 235 x 310 mm.

4. See Amsterdam 1974, 70-71, for *The Vicarage at Etten,* formerly attributed to van Gogh; compare also van Rappard's *Vallée de Josaphat,* ink, March 1881, 30, to van Gogh's *Landscape,* ink and watercolor, c. March 1881 (F874 verso), 31, plus Brouwer's commentary and reference to van Gogh's letters, 32.

5. On van Gogh's debts to The Hague school, see Pollock 1972, Amsterdam 1981b, and Charles Moffett's essay, ''Vincent van Gogh and The Hague School,'' in Paris 1983b, 137-146.

6. Van Gogh 1959, letter R34, 3: 382.

7. In Paris 1983b, Hague school works that resemble *The Swamp* include P. J. C. Gabriël's *Polder Landscape,* 22; van Gogh's relative Anton Mauve's *The Marsh,* 252; and Willem Roelofs' *Summer Landscape with Cows at a Pool,* 273, and *Lake at Noorden (Water-Lilies),* 271. Van Gogh had contacted Roelofs for artistic guidance in October 1880 in Brussels around the same time he contacted van Rappard; see 145-146.

8. A condition report prepared 15 July 1987 by the National Gallery of Canada reads in part: ''The support was extensively damaged with large tears and numerous losses. . . . The image reads well as a whole, but many areas are not original drawing. The missing image in areas of loss to the support has been very skillfully added by a restorer. . . .''

9. Van Gogh 1959, letter 649, 3: 295, c. 9 July 1890 to Theo.

10. Van Gogh 1959, letter 130, 1: 188, June 1879 to Theo.

## 47

## *Landscape with Saint John the Baptist Preaching*, 1655

**Claude Gellée,
called Claude Lorrain**

Chamagne 1600–1682 Rome

Pen and brown (iron gall) ink with brown wash and graphite over black chalk heightened with opaque white, on cream laid paper

248 x 318 (9³/₄ x 12¹/₂)

Inscribed by the artist, verso lower center, in pen and brown ink, *Claudi . . . Gellee / IV* (?) *feci 1655 Roma;* by the artist(?), verso upper center along top edge, in pen and brown ink, *25;* by the artist(?), verso lower right, in pen and brown ink, *¹/12;* in an unknown hand, verso center, in graphite, *M;* in another hand, verso center below *M,* in graphite, *P*

Provenance: Sale, P. H. Lankrink, 1693–1694 (Lugt 2090); Richard Houlditch (d. 1736, Lugt 2215, followed by *17,* in pen and brown ink); Viscountess Churchill; anonymous sale, Sotheby's, London, 29 April 1937, lot 89; purchased from P. & D. Colnaghi, London, 1940, through Paul Oppé

Literature: Oppé 1941, 55 and fig. D; Colnaghi 1960, pl. 78; Popham and Fenwick 1965, 142–143, no. 205; Roethlisberger 1968, 293, no. 773

Exhibitions: Florence 1969, no. 31; Washington 1982–1983, no. 51

Acc. no. 4556

The measure of an accomplished artist comes when he treats a popular or traditional theme, or constantly returns to it. Claude Lorrain's liking for this episode from Luke (3:1–18) is all the more interesting in that he drew it several times over but never seems to have painted it. Nor did he do an etching, as he often did, which paralleled a painting of similar subject. Roethlisberger nonetheless connected the Ottawa sheet to five related ones (Roethlisberger 1968, nos. 772–776) that could have led to such a painting, and provisionally dated it to around 1655. (Owing to the discovery of inscriptions on its verso, it can now be securely dated to that year.) *Saint John the Baptist Preaching* is of very high quality, meticulously developed to the last bit of rock or vegetation. The technique is quintessentially Claude's as well, with its vigorous pen lines that not so much intersect as define individual planes and forms. Its brown and gray-brown washes sweep across a highly textured paper. Much of the heavy white heightening has flaked away, shifting the emphasis of the entire drawing toward the inked lines. Microscopic examination reveals, however, not simply unsightly grayish areas of white that have oxidized, but a residual layer of white applied over the existing dark brown ink. The general effect of the drawing as it was can to some degree be restored through an effort of the imagination.

Still more interesting is the discovery of heavy reflecting layers of graphite, principally around the tree trunks at center and on the goats at lower left. This "drawn-over" effect, discreet though it is and not to be confused with heightening, seems part of Claude's ongoing examination of lighting and spatial qualities in landscape. His incessant study of the Roman countryside, perhaps aided by reminiscences of the peculiar quality of light in his native Chamagne, is directly

reflected in the surviving corpus of fifty-
one prints, nearly twelve hundred
drawings, and some three hundred
paintings.[1]

Normally classified with the French
school, Claude was one of many expatri-
ate French living and working in Rome,
remaining there from 1623 until his death
a half-century later. This sheet is typical
of his landscapes—constructed from long
experience and observation, where each
element, down to the flights of birds, has
its own place and no other.

WMCAJ

1. Washington 1982–1983, 63.

48

*Study for "Fame Revealing Cardinal Richelieu," 1642*

**Charles Le Brun**

Paris 1619–1690 Paris

Black chalk, heightened with white chalk, on buff laid paper

255 x 404 (10¹/₁₆ x 15¹³/₁₆)

Provenance: Purchased from H. M. Calmann, London, 1955, through Paul Oppé

Literature: Jouin 1889, 29-30, 595; Popham and Fenwick 1965, 42, no. 203; Brejon de Lavergnée 1986, 348, pl. 1

Exhibitions: Florence 1969, no. 30; Toronto 1972–1973, no. 151

Acc. no. 6318

Long given to Simon Vouet (1590–1649), this sheet, following a suggestion of Jennifer Montagu can be securely reattributed to Charles Le Brun, who passed through the Vouet studio about 1634–1635.[1] It accordingly becomes a very early work of Le Brun, one of the Douze Anciens, or founding members, of the French Royal Academy of Painting and Sculpture (1648), who was largely responsible for the decoration of Versailles, and who became First Painter to the King in 1664, guiding the destinies of the academy until his death in 1690.

The Ottawa drawing's identification and dating derive from the thesis of Jean Ruzé d'Effiat, Abbot of Saint-Sernin in Toulouse, engraved in reverse by Michel Lasne in 1642 (fig. 1).[2] In retrospect, the confusion between the aged Vouet and

Fig. 1. Michel Lasne, after Charles Le Brun, *Fame Revealing Cardinal Richelieu*, 1642, Bibliothèque Nationale, Paris

the young Le Brun is understandable: Fame as a personification appears in many of Vouet's allegories, but the style and technique of the artists are very close, as well. Once it is confronted with the Lasne thesis, however, the Ottawa study clearly relates to one of the two figures "unveiling" Cardinal Richelieu, minister of state to Louis XIII, here seen in the year of his death, when Le Brun was only twenty-three. The drawing has been remounted to follow the orientation of the print, the shading lines along the arms and legs now making sense, which they would not in a figure seen (and drawn) vertically.

Among older sources, only Pierre-Jean Mariette attempted to explain the scene, wherein Richelieu appears surrounded by allegorical figures, each with its label, that define and confirm the power and integrity of his administration: "Fame publishes all these virtues and the Genius of France invites the Minister to continue to care for the administration of his government."[3] In the drawing, the figure of Fame is given only the barest indications of drapery, while the trumpet with the small banner that eventually bears

the legend *CRESCITE EVNDO* is merely suggested. One leg is reprised below and filled out, but, as with most such sheets of Le Brun's, the drawing itself has been greatly reduced on all sides and lacks the margins necessary for esthetic presentation. The white heightening of this two-chalk drawing has been largely abraded, although the exceptionally vigorous construction of the basic forms remains unaltered. As often happens in complex allegorical compositions built on oppositions or complementarities, figures are paired, so Fame must be seen within a larger framework of design principles. The absence of Fame's farther arm in the drawing is explained conclusively by the print: Fame flies *away* from the spectator while withdrawing the curtain from one side of Richelieu's baldacchino; in contrast, the Genius of France (*PLVS QVAM TRIA LILIA SVRGVNT*) swoops down *toward* the spectator to present the cardinal with an orb emblazoned with three fleurs-de-lis.

WMCAJ

1. Letter of 31 January 1984 (National Gallery of Canada, curatorial file); information repeated in Brejon de Lavergnée 1986, 348.
2. Inventaire–XVIIe siècle, 7 (1976): 273, no. 748; illustrated in Wildenstein 1963, 63, no. 284.
3. "La Renommée publie tant de Vertus et le Génie de la France invite le Ministre à continuer de prendre soin de l'administration de son gouvernement," cited in Inventaire–XVIIe siècle, 7 (1976): 273, no. 748.

## 49
## *A Rocky Grotto*

**Claude Gillot**
Langres c. 1673–1722 Paris

Pen and brown ink with brown wash on off-white laid paper; figures introduced on an inset, lower left, within a window measuring 38 x 25 mm

154 x 200 (6¹/₆ x 7⁷/₈)

Watermark: *E C AMBOM* in oblong with rounded corners (upper part trimmed)

Inscribed in an unknown hand, lower center, in pen and brown ink, *Gillot*; verso, top left, in graphite, 18694/24

Provenance: Brigadier F. P. Barclay; his sale, Christie's, London, 26–27 November 1973, lot 288; purchased from Richard Day, London, 1974

Exhibition: Florence 1968, no. 59

Acc. no. 17650

Claude Gillot was an extremely popular artist during his life, although he was rapidly surpassed by his pupils Jean-Antoine Watteau and Nicolas Lancret. He became *agréé* (approved) to the French Royal Academy of Painting and Sculpture in 1710, and *académicien* (a member with full privileges) in 1715, at the age of forty-two. Gillot is mainly known through a large corpus of drawings, made not only for myriads of engravers, but reflected, as well, through his own etchings.[1] Such drawings are mainly decorative in nature, for tapestries, fans, screens, and the like, and were usually engraved posthumously; still others show grotesque and burlesque scenes related to the theater through which Gillot renewed his subject matter during the declining years of Louis XIV (1643–1715). Were we to accept the notion that Gillot designed for the Opéra, training in theatrical design would necessarily have led to rapidity and diversity in the development of ideas, perhaps to the detriment of their possibilities for interpretation. In the theater, speed and topicality are all, careful execution negligible.

Although chalk drawings are by far more numerous than pen drawings in Gillot's oeuvre, *A Rocky Grotto* is an especially attractive example of the latter owing to its high quality in small format. Its subject is as yet unidentified: landscape seems to be the main interest, with its extraordinary water reflections, implied rock bridge with goats on top, and swans and stag at lower right—significantly in a different scale than the humans of this idyllic scene. The figures are somewhat problematic, as well, in that they occur on a patch near the far left margin. We cannot say with any certainty whether they reiterate a botched motif or passage, represent a *repentir* or pentimento, or are even an iconographical intrusion. In any case, they are so well integrated that most viewers fail to notice the transformation, although the process is betrayed by ink caught here and there at the join, and is further noticeable by the fact that the laid lines of the patch are vertical, while those of the sheet itself are horizontal. Some attempt was made, however, to mask these problems through the introduction into the foreground of palm trees, which are out of keeping with the basic foliage types. Moreover, infrared light reveals a marked contrast in the ink

## 50
## *Two Men Standing*

**Jean-Antoine Watteau**
Valenciennes 1684–1721
Nogent-sur-Marne

Red chalk on laid paper

177 x 189 (6¹⁵/₁₆ x 7⁷/₁₆)

Provenance: Pierre Crozat (Lugt 2951, his inv. no. 3270 lower right, in pen and brown ink); Antoine-Joseph Dezallier-D'Argenville; his sale, 18 January 1779 (Lugt–Répertoire des ventes 2940); Madame de Saint(?) (illegible, from annotation on old mount); purchased from H. M. Calmann, London, 1939, through Paul Oppé

Literature: Oppé 1941, 55, fig. B; Parker and Mathey 1957, 2: 325, no. 655 (repr.); Popham and Fenwick 1965, 153–154, no. 216; Fenwick 1966, 22, 24; Boggs 1971, pl. 164

Exhibitions: Montreal 1950, 18, no. 97; Toronto 1968, no. 47; Florence 1969, no. 32; London 1969, no. 43; Paris 1969–1970, no. 42

Acc. no. 4548

Jean-Antoine Watteau remains one of the more enigmatic, if fascinating, representatives of the awkward artistic transition in France from the seventeenth to the eighteenth century. He died at thirty-seven and painted little, and his more memorable surviving works seem almost subjectless—at very least, scenes with telling details or revealing symbols, such as sculpture or specific theatrical figures, which situate the action. Coming to Paris in 1702 from a Flemish area annexed to France in the year of his birth, Watteau entered (and rapidly left) the studios of Claude Gillot and Claude III Audran, and went to England in 1718–1719, having been received as *académicien* in 1717 with the *Embarkation for Cythera*, in progress since 1712.[1]

By the last decade of his life, he had radically transformed the course of painting through his *fêtes galantes*, or *pastorales*, to which this sheet probably relates. Watteau's numerous drawings functioned like model books for designers, with ideas being kept for reference, ultimately to be transformed through counterproofs, changes in costume, and other specific details. What the sanguine drawings Watteau preferred have in common, as Grasselli observed, is "full plastic form with exquisite surface effects, finely differentiated textures, and clearly observed details of feature, dress, and pose."[2] The Ottawa sheet illustrates these precepts by distinctions in its two male figure studies: the one turned away from us is more detailed, the other, with arms apart and facing us, is more loosely sketched and generalized. As a result, one sees more clearly how Watteau brought his figures up through changes in detail and focus: the figure at left has sufficient strength and emphasis *as it is* to tell at a distance, while the figure to the right bears witness to Watteau's fluency and lightness of touch. The leftmost figure is also characteristic in its peculiar strengthening of the back of the leg down through the contour of heel and foot—a detail usually more perceptible in black-and-white reproductions than in the drawing itself. Parker and Mathey suggested affinities between the lefthand figure in the drawing and standing male figures in *Réunion en plein air* (fig. 1), and the *Italian Comedians*.[3]

Whether from paintings or drawings,

used for the patch, even if similar traces are found throughout. The single greenish-black ink that defines the border also appears in the mouth of the cave and the tree trunk in the foreground.

Such modifications were greatly facilitated by Gillot's technique of drawing with parallel lines of different densities, but scarcely varying in width. As Mimi Cazort observed, the lines form a screen or mist over the entire composition,[2] resulting in a drawing of considerable brilliance for all its economy of means. The orientation of lines changes constantly, and is further enhanced by slightly different inks for a richer tonal effect. Such subtleties in the handling of ink suggest at least superficial analogies with engraving, most notably the vignettes of *Daphnis and Chloë* (1718), drawn by Antoine Coypel and engraved for the Regent Philippe d'Orléans by Benoît I Audran. Gillot eludes our best attempts at classification, if only through the sheer force of his imagination and a very controlled, yet seemingly loose, style passed on to Watteau.

WMCAJ

1. Inventaire–XVIIIe siècle, 10 (1968): 233–273.
2. Memorandum of 21 November 1973 (National Gallery of Canada, curatorial file).

Fig. 1. Jean-Antoine Watteau, *Réunion en plein air*, c. 1719, Staatliche Kunstsammlungen Dresden, Gemäldegalerie Alte Meister

Watteau was much engraved, albeit posthumously. This sheet also poses the question of the use of prints "in the crayon manner" to disseminate studies taken from the work of great contemporary and near-contemporary French masters such as François Boucher, Carle Van Loo, Watteau, Joseph-Marie Vien, and Charles Parrocel—they were highly finished drawings, not just academic nudes from the studio. A major study has yet to be done to identify and date the compositions from which such prints were extracted, and to see what their implications are in their own right and for the history of taste. Hérold was certainly right in saying that Watteau renewed the art, the technique, and the taste for drawing, thereby providing further impetus for the reproductive print and its techniques.[4] Since one of the most comprehensive contemporary statements about Watteau's drawings was made in 1745 by Antoine-Joseph Dezallier-D'Argenville,[5] it is fitting that the rakish left figure in the Ottawa drawing was fac-similed in the same sense, with the addition of ground shadow and a suggestion of foliage to his right, by Jean-Charles François (1717–1769) as the fifth of six plates from the Dezallier-D'Argenville Collection, posthumously dispersed only in 1779.[6] The supposition of previous cataloguers that the remaining figure from the Ottawa sheet was facsimiled as the last print of the series is, however, incorrect. It is another drawing altogether.[7]

WMCAJ

1. Washington 1984–1985, 396–406, no. 61 (Musée du Louvre, Paris, inv. no. 8525).

2. Grasselli 1986, 378.

3. Parker and Mathey 1957, 2: 21. Gemäldegalerie, Dresden, inv. no. 781; National Gallery of Art, Washington, inv. no. 774 (Washington 1984–1985, 439–443, no. 71).

4. Hérold 1931, 8, although the major and continuing impetus for this type of decorative print came, as might be expected, from Boucher.

5. Cited in Washington 1984–1985, 56.

6. Reproduced in Dacier and Vuaflart 1929, 1: 193, fig. 82, along with a full description of the suite.

7. Reproduced in Hérold 1931, pl. XI, fig. 59.

**51**

*Battle Scene*

**Charles Parrocel**
Paris 1688–1752 Paris

Red chalk on laid paper, laid down on laid paper

333 x 529 (13¹/₈ x 20³/₁₆)

Inscribed by the artist, lower right, in pen and brown (iron gall) ink, *C. Parrocel 17* (?)

Provenance: Gift of Theodore Allen Heinrich, Toronto, 1978

Exhibition: Ottawa 1976, no. 18

Acc. no. 18969

Like his father, Joseph (1646–1704), the Avignonese artist Charles Parrocel was a painter of horses and battle pieces, a genre that was difficult to encompass within the hierarchy of academic painting of the time. Perhaps because of this,

and his own hesitations, he progressed slowly through the artistic hierarchy, becoming a full member of the French Royal Academy of Painting and Sculpture only in 1721, counsellor in 1735, adjunct professor in 1744, and professor in 1745. Even his reception into the Academy was overshadowed by his father's memory, for he was ''received Academician in consideration of his father and his merit, for which She [the Academy] retains an uncommon esteem.''[1] Moreover, it seems that the painter Nicolas Lancret (1690–1743), who worked in a popular sub-Watteau genre and had less personal

reticence, gained almost effortlessly all that Parrocel sought.

His friend and biographer, the engraver Charles-Nicolas Cochin fils (1715–1790), gave the best insights into Parrocel's work; despite his large historical paintings and tapestry cartoons, Parrocel was a draftsman's draftsman. Fond of the colorists van Dyck and Rubens, whose prints he collected, Parrocel used prints neither for inspiration nor reference, but rather as a means of seeing and analyzing form through others' eyes. His form is often raw, but sure, despite its apparent disorder. As Cochin remarked, "his drawings, generally having little finish (and consequently unattractive for those having only a feeble knowledge of the arts), are the admiration of people of taste by their conspicuous fire, wit, and sureness. . . . Sometimes there are only simple strokes, but always applied with astonishing certitude and liberty. The strokes are squarish and even somewhat exaggerated in this respect. And if there are incorrections, these are, if you will, savant incorrections resulting from the will to emphasize palpably the truths and beauties of nature that one experiences keenly and that one expresses with excess, and very different from incorrections arising from ignorance or any lack of feeling."[2]

The Ottawa sheet belongs to this current of expressive rather than pretty drawing. It is signed and dated, and may be presumed finished; but it does not seem to relate to any identifiable painting. Typical of Parrocel's enormous production, it is drawing for its own sake, rapidly executed in sanguine, although he did not disdain the "three-crayon" technique either. Interpretation rests with the beholder, and even the painter himself would have had difficulty bringing such a drawing to canvas. In fact, Cochin described the artist laying down his brush and compulsively drawing, whether or not the work was related to what he was then doing. This sheet may well show a tumultuous conflict between Turks (turbans and flags ornamented with crescents) and Christians, although a key motif in the upper right quadrant (standards? a vision?) is difficult to interpret. Parrocel's main emphasis is usually placed on the contours, such as they are, with crude shading lines occasionally being used to give weight and mass to areas otherwise lacking in definition. Even this translates well into engravings in the crayon manner by, among others, Jean-Charles François and Gilles I Demarteau.[3]

WMCAJ

1. Procès-verbaux, 4 (1881): 310–311.
2. Read before the Academy 6 December 1760 (reread 2 June 1764), Procès-verbaux, 7 (1886): 150, 253; already used by Charles Blanc for his study on the artist (Blanc 1865, 2: 8 pages).
3. Hérold 1931, pl. XVIII.

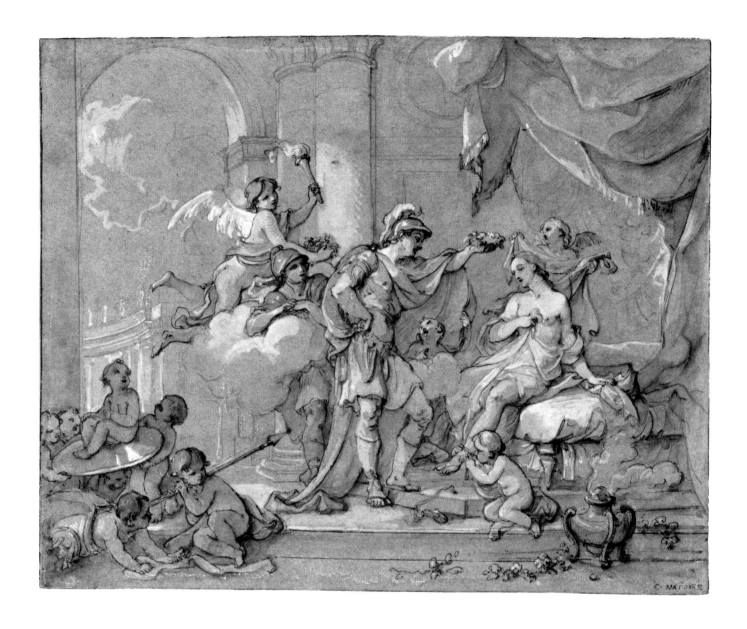

## 52

### *The Marriage of Alexander and Roxanne*

**Charles-Joseph Natoire**
Nîmes 1700–1777 Castel-Gandolfo

Pen and brown (iron gall) ink with brown wash, heightened with opaque white, over black chalk and graphite on blue laid paper, laid down on laid paper

325 x 411 (12¹³/₁₆ x 16³/₁₆)

Inscribed in an unknown hand, lower right, in pen and brown ink, *C. NATOIRE*; in another hand, verso lower left, in graphite, *Alexandre offert la couronne à Roxanne*

Provenance: Purchased from H. Shickman Gallery, New York, 1976

Acc. no. 18658

As recounted by classical authors such as Plutarch and Quintus Curtius, the marriage of Alexander the Great (355–323 B.C.) and Roxanne became an attractive subject for artists from the Renaissance on because of its contrast between martial and amatory pursuits—a type of "Mars disarmed and Venus disrobed" taken from ancient history.

Alexander invaded Asia Minor with a

considerable force of horse and foot to avenge the incursions into Greece, two centuries earlier, of Darius and his son Xerxes. In so doing, he extinguished the Persian empire and extended his rule from the Mediterranean to the Ganges, whereupon he died unexpectedly at Babylon in the thirty-second year of his life and the twelfth of his reign. His romantic interlude with the Persian woman Roxanne is ingeniously presented in Charles-Joseph Natoire's version of the scene: Hymen, god of marriage, floats in with his torch and crown, while Alexander's witness rests himself on the clouds just below.[1] Some putti assist Roxanne in disrobing; others play with Alexander's discarded arms and armor in a décor resembling a stage set—a reminder that Natoire once specialized in the decoration of Parisian private *hôtels*. However conventional the subject, Natoire brings its elements together distinctively, using opulent settings and perspectives in an Italianate manner that corresponds to the rising taste at mid-century for grave and antique subjects, albeit in a sentimental style.

A highly diluted iron gall ink is washed over the paper's black chalk and graphite underdrawing. Rather than following the forms, the wash defines general massing. The figures themselves are defined by ink or suggested by opaque white—all of which is enhanced by the freshness of the blue paper, so desirable in this type of coloristic work.

François Boucher and Natoire were both pupils of François Lemoyne; both became *académiciens* (full members) of the Royal Academy of Painting and Sculpture in 1734, professors in 1737. They even collaborated on decorative ensembles, only to go their separate stylistic ways over the years. Albeit only a representative historical painter heavily influenced by the Bolognese and Venetian schools, Natoire was particularly known for his life drawings and landscapes, which were coveted in the eighteenth and nineteenth centuries alike.[2] Upon being named director of the French school at Rome in 1751, he painted less and drew more, remaining in Italy even after his retirement. He is remembered more for the fact that Fragonard and Hubert Robert were in Rome during his directorate than he is for his paintings, but his drawings maintain a deserved popularity.

WMCAJ

1. Boyer 1949, 90, no. 507, records this subject in black chalk only, so it cannot be the Ottawa drawing.
2. See Lise Duclaux in Troyes 1977, 20, for the roster of Natoire's devoted collectors: Pierre Crozat, Jean de Jullienne, Jean-Denis Lempereur, Pierre-Jean Mariette, and the Marquis de Marigny, later Ménars; and such nineteenth-century eminences as the Goncourts and Philippe de Chennevières.

## 53

Recto: *Seated Boy, Studies of his Head and Hands*, 1733

Verso: *Another Study of the Same Boy*

**François Boucher**
Paris 1703–1770 Paris

Recto: red and white chalk on brown laid paper, with a border in pen and black ink; verso: red and white chalk

350 x 269 (13¹³/₁₆ x 10⁵/₈)

Inscribed in an unknown hand, lower left, in pen and black ink, *L. Chardin*, over *F. Boucher* in graphite

Provenance: Purchased from Tan Bunzl - De Rothschild, London, 1983

Literature: Ananoff 1976, 1: 233, no. 89, fig. 374

Acc. no. 28217

Certain drawings gain in interest when compared with their engravings, not their paintings, proof, if proof were needed, that the connection between drawings and paintings is not always more important, though more immediate, than the far-reaching relations between drawings and engravings—particularly when the painting cannot be located. Paintings of any importance were often known, discussed, and appreciated through fine engraving since prints were more accessible than canvases hidden away in private collections. What must be resolved on a case-by-case basis are whether the print reverses the composition as drawn or painted, and why some paintings were engraved at the moment of their creation while others waited years, even decades, before their general diffusion as reproductive prints. In this case, the print evidence retrospectively situates the entire creative process leading up to the painting, and, moreover, assists in titling it properly.

Whereas it is usual to see a composition develop through an extended sequence of drawings, this double-sided sheet is unique in showing how François Boucher could work up a composition in short order. Boucher's painting of 1733 (fig. 1) was given an oval format, and so was its corresponding engraving (fig. 2),

titled *De trois choses en ferez-vous une?*[1] This was paired with a different *type* of Boucher, *Elle mord à la grappe* (fig. 3), to form pendant prints some thirty-five years after completion of the Ottawa drawing.[2] The prints respond to each other through their titles, which in literal translation would be something on the order of: *Of three things will you make/do one?*—or more elegantly as *Will you make us one?*—and *She takes the bait.*[3]

We may suppose that the verso of the Ottawa drawing came first, but was quickly rejected: the boy leaning on his right hip with his hands resting on a summarily indicated table is rather too much like Jean-Baptiste-Siméon Chardin of the 1730s, although not nearly as interiorized in mood as a Chardin since he is not engaged in cardplaying or other absorbing occupations.[4] Boucher as a rule preferred unimpeded physical contact between principals and a more intimate, more telling framing in his two-figure compositions: here the oval format concentrates the action and largely dispenses with setting. On the recto, the boy is now seated in only the barest suggestion of a chair, and turned toward us. There is a more finished study of the three hands— perhaps the "trois choses" of the print title—as the boy asks for the hand of his beloved, while a more vital and detailed

Cat. 53, verso

Fig. 1. François Boucher, *De trois choses en ferez-vous une?*, Fondation Ephrussi de Rothschild, Musée Ile-de-France, Saint-Jean-Cap-Ferrat

Fig. 2. Jacques-Jean Pasquier, after François Boucher, *De trois choses en ferez-vous une?*, Musée du Louvre, Paris, Collection Rothschild (Cliché des Musées Nationaux)

Fig. 3. Jacques-Jean Pasquier, after François Boucher, *Elle mord à la grappe*, Musée du Louvre, Paris, Collection Rothschild (Cliché des Musées Nationaux)

character sketch of his head brings us a step closer to the particular forms of the painting. Boucher was a master of the rapid notation of elements for later incorporation and variation. Unfortunately, the natural progression of thought documented in this sheet is pretty well restricted to his youth, as Boucher's working method rapidly became formulaic in order to meet the demands of large-scale production and of collectors.

In this context we might note the passage from Sir Joshua Reynolds' *Twelfth Discourse* (1784) in which he remarked the unusual facility of the French in *ex tempore* invention, that is, without drawings or models of any kind. He harked back to a visit to Boucher's atelier, where the artist confirmed that "when he was young, studying his art, he found it necessary to use models; but he had left them off for many years." This type of industrial output has been much discussed and remains controversial, but it is a significant aspect of Boucher's career since he was early (and continuously) engraved, and since his drawings, like those of Jean-Antoine Watteau, were particularly known through the print medium. By

mid-century there was already a scandal concerning some "unauthorized" engravings made by Claude Duflos after Boucher, in which mention is made of "drawings furtively removed by the pupils of this painter" and handed over to engravers.[5] Duflos' reply was not long in coming (two months), and it was brutal: "But every great man has his manias; that of Boucher is not to be engraved. Occupied by many works that please, time escapes him, he doesn't always have the time to be new. His paintings, scattered among private collections, are known to few; if the provinces ask him for some, a few crayon strokes, a few lines skilfully added or changed, make new portraits and give painters time to breathe: the engraving medium loses, and the public as well, but the Académicien gains by it."[6]

Duflos here situated the role of reproductive engraving, which is to clarify both drawings and paintings through linear means; in so doing, he suggested how Boucher produced as much as he did, beyond any official commissions and duties arising from his reception as *académicien* in 1734 to his duties as First Painter to the King during the last five

years of his life.[7] Whether from drawings or paintings, Boucher was often engraved, so the relative chronology of prints and their models, and the conditions of their engraving, become paramount for an understanding of his success. Even working drawings on the order of the Ottawa sheet were already becoming collector's items, so the rise of "crayon-manner" prints during the 1750s and 1760s corresponds to a general enthusiasm. We would, of course, wish that less of the white heightening had been lost from this drawing: it would have set off even more brilliantly the two shades of red, darker and lighter, doubtless corresponding to wet and dry chalk applications. Yet, as a drawing or a painting, the Ottawa composition's appealing subject and unpretentious, direct treatment is consistent with the year 1733, when the thirty-year-old Boucher had just returned from Italy. It bears witness to a temperament and training that Boucher left behind, or integrated rather too thoroughly into his intellectual baggage: when Jacques Jean Pasquier engraved *De trois choses en ferez-vous une?* in 1768, he gave it a pendant more in keeping with what

Boucher had become, and the print titles maintain the distinction, not only in themselves, but in respect of the images they accompany.

WMCAJ

1. Jean-Richard 1978, 349–350, nos. 1447–1448.
2. Jean-Richard 1978, 350, nos. 1449–1451.
3. New York 1986–1987, 139–141, no. 19 (Institut de France, Fondation Ephrussi de Rothschild, Saint-Jean-Cap-Ferrat).
4. Paris 1979a, nos. 54, 64, 59 and 71 respectively.
5. Mercure de France 1755a, 145–146.
6. Mercure de France 1755b, 131–133: "Mais tout grand homme a sa manie; celle de M. Boucher est de n'être point gravé: occupé de beaucoup d'ouvrages qui plaisent, les momens lui échappent, il n'a pas toujours le tems d'être neuf; ses tableaux répandus chez des particuliers, ne sont pas connus de tout le monde; si la province lui en demande, quelques coups de crayon, quelques traits habilement ajoutés ou changés, en font des portraits nouveaux, & donnent aux Peintres le tems de respirer: la gravure y perd, & le public aussi, mais l'Académicien y gagne."
7. The only study to date of the First Painters as a whole is New York 1985–1986, accompanied by a repertory of their work in American collections.

## 54

### Le Couché de la mariée, 1767

## Pierre-Antoine Baudouin
### Paris 1723–1769 Paris

Gouache over red chalk and traces of graphite on laid paper, laid down on multilayered cardboard

360 x 317 (14¹³/₁₆ x 12⁷/₁₆)

Inscribed in an unknown hand, lower right, in pen and brown ink, *Baudouin;* verso of secondary support, nineteenth-century printed label, *ADOLPHE REUGNIET*

Provenance: Purchased from R. M. Light & Co., Santa Barbara, 1984

Acc. no. 28441

This hitherto unrecorded study gives the subject of a gouache exhibited by Pierre-Antoine Baudouin at the Salon du Louvre (1767, no. 73), where it received scathing criticism from Diderot.[1] It is one of no less than forty-eight Baudouins engraved, and a comparison with the print begun by Jean-Michel Moreau le Jeune and completed by Jean-Baptiste Simonet in 1770 (fig. 1) affords food for thought in considering such "cabinet pieces,"[2] the genesis of which is often extremely complex. While the Salon gouache evidently belonged to the Marquis de Marigny, brother of Madame de Pompadour and Superintendent of the Arts from 1754 to 1773, such compositions normally went through several stages or versions before the copyists arrived on the scene. What the artist himself did for private commissions, for public exhibition, and for circulation may be very different things, and very difficult to identify on the basis of early documentation, so detailed analysis is useful in understanding the kinds of changes effected toward specific ends—particularly if any association with Marigny is maintained.

The Ottawa drawing follows Baudouin's customary technique of gouache over red chalk and graphite, some design elements of which can be seen despite the overlay, while others, such as the use of pointed red chalk for features, give sharpness to the flesh

Fig. 1. Jean-Michel Moreau le Jeune and Jean-Baptiste Simonet, after Pierre-Antoine Baudouin, *Le Couché de la mariée,* 1770, Bibliothèque Nationale, Paris

Fig. 2. Pierre-Antoine Baudouin, *Le Modèle honnête,* National Gallery of Art, Washington, Gift of Ian Woodner

tones that is impossible with opaque watercolor alone. When compared with Simonet's engraving in reverse, almost all compositional details, except for the screen in front of the door, are present. The important passages, including the figural groupings, are more precisely delineated than the furniture, paneling, and ceiling. Before the engraving, a number of modifications were effected to place the scene in a more general context. These include suppressing the official decoration pinned on the groom's dressing gown, replacing the statuette on the mantelpiece, changing the cipher and devices of the overdoor, and modifying the nature of the flower garlands on the walls and ceiling. These last appear in the drawing as cut-flower garlands, which also surround the mantelpiece statuette based on the well-known classical type of Eros and Psyche. It is transformed here, through the addition of a third figure, into *Amour et Hymen unis par l'amitié* (Love and Marriage United by Friendship), as stated in gouache on the socle. In the print, the garlands seem to have almost been made a part of the heavily carved paneling through their translation into more legible linear forms.

Through engraving, the lighting of the

composition was forced for drama; and with its accentuated chiaroscuro, the paneling.[3] The statuette, whose theme of Love and Friendship was a favorite of Madame de Pompadour,[4] is replaced by a candelabrum and bowl of roses, while the overdoor is now occupied by two cupids proffering a floral crown previously visible at the top of the mirror. The bride's uncovered knee is now veiled, as is the farther knee of the groom, while the chambermaid lifting up the covers has a more erect (and less interesting) posture.

Yet the couple may be identifiable, and this would fundamentally alter the way in which we view the gouache and, eventually, the print. The elevated rank of the newlyweds is indicated by the groom's decoration—seemingly the Order of Saint-Louis—while the initial *M* and two entwined hearts of the overdoor, suggest an identification with Marigny, who married early in 1767.[5] (Otherwise the question revolves around who could afford such a commission.) Since the next item in Marigny's sale after *Le Couché de la mariée* (Bringing the Bride to Bed) was another Baudouin gouache, this time an allegory of his marriage,[6] the Ottawa piece may represent an attempt at the confla-

tion of the two subjects, increasingly depersonalized in later stages of development. If so, Baudouin had an extraordinary subject to work up into finished form by the opening of the Salon in August.

Despite its innate theatricality, this incident is more complex and more subtly orchestrated than a Jean-Baptiste Greuze. It is psychologically complex in its gestures and glances, to the point that its viewers could examine it in detail, considering it both as a narrative sequence and through its accessories.

Pupil and son-in-law of François Boucher, Baudouin became *agréé* in 1761 and *académicien* in 1763, moving rapidly away during his short life from biblical and mythological scenes to gouaches of a somewhat equivocal nature. Exhibiting at only four biennial Salons, from 1753 to 1769, very few of his gouaches were described or titled (they were for the most part grouped under given catalogue numbers), so their identification and discussion is largely dependent upon the anonymous Salon critiques. Diderot, who considered Baudouin a libertine, regularly took him to task for his "poor choice" (or development) of subject matter, and dwelt perhaps too long on his "little infamies," the better to maintain his leitmotif of "Greuze painter and preacher of good morals; Baudouin, painter and preacher of bad ones."[7] And while some of Baudouin's subjects were at the limit of public tolerance and were censured by church and salons alike—resulting in even more clients for bravura pieces in small format— Baudouin's technique is as singular as are the pastels of Maurice Quentin de La Tour during the 1730s and 1740s, although his subjects escape the constraints inherent in the portrait genre. His treatment of subject is also superior to that of Nicolas Lavreince and Sigmund Freudeberg, who were more specific in their choice of situation and left less to the imagination.

In the end, the Ottawa gouache seems more personal in its references than most other Baudouins; and if the connection with Marigny is tenable, this scene corresponds to a specific event. Its further development for public exhibition, however, would have required the patron's approval. As it is, the few modifications present in this study are minor and of only formal nature: two elliptical patches

and some corrections in the bed curtains, while *all* recognizable personal references were suppressed in the engraving. If Diderot were aware of the allusion, he breathed nary a word in public.[8]

The closest parallel to this work, likewise castigated by Diderot for its equivocal nature—which can be a merit in art— is *Le Modèle honnête* (The Honorable Model). Shown by Baudouin at the next Salon (1769, no. 68), and now in the National Gallery of Art, Washington, it was likewise engraved by Simonet (fig. 2).[9]

WMCAJ

1. Diderot 1957–1967, 3 (1963): 29, 197–198.
2. Bocher 1875, 18–19, no. 16.
3. Moreau and Simonet clarified and transformed the work into a real *nocturne*, with its intense specific and sparse general lighting, the latter of which fades away into the darker recesses of the apartment. This change underscores Diderot's pointed mention of the shortcomings of the gouache medium in this subject and others like it: "Point de nuit; scène de nuit peinte de jour; la nuit, les ombres sont fortes, et par conséquent les clairs éclatans; et tout est gris."
4. Réau 1922, 213–218.
5. Suggested in conversation by Alden Gordon, 3 February 1984 (memorandum, National Gallery of Canada, curatorial file).
6. *Catalogue des différens objets de curiosités dans les sciences et arts, qui composoient le Cabinet de feu M. le Marquis de Ménars* [Marigny] (Lugt–Répertoire des ventes, 3389), 65, lot 279. The allegory (191 x 127 mm) is described as "l'Hymen allume son flameau, & couronne deux coeurs posés sur un autel qu'un jeune Amour entoure de fleurs," and sold for 84 *livres*.
7. Diderot 1957–1967, 2 (1960): 140.
8. Marigny's gouache (his sale, 1782, 65, lot 278) sold for 821 *livres* and is described as "connue par l'Estampe qui en a été gravée par Simonet. Ce morceau, exécuté à la gouache avec tout l'esprit possible, est sous glace de 15 pouces sur 11 de large, dans une riche bordure." This gives rise to a discrepancy that may be impossible to resolve at this point in time, for in his criticism Diderot noted "tout à fait à gauche, sur un guéridon, un autre flambeau à branches; sur le devant, du même coté, une table de nuit avec des linges." These motifs are lacking in the Ottawa gouache, yet are reported as present in Marigny's Salon gouache, but remain unaccounted for in the engraving said to be done after the latter.
9. For the criticism, see Diderot 1957–1967, 4 (1967): 31, 95; for the engraving, Bocher 1875, 36–37, no. 34.

55

## *Return of the Traveler*

**Jean-Baptiste Greuze**
Tournus 1725–1805 Paris

Brush and gray, black, and dark brown (iron gall) wash over graphite on laid paper, laid down on laid paper

351 x 456 (13¾ x 18)

Inscribed in an unknown hand, verso lower left, in pen and blue ink, *J.B. Greuze / Le Paralytique*

Provenance: Unidentified collector's mark: verso of secondary support, upper and lower right corners, stamped in black ink, *C.R.* (encircled); sale, Hippolyte Walferdin, 12–16 April 1880, lot 306; probable sale, Josse, 1894; sale, Nicolas Rausch, Geneva, 18–19 June 1963, lot 260 (repr.); purchased from Galerie Cailleux, Paris, 1973

Acc. no. 17235

Despite a moral content that Diderot all too readily opposed to Boucher's frivolous appearances and Baudouin's libertine subjects, the "pictorial novels" or "speaking pictures" of Jean-Baptiste Greuze have their problems, mostly one

Fig. 1. Jean-Baptiste Greuze, *Le Paralytique*, The Hermitage, Leningrad

of overemphasis. The Ottawa drawing, traditionally called *The Paralytic* by superficial analogy to the great painting now at Leningrad that dominated the Salon du Louvre in 1763, no. 140 (fig. 1),[1] is, by its internal logic and following a suggestion by Edgar Munhall,[2] more likely a *Return of the Traveler.*

Whatever one thinks of Greuze, the Ottawa drawing is masterful within its context. Few other artists could cram as much emotional urgency into such a fleeting observation: no less than five figures anxiously gather around the central figure of the old man, whose hat and walking stick have been thrown down as he collapses into a chair, while his travel gaiters are removed and his brow mopped. It is not, however, clear whether only he has been traveling (his wife has a scarf about her head and is enveloped in a *pèlerine*), or whether some part of the family has also been on the road.

Unlike the Nicolas-Bernard Lépicié figure (see cat. 58) with which it may be compared, this is a full compositional sketch, broadly executed and seemingly not intended for close viewing. The combination of heavy gray and black wash overlaid with iron gall browns that almost seem to have been applied with a stencil, as on the *pèlerine*, was accepted by Munhall as a Greuze technique.[3] Here, Greuze works darker and darker to correct and emphasize forms by alternating warmer and cooler washes overrun with brushed detail—a technique that accentuates the extraordinary variety of angles assumed by objects and figures within a relieflike composition held together, even dominated, by a single figure. Also a Greuze ''signature'' is the general indifference to background— barely relieved by angling light—and the sharp emphasis on the eyes and craggy physiognomies. This type of subject in this size, perhaps intended for engraving, rings truer than many of Greuze's larger, more emphatic compositions, although this may simply be the result of closer focus. In any case, we see Greuze as a master of the differentiated wash drawing.

WMCAJ

1. Paris 1984–1985, 232–237, no. 62; the drawing that may have preceded it (Salon of 1761, no. 106) is catalogued 230–231, no. 61.
2. Letter of 5 May 1976 (National Gallery of Canada, curatorial file); see Hartford 1976–1977, 76, no. 28.
3. Cited in letter of 4 April 1973 (National Gallery of Canada, curatorial file) as ''not unusual in Greuze's work.''

Cat. 56

## 56

## *A Young Lady Arranging Her Garter,* 1780s

**Jean-Honoré Fragonard**
Grasse 1732–1806 Paris

Black chalk with brown wash on laid paper, laid down on laid paper

315 x 250 (12½ x 9¾)

Provenance: Sale, Hippolyte Walferdin, 3 April 1880, lot 183 (Lugt–Répertoire des ventes, 40041); sale, Léon Ducloux, 14–15 February 1898, lot 66; Thomas Pietri; Sigismond Bardac; George Blumenthal; Baroness van Wrangel; purchased from H. Shickmann Gallery, New York, 1978

Literature: Portalis 1889, 304; Dayot and Vaillat 1907, 18, no. 149; Ananoff 1961–1970, 1 (1961): 101, no. 103

Exhibitions: Paris 1907, no. 160 (repr.); Washington 1978–1979, no. 56 (repr.)

Acc. no. 23001

Known in his time for painting in almost all the fashionable genres, Jean-Honoré Fragonard has become increasingly and nearly exclusively associated with his innovations in amorous subjects from 1774 to 1791, many of them engraved.[1] Here we see his abilities in a scene drawn from life, without any special pretense.

Most drawings have an apparent focus that reveals their purpose. This one, however, gives us another Fragonard than we usually think of, for while its object is a young lady somehow interrupted in the process of tying her garter, its subject is rather more the costume than the sitter. In the absence of a defined spatial context, her directness of gaze, understandable in the circumstances, establishes a link between viewer and sitter— an old artistic device for which Fragonard had some predilection. The figure is not highly developed: the right leg and arm, and even the head (usually the expressive means that defines or expands upon the scene), are so summarily indicated that they function almost like underdrawing. So it is much more likely that this subject is a pretext for a costume study, since the drawing comes alive only with the double pouf of the robe's sleeves and through the complications of the train spilling out over the chair.

The brown wash around the figure gives unity to the whole as it darkens from left to right, complementing, as it does, the deep chalk shading at extreme right, behind the chair. The wash gives an impression of atmospheric solidity that might not occur with more customary diagonal lines as a means of indicating background, or with the farther and nearer parts of the figure itself. By analogy with a number of portrait roundels traditionally identified as those of Fragonard's own family, and seconded by the *robe à l'Anglaise,* Eunice Williams places the Ottawa sheet in the 1780s.[2]

WMCAJ

1. Paris 1987–1988, 418.
2. Washington 1978–1979, no. 56.

## 57

## *Vue de l'Amirauté et de ses environs en regardant de la Porte Triomphale vers l'Occident*, c. 1750–early 1760s

**Louis-Nicolas de Lespinasse**
Pouilly-sur-Loire 1734–1808 Paris

Pen and gray and brown ink with watercolor washes over traces of graphite, with touches of opaque white and gouache, on laid paper

217 x 324 (8⁹/₁₆ x 12³/₄)

Inscribed by the artist, bottom left, in pen and black ink, *d. L.*; in an unknown hand, verso center, in pen and brown ink, *Vue de L'Amirauté et de Ses Environs, en regardant de la porte triomphale Vers L'occident*

Provenance: Private collection, Paris; sale, Ader and Picard, March 1968; sale, Palais Galliéra, Paris, 3 April 1968, lot 201; purchased from Galerie l'Oeil, Paris, 1968

Literature: Briganti 1970, 290, 296, 299, pl. 200 (detail)

Acc. no. 15713

This delicate watercolor of the Admiralty in Saint Petersburg from the southeast is one of two views by Louis-Nicolas de Lespinasse in the National Gallery of Canada of buildings along the Neva River in Saint Petersburg. The Chevalier Lespinasse received his Croix Royale et Militaire de Saint-Louis during his military career, about which very little is known. In the 1770s he began to paint watercolor and gouache views of Paris, which were often engraved. At the age of fifty-three, in 1787, he was presented to the Royal Academy of Painting and Sculpture by the professor of perspective as an aspiring painter of landscape and perspective views in gouache. That same year he exhibited nine works at the Salon, mostly views of Paris, including his reception piece—a large panorama of the city (Musée Carnavalet, Paris). Reviewers praised his precision, detail, perspective, and ability to capture the atmosphere and light of a specific time of day.[1]

He continued to exhibit at the Salon until 1801, the year he published his two treatises on perspective, one of which was written for the guidance of artists and the other for the military.[2] He had probably learned to draw as part of his military training, since topographical drawing and perspective were often included in the curriculum of military academies. The character of the present drawing is typical of work produced by military "amateurs," but the skill with which it is drawn is far superior to most.

This drawing came to the National Gallery with Lespinasse's other view of Saint Petersburg, which depicts both banks of the Neva looking east from a bridge crossing the river in front of the Admiralty (fig. 1). The viewpoints Lespinasse chose for both these drawings are almost identical to those chosen by the Russian artist Michael Makhaev (1716–1770) for two of his views of Saint Petersburg, which were published with twenty-two others by the Academy of Sciences in 1753 to celebrate the fiftieth anniversary of the city's founding.[3] The question arises whether Lespinasse actually visited Saint Petersburg himself and drew his views on the spot or whether he simply copied Makhaev's views.

A close comparison of the two artists' works indicates that Lespinasse used an identical viewpoint for his view of the Neva (see fig. 1), even beginning his drawing at the same windows of the

buildings on each side of the drawing as Makhaev, altering only his figures and the ships on the river. However, in his watercolor of the Admiralty, Lespinasse's viewpoint and details of some of the buildings differ significantly from those in Makhaev's view.

Before listing these differences, it may be helpful to identify the buildings in Lespinasse's view. The Neva is glimpsed between gaps in the buildings in the middle distance, and the buildings on the river bank on the viewer's side are, from left to right: a palace of the nobility; the spire and dome of the Cathedral of Saint Isaac of Dalmatia (built in 1727 and replaced in 1768);[4] the Admiralty (built in 1738, replaced in 1806) with its distinctive spire, which terminated the view down

Nevsky Prospect, and its fortifications and buildings forming a U around the shipyard indicated by the masts in the center of the view; and, on the extreme right side, the end pavilion of Domenico Tressini's Winter Palace (redesigned and rebuilt in 1754–1762 by Bartolommeo Rastrelli). On the far side of the Neva, to the right of the Admiralty spire, are the Cadet School, the Twelve Colleges, and the beginning of the Academy of Sciences, whose three-part central tower, Peter the Great's Kunstkammer, is clearly visible in Makhaev's view.[5]

It is on this side of his drawing that Lespinasse differs importantly from Makhaev. In the French artist's view, an additional block is seen on this corner of the Admiralty and the Winter Palace is

cut off at the first pavilion, indicating that his drawing is later than Makhaev's but before Rastrelli's work on the Winter Palace was completed. Perhaps Lespinasse cut off his view at this point because the construction work marred the rest of the view. A date in the 1750s or early 1760s is thus indicated for this drawing.

That Lespinasse knew the engravings after Makhaev and deliberately chose the same viewpoint is confirmed by the inscriptions on the backs of his two drawings in the National Gallery, which are exact transcriptions of the titles printed along the bottom of Makhaev's views.

This drawing of the Admiralty by Lespinasse was engraved by Claude Niquet as plate 7 in a publication by Paul or François Denis Née, who were known for

Fig. 1. Louis-Nicolas de Lespinasse, *Vue des bords de la Neva en remontant la rivière entre l'amirauté et les Batimens de l'académie des Sciences*, National Gallery of Canada, Ottawa

works. This combination of minute precision and elegance of line with a naiveté in approach and wash technique makes them not only valuable but also aesthetically charming documents.

<div align="right">K S</div>

1. For transcriptions of these reviews and the few known facts of his life, see Bourin 1910, 25–32, and London 1977, 78, 79, nos. 98–100.

2. *Traité de Perspective Linéaire; à l'Usage des Artistes* and *Traité du Lavis des Plans, appliqué principalement aux Réconnaissances Militaires* (2d ed. 1818). On the title pages he was described as "Chef de Bataillon, Membre de l'Ancienne Académie de Peinture et Sculpture."

3. Komelova 1968, 89, 22 (repr.), 23, 43.

4. This cathedral was incorrectly identified as the Cathedral of Saints Peter and Paul in the Fortress on the opposite bank of the Neva, in Briganti 1970, pl. 200.

5. For an account of the architects and dates of these buildings, see Hamilton 1954, 171–173, 209.

6. See entries on Née and Niquet in Bénézit, 7: 672–673, 728–729.

7. A third watercolor by Lespinasse once belonged with the two now in the National Gallery (lot 202 in the sale at Palais Galliéra, Paris, 3 April 1968). This *Vue de Sver située sur la Svertzd* was the same size as the watercolor of the Admiralty. It depicted a walled monastery and town on the banks of a navigable river, perhaps the Svir canal, which connected Saint Petersburg to the lakes and rivers that formed the route to the Near East. Unlike the other two watercolors, this one does not bear any known connection with a view by Makhaev.

8. *The Place Louis XV Seen from the Champs Elysées;* see Huisman 1969, 58, 134, 59 (repr.).

VUE DE L'AMIRAUTÉ ET DE SES ENVIRONS,
*en regardant de la Porte Triomphale vers l'Occident.*

Fig. 2. Claude Niquet, after Louis-Nicolas de Lespinasse, *Vue de l'Amirauté et de ses Environs*, National Gallery of Canada, Ottawa

their books of picturesque views of Switzerland, France (1781), Greece, and so forth.[6] The engraving (fig. 2) does not appear in any of their known publications and must have been printed for one that is now lost, perhaps a picturesque tour of Russia.[7]

Because of his attempts to be exact in every detail, Lespinasse's watercolors of Paris are invaluable documents; even niches are left empty waiting for their statuary in his earliest known view of Paris of 1775.[8] The composition, light and shade, figures and foliage are more accomplished in his later works than in his early views and the National Gallery's watercolors of Saint Petersburg. More amateur in style and technique—pen and ink drawings lightly washed in a small range of blues, grays, and greens—these views are, however, as meticulous and skillful in detail and penwork as his later

## 58

*Study of a Seated Man,* 1777

**Nicolas-Bernard Lépicié**
Paris 1735–1784 Paris

Black chalk with stumping and touches of red chalk,
heightened with white chalk, on tan laid paper

353 x 412 (13⅞ x 16¼)

Provenance: Purchased from Adrian Ward-Jackson,
London, 1976

Acc. no. 18731

Although a prolific and much-appreciated artist in his day, Nicolas-Bernard Lépicié's artistic personality was eclipsed after his death to the point that his work was often ascribed to Jean-Baptiste-Siméon Chardin and Jean-Baptiste Greuze. Rehabilitated by Charles Blanc in 1865,[1] he has increasingly returned to favor with the renewal of interest in the anecdotal painting of the eighteenth and nineteenth centuries.

Son of François-Bernard Lépicié, perpetual secretary and historiographer of the Royal Academy of Painting and Sculpture from 1737 until his death in 1755, Nicolas-Bernard enjoyed all the educational advantages accorded relatives of members of a closed corporation. Recipient of a Quarterly Prize in 1751 and 1752, he was second in the Grand Prix for 1759, and was named *agréé* in 1764, becoming an *académicien* with full privileges in 1769, at the age of thirty-four. He exhibited at the Salon du Louvre from 1765 to his death in 1784, and posthumously in 1785. Lépicié's career provides an example (Greuze being another) of the many artists, who contrary to their natural bent, unsuccessfully attempted the "grand genre" of history painting. Notwithstanding this, he did excellent mythologies, such as the two overdoors for the Grand Salon de Compagnie of the Petit Trianon, *Death of Adonis* and *Death of Narcissus* (the latter Salon of 1771, no. 30),[2] and *Quos Ego* (Salon of 1771, no. 34). The latter two are known through the work of Jean-Charles LeVasseur, who specialized

in the engraving in large format of "modern" paintings.[3] Lépicié was also responsible for some fine panoramas, such as the *Interior of a Customs-House* (Salon of 1775, no. 23),[4] although his historical and religious works, such as the *Zeal of Mathatias in Killing a Jew Sacrificing to Idols* (Salon of 1783, no. 5),[5] carry less conviction. Lépicié's forte was, however, accomplished genre painting. Like Etienne Jeaurat before him, he adapted the style and subject matter of the Low Countries to French taste in a manner at once durable, recognizable, and sought-after. In the words of a 1781 critic: "Oh, for now, M. Lépicié, paint for us the departure of a poacher, the game ot marbles, and that of cards!"[6]

Lépicié doubtlessly received his initial impetus toward genre painting from his father and his mother, Renée-Elisabeth Marlié, who both specialized in the engraving of prints after Chardin from 1738 to 1744.[7] Yet he never really depicted the cultured upper bourgeoisie of Chardin or Greuze, and is best compared to Etienne Aubry (1745–1781) in his choice of social level and situation. While he was generally thought to have a clear and unhesitating hand in his human and animal drawings, his paintings were felt to be less masterful, albeit remarkable in their details. Lépicié seems not to have employed professional models, using his family, friends, or pupils instead, and this splendid three-chalk life study has the easy informality associated with this practice. Indeed, the male figure lends it-

Fig. 1. Bervic (Charles-Clément Balvay), after Nicolas-Bernard Lépicié, *La demande acceptée* (The Proposal Accepted), Bibliothèque Nationale, Paris

self to ready comparison with Greuze's *Return of the Traveler* (see cat. 55), not only because of the pose, but because of the contrast in technique or, if one will, intention. Against a background of two densities of black chalk, stumped to soften and blend the general effect, only a touch of sanguine picks out the cheeks, nostrils, and mouth, while the resource of white heightening is sharply curtailed—a technique very typical of his work, although Lépicié occasionally employed pastel and watercolor. The Ottawa sheet is an indication of the high quality and appealing facility to be expected from Lépicié's life drawings, which are less artificial and certainly less concerned with types than Greuze's, and less preoccupied with social contrast than Aubry's. Such drawings must have existed in great numbers and been preserved for their intrinsic value, suggesting their importance in their own right,

not just in their perceived relations to paintings.

However, the figure in the Ottawa drawing is not just any figure, but a study for the father in one of Lépicié's better-known paintings *La réponse désirée* (Salon of 1777, no. 12), later engraved by Charles-Clément Bervic (fig. 1) under the title *La demande acceptée* and exhibited the year after Lépicié's death (Salon of 1785, no. 313).[8] Through Bervic, we see the coarsening of the character as painted, and a certain weakness of composition when compared to a similar subject, Greuze's *L'accordée de village* (Salon of 1761, no. 100) as engraved by Jean-Jacques Flipart (fig. 2; Salon of 1785, no. 304).[9] While Greuze concentrated on the formal ceremony, with its signing of the marriage contract before a notary and the ostentatious turning over of the dowry by the father, Lépicié focused on an earlier episode—the gaining of the mother's

consent and the overcoming of her (evident) reticence, where the father assumes the role of a bystander. This striking contrast in episode demonstrates how rapidly such scenes moved from the moral to the sentimental between the 1760s and 1770s, and how rapidly seminal paintings were transmitted through prints, in each case roughly a decade after the painting's exhibition at the Salon. A page from the 1777 Salon handlist, with marginal illustrations by Gabriel de Saint-Aubin,[10] also proves that the Ottawa study—with its clarification of coat detail retained in the engraving—is in the sense of the painting, a matter of some importance since, to judge from his catalogued work, Lépicié made widespread use of counterproofs.

It was remarked at the time that the very strength of Lépicié's individual figures ultimately weakened his general effects, to the point that his working pro-

Fig. 2. Jean-Jacques Flipart, after Jean-Baptiste Greuze, *L'accordée de village* (The Village Bride), Bibliothèque Nationale, Paris

cesses seem to have contributed to compositional impoverishment in his paintings, even as his drawings retained an undiminished presence: ''Everything has the same value: the light is so dispersed that any of the figures taken by themselves could make a painting. Bringing them together produces no effect.''[11] Such focus may be why his smaller paintings and portraits succeeded, while his larger efforts failed. In any event, the Ottawa sheet shows Lépicié at the height of his reputation in 1777, when he had just become professor at the academy. It also shows him at his best in a type of subject matter in which he grudgingly excelled.

WMCAJ

1. Blanc 1865, 2: 8 pages, unpaginated.

2. Musée national du château de Versailles, inv. nos. 8339, 8340.

3. Delignières, 1865, 12–13, nos. 25–26.

4. Thyssen-Bornemisza Collection, Lugano.

5. Musée des Beaux-Arts, Tours, inv. no. 803-1-13 (Lossky 1962, no. 70).

6. *Lettres d'Artriomphile à Mme Mérard de Saint-Just*, cited in Gaston-Dreyfus 1923, 19. The *Departure of the Poacher* (Salon of 1781, no. 22) has just entered the Musée Joseph-Dechelette, Roanne (Moinet 1986, 296–297), and gives an adequate idea of his coloristic effects.

7. See Bocher 1876, 125, for a listing of their work in this context (Lépicié fils presumably abandoned engraving for painting because of poor eyesight).

8. According to the *Vente de tableaux, desseins, estampes et ustensiles de peintre, après le décès de M. Lépicié, Peintre du Roi* of 10 February 1785 (Lugt-Répertoire des ventes, 3825), 4, lot 2, the painting was still in his possession and was *just then* being engraved by Bervic.

9. Hartford 1976–1977, 84–86, no. 34, some preliminary drawings also being included, 78–83, nos. 30–33; Musée du Louvre, inv. no. 5037.

10. Paris, Bibliothèque Nationale, Estampes Yd² 1134 rés. in-8°, p. 6 (negative 66 B 40907).

11. *Le Véridique au Salon,* cited in Gaston-Dreyfus 1923, 18.

## 59

## *Young Witch Flying on a Rope Swing, 1824–1828*

**Francisco Goya y Lucientes**
Fuendetodos (Saragossa) 1746–1828
Bordeaux

Black chalk and lithographic crayon on greenish-white laid paper

191 x 155 (7¹/₂ x 6¹/₁₆)

Inscribed by the artist, upper right, in black chalk, *19;* by the artist, lower right, in black chalk, *Goya;* verso, imprint of following sheet in album (H 20)

Watermark: Saint Andrew's cross between two lions

Provenance: Probably bought in Madrid by John Savile Lumley, 1st Baron Savile of Rufford (secretary to British Legation in Madrid, February 1858–April 1860); Rufford Abbey (Nottinghamshire), John Savile, 2nd Baron Savile; purchased from P. & D. Colnaghi, London, 1923, through H. P. Rossiter

Literature: Lopez-Rey 1956, 140; van Hasselt 1957, 87; Fenwick 1964, 1, 13, fig. 18; Popham and Fenwick 1965, 207, no. 306 (repr.); Sayre 1966, 87, fig. 12; Vertova 1969, 43, pl. 8; Dieterich 1972, 42; Boggs 1975, 1, fig. 1; Gassier 1973, 2:637–638, no. 436 (H 19)

Exhibitions: New York 1950, no. 3; Bordeaux 1951, no. 9; Winnipeg 1955, no. 25; London 1963–1964, no. 203, pl. 62; Toronto 1968, no. 52; Florence 1969, no. 40; London 1969, no. 69; Paris 1969–1970, no. 72; Boston 1974–1975, no. 261; Paris 1979, no. 180, fig. 3

Acc. no. 2996

In 1923 the National Gallery of Canada was fortunate in acquiring five drawings by Francisco Goya. Although the drawings share a provenance from c. 1860, their earlier history is not known.[1] Four of these sheets (including this one and cat. 60) are from the two late Bordeaux Albums, now dated between 1824 and 1828.[2] The fifth is related to the lithographic series of 1825, the Bulls of Bordeaux. The attribution of this drawing to Goya was long doubted, but has now been accepted by Eleanor Sayre.[3]

The "young witch" has undergone different interpretations over the years. Since she was not christened by Goya in an inscription, she was described as "girl skipping rope" until Sayre noted that she was, in fact, perched on a rope suspended in air and that her locomotion was aided by bat-wing slippers.[4] Gassier disputed her identification as a witch, claiming that her headband was not a witch's attribute, and that the wings on her shoes were not, as Sayre contended, bat wings.[5] The distinction between seductive young women and witches is often blurred in Goya's work, and for this reason these refinements of argument are perhaps not relevant except in terms of citing thematic continuity in Goya's late work.

Sayre did indeed relate the *Young Witch* drawing to the late etching of an old warlock on a swing, which she dated 1826–1828.[6] Both etching and drawing show figures with faintly demonic smiles on their faces, swooping along on rope swings whose means of suspension is not shown. The copper plate on which the warlock is etched bears on its verso an etching of a witch on a swing. Sayre suggested that the prints may have been intended for a new set of *Caprichos*, "conceived in the eightieth year of [Goya's] life." It is interesting that the copper

plate was in the collection of John Savile Lumley, the original owner of the *Young Witch* drawing.[7]

Gassier, in his introduction to the discussion of the Bordeaux Albums, suggested that Goya used both black chalk and lithographic crayon in these sheets, the latter for the dramatic accents and bold contours characteristic of his style of these years.[8] Sayre, who is currently studying the technique of these sheets, noted that results of work by the conservation staff at the Boston Museum of Fine Arts suggest that these velvet-black lines were produced by dampened chalk rather than lithographic crayon. Examination of the National Gallery drawings by the conservators in Ottawa has verified that some of the lines and accents were indeed done with a waxy crayon like a lithographic crayon. It seems therefore that at least some of the late drawings were informed by Goya's contemporary work in lithography, and that their vigor and power are due in part to some experimental combination of the old and new media.

MC

1. Letter from P. & D. Colnaghi, London, 31 December, 1952 (National Gallery of Canada, curatorial file).
2. Gassier 1973, *Album G* and *Album H.*
3. Sayre, verbal communication, 1987.
4. Sayre 1966, 87.
5. Gassier 1973, 2: 637.
6. Boston 1974–1975, 317.
7. Boston 1974–1975, 317.
8. Gassier 1973, 2: 499.

## 60

## *The Death of Anton Requena,* 1824–1828

### Francisco Goya y Lucientes
Fuendetodos (Saragossa) 1746–1828
Bordeaux

Black chalk and lithographic crayon on greenish-white laid paper

192 x 156 (7⁹/₁₆ x 6¹/₈)

Inscribed by the artist, upper right, in black chalk, *53;* lower left, in black chalk, *Muerte de / Anton Requena;* verso, imprint of following sheet in album (H 54)

Provenance: Probably bought in Madrid by John Savile Lumley, 1st Baron Savile of Rufford (Secretary to British legation in Madrid, February 1858–April 1860); Rufford Abbey (Nottinghamshire), John Savile, 2nd Baron Savile; purchased from P. & D. Colnaghi, London, 1923, through H. P. Rossiter

Literature: Lopez-Rey 1956, 140; van Hasselt 1957, 88; Popham and Fenwick, 1965, no. 308; Fenwick 1966, 22; Gassier 1973, 2:622 (repr.), 645, no. 466 (H 53)

Exhibitions: New York 1950, no. 72; Bordeaux 1951, no. 8; Winnipeg 1955, no. 27; London 1963–1964, no. 199; Kingston 1965, no.12; Boston 1974–1975, no. 261, pl. 216

Acc. no. 2998

All the drawings from Francisco Goya's late sketchbooks have been published and discussed sheet by sheet in detail, and so it is probably impossible to say anything new about them. The present drawing, however, because it bears an inscription suggesting a specific historic event, has continued to tantalize scholars. It is unique among the drawings in the sketchbooks, which contain numerous depictions of pathological brutality, in having the name of the victim, Anton Requena, inscribed on it. However, no research to date has revealed his identity.

Gassier confessed bemusement, and described the victim as "apparently asleep with his head cradled in his arms, which rest on what looks like a big sculptured rock."[1] In studying the drawing of the man's torso carefully, we observe that his right arm, at least, is missing. If it were dangling, we would see it; if it were supporting the head, we would see less of the man's profile and more of his

Muerte &
Anton Requena.

shoulder and upper arm. The artist has carefully delineated the upper edge of the victim's right shoulder and the circular top of the mass (rock?) that supports him. These two contours almost meet, but their juncture is interrupted by an outburst of jagged scribbles. Where the arm would naturally be, there is only evidence of violence. And what is the shapeless lump on which he rests his head? Is it his left arm? If so, where is his hand?

The form that supports him is equally ambiguous. Since the scene is clearly an interior (with a faint face peering around the door), what is a "rock" doing there? One tries in vain to distinguish huddled figures in this strange mass. Why also is Anton Requena not protesting, but rather seems to smile in his sleep? It seems unlikely that he was caught napping in such a position. Is he already dead, or perhaps moribund with the mad-eyed assassin administering the coup de grace?

Goya was obsessed periodically by terrible images of bodies with hacked off limbs (one tries to forget some of the images in *Los Desastres de la Guerra*). He treated the subject in another sheet from the late albums, which shows the body of a man suspended in a sack hung from a hook on a city wall. Goya's inscription tells us that this unnamed person was discovered thus, with his hands or arms hacked off, one day in Saragossa "a principio de 1700,"[2] thus well before Goya was born. The sheer grotesqueness of the story must have haunted the artist who, as he often did in the late album sheets, plucked the incident from memory and drew it. The same could be true of the story of Anton Requena.

MC

1. Gassier 1973, 2: 645.
2. Gassier 1973, 2: no. G 16.

61

*The Death of Montcalm*, c. 1783

**Attributed to
François-Louis-Joseph Watteau**
Valenciennes 1758–1823 Lille

Brush and brown and gray wash over black and red chalk, heightened with white, on laid paper

436 x 596 (17³/₁₆ x 23¹/₂)

Provenance: L. G. Duke; Spink and Son, London; gift of W. A. Mather, Montreal, 1953

Literature: Popham and Fenwick 1965, no. 228

Exhibition: Hamilton 1982

Acc. no. 6172

The attribution of this drawing comes from Juste Chevillet's (1729–after 1802) engraving (fig. 1), whose publication was announced in the *Journal de Paris* of 3 July 1783.[1] Because of the inscription *Vateau delineavit* below the framing line on the print, the work was traditionally given to Louis-Joseph Watteau (1731–1789),[2]

Fig. 1. Juste Chevillet, after François–Louis-Joseph Watteau, *The Death of Montcalm*, National Archives of Canada, Ottawa, C-4263

nephew of the great Antoine and a Lille artist who dealt with military subjects and genre scenes and perpetuated the vogue for *fêtes galantes*. This sheet should instead be attributed to his son François-Louis-Joseph,[3] who in 1783 was still in Paris, having studied with Louis-Jacques Durameau (1733–1796) at the Ecole des Elèves protégés. The drawing, which presents several awkward passages in the disposition of the groups and in the treatment of the anatomy, seems to be the work of a young artist active in the movement to revive history painting. The decoration of the Chapelle Royale in the Ecole militaire (1773–1774), and the Comte d'Angiviller's commissions from various academicians of works on the theme of the history of France (1775),[4] brought back into favor subjects inspired by modern history. The neoclassical esthetic, which celebrated ancient heroes who could also serve as models of conduct, also searched out contemporary equivalents. The death of the Marquis Louis-Joseph de Montcalm (born in 1712) on 13 September 1759 was taken as an ex-ample of patriotic virtue. France could make the best of the defeat of Quebec by the fact that its commander gave his life on the field of battle.[5]

Although the event had occurred relatively recently, the depiction of it in the drawing had little in common with historical reality, as Père Martin noted in 1867: "The last moments of Montcalm did not occur on the battlefield, and one would not see in Canada a palmtree shading his head."[6] The artist not only imagined the place, but also invented the scene. The English army, commanded by General Wolfe (see cat. 76), succeeded in mounting an assault on the heights of Quebec and met the French troops on the Plains of Abraham outside of the city walls. During the operations, Montcalm was mortally wounded and taken to Quebec to the house of Arnoux, surgeon-major of the French army, where he died. He was buried in the Chapel of the Ursulines the next day.[7] The lower right part of the composition, where two men remove a cannonball from a hole, alludes to a cruel irony of fate, reported by M. de Foligné, a witness, who noted that Montcalm was interred in a trench dug by an English bomb.[8]

The military uniforms in Watteau's design are also very different from those worn in actual battle. For example, there were no lapels on the uniforms of cavalry officers serving in Quebec.[9] The clothes depicted include changes authorized in the French army at the end of the 1760s and during the 1770s, such as the wearing of cockades and epaulettes. If it is unusual that the job of flagbearer has been given to a dragoon, the artist correctly notes that the regiments were often accompanied by a black musician (the turbaned face between the two soldiers nearest the tent opening) in oriental dress.

The dark wash suits the gravity of the scene, while complimenting it. It suggests the tragic tone with which the artist wished to charge this moment, which is rendered in an idealized manner where myth gives way to reality.

LL

dynamism seen in the Ottawa drawing, Girodet ultimately opted for frozen motion, seconded by large, flat surfaces, and a friezelike grouping.

WMCAJ

1. Musée du Louvre, Paris, inv. no. 4935.
2. Musée national du château de Rueil-Malmaison (Paris 1974–1975, 455–457, no. 80).
3. Musée du Louvre, Paris, inv. no. 4934.
4. Musée national du château de Versailles, inv. no. MV 1549.
5. Musée national du château de Versailles, inv. no. MV 1497.
6. Musée du Louvre, Paris, inv. no. 4958.
7. The passage is both inexact and incomplete when compared with that from the novel: ''J'ai passé comme une fleur; j'ai séché comme l'herbe des champs. Pourquoi la lumière a-t-elle été donné à un miserable, et la vie à ceux qui sont dans l'amertume du coeur?'' These words, moreover, were merely sung to a traditional air by Father Aubry and have no inscriptional context whatsoever.
8. ''Navré de douleur, je promis à Atala d'embrasser un jour la religion chrétienne. A ce spectacle, le Solitaire se levant d'un air inspiré, et étendant les bras vers la voûte de la grotte; 'Il est temps, s'écria-t-il, il est temps d'appeler Dieu ici!' ''

## 63

## *Augustus, Octavia, and Livia Listening to Virgil Reading from the Aeneid (Tu Marcellus Eris)*

**Jean-Auguste-Dominique Ingres**
Montauban 1780–1867 Paris

Graphite, squared for transfer, on two pieces of laid paper joined horizontally, laid down on card

398 x 321 (15⅝ x 12⅝)

Provenance: Sale, J.-A.-D. Ingres (Lugt 1477, with *Ing* in graphite and *Rig* in pen and black ink); Emile Joseph Rignault, Paris (Lugt 2218); Jaccottet; purchased from Fritz Nathan, Zurich, 1972

Exhibition: Louisville 1983–1984, 53, 244, no. C100, fig. 4

Acc. no. 17134

This sheet alludes to Virgil's prophetic vision of the Roman people in the *Aeneid*, at the very moment his recitation goes wrong in the presence of Augustus' third wife, Livia Drusilla, and his sister Octavia, and the emperor is obliged to suspend the reading. Octavia has just swooned on hearing the lines ''Heu, miserande puer! si qua fata aspera rumpas, / Tu Marcellus eris'' (6. 882–883), at which she is reminded of the deceased Marcellus, universally regretted son by her first marriage, who would otherwise have succeeded to the empire at the death of Augustus.[1] The nuanced emotions of the three principals at this moment gave rise to a scene to which Ingres often returned during the period 1810–1822, which occupied him in one way or another until his death, and for which over ninety preparatory drawings exist. This graphite study on the joined paper Ingres often used is from his death sale in 1867. Despite its fragmentary quality, it is, like the Ottawa Girodet (see cat. 62), pivotal in the development of its characters' types and psychology, even though its suggestions were ultimately rejected.

The *Tu Marcellus Eris* is one of the best examples of Ingres' search for ''amplified'' and ''abbreviated'' variants of the same action, beginning with the Brussels

Fig. 1. Anne-Louis Girodet de Roucy Trioson, *The Entombment of Atala*, Musée du Louvre, Paris (Cliché des Musées Nationaux)

structural lines somehow manage to dominate the incidental ones. Such a drawing is notoriously difficult to read because the draftsman is feeling his way through the composition, yet the *under-drawing* reveals a major shift away from the left of the sheet: there is a Father Aubry in graphite behind the present Chactas, although the dense all-over network of ink effectively obscures any other figures, were they ever present or developed to any degree. (Both infrared reflectography and infrared photography hardly penetrated the surface and only slightly enhanced the underdrawing, which, as a result, cannot be readily separated for individual study or analysis.) In the end, such changes may reveal a different choice of *episode,* not a stylistic variant.

The story is this. As recounted in 1725 by the aged Chactas to the Frenchman René (known from other Chateaubriand works), Atala died in Father Aubry's mountain grotto about 1669, having poisoned herself at eighteen as a result of a type of misunderstanding that is the stuff of novels. Two years earlier, Atala's

mother obtained on her deathbed from her daughter a *simple* vow of chastity (respected to the end, despite her love for Chactas), from which Atala could have been released by the bishop of Quebec, had she only known the procedure. As her end approached, Chactas recalled: ''Broken-hearted, I promised Atala one day to embrace the Christian religion. At this spectacle, the Hermit, rising with an inspired air and extending his arms towards the vault of the grotto: 'It is time, he cried, it is time to call God here.' ''[8] At which, Chactas fell on his knees before the expiring Atala.

These circumstances could be why the Ottawa drawing shows Father Aubry, cowl drawn back, exhorting Chactas, identifiable by his loincloth and plumes as he bends toward or over Atala. They could, as well, be why Girodet reworked, and thus layered, his forms and motifs in a search for expressive contrast: Chactas and Atala each have two heads, his supplementary head being located in his chest, hers presenting both profile and three-quarter solutions—the latter remarkably like the Louvre picture, al-

though her corpse is not yet wrapped in the shroud of ''European linen'' that symbolizes her Christian heritage on her father's side. The figures of the drawing are seen in their entirety, with Father Aubry having alternate sets of arms, as does Atala, whose left shoulder is supported by the missionary. Given the superimposition and bonding of the ink, viewers may decide their own preference for the solution envisaged by the artist. Yet the concentration of reprises in the upper right quadrant—notably in the faces and gestures—shows the evolution of the concept through an astonishing exercise in pure (formal) drawing, where rapid readjustments preserve lines even when they differ in function. Although the left margin of the sheet has been reduced, little of significance is presumed missing.

What is clear is that Girodet constantly pared down his accessories and his emotions, simplifying his forms and putting psychological distance into his canvas, the better to personify the very different worlds incarnated by the two male figures whose spiritual convergence is Atala's inert figure. From the spatial

through a succession of closely related figural and compositional drawings, but it is equally instructive to consider it through the disparate or "rejected" solutions inherent in free studies such as this, where shifts in conceptual emphasis and refinements of form are more striking since niggling details are absent. Based on Chateaubriand's novel *Atala, ou les amours de deux sauvages dans le désert* (1801), the Ottawa drawing and the Louvre canvas present very different ambiences, from the emotionally charged to one of contained grief. Neither can be

said to illustrate the text as much as to evoke it—unlike Claude Gatherot's canvas of the *Convoi d'Atala* (Salon of 1802, no. 109)—so the changes inherent in this shift of focus are more of degree than of kind. They depend largely upon what actions are considered appropriate to the "surviving principals": Chactas, the Natchez Indian and lover of Atala, and Father Aubry, the aged missionary of New France.

In the painting, the entombment is well along (the artifice of the hidden legs being much remarked at the Salon). Light

streams in to illuminate the figures, incidentally bringing into relief the inscription from Job graven into the rock: *J'ai passé comme la fleur / J'ai seché comme l'herbe des champs* (I faded like a flower / I dried like the grass of the fields).[7] The landscape without is dominated by a large cross, thereby situating Atala's burial under the natural rock bridge near the Groves of Death, or Indian Cemetery, and the Stream of Peace. The drawing, however, is a series of constantly reprised slashes of iron gall over graphite, resulting in heavy ink deposits whose

1.  Inventaire–XVIIIe, 4:353. There were at least two editions of Chevillet's print at the end of the eighteenth century, a sign of its popularity. In the distance, the engraver added Benjamin West's composition of *The Death of Wolfe*, which itself had achieved fame as an engraving (see cat. 76, fig. 1). Watteau's composition was also engraved by Johan Lorenz Rugendas (1775–1826) in mezzotint and by Pietro Antonio Martini (1739–1797). Chevillet also engraved other portraits of American soldiers and politicians, including Benjamin Franklin, George Washington, and Nathaniel Greene.

2.  This attribution appeared in Spendlove 1958, 82, and was repeated in Popham and Fenwick 1965, no. 228.

3.  François-Louis-Joseph Watteau painted a *Death of Socrates* in 1780, which was exhibited at the Salon of Lille. His talent seems to have manifested itself quite precociously, as witnessed by both his winning the medal of honor at the Academy of Lille in 1774 and the engraving published by the Campion brothers representing the painter Simon-Mathurin Lantara and identified "Drawn from Nature by Vateau[sic] junior, 1776" (Bibliothèque Nationale, Paris, Cabinet des estampes, AA3 bound supplement). On this still little-known artist, see Ettesvold 1980, 62–66. Poncheville 1928, 65–66, notes another son of Louis-Joseph Watteau, Martin-Raphaël, who was a drawing instructor at the Ecole des Ponts et Chaussées in Paris; however, his production is even less well documented than that of François-Louis-Joseph.

4.  On this subject, see the still useful Locquin 1912, 276–286, and Frederick J. Cummings, "Painting Under Louis XVI 1774–1789" in Paris 1974–1975, 31–43.

5.  The theme of sacrificing one's life associated with the honors of the funeral bier was studied by Rosenblum 1974, 28.

6.  Martin 1867, 219.

7.  Casgrain 1903, 34–35.

8.  "At eight o'clock in the evening [14 September] in the Ursuline church was buried in a pit made by the action of a bomb, the Marquis de Montcalm who had died at four o'clock in the morning" (M. de Foligné, *Journal mémoratif de ce qui s'est passé de plus remarquable pendant qu'a duré le siège de la ville de Québec*, Archives de la Marine, France, quoted in Doughty 1901, 4:207). This incident was particularly intriguing in the account of his death. The caption at the bottom of Chevillet's engraving also states: ". . . and buried by his own order in a hole dug by a bomb." The announcement that appeared in the *Journal de Paris* at the time of the publication of Chevillet's print gave more details: ". . . it shows Montcalm dying of his wounds in the arms of M. de Montreuil, maréchal de camp and his friend, and indicating the place where he wants to be buried: in a ditch made in the earth by an exploded bomb, from which two savages extract shell fragments. Further away, [the bodies of] M<sup>rs</sup> de Senzergne and Defontbonne, general officers who commanded both flanks of the French army, are carried away on a single stretcher" (no. 184, 3 July 1783, 767).

9.  The regimental uniforms used in New France under the command of Montcalm are reproduced in Robitaille 1936, 87.

## Anne-Louis de Roucy-Trioson, called Girodet

Montargis 1767–1824 Paris

## 62

## *Atala au Tombeau,* c. 1806–1807

Pen and brown (iron gall) ink over graphite on laid paper

328 x 425 (12⅞ x 16⅝)

Watermark: Center, profile in crescent moon (similar to Briquet 5327–5338 and Eineder 420)

Inscribed in an unknown hand, lower right, in graphite, *Girodet* / (?) *de* (?) *Atala* / (?) *40*

Provenance: Purchased from Galerie du Fleuve, Paris, 1973

Literature: Lochnan 1980, 25 (repr.)

Exhibition: Washington 1975–1977, no. 266

Acc. no. 17288

Girodet has emerged over the years as a pivotal and perhaps the most interesting painter in early nineteenth-century France as a result of his varied output, his ability to synthesize historical and literary themes, and the high quality of his portraits. Having entered the studio of Jacques-Louis David in 1784, he won the Prix de Rome in 1789 and went to Italy for the next five years, first attracting attention with *Endimion. Effet de lune* (Salon of 1793, no. 296).[1] As did most younger artists trained under the *ancien régime,* he successfully made the transition through the revolutionary, Napoleonic, and Restoration epochs, putting out in rapid succession such contradictory works as *Ossian Receiving Napoleonic Officers* (Salon of 1802, no. 907),[2] *Scene of the Deluge* (Salon of 1806, no. 223, re-exhibited Salon of 1814, no. 436),[3] *Napoleon Receiving the Keys of Vienna* (Salon of 1808, no. 257),[4] and *The Revolt at Cairo* (Salon of 1810, no. 369).[5] Despite the political insecurity of Napoleon's Hundred Days, which disrupted the Salon of 1814 and caused many artists to show only known works, Girodet put on a personal retrospective of no less than fifteen paintings, including the *Atala au tombeau* (Salons of 1808, no. 437, and 1814, no. 258; fig. 1)[6] that relates to the Ottawa drawing.

It is usual to trace a painting's gestation

Fig. 1. Jean-Auguste-Dominique Ingres, *Auguste écoutant la lecture de l'Eneide,* Musées Royaux des Beaux-Arts de Belgique, Brussels (Copyright A.C.L. Brussels)

Fig. 2. Charles-Simon Pradier, after Jean-Auguste-Dominique Ingres, *Tu Marcellus Eris,* Bibliothèque Nationale, Paris

(fig. 1) and Toulouse canvases,[2] and ending with the Pradier engraving. Many of the studies of c. 1812 in the Fogg Art Museum, Harvard University, share the same "intimate" family grouping as the Ottawa study, although in time Livia becomes progressively estranged, in spite of the insertion of scenic and iconographic detail.[3] Ingres' interest in primitive and archaic styles derived from the study of classical vase painting and Italian quattrocento works, and the Ottawa sheet is consonant with this since the figures depend upon the quality of their contours and their strong patterning: in general, Augustus remains in full profile, with his arm up in earlier examples, and outstretched as Ingres proceeds toward the so-called definitive composition engraved by Pradier (fig. 2). It must also be noted that while Pradier's engraving is dated 1832, it or a close approximation was already publicly exhibited nearly a

decade earlier (Salon du Louvre 1824, no. 2044).

In the Ottawa drawing, emphasis is placed upon the relationship between the two women: Livia bends over Octavia's inert form rather than settling impassively back into her chair, as she finally does. Her "change of attitude" could be due to any of three factors, taken singly or in combination: the adoption of a more classical mode and setting; a greater reliance upon classical statuary and its neoclassical adaptations;[4] or an acceptance of the story that Livia had some hand in Marcellus' untimely death.

The drawing is, in any case, comparable to those of Ingres' early period in its delicacy and exceptionally fine pencil work. Agnes Mongan suggested in passing that the Ottawa sheet may have been strengthened by Ingres himself prior to his death;[5] and, indeed, microscopic examination indicates that some accents

may have been added later, such as the left leg of Augustus and the junction of his leg and heel. What ultimately distinguishes this stage of composition is Octavia's outstretched arm over *both* of Augustus' legs, rather than her body cradled *between* them.

WMCAJ

1. The passage begins with an evocation of Marcellus in the Elysian Fields, surrounded with the acclamations and trappings of glory he would have had, had he escaped his fate.
2. Musées Royaux de Belgique, Brussels; Musée des Augustins, Toulouse, inv. no. 124.
3. Mainly as concerns the statue of the deified Marcellus and the figures of Agrippa and Maecenus at far right. The best summary to date of the issues is in Louisville 1983–1984, 28–30, 52–59, and 160–166.
4. Cambridge 1967, nos. 20–21, both of 1812.
5. Cited in a letter of 18 September 1974 (National Gallery of Canada, curatorial file).

## 64

## Study for the Head of "The Virgin with The Host," 1863

**Jean-Auguste-Dominique Ingres**

Montauban 1780–1867 Paris

Graphite, heightened with white chalk, on tracing paper (one main sheet with three smaller strips added top and right), mounted on wove paper

478 x 374 (18¹³/₁₆ x 14¾)

Inscribed by the artist, lower left, in graphite, *Ingres / delineavit / 1863;* on veil, in graphite, *ombre;* on neck, in graphite, *grand clair;* lower left on mount, in graphite, *J. Ingres in^(it) et Del^(vit) / 1863;* lower right on mount, *Meung 6 Octobre*

Provenance: Purchased from Edouard Jonas, Paris, 1952

Literature: Popham and Fenwick 1965, 166, no. 238

Exhibitions: Montreal 1953, no. 183 (repr.); Winnipeg 1954, no. 14; Bloomington 1968, no. 67 (repr.); Florence 1969, no. 38; London 1969, no. 49; Paris 1969–1970, no. 48; Louisville 1983–1984, 207, 245, no. C118, fig. 56

Acc. no. 6144

It was remarked in Ingres' time that he was an "Aristarchus of his works," constantly destroying and restructuring his paintings in the full confidence he could do better.[1] His oeuvre is, therefore, limited to a number of favorite themes repeated throughout his long life and known through myriads of preparations and variants, which in any other context would be thought to have a primarily documentary interest. A given concept may often be found with great differences in format and accessories, however, making Ingres the average art historian's dream, since a line of thought can be followed through to exhaustion. Such is the case of the *Virgin with The Host,* first reduced from and then developed independently of the *Vow of Louis XIII,* shown at the Salon du Louvre (1824, no. 922) and itself constructed over a period of years.[2] The works to which the Ottawa drawing relates accordingly begin with an oval reduction done for the Comte de Pastoret in the 1820s.[3]

By 1841, when Ingres was director of

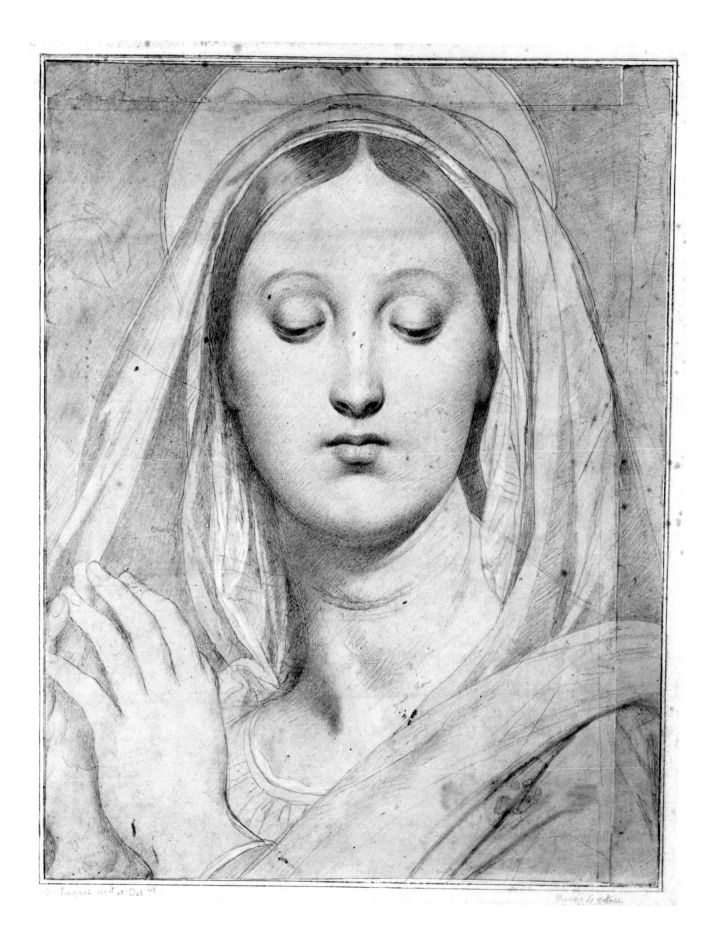

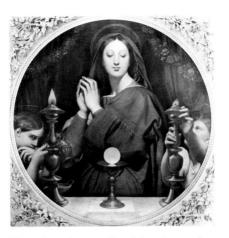

Fig. 1. Jean-Auguste-Dominique Ingres, *La vierge à l'hostie* (The Virgin with The Host), Musée du Louvre, Paris (Cliché des Musées Nationaux)

the French school in Rome, a new focus—The Holy Sacrament, usually with two subsidiary figures in a variety of formats—comes into play, culminating in the great Louvre tondo of 1854 (fig. 1). While this drawing is closest in time to the Louvre tondo, its accessories and details derive more from the Pastoret type, despite the inclusion of a halo: the clasped hands with *rounded* finger articulations, the scoop-neck robe.[4] The head at Ottawa is significantly younger, certainly less moon-faced than the Louvre piece, and the pouty lips are very much reduced in proportion to the nose, as is the fuller lower lip. Further interpretation of the drawing largely rests upon whether the Virgin's downcast eyes, with barely perceptible pupils, are thought to show abstract contemplation or can be presumed to have some focus outside the composition, now reduced to a dramatic close-up. All things considered, such modifications seem consistent with Ingres' autonomous drawing. The late date of the Ottawa sheet (only four years before his death) and the patched tracing paper used as a support seem further to indicate study for study's sake.

It may be remarked that the graphite notations of the Ottawa sheet—"ombre" just above the hands, and "grand clair" at the neck—refer to value, not color.[5] From the trouble taken to extend the paper support—one large rectangle supplemented by three strips along top and right—it is evident that the act of creation (or re-creation) ultimately conditioned

the format, not the reverse. By the 1840s, Ingres commonly employed tracings to adapt ideas dissimilar in scale, shape, and color, and to make figural groupings through the suppression of internal modeling and the refinement and accentuation of contours.[6] This is less easily done through the use of normal (opaque) papers; the join lines and the uneven surface of this sheet (even its irregularly shiny and mottled appearance, perhaps accentuated by varnish), are quite peripheral to Ingres' concentration on the geometric perfection of the Virgin's face. True, the patching process permits the extension of the garment and halo, which is much smaller than in the Louvre tondo, while drastically modifying the proportions and balance of the composition as a whole.

The four pieces were apparently laid down before the drawing was completed, since the graphite strokes flow continuously from the main sheet onto the additions. (Despite the original heavy border lines, some strokes at bottom and top extend even onto the secondary mounting support.) This work's concern with formal perfection reveals, beyond Ingres' abiding love of Raphael, a trait common to many older artists. It also shows great freedom of means. Few are the draftsmen who could execute such fine diagonal shading lines running in the same direction to define not only the facial contours and distinctions between the jaw and neck, but the subtleties of their fleshy parts as well.

WMCAJ

1. As Amaury-Duval in 1878, cited in Louisville 1983–1984, 11.
2. Louisville 1983–1984, 10.
3. Louisville 1983–1984, 134–137.
4. Louisville 1983–1984, 205–207, nos. 54–56.
5. Although fewer in number, these are similar to the detailed indications used in the engraving of Ingres' major paintings, such as the Calamatta proof states for the *Vow of Louis XIII* (Paris, B.N. Est., AA5 rés.).
6. Best characterized as a working procedure in Louisville 1983–1984, 14–16.

65

*A Man Dragged by Demons, Chased by Furies,* c. 1818

**Théodore Géricault**
Rouen 1791–1824 Paris

Pen and brown (iron gall) ink on beige laid paper

142 x 220 (5⁹/₁₆ x 8⁵/₈)

Provenance: E. D. (not identified, Lugt 841 and Lugt suppl. 841);[1] Pierre Dubaut, Paris (Lugt suppl. 2103 b.); Hazlitt, Gooden & Fox, London, 1978; purchased from Hazlitt, Gooden & Fox, London, 1979[2]

Literature: Eitner 1983, 145–147, pl. 128; New York 1985, 67, pl. 21a; Eitner 1986, 56

Exhibition: London 1978, no. 11, pl. 10

Acc. no. 23217

Viewed as the father of the French romantic movement, Théodore Géricault lived his short life with the same passion and vigor that underlie his powerful artistic statements.

Since his wealthy father disapproved of his desire to become a painter, it was with the encouragement of his uncle and aunt Jean-Baptiste and Alexandrine-Modeste Caruel that Géricault realized

Fig. 1. John Flaxman, ''Look, look! Distractions in the sight: I fly, I fly, Choephoroe,'' plate 27 from *Aeschylus*, 1795, The E. P. Taylor Reference Library, Art Gallery of Ontario, Toronto

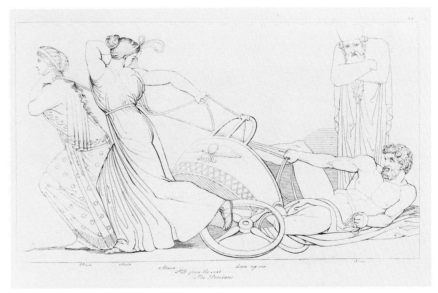

Fig. 2. John Flaxman, ''Atossa . . . down my son. Fell from the seat,'' plate 34 from *Aeschylus*, 1795, The E. P. Taylor Reference Library, Art Gallery of Ontario, Toronto

his ambition. After studying under the protoromantic painter Carle Vernet (1758–1835), Géricault entered the school of Pierre-Narcisse Guérin (1774–1833) and was immersed in Davidian neoclassicism before leaving to follow his romantic inclinations. After a period of intense activity during which he laid the foundations of his romantic style, he returned in 1814–1816 to neoclassical subjects and made small figural and compositional sketches based on the Outline engravings of John Flaxman (1755–1826).[3]

In 1815, Géricault fell in love with his aunt Alexandrine-Modeste Caruel, who was only six years his senior. Despite his attempts to seek escape through separation and travel in Italy in 1816–1817, he resumed the obsessive relationship upon his return, and in November 1817 a child was conceived. During the spring of 1818, Géricault lived in the knowledge that his guilty secret would soon be exposed, bringing disgrace on the entire family.

It was in this period that the Ottawa drawing appears to have been made. Géricault's affair and his trip to Italy inspired a number of sepia drawings on violent or erotic classical themes. Lorenz Eitner, who dated this sheet c. 1818, iden-

tified it as one of a group of nine allegorical drawings that, while unrelated to a project for a painting, have certain features in common. These include "the reference to force, to vice, voluptuousness and folly; the recurrence of demons and furies or Erinnyes; and the central figure of a male victim, assailed by vices, demons and avenging furies." Eitner believed that "all these compositions have reference to Géricault's ill-starred love affair."[4]

In the Ottawa drawing a nude man is dragged along the ground by demons, who are in turn driven by Furies. The fearful Greek goddesses could destroy men's peace of mind, lead them into misery and misfortune, and inflict vengeance through the secret stings of conscience. The remorseless pursuit of the Fury who brandishes a flaming torch in one hand and a serpent scourge in the other contrasts starkly with the passive anguish of the tortured figure of the man, who, hopelessly outnumbered, is totally incapable of resistance. Drawn by fate into a situation from which there was no escape, a victim of a tragic passion in a society whose moral and legal code he had violated, Géricault must have identified fully with his subject.

The style of the sheet combines elements of neoclassicism and romanticism. The friezelike disposition of the figures and the bulging contour lines barely contain the romantic energy. After his return from Italy, Géricault was under the influence of Michelangelo. Eitner described his drawing style at this juncture as "Flaxman driven mad by Michelangelo,"[5] and indeed the distinctive horizontal hatching clearly betrays the influence of John Flaxman. Telling parallels exist between this sheet and a number of Flaxman's *Aeschylus* engravings of 1795 in which Orestes is pursued by Furies brandishing torches and serpent scourges (fig. 1) and Xerxes is dragged along the ground behind his chariot (fig. 2).[6]

While awaiting the *dénouement*, Géricault threw himself into making studies for *The Raft of the Medusa*, and in fact the composition of this sheet may anticipate the surging mass of figures on the raft. When the personal storm finally broke, Géricault went into self-imposed exile, living in his studio surrounded by putrifying human flesh, and painted the work which was destined to transform the history of Western art.

K L

1. Lorenz Eitner suggested that the unidentified collector's mark is that of Eugène Déveria (1805–1865), letter from Eitner to Mrs. Stefanie Maison, 22 February 1978 (National Gallery of Canada, curatorial file).
2. Although the drawing entered the collection of the National Gallery of Canada in 1979, it was published by Eitner 1983 as "Lately" (1978) with Hazlitt, Gooden & Fox, London, under the title "Allegorical Subject," c. 1818, and by Grunchec 1985 as in a "private collection."
3. These are found in the Zoubaloff sketchbook in the Louvre, and are based on figures from Flaxman's *Iliad* and *Odyssey*. See Symmons 1984, 146–151.
4. Letter to Mrs. Stefanie Maison, 22 February 1978. The drawings Eitner proposed as part of this group have been itemized as follows: (1) simple allegories: (a) *La Force* (man bending a staff), P. Dubaut, (b) *La Force* (man bending a staff; a lion), formerly Christopher Powney; (2) more elaborate allegorical compositions: (c) *L'homme entrainé par la volupté et la folie*, formerly His de la Salle, now in Dijon, (d) *L'homme s'arrachant des bras du vice*, P. Dubaut; (3) dramatic scenes with allegorical overtones: (e) *Man Attacked by Furies, Spurned by a Woman*, pen tracing, Nathan Collection, Zurich, (f) *Man Attacked by Demons and Furies*, formerly Christopher Powney, (g) *Man Dragged by Demons, Followed by Furies*, formerly P. Dubaut (now National Gallery of Canada), (h) *Man Dragged at the End of a Chain*, formerly P. Dubaut (now Shepherd Gallery), (i) *Man Surrounded by Spirits, Spurs a Dagger; Demons and Furies Escape*, Rouen Museum.
5. Eitner 1983, 80.
6. Flaxman brought presentation copies of *Aeschylus* with him when he visited Paris in 1802, and in 1803 a French edition was published (Symmons 1984, 116–118). The plates which bear the closest parallels are pl. 27, "Look, look! Distractions in the sight: I fly, I fly, Choephoroe"; pl. 31, "When, mantled in these sable-shaded stoles . . . Furies"; and pl. 34, "Atossa . . . down my son. . . ."
Eitner proposed as a possible artistic source P. A. Hennequin's popular painting *Les remords d'Oreste*, which was shown at the Salon of 1800. (Eitner 1983, 146, pl. 129, 147). This work was exhibited in the Salon of 1814 under the title *Oreste poursuivi par les Furies*. Géricault would undoubtedly have known it since he exhibited in this Salon. I am grateful to Arnauld Brejon de Lavergnée, conservator, Musée des Beaux-Arts, Lille, for establishing the fact that the same painting was exhibited in both salons under different titles (letter to the author, 22 October 1987).

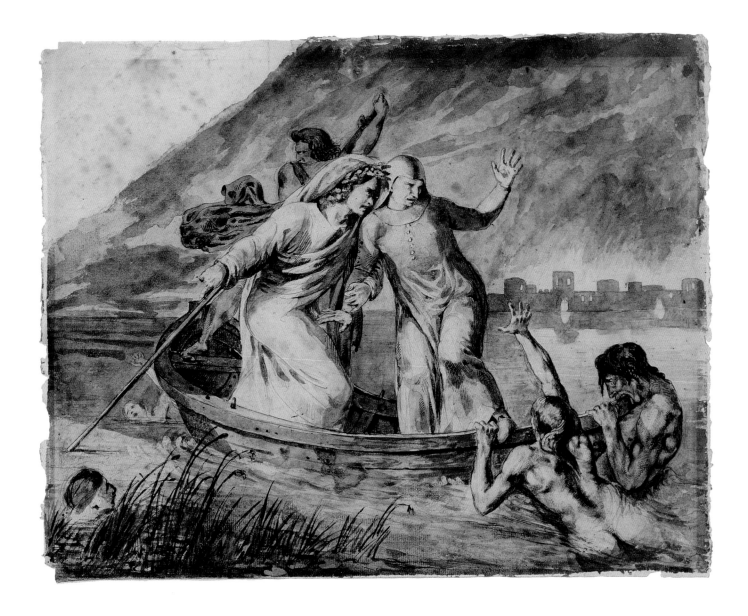

66

*La Barque de Dante*, c. 1820

**Ferdinand-Victor-Eugène Delacroix**

Charenton-Saint-Maurice 1798–1863 Paris

Pen and brown (iron gall) ink with brown wash and touches of gray wash over graphite on laid paper (loss at upper left corner)

310 x 396 (12³/₁₆ x 15⁹/₁₆)

Inscribed in an unknown hand, verso lower right, in graphite, *1095* (illegible) *53–48/53–48 cadeau 58–48*

Provenance: Jenny Le Guillou; André Schoeller, Paris, by 1930; Ruth L. Massey Tovell, Toronto, 1930; bequest of Ruth L. Massey Tovell, Toronto, 1961

Literature: Johnson 1958, 228, fig. 6; Jones 1963, 20, 22 (repr.); Fenwick 1964, 2 (repr.); Popham and Fenwick 1965, 169, no. 243 (repr.); Trapp 1971, 25, fig. 18; Schwager 1977, 321, fig. 41; Johnson 1981, no. 100

Exhibitions: Paris 1930, no. 236; Toronto 1962–1963, no. 26; Bordeaux 1963, no. 82; Berne 1963, no. 95; Bremen 1964, no. 92; Kingston 1965, no. 3; Ann Arbor 1965, no. 31; Toronto 1968, no. 51; London 1969, no. 50; Florence 1969, no. 47; Paris 1969–1970, no. 51

Acc. no. 9729

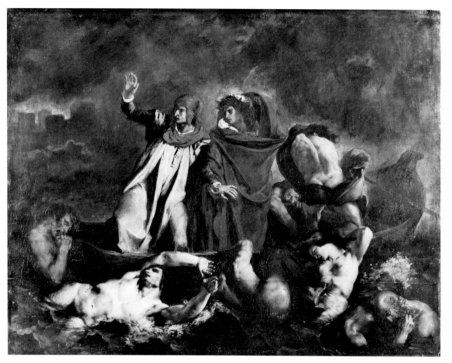

Fig. 1. Eugène Delacroix, *Barque de Dante,* 1822, Musée du Louvre, Paris (Cliché des Musées Nationaux)

Eugène Delacroix is regarded as the leader of the French romantic school, and the artistic heir of Théodore Géricault (see cat. 65) whom he met while a student at Pierre-Narcisse Guérin's (1774–1833) atelier in the autumn of 1817. Delacroix posed for one of the figures in Géricault's *The Raft of the Medusa* in 1818–1819, and was greatly influenced by observing the work in progress. In 1819, the year Géricault's painting achieved its spectacular success at the Salon du Louvre, Delacroix began to translate passages from Dante's *Inferno,* and to make sketches inspired by them.[1]

The passage that captured his imagination here is in Canto 3, and describes the infernal boatman Phlegyas ferrying Dante and Virgil across the stagnant swamp surrounding the walls of the flaming city of Dis. The temporal horrors of being lost or drowned at sea that haunted Géricault pale before the eternal horrors of the damned who are forced to inhabit a watery grave.

Lee Johnson believed that it was while staying with his sister in the Forêt de Boixe in Charente in September or early October 1820 that Delacroix made the Ottawa drawing.[2] During this visit he came down with a fever, and made a number of sheets recording "toutes les folles qui me passaient par la tête."[3] A year and a half later he recalled this occasion in a letter of 11 March 1822 to his sister when he described the subject of his first Salon painting, then in progress, as "celui dont je fis le dessin pendant ma fièvre à la forêt."[4]

In the course of conceiving the painting, entitled *Barque de Dante* (fig. 1), Delacroix made many sketches, at least forty of which were sold in the artist's posthumous sale.[5] The Ottawa sheet was not among them, but is believed to have been given by the artist to his housekeeper, Jenny Le Guillou, and was first exhibited in 1930.[6] Johnson considered this sheet important because no drawing of a comparable stage of development for the whole composition has come to light.[7] Having convincingly dated a

closely related double-sided sheet of sketches for the figures of Dante and Virgil (figs. 2 and 3) in the Louvre to c. 1820, Johnson assigned the Ottawa drawing to the same period.[8]

Despite the superficial similarities between the Ottawa drawing and the Salon painting of 1822, there are significant differences. The exaggerated theatrical gestures, the instability of the figures in the boat, and the shallow picture space found in the drawing are characteristic of the gothicizing style that would find full expression in Delacroix's *Faust* lithographs of 1828.[9] Working in private on paper, in a "minor" medium, the artist may have felt free to express artistic tendencies that when they finally made their public début, were regarded by many contemporary and later critics as signs of immaturity, ill health, poor working conditions, or an inability to draw.

Awkward though the style of the drawing may be, it could be argued that it is much more adventurous, and the result more sublime, than that of the Salon

Fig. 2. Eugène Delacroix, *Sketches for the Barque de Dante* (Album 9.151, fol. 41, recto), Musée du Louvre, Paris, Cabinet des Dessins, (Cliché des Musées Nationaux)

Fig. 3. Verso, fig. 2

painting. In the painting the destabilizing tendencies are removed, and the base of the pyramidal composition is reinforced through the application of a frieze of figures derived from Michelangelo, Peter Paul Rubens, and Géricault, calculated to please the Salon jury.[10] Attention is focused in the foreground, and the sea, which replaced Dante's marsh, is whipped into a baroque frenzy.

In style, this sheet owes a debt to Géricault's more ambitious pen and wash drawings on classical themes made in the period 1815–1817, to which Delacroix would have had access. The most immediate source for the composition may be found in the English artist John Flaxman's (1755–1826) Outline engraving to Canto 3 of *Dante's Inferno, The Barque of Charon* (fig. 4), which shows Dante and Virgil in Phlegyas' (Charon's) boat. The figure of Phlegyas in Delacroix's drawing more closely resembles the Phlegyas in the engraving than it does the Phlegyas in the Salon painting, which was modeled after a cast of the Belvedere Torso.[11]

Fig. 4. John Flaxman, ''Charon, dans sa barque, sur le bord de l'Achéron, passe les âmes sur l'autre rive,'' plate 3 from *Inferno*, 1807, The E. P. Taylor Reference Library, Art Gallery of Ontario, Toronto

The painting was a great success at the Salon of 1822, and established Delacroix's artistic reputation. It was acquired by the State and placed on exhibition in the Palais de Luxembourg.

KL

1. Johnson 1981, 77.
2. First published by Johnson in Toronto 1962–1963, 63, no. 26.
3. Delacroix 1950, 1:87.
4. Delacroix 1950, 1:87.
5. Johnson 1981, 77. These have not all been accounted for.
6. Letter to Dr. H. M. Tovell from André Schoeller, 10 November 1930 (National Gallery of Canada, curatorial file).
7. He has also pointed out the relationship between the Ottawa sheet and other studies made in the process of clarifying details. These include a drawing in the Louvre, also in sepia wash, for the infernal city of Dis that appears in the background of the Ottawa drawing, and which employs the device of window apertures to create visual interest (''Feuille d'Etudes pour la Barque de Dante,'' Louvre RF 9177; Paris 1963, no. 40, 24, repr.). The other most closely related sheet is a study from life of the figure biting the stern thought to be the Florentine Philip Argenti, which is now in the Metropolitan Museum of Art (''Etude de Damné pour la Barque de Dante,'' Rogers Fund, 61.230; Paris 1963, no. 31, 22).

8. Musée du Louvre RF 9151, fol. 41, recto; Johnson 1956, 23, figs. 31 and 32; Johnson 1981, 77.
9. In some respects, this drawing may be seen as an antecedent to the *Faust* plate *L'Ombre de Marguerite apparaissant à Faust* (Delteil, 3:72), in which Mephistopheles shows the vision of Margaret to Faust at the Witches' Sabbath. For a discussion of the ''Faust style,'' see Lochnan 1986, 6–13.
10. Johnson 1958, 232.
11. Johnson 1958, 232. Johnson also pointed out that the figure of the damned soul peering over the far side of the boat in the painting is taken from Flaxman's Outline illustrations to Dante's *Divine Comedy* of 1807, pl. 11. Johnson 1981, 76.

67

*Horace and Lydia, 1843*

**Thomas Couture**
Senlis 1815–1879 Villiers-le-Bel

Black chalk, heightened with white chalk, on gray-blue laid paper
Verso: *Hind Quarters of a Quadruped*
Black chalk
136 x 160 (5³/₈ x 6⁵/₁₆)
Inscribed by the artist, lower left, in black chalk, *T.C.*; in an unknown hand, verso center right, in graphite, *or et vert / t. / p.p.*
Provenance: Purchased from Galerie du Fleuve, Paris, 1974
Acc. no. 17910

*Horace and Lydia* demonstrates Thomas Couture's conception of drawing and painting as an art of elimination, achieved through strong dark outline and lighting that flattens figures and settings alike. Despite its diminutive scale, this drawing describes certain intermediary areas that remain less visible in the 1843 Wallace Collection canvas of the same subject (fig. 1).

Cat. 67, verso

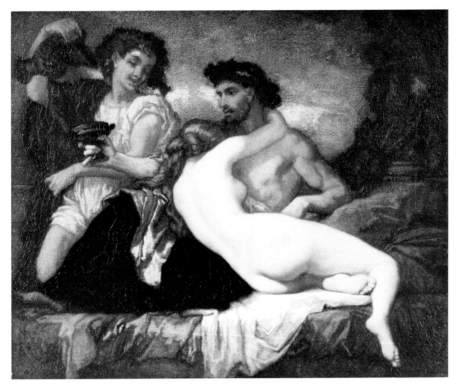

Fig. 1. Thomas Couture, *Horace and Lydia,* 1843, The Wallace Collection, London

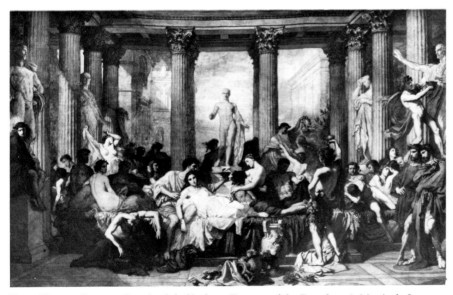

Fig. 2. Thomas Couture, *Romains de la décadence* (Romans of the Decadence), Musée du Louvre, Paris (Cliché des Musées Nationaux)

This subject is one of several from 1843 to 1847 that took the young Couture further and further away from current Netherlandish genres into Venetian subjects and style. According to Boime, the latter all deal with ''aspects of epicurean existence, bacchic festivals, languid sexuality and orgies of the senses.''[1] *Horace and Lydia* can be seen as an embryonic grouping that prepares the way for Couture's much-discussed signature piece, *Romans of the Decadence* (Salon du Louvre, 1847, no. 400; fig. 2).

The Ottawa sheet is typical of the closer focus and modest scale of Couture's early works. In its attempt to combine classical precepts and classical style as it was comprehended by the nineteenth century, Couture's work becomes emblematic. Its figures personify given traits or qualities that gain force and nuance from their interaction. The poet and satirist Horace (65–8 B.C.), favorite of the emperor Augustus and his minister Maecenas, appears in the throes of accidie—withdrawn and distracted, equally unresponsive to the blandishments of the servant pouring wine and of the courtesan Lydia.[2] He appears as the scholar caught between instinct and reason. The setting is not calculated to detract from the figures, either, with its vague atmosphere and minimal detailing, although the facial expressions are not as fully developed as in the Wallace Collection painting. Lydia's contours are here made fuller and purer in the absence of other means of indicating her qualities (her incorrectly drawn left shoulder is remedied in the painting).

W M c A J

1. Boime 1980, 124.
2. Horace's success in depicting social life and manner in the ancient world was furthered by his moralizing tendency and acute observation of character.

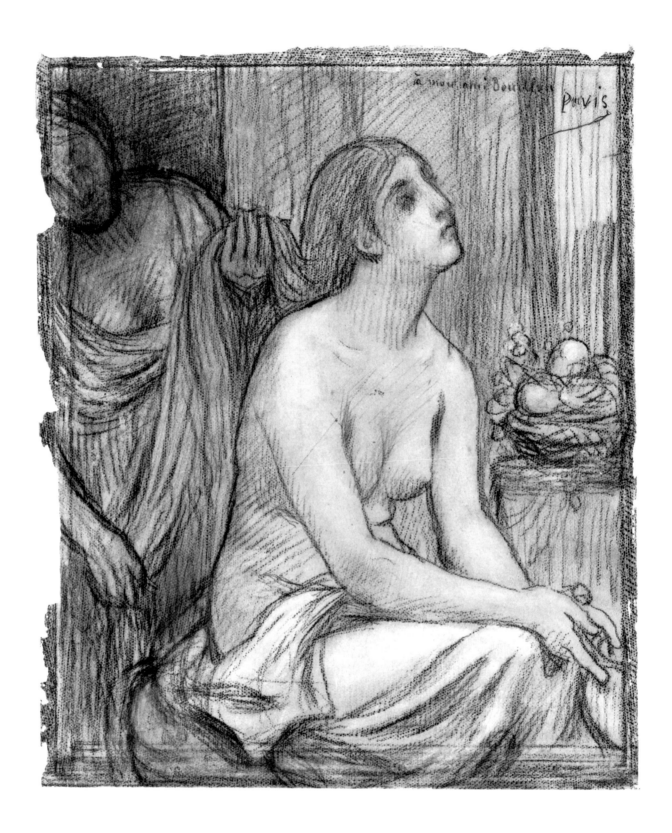

## 68

## *La Toilette*, c. 1883

**Pierre C. Puvis de Chavannes**
Lyon 1824–1898 Paris

Black chalk with stumping, heightened with white chalk, on tracing paper (lithographic transfer paper?), laid down on textured card

312 x 261 (12⅛ x 10⅛), irregular

Inscribed by the artist, upper right, in black chalk, *a mon ami Bouillon / Puvis*

Provenance: Jacques Dubourg, Paris; purchased from Margo Pollins Schab, New York, 1983

Literature: Ottawa 1976–1977, under no. 167

Acc. no. 28269

Toward the end of his life, Pierre Puvis de Chavannes allowed five of his earlier drawings to be published as photolithographs in the journal *L'Epreuve,*[1] including one entitled *La Toilette.* Douglas Druick discussed this print, and he and Marie-Claire Boucher explored the intricate interrelationships between a number of other drawings and paintings related to it by subject and composition in their section on "Woman at her Toilette" in the Puvis exhibition catalogue of 1977.[2] Druick posited the existence of the present drawing, whose location was then unknown, as a study for this lithograph, an assumption based on a photograph of the original drawing that he had found in the files of the documentation service of the department of paintings of the Louvre, and which agrees in all details with the lithograph. When the drawing came to light in New York in 1983, Druick recognized that it was, in fact, the lost sheet.

The drawing is closely related in its subject, that of a semi-nude woman having her long hair combed by a shadowy woman in the background, to two paintings. One of these is in the Musée d'Orsay in Paris (fig. 1), and one in the National Gallery, London (fig. 2).[3] The drawing is closer to the Paris painting in the inclusion of the bowl of fruit on the table and in the woman's seated pose and position of her hands, which hold, in

Fig. 1. Pierre C. Puvis de Chavannes, *Femme à sa toilette*, Musée d'Orsay, Paris (Cliché des Musées Nationaux)

the painting, flowers, and in the drawing, a mirror. It is closer to the London painting in the pose of the maid. The London painting was tentatively dated to 1877 by Martin Davies who quoted the Vachon Puvis catalogue of 1895 as stating that the painting was exhibited in the Salon du Louvre of 1877, but then noted that Puvis was not represented in this Salon.[4] Boucher dated the London painting to 1870 without, however, explaining the reason for this date.[5]

Fig. 2. Pierre C. Puvis de Chavannes, *The Hair Dressing*, The National Gallery, London

Fig. 3. Pierre C. Puvis de Chavannes, *Femme assise*, Musée du Petit Palais, Paris (Photograph: Bulloz)

Druick commented that the London painting, a small and intimate genre piece, was not appropriate for a Salon work. The Paris painting is signed and dated 1883, and Druick suggested that the drawing was probably done slightly earlier. It is possible, of course, that it is a record and not a preparatory sketch, but its spontaneity suggests otherwise. The existence of several other drawings of the seated woman in varying poses, all obviously in a general sense preparatory sketches for the Louvre painting and, like the present drawing showing the woman holding a mirror, suggests that the entire group was preparatory (fig. 3).[6]

MC

1. *L'Epreuve*, no. 4, pl. 1, March 1895.
2. Ottawa 1976–1977, 183–184. Druick treats the lithograph in no. 166; Boucher the paintings and drawings in nos. 165, 167, 168.
3. Ottawa 1976–1977, no. 165.
4. Davies and Gould 1970, 117, no. 3267.
5. Boucher 1979, 84.
6. These other drawings are: *Femme nue assise* and *Femme assise* in the Musée du Petit Palais, Paris (inv. nos. P.P.D. 269 and 285); two studies in the Musée Sainte-Croix de Poitiers (inv. no. 899.1.20) and the Musée de Picardie (inv. no. 912 bis 10); four compositional studies owned by the descendants of the artist including a watercolor now in a private collection in Paris and two studies that appear to relate to the London painting; and a study in the Musée des Beaux-Arts, Lyon (Gernsheim, no. 6046).

## 69

## *Hesiod and the Muse, 1858*

**Gustave Moreau**
Paris 1826–1898 Paris

Pen and brown ink with black chalk and brown wash, heightened with opaque white and watercolor, on heavy cream wove paper

376 × 290 (14¹³/₁₆ × 11⁷/₁₆)

Inscribed by the artist, lower left, in pen and brown ink, *GM* (in monogram) / *Gustave Moreau. Rome. 1858*

Provenance: Brame, Paris; A. Marmontel, Paris; Marmontel sale, Hôtel Drouot, Paris, 25–26 January 1883, lot 210;[1] Marmontel sale, Hôtel Drouot, Paris, 28–29 March 1898, lot 173; purchased from Stephen Higgons, Paris, 1966

Literature: Chesneau 1866; Laran and Deshairs 1913, 37–38; Osler 1968, 20–28; Boggs 1969, 155; Boggs 1971, no. 171; Mathieu 1972, 11:322; Hahlbrock 1976, 191 and pl. 91; Mathieu 1976, no. 42, 62, 64, 102, 301; Selz 1979, 6, 20, 27; Richardson 1979, no. 58; Kaplan 1982, 33, 36, 182–183; Mathieu 1984, 28–29, 74; Anonymous 1987, 40

Exhibitions: Paris 1866, no. 2430 (*Hésiode visité par la Muse*);[2] Toronto 1968, no. 56; Bloomington 1968, no. 76; Florence 1969, no. 58; London 1969, no. 55; Paris 1969–1970, no. 60; Philadelphia 1978–1979, no. vii–49; Zurich 1986, no. 10

Acc. no. 15213

Despite an academic training at the Ecole des Beaux-Arts (1846–1849) and some success in the 1850s with commissions and at the Salon du Louvre, Gustave Moreau devoted nearly two years in Italy (October 1857–September 1859) primarily to copying classical and Renaissance art. The only major original project to date from this period of self-imposed mature study is a series of drawings depicting Hesiod, the latest of which is this sheet.[3] The drawings reveal Moreau synthesizing a variety of influences. In their Greek subject, their planarity, and their relation to a Hellenistic relief of Endymion in the Capitoline Museum, Rome, they recall Moreau's training with the neoclassicist François Picot.[4] Such classical forms and influences have been given an inflection of mannerist elongated elegance, which has prompted comparisons to Bernardino Luini and the School of Fontainebleau.[5] The *sfumato* and androgynous treatment of Hesiod have reminded writers of Leonardo da Vinci, Antonio Correggio, and Pierre-Paul Prud'hon.[6] The theme reflects Moreau's intense admiration of Eugène Delacroix, who had depicted the subject of Hesiod and the Muse on a pendentive of the poetry cupola in the library of the Palais Bourbon, c. 1842.[7]

While retrospective in its sources, *Hesiod and the Muse* is one of Moreau's first treatments of a theme that was to become an obsession: the inspiration of the poet. He kept returning to Hesiod as a subject (the latest version dates from 1891) and pursued similar themes in his many depictions of Apollo and the Muses, Orpheus, or simply generic "poets."[8] Here he represents the Greek poet from Boeotia who, in the eighth century B.C., composed the *Theogony*, which recounts the genealogy of the Greek gods. Moreau's drawing was inspired by the beginning of Hesiod's poem:

The Muses once taught Hesiod to sing
Sweet songs, while he was shepherding his
  lambs
On holy Helicon . . .
So spoke the fresh-voiced daughters of great
  Zeus
And plucked and gave a staff to me, a shoot
Of blooming laurel, wonderful to see,
And breathed a sacred voice into my mouth
With which to celebrate the things to come
And things which were before.[9]

In Moreau's drawing, Hesiod is identified as a shepherd by his panpipes and Phrygian cap. In his left hand he holds the staff wrapped in laurel, while his "right forearm is raised and points in the direction of the Muse as though to signify recognition."[10] His closed eyes befit receptivity to divine visitation and the proximity of the Muse's fingers and head to his face conveys inspiration of the sacred voice into Hesiod's mouth. Soon the lyre on the Muse's hip will be used by Hesiod to celebrate the gods.[11]

At one level, Moreau's drawing is a positive and faithful illustration of Hesiod's poem.[12] Yet, by reducing Hesiod's nine muses to one, Moreau allowed the theme of inspiration to suggest an erotic encounter, prompting one writer to ask, "Is this muse really a temptress?" and another to see here a foreshadowing of Moreau's recurrent "thematic duality . . . [of] the aggressive woman-monster and the passive male."[13] Certainly Hesiod's androgyny and the possibility of reading his staff as phallic are unsettling and ambiguous notes, perhaps revealing Moreau's very ambivalent feelings about a paganism-woman-matter-nature nexus.

Whereas this 1858 drawing seems to celebrate the pagan poet and his muse, just before his death Moreau wrote regarding *The Dead Lyres* project: "The pagan poets and bards die from this embrace, this passionate communion with matter in forms that they themselves have created. . . . But the great lyre of the soul, the great voice with its cords vibrating with the true ideal of the divine has just silenced and annihilated all the voices of the senses, those voices that glorified nature."[14]

Among the "voices that glorified nature," one may assume that Moreau now included Hesiod's.

RJM

1. In the sale catalogue of the Marmontel Collection, Hôtel Drouot, Paris, 25–26 January 1883, this drawing appears with the illustration as no. 210 with the title *Le Génie de la musique inspirant le berger Paris*. Stephen Higgons acquired the drawing under this title (letter from Higgons to Pamela Osler, 2 February 1968, National Gallery of Canada, curatorial file). Osler 1968, however, advanced a strong argument for the *Hesiod and the Muse* title. Pierre-Louis Mathieu in a letter of 20 January 1970 to Osler (National Gallery of Canada, curatorial file) supported Osler, noting that in the archives of the Musée Gustave Moreau there is an autograph list by Moreau, "Catalogue des tableaux et dessins vendus de l'année 1850 à . . . ," wherein one finds, as no. 41, "Hésiode et la Muse (dessin) Brame, vendue à Marmontel 500F."
2. Such is the contention in Mathieu 1976, no. 42. His citation of Chesneau 1866, Paris 1866, and Laran and Deshairs 1913 follows from this opinion. Laran and Deshairs 1913, 37–38, cites Chesneau 1866 but reproduces (39) a different image (Mathieu 1976, no. 392—an oil mistakenly termed a watercolor by Laran and Deshairs) and cites a third version, "celle qui appartient à M. Taigny," as that likely exhibited at the 1866 Salon. Mathieu's case that Chesneau's comments best described the National Gallery of Canada's drawing is more persuasive. Chesneau wrote:

Hesiod receiving the chaste kiss of the Muse. Wearing a Phrygian cap from which his long flowing hair hangs loose, the young handsome shepherd listens with closed eyes, for intenser self-communion, to the inspired word uttered by the Muse who has descended from Olympus on her great wings, a wholly aerial figure suspended like a light cloud, brushing the poet's brow with her fingers and her fragrant breath. The drawing in bistre is heightened with white modelled by means of free, delicate hatchings setting off the contours and muscles. The paper ground, skilfully tinted, offers contrasts of values and tone which give this small drawing all the attraction and value of a painting. (As cited and translated in Mathieu 1976, 301.)

3. Osler 1968 reproduces the works and establishes a sequence for them.
4. Kaplan 1982, 33, connected the related 1857 *Hesiod and the Muse* drawing in the Seligman collection, New York, to the Endymion relief.
5. Richardson 1979, no. 58.
6. For Leonardo, see Richardson 1979, no. 58; for Correggio and Prud'hon, see Mathieu 1976, 62.
7. Philadelphia 1978–1979, 398.
8. For other Hesiod works, see, for example, Mathieu 1976, nos. 41, 98–99, 100–102, 192, 392; for Apollo and the Muses, no. 38; for Orpheus, nos. 71–77, 354, 358(?), 394; for the Muses, nos. 122, 127; for unnamed poets, nos. 103, 113, 290, 345, 346–348, 362–363, 383, 403–405a, 409, 414. One could add Arion (no. 393) and Sappho (nos. 1, 84, 104, 137, 138–141, 193–194, 294–297, 389, 406). This list does not include related sketches.
9. Wender 1984, 23–24.
10. Osler 1968, 24.
11. Hesiod holds the lyre in Mathieu 1976, nos. 98, 192, 392.
12. Regarding a *Hesiod and the Muses* oil begun in 1860, Moreau wrote:

Entouré des soeurs vierges, voletant légères autour de lui, murmurant les mots mystérieux, lui révélant les arcanes sacrés de la nature, le jeune pâtre enfant, étonné, ravi, sourit émerveillé, s'ouvrant à la vie tout entière.
  Néophyte sacré, il écoute les leçons d'en haut mêlées de caresses et d'enchantements. Tandis que la Nature, toute dans son printemps, s'éveille aussi et sourit à son chantre futur." (As cited in Laran and Deshairs 1913, 39–40; repr. 41.)

13. Richardson 1979, no. 58; Kaplan 1982, 36.
14. Dated 24 December 1897; cited in Paladilhe and Pierre 1972, 67–68, and there described as "probably the last page he ever wrote."

## 70

## Recto: *Study of Trees*

## Verso: *Landscape with Houses and Trees*

**Paul Cézanne**
Aix-en-Provence 1839–1906
Aix-en-Provence

Recto: graphite on wove paper; verso: watercolor over traces of graphite

472 x 315 (18¹/₂ x 12³/₁₆)

Inscribed in an unknown hand, upper right, in graphite, [illegible, *Millet?*]

Provenance: Ambroise Vollard, Paris; Dr. Simon Meller, Budapest and Munich; Paul Cassirer, Amsterdam; Franz Koenigs, Rotterdam; Mr. and Mrs. van der Waals-Koenigs, Heemstede; purchased from John and Paul Herring, New York, 1979

Literature: Venturi 1936, nos. 1632 (recto) and 1633 (verso); Venturi 1951, 48 (verso); Chappuis 1973, no. 1180 (recto); Adriani 1983, no. 39 (verso); Rewald 1983, no. 264 (verso)

Exhibitions: Amsterdam 1938, no. 16; Amsterdam 1946, no. 17; Paris 1964a, no. 205; Tübingen 1982, no. 39

Acc. no. 23532

This sheet bears fine examples of Paul Cézanne's mature styles[1] in drawing and watercolor applied to two of his favorite subjects: trees beside a clearing, on the recto, and simple architecture screened by a wall and a tree, on the verso.[2] Both motifs are likely based upon his surroundings at the Jas de Bouffan, his family's estate.[3] Such ordinary subjects were sufficient stimuli for Cézanne to realize his aspirations "of putting in as much inter-relation as possible" and of becoming "classical by way of nature."[4]

The watercolor is classical in its organization by parallel planes and in its reliance on a stable geometry of triangles and rectangles. Over a light and summary graphite scaffolding, Cézanne applied a few translucent touches of color, superimposed in fairly regular brushstrokes of square or triangular form, which primarily stress boundaries between objects. The strokes are dispersed sparingly in a way that underscores the triangle and rectangles. Virtually nowhere does a line completely contain a form. Much of the paper is left untouched.[5] This makes the white paper function as strong southern light, as highlights on specific objects, and as a modernist acknowledgment of the two-dimensional support. As such, the white creates a complex figure-ground oscillation. Consider the foreground tree: its base reads as foreground highlight in front of the wall, but in the middle of the sheet its contours are interrupted so that highlight white dissolves into what is likely a middleground plane of bushes, which plane is itself negatively insinuated by white paper. The tree's contours resume in front of the background buildings, reestablishing the white of the tree as foreground form. Almost immediately, however, the unclosed white of the tree's limbs becomes the white of the sky, which is also frankly the white of the support. Color too both creates and denies space: the range from warm buff to cool blues and greens functions as volume-creating light and shade for both buildings and walls, yet despite the two zones' spatial distance, they are rendered in colors and values that are identical.

## 71

## *The Poet and Pegasus (Captive Pegasus)*, c. 1891–1898

**Odilon Redon**

Bordeaux 1840–1916 Paris

Charcoal on buff wove paper with ruled graphite border

481 x 378 (18¹⁵/₁₆ x 14⁷/₈)

Inscribed by the artist, lower right, in pen and violet ink, *Od.R.*

Provenance: Ambroise Vollard, Paris; purchased from Stephen Higgons, Paris, 1965[1]

Literature: Boggs 1969, 155; Lochnan 1980, 2; Mesley 1983, 388–390

Exhibitions: Paris 1964b, no. 38 (as *Cheval*); Neuss 1965, no. 10; Toronto 1968, no. 57; Florence 1969, no. 60; London 1969, no. 57

Acc. no. 14846

Like Gustave Moreau (see cat. 69), whom Odilon Redon admired and was influenced by, Redon often treated mythological subjects relating to the artist and his inspiration.[2] Usually, however, his handling of myth is freer and more indeterminate in both style and iconography. Whereas Moreau used Pegasus occasionally and incidentally as companion to a muse or poet, Redon transmuted the myth into an important personal symbol of the mission, achievement, and potential reward of the artist.[3]

In Greek mythology, the winged horse Pegasus was fathered on Medusa by Poseidon and became beloved by the Muses of Mount Helicon. In time Bellerophon, charged with slaying the Chimera, sought out Pegasus who was drinking at the Peirenian spring. He tamed the horse by throwing a golden bridle over his head and rode off to kill the Chimera. Eventually Bellerophon presumed to undertake a flight to Mount Olympus on Pegasus, as if he were an immortal. Zeus punished Bellerophon for his hubris by sending a gadfly to sting Pegasus, who reared and threw his rider to earth. The horse, however, completed the flight to Olympus. In art and literature, Pegasus became linked to poetic inspiration, to

Fig. 1. Odilon Redon, *Captive Pegasus*, National Gallery of Canada, Ottawa

defeat of the powers of darkness, and to potential for apotheosis.[4]

Sometimes Redon followed the myth more literally, depicting Bellerophon throwing the bridle over Pegasus or leading him by the bit.[5] Here, however, the horse has no evident wings and there is no bit or bridle. The rider holds only a leafy branch—probably laurel, a sign of poetic achievement and concomitant ar-

For Cézanne, "the disposition of colors with an eye to the rhythm of the surface was more important . . . than a faithful attention to the phenomena of aerial perspective. . . ."[6]

If the watercolor side is classical, the recto drawing is more baroque. The trees rise from lower left in a rushing diagonal, their limbs writhing in curves and angles. Although the drawing is smudged, Chappuis' evaluation of it as "very fine" is justified.[7] Cézanne once explained his mode of integrating separate perceptions into a system of harmonious construction by locking together the fingers of his hands.[8] Here tree trunks interlock in a way that, as in the verso, implies depth yet also affirms surface pattern. Diminution of scale and alignment of the trees on a diagonal, which recalls perspectival recession, suggest depth. Among the factors that return the eye to the surface are: strong value contrasts in the middleground that tend to push forward; white paper flowing into trunks in both foreground and background, which, while asserting the surface also serves as volumetric value highlights; and formal rhymes where, for example, the upper-center crook of a foreground tree is echoed, sideways, in a rhythmic series that descends toward the center right and encompasses middleground and background trees.

The planar fragmentations and the confluence of surface and depth on both sides of this sheet certainly prefigure cubism, but the stress on realizing one's sensations in front of nature was more crucial to Cézanne's art than it would be to his twentieth-century heirs: "Familiarity with nature became at one and the same time his inspiration, his starting point, and his creative objective: for his originality was not so much that of an inventor as it was of an eyewitness blessed with an unerring sense for the essentials, so that he could make even the most banal objects appear in a new, yet intellectually feasible way."[9]

RJM

1. Cézanne dated virtually none of his drawings or watercolors. Thus there is a range of opinion as to the dates of the works on this sheet, as follows: Venturi 1936, both recto and verso c. 1890; van Hasselt (Paris 1964a), recto c. 1896 but verso c. 1900; Chappuis 1973, recto 1896–1899; Rewald 1983, verso 1885–1890; Adriani 1983, verso 1888–1890 but recto 1896–1899. I favor Adriani's date, inasmuch as the verso is like the "classic" style of the 1880s and the recto like the later "baroque" style.
2. For the recto compare, for example, Chappuis 1983, nos. 792, 917, 1145 and Rewald 1983, nos. 76, 169, 183, 322; for the verso, Chappuis 1983, nos. 737, 878, 880 and Rewald 1983, nos. 7, 86, 114, 178, 263.
3. Compare, for example, Chappuis 1983, nos. 737, *View of the Farm at the Jas de Bouffan*, early 1874, and 880, *The Farmhouse of the Jas de Bouffan*, 1883–1885. Rewald 1983 aptly reproduces beside the verso of our sheet as his no. 264 *La Montagne Sainte-Victoire vue par delà le mur du Jas de Bouffan*, 1885–1888. The pairing implicitly helps to identify the locale of our drawing as well as to suggest an equivalence of house and mountain as stable structural triangles.
4. Adriani 1983, 17, and Newcastle upon Tyne 1973, 25, citing Cézanne.
5. It is possible that Cézanne abandoned the watercolor before its completion; compare Rewald 1983, 40: "Among the watercolors Cézanne abandoned in the course of execution one might consider those on the reverse of more finished works as having been rejected as unsatisfactory. But that is not necessarily so." Cézanne's own comment on his lack of finish was: "the sensations of colour, which give the light, are for me the reason for the abstractions which do not allow me to cover my canvas entirely nor to pursue the delimitation of objects where their points of contact are fine and delicate; from which it results that my image or picture is incomplete" (Adriani 1983, 69).
6. Adriani 1983, 67.
7. Chappuis 1973, 9.
8. Theodore Reff in Chappuis 1973, 15.
9. Adriani 1983, 56.

Cat. 70, verso

tistic immortality (compare Moreau's *He-siod and the Muse,* cat. 69).[6] As such, this drawing's past title of *Captive Pegasus* seems unwarranted, despite affinities to an 1889 lithograph of that title (fig. 1). Instead, the work suggests a free adaptation of the Pegasus myth in order to create a symbolic image of the apotheosis of the poet. The poet, as he stands and rides bareback, resembles a circus rider (compare Georges Seurat's *Le cirque,* 1890–1891). Like such a rider, this poet's art relies upon being in harmony with nature (as symbolized by the horse) rather than upon constraint of it. The laurel connotes both artistry and immortality; hence, if there is flight here, it is a soaring that derives from the poet's art and certainly not from the horse's nonexistent wings. This rider, unlike the Bellerophon of myth, *does* have a valid claim to immortality; both horse and rider can expect to attain the Olympian heights.[7]

RJM

1. The work was purchased in 1965 as *Le Pégase captif (I pensée),* a title likely derived from its resemblance to Redon's 1889 *Pégase captif* lithograph (Mellerio 1913, no. 102). The drawing, however, has been exhibited simply as *Cheval* (Paris 1964b, no. 38) and as *Le poète et le Pégase* (Art Gallery of Ontario, Toronto, 1980, no catalogue), the latter probably because of a paper I read at the National Gallery of Canada in 1980, demonstrating the drawing's links to Redon's *Le poète et le Pégase* lithograph of c. 1898. Because of the drawing's connection with the 1889 lithograph, the drawing has usually been dated "c. 1889." I have noted elsewhere (Mesley 1983, 388–390) that the drawing also derives from an 1891 lithograph *Pèlerin du monde sublunaire* (Mellerio 1913, no. 113) and anticipates Redon's lithograph of c. 1898 known both as *Homme sur Pégase* and *Le Poète et le Pégase* (Mellerio 1913, no. 171); hence my reiterated proposal of a revised title and date.

2. For accounts of the Redon-Moreau relationship, see Mathieu 1976, 240–243, and Paladilhe and Pierre 1972, 137–140.

3. Note Pegasus' presence in Moreau's *Hesiod and the Muses,* begun 1860 (Mathieu 1976, 102), and *A Muse and Pegasus,* c. 1871 (Mathieu 1976, 316, no. 127). For some of Redon's many important works based on the Pegasus myth, see Mesley 1983, 384–418, and Durand 1974, 348–351.

4. On Pegasus, see Yalouris 1975.

5. For example, a *Pégase et Bellerophon,* c. 1889, charcoal drawing and the *Pégase captif,* 1889, lithograph, both discussed in Mesley 1983, 388.

6. Also, in Moreau's *Apollo Receiving the Shepherds' Offerings* of c. 1885 (Mathieu 1976, 353, no. 320), Apollo holds a comparably large laurel branch as his attribute as patron of poetry.

7. That the drawing is not to be read naturalistically is indicated by the unnatural scale relationship of rider to horse and by Redon's use of a low horizontal band above which horse and rider loom. This blank foreground band is a device frequently used by Redon to signify that what happens above or beyond the barrier transpires on a heightened, visionary, or transcendental plane of existence. That the poet who holds the laurel, attribute of Apollo, is bathed in light suggests that he is returning to the Olympian home of Apollo, god of light and patron of poets.

English

## 72

### *Hudibras Beats Sidrophel and His Man Whacum,* c. 1725

**William Hogarth**

London 1697–1764 London

Pen and brown ink with gray wash, incised throughout with stylus, on cream laid paper, trimmed to pen and brown ink border line, laid down on laid paper[1]

230 x 339 (9⁷/₁₆ x 13⁵/₁₆)

Inscribed by the artist, center right on amulet around Sidrophel's neck, in pen and brown ink, *Homo sa: / carus mu: / seo Iomea / Cheruboz / ca* [an unintelligible formula of conjuration]; center on paper on table, various signs of the zodiac and planets, left side facing Sidrophel, [Aquarius] / [Capricon] [Leo] / [Gemini] [Taurus], right side, [crescent] [Mars] / [triangle] [Jupiter, backward] / [square] / [star]; lower right on paper on floor with magic circle and the deity's names invoked in magic spells, *Otheos yon / Mala / iii*

*/ Mala / la / B[?]GO / ely eloy;* lower right on knife, *AGLA;*[2] in a later hand, verso lower right edge, in graphite, trimmed, *15 15 0;*[3] in another later hand, verso lower left, in graphite, *S / is / x;* by Edward Cheney, verso of old mount, in pen and brown ink, *This* [over same word in graphite] *drawing—plate VIII of the engravings, ''Hudibras beating / Sidrophel'' was bought by Mess. Colnaghi at Sir J. Baring's / sale May 24. 1831 for 12.1.6. It was resold at Mr. Standley's [sic] / sale ap. 19. 1845. (no. 1087), by Mss. Graves for 9.19.6. / & was bought by me ap. 1855 for 12 £.* <u>E.C.</u>

Provenance: Samuel Ireland;[4] Sir J. Baring; his sale, Christie's, London, 24 May 1831, lot 123 (11¹/₂ guineas to Colnaghi); H. P. Standly; his sale, Christie's, Lon-

Fig. 1. William Hogarth, *Hudibras Beats Sidrophel and His Man Whacum*, 1726, The British Museum, London (Courtesy of the Trustees of The British Museum)

don, 14 April 1845, lot 1087 (9½ guineas to Graves); Edward Cheney (see his inscription, above) in 1855 for 12 pounds; Alfred Capel-Cure;[5] Francis Capel-Cure; his sale, Sotheby's, London, 15 May 1905, lot 97 (15 guineas to Harvey); Major General Julian Steele, in 1905? (died 1926);[6] his widow, Mrs. Julian Steele (died 1965); her son, M. A. Steele, Scotland (died 1975); his widow, Mrs. M. A. Steele; her sale, Christie's, London, 17 June 1975, lot 56 (repr.); purchased at the sale

Literature: Nichols 1785, 143; Ireland 1799, 16–17, 25–26, reproduced in aquatint by Rosenberg as pl. 5, opp. 25; Nichols 1833, 285, 390–391; Oppé 1948, 28; London 1987a, under no. 198

Exhibition: Halifax 1976, no. 43

Acc. no. 18481

Like the industrious apprentice he was later to immortalize, young William Hogarth was driven by a keen ambition and impatience to succeed in his chosen profession. Having been bound to a lowly silver-plate engraver, Hogarth abandoned his master to set himself up as an independent engraver, looking to caricatures and book illustrations to advance his career. At some point in the early or mid-1720s, he undertook to illustrate a new edition of Samuel Butler's famous poem *Hudibras,* a mock-heroic epic that burlesqued Puritan hypocrisy and fanaticism.[7] Originally published in parts between 1663 and 1678, *Hudibras* continued to be popular for political and religious reasons, although it was also considered to be very funny. It is significant that Hogarth virtually began his career as a serious artist by illustrating one of the great English satirists, a precursor of Alexander Pope and Jonathan Swift.

Hogarth based his seventeen small plates on the anonymous illustrations of an earlier 1710 edition of the poem,[8] but before they were published the artist apparently decided to produce a much more ambitious suite of twelve *Hudibras* prints in a larger format as independent pictures with captions excerpted from Butler's text at the bottom of each plate. The inspiration for this set, which looks forward to Hogarth's major narrative print cycles, was Charles-Antoine Coypel's *Don Quixote* prints, large copies of

Fig. 2. William Hogarth, *Hudibras Visiting Sidrophel*, 1726, University of Illinois Library at Urbana-Champaign

which had been published in 1725 by Philip Overton, the same publisher who issued Hogarth's large *Hudibras* suite.[9] Butler's poem was a logical choice, since Hudibras was commonly known as the Don Quixote of the English nation. Hogarth's twelve large prints were published in February 1726, followed in April of the same year by the seventeen small illustrations with Butler's text, the latter evidently capitalizing on the success of the large set.[10]

Butler's poem tells of the picaresque adventures of a fat Puritan knight, Sir Hudibras, and his sidekick Ralpho. While on their quest to make the world conform to their bigoted views, the pair randomly attacks merrymakers and folk activities that they encounter and misinterpret. Having his greedy eye on the property of a widow, Hudibras decides to consult the astrologer Sidrophel concerning his future matrimonial prospects. The braggadocio soldier and the quack magician become embroiled in a heated argument concerning astrology that

erupts into an open brawl. In the drawing, which was engraved as plate 8 of the series (fig. 1),[11] Hudibras is just about to draw on the wizard and his accomplice Whacum, as Ralpho is seen disappearing out the door to get a constable (*Hudibras*, part 2, canto 3, lines 1035–1040).

The essential details of the scene are already present in Hogarth's eleventh plate of the small illustrations (fig. 2),[12] but the larger format of the more ambitious suite has allowed the artist to develop the comic potential of the encounter in a thoroughly original way. Basing his setting and also his drawing style on such seventeenth-century Dutch precedents as the work of Adriaen van Ostade with its many astrologers' and alchemists' dens, a tradition that had been brought to London by Egbert van Heemskerk the Younger, Hogarth not only elaborated the comic details, but also increased their symbolic significance, a lesson also learned from Dutch genre painting.[13] For example, the stuffed crocodile hanging from the ceil-

ing was a commonplace item in collectors' specimen cabinets or alchemists' lairs,[14] but here Hogarth's marvelously whimsical creature becomes, because of its size and prominence, the presiding *genius loci.* Since crocodiles had been symbols of hypocrisy from the medieval bestiaries onward (still surviving in our expression ''crocodile tears''), Hogarth's reptile comments on the duplicity of both protagonists, hypocrisy being one of the main vices that Butler castigates in his poem.[15] The emphasis on the teeth of the swordfish and crocodile in Hogarth's representation highlights, moreover, the essentially predatory nature of the magician. Even such a minute detail as the Great Bear outlined on the celestial sphere in the lower right corner of the drawing is meant to evoke the bear that had featured in Hudibras' earlier ignoble history and that is specifically mentioned in the caption to the print. Almost every detail of the picture may, therefore, be read as a comment upon the action.[16]

The highly finished preparatory drawing, which is a mirror image of the print, has been incised with a stylus to transfer it to a copper plate of approximately the same size.[17] Hogarth introduced a number of changes, most notably the angry cat replacing the chamber pot, and the hat falling off Whacum's head. Unfortunately, the artist exchanged Sidrophel's wonderful skeletal chair for the more conventional wooden one in the print.[18] The assorted zodiacal and planetary signs in the paper on the table become in the print a highly unfavorable horoscope for Hudibras, which Hogarth expected his audience to decipher and relish.[19]

Six other original drawings for plates 1, 2, 3, 7, 11, and 12 of the large *Hudibras* set are preserved in the Royal Collection at Windsor, all but one in the same medium of pen and ink with wash; two further sheets for plates 5 and 9, formerly in the Robert Mond Collection, considered by Oppé to be copies after Hogarth, but now accepted as originals, are with the Leger Galleries, London, and in the British Museum, London.[20] For many of his later print sets, Hogarth produced oil paintings as *modelli* rather than drawings, but when drawings were prepared, such as the two sets for *Industry and Idleness* in the British Museum, Hogarth favored a similar robust application of pen and ink with wash, as in the *Hudibras* drawings.[21]

The fact remains that authentic drawings by Hogarth are surprisingly rare.[22]

William Ward, one of the dedicatees of the large prints, reputedly commissioned the artist to produce a set of oil paintings of his *Hudibras* subjects, and several sets of paintings are recorded.[23] One such set, formerly in the Paul Mellon Collection, has been attributed to Hogarth but is doubted by Paulson; it is closely related to the prints and is in the same direction.[24]

According to George Vertue, Hogarth made his reputation with the large *Hudibras* prints.[25] Samuel Ireland, an early admirer and collector of Hogarth, who owned the present drawing as well as the Windsor ones, felt that the *Hudibras* set displayed "the peculiar talent of Hogarth for genuine humour, and a bold and masterly style of execution peculiar only to himself, and which we will venture to say, he never excelled at any future period of his life."[26] Ireland goes on to report, on the assurance of Hogarth's widow, that *Hudibras* was the artist's "favourite work and that whenever he met with an early set of impressions of the plates, he never failed to become a purchaser."[27]

DES

1.  The area of the wall around Sidrophel's head appears abraded. It seems that the artist wished to lighten this area to emphasize the dramatic spotlight effect of the lamp on the figures of Sidrophel and Whacum. It should be noted that the shadow of Whacum's hat on the wall is not included in the print, and the light effect on the wall is much less emphatic.

2.  The inscriptions were considerably changed in the print. For their full significance, see Paulson 1970, 1:121–122.

3.  The price realized in the Capel-Cure sale was 15 guineas; see Provenance.

4.  According to Oppé 1948, 28, the drawing did not appear in the Ireland sales (Christie, Sharp and Harper, London, 28 March 1797; resold in same rooms, 6 May 1797, 189 lots; remainder sold after his death, 7–14 May 1801).

5.  According to Lugt, 80, Edward Cheney's collection was inherited by Colonel Alfred Capel-Cure, although it belonged to Francis Capel-Cure when it was sold in 1905.

6.  Information about the Steele family was kindly communicated to me by Julian Steele (letter of 31 August 1987).

7.  Paulson 1971, 1:67, suggests that this may have been Hogarth's first effort at book illustration, as early as "before 1721 or 1722."

8.  Paulson 1970, 1:125. For a comparison of Hogarth's seventeen small plates with the 1710 illustrations, see Brown 1905, 111–114. One of the 1710 illustrations is reproduced by Antal 1962, pl. 13a, who attributes it to Le Pipre.

9.  Paulson 1971, 1:146–147.

10.  Paulson 1970, 1:115–125, nos. 73–84, and 125–127, nos. 85–101; 2: pls. 77–88 and 89–105, 244.

11.  Paulson 1970, 1:121–122, no. 80.

12.  Paulson 1970, 1:127, no. 96. Plate 12 of the small illustrations shows in cinematic fashion the continuation of the fight with Sidrophel on the floor and Hudibras beating him.

13.  For the Dutch influence on Hogarth, see Antal 1962, 87–88, 99–105. It is also probable that contemporary theater exerted an influence on Hogarth's *Hudibras* illustrations, particularly in their planimetric compositions and stagelike sets. For example, all the ingredients of the Sidrophel design could be found in Ben Jonson's *The Alchemist,* which included a satire on Puritanism. Jonson was also one of Hogarth's dramatic heroes (see Hogarth's *Masquerades and Operas* [1724] and *A Just View of the British Stage* [1724] in Paulson 1970, 1: nos. 34, 45).

14.  See, for example, Thomas Rowlandson's delightful *A Conversazione at Dr. Heaviside's Museum* (c. 1805–1810; Toronto 1987b, no. 7), and Adriaen van Ostade's drawings *The Alchemist* or *The Bone Operation* in Schnackenburg 1981, 1:83, nos. 17–18; 2:10, pls. 17–18. Both Rowlandson, who owned a complete collection of Hogarth's prints, and James Gillray may have copied Hogarth's crocodile in their work; see, respectively, *The Fortune Teller* (Wark 1975, no. 318) and *French Generals Retiring on Account of Their Health* (Williams 1970, fig. 228).

15.  The title page and frontispiece to Hogarth's large *Hudibras* set emphasize the exposure of hypocrisy as one of the aims of the poem and Hogarth's illustrations (Paulson 1970, 1:115–116).

16.  The exposé of a quack became one of Hogarth's favorite themes; he took it up again in plate 3 of *Marriage à la Mode,* which features the crocodile and skeleton from this *Hudibras* design. Paulson 1970, 1: no. 230; 2: pl. 270.

17.  The verso of the sheet may have been rubbed with red chalk to facilitate the transfer, as in several of the Windsor *Hudibras* drawings, but this cannot be verified because the sheet has been laid down.

18.  Incised lines on top of the skeletal chair block in the simpler wooden one.

19.  Paulson 1970, 1:121–122.

20.  For the Windsor sheets, see Oppé 1948, 28–29, nos. 5–10; for the drawings formerly in the Mond Collection, see Borenius and Wittkower, 130–131, nos. 484–485; Oppé 1948, 28; London 1984b, no. 22.

21.  Oppé 1948, 40–44, nos. 40–63.

22.  Oppé 1948 catalogued ninety-seven extant examples, plus another twenty that remain untraced.

23.  Paulson 1971, 1:156–157, 525 n. 2; Nichols 1833, 349–350. Panels from a set of *Hudibras* paintings by Francis Le Piper or Le Pipre (1640?–1695) survive in the Tate Gallery, London (four episodes), and in the Rye Art Gallery, Sussex (three episodes, including two devoted to Sidrophel). Although the exact relationship of the Le Piper pictures to Hogarth's prints has never been established, they do not seem to have influenced Hogarth, at least in compositional terms (see Tate Gallery 1964, 30–31, nos. T 620–T 621). My sincere thanks go to Elizabeth Einberg of the Tate Gallery who forwarded the above information.

24.  Washington 1971b, 14–17, nos. 2a–2l. Sold Sotheby's, London, 18 November 1981, lots 16–21.

25.  Quoted in Paulson 1971, 1:176.

26.  Ireland 1799, 18.

27.  Ireland 1799, 18.

73

*Dumbarton Castle,* c. 1779 – 1780

**Paul Sandby**

Nottingham 1731–1809 London

Gouache over graphite with graphite details and black chalk accents on unidentifiable paper, laid down on wood panel

471 x 623 (18¹/₂ x 24¹/₂)

Provenance: Walker's Galleries, London; Mrs. Nicholas Brady, Long Island, New York, 1940–1941; Mrs. James F. McDonnell, New York, 1975; purchased from Thomas Agnew & Sons, London, 1976

Literature: Ross 1986, 21–22, pl. 26

Acc. no. 18728

For most of his artistic career, Paul Sandby worked for the military in one capacity or another. From March 1747, soon after his arrival in London, he was employed in the Drawing Room of the Board of Ordnance at the Tower of London. It was the business of that office to draw "fair copies" of maps made by survey teams all over Britain.[1] These final versions depicted not only the hills, buildings, towns, streams, and roads found on ordnance survey maps today, but they were also embellished with vignettes of detailed elevations of buildings, and plans and prospects of fortifications, harbors, and the like.

Fig. 1. Paul Sandby, *North View of Dumbarton Castle*, The British Museum, London (Courtesy of the Trustees of The British Museum)

In September of that year, Sandby was appointed chief draftsman of the Ordnance Survey of Scotland, whose office was in Edinburgh Castle, where Sandby was in charge of the fair copies of the map of the Highlands. He spent the winters in Scotland and the summers, until 1752 when he returned to London, working with military survey parties in the field. During this time, he filled several sketchbooks with landscape and figure drawings, which he was to draw upon for the rest of his life. He also made a large number of etchings while he was in Scotland, including a series of eight large views of Scottish castles and towns published in Windsor in 1751. Straightforwardly topographical in style, they were etched "on the spot," and included a view of Dumbarton Castle (fig. 1), which Sandby used as the basis for the gouache in the National Gallery of Canada. Apart from the figures and the group of trees

and cows on the near bank, all the details are identical, even the vegetation and shading on the castle and rock.

Dumbarton Castle played an important role in the history of the ancient Britons, and in the eighteenth century it was still an active military fortress, garrisoned by a governor and troops.[2] Sandby probably visited or passed by it several times while he was in Scotland. The National Gallery of Scotland, Edinburgh, has a pen and ink drawing of Dumbarton Church by him, dated 1747, and the National Library of Wales has a panoramic pen, ink, and wash landscape of about the same date looking northward from the castle toward Ben Lomand.[3]

Unlike the early topographical drawings, the present large gouache was obviously intended for exhibition in London. Sandby showed oil, watercolor, and gouache history paintings and landscapes at the Society of Artists from 1761,

Fig. 2. Paul Sandby, *The Duke of Cumberland with a Gentleman, a Groom, and Some Horses and Dogs*, Royal Library, Windsor Castle (Reproduced by Gracious Permission of Her Majesty The Queen; copyright Her Majesty The Queen)

and in 1768 he was a founding member of the Royal Academy. At the 1779 Royal Academy exhibition he showed a gouache drawing of Bothwell Castle, a subject that he returned to throughout his life, based on sketches made during the Scottish years. The present view of Dumbarton Castle, also based on a work from Sandby's period in Scotland, has certain similarities to other exhibition pieces by him, indicating that this work should also be dated to the end of the 1770s.

The practice of laying his paper on wooden panels for large gouache drawings was used consistently by Sandby in the 1770s but not earlier. A large amount of white opaque color is evident in this work, giving it a chalky texture, and seems to have been intended to have a unifying effect by lightening the overall tone. Other works with similar pastel colors, the same delicately detailed style of foliage, and a similar skill in incorporating the figures into the composition also date from the late 1770s, notably a pair of views of Bothwell Castle (National Gallery of Scotland, Edinburgh, and Yale Center for British Art, New Haven) and the Yale Center's view of Roslin Castle.[4]

All of these works show more skill at making a picturesque composition than is evident in Sandby's work of the 1750s and 1760s, which tended to be topographical in character. It was not until his tours of Wales in the early 1770s that Sandby began to display compositional skills learned from a study of Claude Lorrain and Richard Wilson. Their use of

foreground trees to frame a view is clearly evident here. Sandby was also undoubtedly influenced in these later depictions of Scottish scenery by the main guide to the picturesque, William Gilpin, whose *Observations on the Picturesque Beauty . . . of the High-Lands of Scotland* had a chapter devoted to Dumbarton Castle, ''one of those exhibitions, which nature rarely presents'' whose form ''is very picturesque.''[5] Although this guide was not published until 1789, the tour itself was made in 1776, and the manuscript circulated widely among Gilpin's acquaintances, who included Paul Sandby who often worked with Gilpin's brother, the animal painter Sawrey Gilpin.

A drawing made by Sandby, possibly with the assistance of his brother Thomas Sandby and Sawrey Gilpin, apparently served as a study for the figures on horseback in the foreground of *Dumbarton Castle. The Duke of Cumberland with a Gentleman, a Groom, and Some Horses and Dogs* (fig. 2) was actually executed as a preparatory drawing for a series of paintings commissioned by the Duke of Cumberland in the 1760s.[6] The poses of the three dogs, horses, and men are identical in the gouache except that the white horse has been moved to the center of the group and the man on this horse is no longer the duke. The man in the view of Dumbarton Castle is less portly and his uniform has been changed from red to blue—the color of the master general of the Ordnance or of an officer in the Royal Artillery, to which the Ordnance

belonged.[7] The uniform of the man on the right in the Ottawa drawing is that of an officer in the infantry.[8] The third figure is a civilian—possibly Sandby himself, or William Roy, the civilian assistant to the quartermaster general, who led the survey teams.[9] The infantry troops, which Roy had to dispose and quarter, seen disappearing off down the road to the right, are perhaps heading for the military encampment near the castle, which was depicted in Sandby's panoramic view in the National Library of Wales.

The careful attention to the appropriate details and colors of the uniforms suggests that these figures may have been intended as portraits, although this would have been highly unusual in a work like this by Paul Sandby; the ''Mother Goose'' figure and the man and woman with the cart are far more typical of the sort of person he normally used to people such works, basing them on his stock of drawings of figures built up over the years. This view of Dumbarton Castle, then, may have been intended as a tribute to Sandby's colleagues and employers: not only the Ordnance Survey for whom he worked in his early years in London and Scotland, but the military in general, who provided him with a steady income nearly all his life, since in 1768 he had been appointed chief drawing master at the Royal Military Academy, Woolwich, a position he held until he retired in 1797.

KS

1. For a discussion of "fair copies" and the role of the Board of Ordnance, see London 1976b, 3–10.
2. Dumbarton was in ancient times called Dunbriton and hence also often Dunbarton; see Lewis 1846, 302, and Carlisle 1813, n.p.
3. For the drawing in Wales, see Joyner 1983, 3, 9–10, no. 4 (repr.). Thomas Sandby, Paul's older brother, had been in Scotland with the Duke of Cumberland earlier in the 1740s and a close-up topographical view of the castle seen from the banks of the river probably by him is also now in the National Gallery of Scotland, Edinburgh (inv. no. D118); see National Gallery of Canada, curatorial file, correspondence with James Holloway, assistant keeper of prints and drawings, National Gallery of Scotland.
4. For reproductions of Yale's gouaches, see New Haven 1985, nos. 108–109. Sandby also used an earlier print as the basis for his *View of Bridgenorth, Shropshire* in the Yale Center for British Art (New Haven 1985, no. 130).
5. Gilpin 1789, 44, 46.
6. For the question of attribution, and for another version of this drawing in the Yale Center for British Art, see New Haven 1985, 61 (repr.), no. 75.
7. The position of master general of the Ordnance was vacant from 1749 to 1755, while Sandby was in Scotland; see Herrmann 1965, 467. For the identification of the uniforms, see Carman 1985, 194–195.
8. See National Gallery of Canada, curatorial file, correspondence with René Chartrand.
9. London 1976b, 3–13, nos. 4, 8–12.

## 74

## *The Flight of Theseus and Ariadne from Minos*, c. 1775–1780

### George Romney
Dalton-in-Furness, Lancashire 1734–1802
Kendal, Westmorland

Pen and brush and brown (iron gall) ink over graphite on laid paper

278 x 412 (10¹⁵/₁₆ X 16¼)

Provenance: Purchased from P. & D. Colnaghi, London, 1960

Literature: Roberts 1969, 467–468, fig. 71; Boggs 1969, 155; Boggs 1971, 58, pl. 181; Lochnan 1980, 2; London 1987c, under no. 6

Exhibitions: Kingston 1965, no. 16; Toronto 1968, no. 43 (repr.); London 1969, 9, 79 (repr.), no. 71; Florence 1969, 55, pl. 43; Paris 1969–1970, 70–71, no. 74, pl. 35; Edmonton 1982, 32 (repr.), 35, 83, no. 42; Kitchener-Waterloo 1985–1986, 43, no. 8, pl. II

Acc. no. 9069

This drawing entered the collection of the National Gallery of Canada with the title *Dido Bidding Farewell to Aeneas.* According to Virgil's *Aeneid* (4:290–400), Dido found Aeneas at the harbor where his ships were being prepared for departure and, turning away from Aeneas but glaring at him over her shoulder, she cursed him for abandoning her. The setting and the figures in the drawing do not fit this passage very well, and therefore the subject has been questioned. Various other episodes from the classics have been proposed, notably Homer's tale of Odysseus leaving Calypso on the island of Ogygie and the same hero's first meeting with Nausicaa when he was shipwrecked on the coast of Scheria. Euripides' description of Jason and Medea pledging mutual faith and even the medieval characters Troilus and Cressida have also been suggested.[1]

In 1963 two drawings originally in the collection of George Romney's granddaughter, Elizabeth Romney, were sold by the Folio Society, London, under the description of "Classical warrior sailing away in a ship with a maiden" (fig. 1 is probably one of them).[2] It seemed proba-

ble to the cataloguer of that sale that Theseus and Ariadne were represented. Indeed, of all the subjects suggested for the drawing in the National Gallery of Canada, only the episode of Theseus and Ariadne fleeing Minos after killing the Minotaur actually takes place with both figures on board a ship at sea under full sail. Romney was not always strictly faithful to all the details of his sources, but it is doubtful that he would have altered so greatly the setting and actual events of such a well-known episode as Dido cursing Aeneas for leaving her. The present whereabouts of the other drawing sold in 1963 is not known, but their description, size, and approximate date, 1776–1778, suggest that, with the present

drawing, they once formed a small group of drawings of this subject that were typical examples of Romney's favorite method of working out compositional ideas for history paintings.

Romney began his artistic training in Kendal in the Lake District, but he left there for London in 1762, where he competed for premiums for history paintings at the Society for the Encouragement of Arts and Sciences. Although he made his living painting portraits in London for the rest of that decade, indeed for most of his life, he respected Sir Joshua Reynolds' dictates concerning the importance of historical paintings in determining the merits of truly great artists, and he continued to draw and paint subjects

from history, Shakespeare, Milton, and the Bible.

He was thirty-nine years old in 1773 when he left for Italy with the painter Ozias Humphry (1742–1810), intending to devote his time there to improving his work by studying from life, the antique, and the old masters. He did little actual painting while he was in Italy but kept a list of "Passages for Pictures in Poetry and History,"[3] a practice he continued for the rest of his life, especially during the period just after his return from Italy in 1775. Romney's son mentions that Mr. Orde, later Lord Bolton, was a frequent visitor who used to read to Romney "such passages in the poets as he thought would afford good subjects for

Fig. 1. George Romney, *Theseus and Ariadne*, P. & D. Colnaghi, London

power of his conception, but if this work had been transferred to canvas it is unlikely it would have been successful. The pressure of his portrait business seldom allowed Romney the time to realize his ideas for history painting on canvas. From the few that he did attempt, it is evident that Romney had a basic inability to make decisions on a large-scale canvas with multiple figures and a landscape setting, and in them he lost the impact he achieved in pen and ink in works like this image of Theseus and Ariadne.

K S

1. These suggestions and the scholars who have proposed them are listed in the curatorial file for this drawing.
2. London 1963a, nos. 24–25. These drawings are described as being in pencil and 11 x 15 and 11 x 14 inches respectively. They had passed through the collections of Sir Alfred and Otto Beit before going to the Folio Society. One of them may be the drawing from the Beit collection (fig. 1), exhibited recently at Colnaghi's (London 1987c, no. 6 [repr.] as *Dido Bids Farewell to Aeneas*, pencil, 11 x 16¹/₄ in.).
3. Cambridge 1977, 16.
4. Romney 1830, 136.
5. Romney 1830, 157, 168–172. See also two notebooks labeled "Hints for Historical Drawings" and "Hints for Pictures" or "Miscellaneous Hints for the Pencil" in the Romney Papers in the National Art Library, Victoria & Albert Museum, London (L. 1451-1452-19577).
6. For examples of similar work by Fuseli and other artists Romney would have known in Rome, see New Haven 1979, especially nos. 33–34, 37, 40–41, 52–53, 87–88.

pictures."[4] Doctor Robert Potter, translator of Greek tragedies by Aeschylus and Euripides, and Lord Chancellor Thurlow, who sent Romney a translation of Virgil's description of Orpheus and Eurydice, were two of many literary friends who suggested episodes from the classics that would make good history paintings.[5]

At the beginning and near the end of his career, Romney favored pencil or pen and ink outline for the numerous drawings he would execute while planning a painting in oil. The style of drawing varied according to the stage of the composition—very rough sketches for first ideas for compositions were followed by more careful outline or shaded drawings and often a series of studies for details of the composition. However, while he was in Rome he began to rely on fairly dark ink wash applied with a brush for the second and third stages of planning a composition, presumably because this allowed quick, free expression of the basic components of a composition, at the same time enabling the working out of its chiaroscuro. In Rome, Romney had become aware of the importance of the disposition of light and shade, partially as a result of his study of the old masters but probably even more from his exposure to the work of Henry Fuseli (see cat. 77), whose style and method of working in Rome closely resembled this new approach of Romney.[6]

Fuseli successfully translated hundreds of his pen and ink ideas for history paintings into large oils on canvas. Romney, on the other hand, drew thousands of ideas for history paintings but only managed to execute a few dozen on canvas, most of which are now lost or destroyed. In the Ottawa drawing, as in many others, Romney had all the right elements for an effective history painting: a turbulent storm at sea with a mountainous island and city glimpsed through the clouds, the opposing curves of the bow and sail of the ship framing two powerful figures just off center of the composition, and the opportunity, which he fully exploited, for swirling pools of darkness and light. This medium allowed Romney's hand to convey the passion and

## 75

*View on the River La Puce near Quebec in Canada, 1792*

**Thomas Davies**
Woolwich c. 1737–1812 Blackheath

Watercolor over graphite on laid paper
513 x 342 (20⅛ x 13½)

Inscribed by the artist, lower right, in pen and blue-black ink, *T. Davies Pinxit 1792*; by the artist, verso upper center, in graphite, *View in the River La Puce near Quebeck in Canada*

Watermark: Whatman crest

Provenance: The Earl of Derby, Knowsley Park, Lancashire; Christie, Manson & Woods, London, 19 October 1953, lot 137; purchased from Frank T. Sabin, London, 1954

Literature: Fenwick and Stacey 1956, 273 (repr.); Hubbard 1959a, 42–43 (repr.); Harper 1966, 51; Winchester 1967, 62; Hubbard 1972, 55–56

Exhibitions: Ottawa 1967–1968, no. 29; Ottawa 1972, no. 59

Acc. no. 6274

Thomas Davies was a distinguished officer in the Royal Artillery, a knowledgeable naturalist in the circle of Sir Joseph Banks, and a gifted amateur artist who exhibited regularly at the Royal Academy. His military career made it possible for him to expand his interests in art and natural history. During four postings to British North America (primarily Canada and New York) there was sufficient leisure time and travel to allow Davies the opportunity to draw and collect specimens of a new and relatively unknown land.

Davies probably received the standard training in the art of topography under Gamaliel Massiot (active 1744–1768) when he attended the Royal Military Academy at Woolwich from 1755 to 1756. Although Massiot's work is unknown, one can assume from early watercolors and drawings in Davies' only known sketchbook (National Gallery of Canada, acc. no. 26954) that his instruction varied little from the topographical style established in England by Wenceslaus Hollar (1607–1677). Any stylistic chronology of his first twenty years as an artist is hampered by

such factors as the difference between the inscribed dates on the watercolors (which usually refer to the date the scene was first recorded) and the paper type.[1] A watercolor in the sketchbook dated 1776 (fig. 1) shows clearly that by this time Davies had absorbed William Gilpin's principles of the picturesque style of balanced and atmospheric compositions. This watercolor demonstrates that Davies could practice in the most accepted and contemporary style with facility.

By the 1780s Davies was becoming increasingly interested in natural history, and he produced numerous watercolors of botanical and ornithological specimens. Concurrently, and as a result of this work, he was developing a landscape style uniquely his own. He organized his landscapes in the formal compositions of prevailing taste. Yet unlike those of his contemporaries, Davies' landscapes, like his nature studies, displayed a rich, opaque palette and a draftsmanship that captured every nuance of color, form, and texture. Stylizations of landscape detail also had their equivalents in his natural history sub-

Fig. 1. Thomas Davies, *Untitled,* 1776 sketchbook (page 17, verso), National Gallery of Canada, Ottawa

jects: pine branches were treated like fur and rushing water like variegated plumage and down. The final result is one of both sophistication and naiveté.

*View on the River La Puce* was finished in 1792, two years after Davies returned to England from his last posting in Quebec. In this landscape Davies has depicted some of his fellow officers on an excursion exploring the banks of the Sault à La Puce River above Chateau-Richer, a few miles from Quebec City. In the distance is the Saint Lawrence River and on the far shore, the parish of Sainte-Famille on the Ile d'Orléans. This subject is somewhat atypical for Davies' landscapes. Missing are the scattering of Indians or local flora and fauna such as the bears, birds, and exotic plants that delight the viewer and evidently pleased the artist.

Davies was the first British military artist to record the Canadian landscape and, for all intents and purposes, the only one

to depict those qualities in the Canadian landscape that made it different from the European landscape. The crystalline light and brilliant foliage of the Canadian autumn so faithfully depicted in this watercolor was not captured again by an artist in Canada until the mid-nineteenth century. Thomas Davies did not allow the contemporary aesthetic conventions of landscape watercolors to interfere with his need to record the landscape as he saw it.

RLT

1. For example, a watercolor (National Gallery of Canada, acc. no. 6272), dated 1762, is on Whatman wove paper, which was not developed by that firm until the 1780s; see Cohn 1977, 16. All stylistic analyses to date of Davies' work have relied entirely upon inscribed dates. The only catalogue raisonné (Ottawa 1972) did not include an examination of paper type or watermarks. Until an examination of the paper is done for all of Davies' watercolors, no accurate chronology can be proposed.

## 76

## *The Death of General Wolfe,* c. 1769 (?)

**Benjamin West**

Springfield (Pennsylvania)
1738–1820 London

Black chalk and pen and brown and gray ink and wash, heightened with gouache on brown laid paper, laid down on unidentifiable paper laid down on Masonite board

430 x 614 (16⅞ x 24⅛), irregular

Inscribed by the artist, lower left, in gray-brown gouache (over traces of a previous signature in pen and brown ink?), *Benjⁿ West 1765*

Provenance: Estate of the artist; sale, Sotheby's, London, 1 June 1839, lot 120, bought in; Mrs. Albert F. West; sale, Christie's, London, 19 March 1898, lot 139; Obach, London; Samuel Whitaker Pennypacker, Philadelphia, October 1889; Mrs. Mary Pennypacker; Freeman and Co., Philadelphia, 26–27 October 1920, lot 1037; Sotheby Parke-Bernet, New York, 30 May 1984, lot 1; purchased from Hirschl and Adler Galleries, New York, 1984

Literature: Pantazzi 1985, 1–4; von Erffa and Staley 1986, 215–216, no. 99; Laskin and Pantazzi 1987, 300

Acc. no. 28524

The battle of the Plains of Abraham at Quebec in 1759 was only one episode in the Seven Years' War, but it has passed into posterity as the dual symbol of the definitive loss of the French colony and the consolidation of the British Empire in North America. The death on the field of honor of Generals Wolfe and Montcalm (see cat. 61) struck the popular imagination, and history continues to celebrate them, paradoxically, by associating the two enemies who were united by a fatal destiny.

General James Wolfe (born 1723) died from a series of wounds to the chest during the morning of 13 September 1759, after having learned that the British troops had succeeded in routing the French. He was attended by four soldiers, including a surgeon. The career of this young strategist ended prematurely,[1] and of all his military deeds, the last was the one that most inspired the national art of England.[2]

George Romney (1734–1802) and John H. Mortimer (1741–1779) in 1763 and Edward Penny (1714–1791) in 1763 and 1764 all treated the subject of this tragic death. The interest of these works was eclipsed, however, by the presentation at the 1771 Royal Academy exhibition of Benjamin West's masterpiece *The Death of General Wolfe,* 1770 (fig. 1).[3] He made five replicas of it, including one for King George III.[4] West took great liberties with the event while still being careful about the choice of uniforms.[5] He reconstructed the account as his contemporaries would have imagined it, while giving the work a heroic and religious connotation and transforming it into a gallery of military portraits.[6]

This preparatory drawing—once in the collection of the bibliophile Samuel Whitaker Pennypacker, who was elected governor of Pennsylvania in 1903–confirms the care that West took in working out the composition.[7] The precision with which the groups are composed and articulated in space is clearly visible in this *modello.* The artist used several media in a complex way, resulting in something that approaches a painted composition. The use of dark washes, of gouache heighten-

ing, and of strongly underlined contours suggests the effect of a sketch. West used an analogous technique in other compositions, and he often mixed different media to create the desired effect.[8]

The treatment of the scene aims for both a clear understanding of the subject and the glorification of the general. The city of Quebec, at left, suggested by a bell tower appearing through the smoke, and the Saint Lawrence River, at right, set the scene. The arrival of a soldier holding a French army flag, even though the British army has not yet finished arriving at the battlefield, leaves no doubt as to the final outcome of the battle and condenses

the moment of the principal action. Wolfe, in full light, lies on the ground to the right of center. The disposition of soldiers around him, in concentric arcs, gives him the greatest importance. His spread-out cloak and the flag placed just above his head suggest a modest funeral bier. An American Indian chief seated on the ground contemplates the allied general. There are several differences between this drawing and the final composition, the main one being that neither the portraits nor the costumes had yet been worked out in detail.[9]

LL

1. The abundant iconography inspired by the popularity of General Wolfe has been studied on numerous occasions, in particular by John Clarence Webster in 1927 and 1930. A study of the iconography of historical Canadian figures by Denis Martin, *Portraits de héros de la Nouvelle-France*, is currently in press.
2. His final moments were recreated by Grinnell-Mill 1963, 256–257. For his part, historian Charles P. Stacey (1959, 149) suggested that Wolfe was rather vain and that he had exposed himself to danger: ''Perhaps he thus fell a victim of the spur of fame. Perhaps he deliberately exposed himself. It might seem strange that a young general with a brilliant career before him, and a man engaged to be married, should invite destruction, but as we have already suggested, he may well have come to believe that he had only a short time to live in any case, and have thought a quick and glorious death on the battlefield, in the moment of victory which–now he had brought the French to

Fig. 1. Benjamin West, *The Death of General Wolfe*, 1770, National Gallery of Canada, Ottawa, Gift of the Duke of Westminster, 1918

action–he had every reason to expect, far preferable to a lingering and painful illness.'' Contemporary historiography treats with circumspection Wolfe's qualities as a commander and attributes the success of the battle as much to chance as to the poor preparation of the badly disciplined French. See Stacey 1974, 721–730.

3. The date 1765 at the bottom of the drawing poses a special problem, possibly suggesting that this composition is approximately contemporary with works on the same subject by other artists, and that West very early had worked out the problems of composition, only to execute the final painting five years later. As Michael Pantazzi has proposed (1985, 4), however, it is a later inscription, as has been found to be the case in other works by West.

4. Von Erffa and Staley 1986, cats. 94–98.

5. According to Galt (1820), Sir Joshua Reynolds at first disapproved of the decision to use contemporary costumes, the practice being rather rare in English history painting.

6. Six of the figures in the composition were identified by William Woollett (1735–1785), who in March 1776 published a caption that was intended to accompany the original print of the subject that he had published in January of the same year. Different interpretations thereafter have grafted on the names of possible witnesses at Wolfe's last moments. For an analysis of this question, see Stacey 1966, 1–5.

7. In his *Self-Portrait* (c. 1776, Baltimore Museum of Art), he shows himself with a *grisaille* drawing of the grenadier and the aide-de-camp who appear at right in the painting.

8. Among the catalogued works are, for example, *Agrippina Landing at Brundisium with the Ashes of Germanicus* (c. 1767, Philadelphia Museum of Art; von Erffa and Staley 1986, cat. 36) and *The Angels Appearing to the Shepherds* (c. 1774, Victoria & Albert Mu-

seum, London; von Erffa and Staley 1986, cat. 305).

9. Among the other modifications he made, it can be noted that the American Indian is seated in a different pose and his accessories are arranged in another way. The American ''ranger'' hides the person behind him; the arms of the two figures are parallel and the right hand of the ranger is not visible; the other figure is a Scotsman in the painting. The position of the hand of General Monkton is different, and in the painting he holds a handkerchief soaked with blood. The figure placed behind and to the right of Monkton is almost hidden. The positions of the grenadier and the aide-de-camp at right are reversed.

## 77

## *A Woman Standing at a Dressing Table or Spinet*, c. 1790–1792

**Henry Fuseli**
Zurich 1741–1825 Putney Hill

Pen and brown (iron gall) ink with brown and gray wash over graphite, heightened with white chalk, on laid paper[1]

478 x 316 (18¹³/₁₆ x 12⁷/₁₆)

Watermark: Strasburg lily with initial *W* below, similar to Churchill 415, but without *J. WHATMAN* below (1782)

Provenance: Susan, Countess of Guildford;[2] her daughter, Susan, Baroness North (Lugt 1947, in black on verso); her sale, Sotheby's, London, 14–15 July 1885; possibly Arnold Otto Meyer, Hamburg; his sale, C. G. Boerner, Leipzig, 19–20 March 1914, part of lot 230?;[3] anonymous sale, Christie's, London, 12 March 1937, lot 2 (28 guineas); purchased from P. & D. Colnaghi, London, 1937, through Paul Oppé

Literature: Oppé 1941, 56; Fenwick 1964, 1, 12, fig. 16; Popham and Fenwick 1965, viii–ix; Fenwick 1966, 24; Schiff 1973, 1:547, no. 1069, 2:314, fig. 1069; Briganti 1977, 198–199, fig. 195

Exhibitions: Kingston 1965, no. 7; Edmonton 1982, 13, 81, no. 7

Acc. no. 4374

Whether in his historical themes—Lady Macbeth, Lucrezia Borgia, Brunhild, Eve, Delilah, and Salome—or in his private drawings such as the present example, Fuseli always preferred to portray lustful amazons or dominating viragos who invariably triumph over his Michelangelesque supermen. His combination of kinky sex with such stylistic exaggerations of female anatomy as elongated necks and swelling hips (derived from Parmigianino and even Bellange),[4] has led one wag to characterize his art as "Sado-Mannerism."[5] Fuseli's friend and artistic ally, William Blake, defended his work with the suggestion that "he is a hundred years beyond the present generation."[6] And indeed Fuseli's misogynistic view of women seems more at home in the fin-de-siècle after his own, when his cruel courtesans with bare breasts and flails reappear in the adolescent fantasies of Aubrey Beardsley or in the ubiquitous femmes fatales that dominated pan-European art around 1900 from August Strindberg to Félicien Rops. It is no surprise that in the post-Freudian era Fuseli's psychologically disturbing drawings of women have never been more highly regarded or coveted.[7]

Three features of this drawing are typical of Henry Fuseli's work: the fantastically elaborated coiffure, the erotic back view, and the *vanitas* motif of a woman at her dressing table, combined in this instance with the sexually charged image of a woman at her spinet. Immediately after Fuseli's sojourn in Rome (1770–1778) both the fantastic hairdo and the back view appeared in his work in Zurich in 1779,[8] apparently inspired by such drawings as *Three Roman Ladies* by the Scottish artist John Brown (1749–1787), who had been a close associate of Fuseli's in Rome.[9] At the same time, his hair fetishism became more apparent in his extraordinary portraits of the clairvoyant Magdalena Schweizer-Hess, a married woman with whom the artist flirted while at the same time courting Anna Landolt.[10] This

Fig. 1. Henry Fuseli, *Callipyga*, 1810–1820, private collection (Courtesy Sotheby's, London)

Fig. 2. Henry Fuseli, *Girl at a Spinet with an Elf*, private collection (Courtesy Schweizerisches Institut für Kunstwissenschaft, Zurich)

Fig. 3. Henry Fuseli, *Folly and Innocence*, 1800, Nottingham Castle Museum and Art Gallery, Nottingham

almost mystical preoccupation with hair—which was also a feature of Pre-Raphaelite art (see Rossetti and Sandys, cats. 88, 89)—can perhaps be explained by Magdalena's claim that she entered a hypnotic trance when her hair was combed.[11]

Back in London after being refused Anna's hand in marriage by her father—a traumatic failure in love, which may have warped his view of women in general—Fuseli later married Sophia Rawlins, an artist's model much younger than he and his social and intellectual inferior. During the 1790s, the first decade of their marriage, the artist made many beautiful drawings inspired by his young and fashionable wife, some quite flattering, but others satirizing female vanity by stressing absurd fashions and hairdos.[12] It is to this general group that the Ottawa drawing belongs, although it is not specifically a portrait. Gradually these drawings, which were not for public consumption,

merged into an erotic phantasmagoria of courtesans, some with bizarre shaven heads, becoming coarse and overtly pornographic after 1810.[13] Similarly coiffed and costumed females appear as Titania's fairy attendants in Fuseli's *Midsummer Night's Dream* paintings, indicating a demonic aspect of woman, which is often suggested in the private drawings as well.[14]

It is fascinating to discover that this very drawing was recast in a pornographic mode some two decades after it was drawn in the so-called *Callipyga*, c. 1810–1820 (''Beautiful Bottom,'' the name of a famous antique statue in Naples; fig. 1).[15] Fuseli retained the basic design of the Ottawa sheet, but made a number of significant changes. In the earlier drawing, the woman wears a white muslin neoclassical chemise such as Marie Antoinette popularized in France and introduced into England in 1784 by the Duchess of Devonshire.[16] Through the

thin, transparent material Fuseli has emphasized the model's buttocks, as in ''wet drapery''-style antique sculpture or Canova's derivates; in the later version the woman provocatively lifts her skirts to expose her rear. The back view was a commonplace of fashion caricature, especially combined with the burlesque of an elaborate coiffure.[17] Not only did the fashions look most absurd from the rear, but the viewer was able to laugh literally behind the subject's back. Fuseli became so associated with the back view that contemporary artists such as Thomas Rowlandson in *The Lock Up* (cat. 79) included comic quotations of his women in their own work.[18]

The fantastic hairdo has also been changed in the later drawing. In the Ottawa sheet the woman wears a fan-shaped element of hair framing her face, derived from Imperial Roman portrait busts, which Fuseli copied in his sketchbooks,[19] combined with three braids of

hair that hang like cables from a comb rising irrationally from the fan.[20] These braided loops may derive from the "cadogan," a contemporary hairstyle, but Fuseli has given them an impossible and comical arrangement.[21] Fuseli also introduced the mirror frame and the model's reflection into the later reworking. The *vanitas* motif of the woman at her dressing table, familiar from countless Magdalens in European art, is a major theme in Fuseli's work, appearing earlier in his *Adelheide* from the *Jugendalbum* of his teenage years.[22] What is apparently a vanity table in the earlier drawing becomes in the pornographic version an altar to Priapus supported on phallic legs, before which the woman conducts some diabolical rite.[23]

The Ottawa sheet has always been interpreted as a woman at her dressing table, which seems confirmed by the *Callipyga* composition, but there is also the strong suggestion of a woman at a spinet or virginals. From the seventeenth century on, this musical motif in art was symbolic of sexual activity, and Fuseli used it frequently with this connotation, most explicitly in *A Nude Reclining and a Woman Playing the Piano*, which derives from Titian's *Venus and the Organ Player*.[24] Fuseli's tondo of c. 1785–1786 from a series illustrating scenes from *The Winter's Tale* shows an elaborately dressed Perdita standing in front of a spinet (fig. 2).[25] The gesture of her left hand with its flexed wrist and fingers is remarkably similar to that of the woman in the Ottawa sheet, suggesting that the latter is actually playing a spinet with both hands. In the pornographic reworking, the model more obviously leans on the dressing table. The vertical rectangular shapes at either side of the woman's shoulders in the Ottawa drawing appear in the Perdita picture as the music stand above the keyboard. There is no reason why a dressing table should have this particular feature, and indeed the music stand has been removed from the later version. A closely related drawing (c. 1796–1800) in the Courtauld Institute of Art, London, depicts a woman seated at a spinet with parted curtains in the background very similar to the ones in the present sheet.[26] In a key image of 1800 illustrating William Cowper's *The Progress of Error*, Fuseli combined the *vanitas* motif, personified by a woman looking into a mirror over a dressing table, with the sexual symbolism of a second woman playing a spinet, indicating that the two motifs were closely linked in his mind (fig. 3).[27] It is quite possible that both ideas were present simultaneously when he drew the intriguing Ottawa image and that the artist left his work deliberately ambiguous.

If the iconography of the Ottawa drawing is rich and complex, so too is Fuseli's combination of media—pen and brown ink with brown and gray wash over graphite, heightened with white chalk. The use of white chalk is unusual in Fuseli's work, but here it has been applied most effectively to caress the woman's voluptuous form and to suggest the sheer curtains over a pool of brown wash into whose unfathomable depths the woman stares Narcissus-like. It should also be noted that Fuseli has applied his wash from the upper left to the lower right, most clearly evident in the lower-right quadrant, indicating that he drew the work with his left hand. Although he was apparently ambidextrous, Fuseli created most of his important drawings with his left hand; the direction of the shading may, therefore, be used as a test of authenticity in his graphic work.[28]

Within the history of the National Gallery of Canada's collection of European drawings, this sheet holds an important place; it was the first of some 341 drawings purchased for the Gallery by the distinguished connoisseur Paul Oppé between 1937 and his death in 1956.

DES

1. The sheet has obviously been cut along the left edge from a bound volume. Soiling along the top, right, and bottom edges indicates that it was bound for a considerable period of time.
2. Daughter of Fuseli's friend and patron the banker Thomas Coutts, Susan, Countess of Guildford (1771–1837), assembled a large collection of Fuseli's work. She may have acquired the present drawing directly from the artist or from Sir Thomas Lawrence, who purchased all of the artist's remaining drawings and sketches at his death; they were later acquired by the Countess of Guildford (Knowles 1831, 1:412).
3. Probably one of two *Modekarikaturen* in lot 239: "Dame in ganzer Figur, vom Rücken gesehen, in weissem, rotgegürteten Kleide, durch das der Körper sichtbar, mit einer Zopffrisur und hohem Kamm. H. 48, Br. 32 cm" ("rotgegürteten" refers to the pinkish sash).
4. For an extensive discussion of Fuseli's debt to mannerism, see Antal 1956, 28–65, 78–116.

5. Daniels 1975, 22–29.
6. Blake 1980, 122, no. 95 (Blake to Richard Phillips, publisher of the *Monthly Magazine*, published 1 July 1806).
7. For a psychoanalytical interpretation of Fuseli's women, see London 1975, 17–20. Freud had a reproduction of Fuseli's famous *The Nightmare* (Detroit Institute of Arts) hanging in his office (Powell 1973, 15).
8. Schiff 1973, 1:466, no. 553; 2:127, fig. 553.
9. New Haven 1979, 59–60, nos. 58–59.
10. For example, Schiff 1973, 1:469, no. 578; 2:133, fig. 578.
11. London 1975a, 52, no. 4.
12. Schiff 1973, 1:229–233, 549–553, nos. 1084–1119; 2:319–330, figs. 1084–1119.
13. London 1975a, 15–17.
14. Schiff 1973, 1:495, 515, nos. 753–754, 885; 2:187–191, 240, figs. 753–754, 885.
15. Schiff 1973, 1:618, no. 1618; 2:531, fig. 1618. Recently sold at Sotheby's, London, 20 November 1986, lot 44, the drawing is inscribed in Greek *Ponneo*, followed by an illegible capital letter. It seems likely that Fuseli misspelled *Poneo*, meaning both "I suffer pain" and "I inflict pain," which is quite in keeping with his sadomasochistic tendencies. (My sincere thanks to Professor John Thorp of the Classics Department, University of Ottawa, who suggested this interpretation.)
16. Ribeiro 1983, 15, 116–117, no. 129.
17. For an extreme example, with emphasis on both hair and buttocks as in this Fuseli, see the anonymous print ("Drawn by Mr. Perwig," "Engraved by Miss Heel") entitled *Top and Tail* and dated 1777 (in London 1984a, 62, no. 61, pl. 27).
18. Even Turner included such a quote in his *Two Women with a Letter* (c. 1835, Tate Gallery, London; Butlin and Joll 1984, 1:282, no. 448; 2: pl. 449).
19. For example, Schiff 1973, 1:613, nos. 1569–1570; 2:522, figs. 1569–1570.
20. Three similar braids are found in a drawing in Auckland (Tomory 1967, 46–47, no. 13; Schiff 1973, 1:635–636, no. 1774 [dated 1790–1792]; 2:573, fig. 1774).
21. Ribeiro 1983, 142.
22. Schiff 1973, 1:414, no. 218; 2:32, fig. 218.
23. Fuseli also used a phallic motif in the carpet.
24. According to Tomory 1972, 169, the motif represents "the transition between virginity and the breaking of the hymeneal chord." See Schiff 1973, 1:525, 600, nos. 926, 1486; 2:271, 475, figs. 926, 1486.
25. Schiff 1973, 1:494, no. 746; 2:183, fig. 746.
26. Schiff 1973, 1:547, no. 1071; 2:314, fig. 1071.
27. Tomory 1972, 169–170. Besides the Nottingham drawing, there are also a painting and engraving of the same subject (Schiff 1973, 1:548, 567, 578, nos. 1074, 1231, 1331; 2:316, 388, 420, figs. 1074, 1231, 1331).
28. Powell 1951, 12, 27–28.

## 78

## *The Valley of the Eisak in the Tyrol, near Brixen*, 1791

**John Robert Cozens**
London (?) 1752–1797 London

Watercolor over graphite on wove paper laid down on several layers of laid and wove paper

Primary support 489 x 682 (19¼ x 26¾)
Secondary support 567 x 758 (22⁵/₁₆ x 29¹³/₁₆)

Inscribed by the artist, lower left corner of secondary support, in pen and brown (iron gall) ink, *J. Cozens. 1791.;* in another hand on verso of secondary support, in graphite, *By Cozens* [from?] *the sketch* [struck through, *from a* added above] *in the poss. of Sir Ge⁰. B . . .* [illegible]; below this, in another hand, in graphite, *Brizen;* by the artist ? in pen and brown (iron gall) ink, *In the Tyrol-;* below this, in another hand, in graphite, *from a sketch in the large / collection of sketches (very slight) / in the possession of Sir. G. Beaumont Bt.;* in a later hand, on paper laid down on backboard of original frame in pen and brown ink with insertions in another hand in pen and blue ink, *Name of Artist F. J. Cosens. / Title of Work Landscape /* in pen and blue ink, *"IN THE TYROL" /* in pen and brown ink, *Owner Miss Lydia Spence / 171 Maida Vale / London W. 9. / October 25th. 1922. /* in pen and blue ink, *SKETCH OF A PICTURE IN THE COLLECTION OF SIR. GEO. BRIZEN. / (WRITTEN IN PENCIL ON THE BACKBOARD OF DRAWING).;* printed paper label laid down on backboard of original frame, with insertions in pen and brown ink, printed in black, *N.B.—This Label to be affixed to the back of the frame (not the canvas) of the Picture.* (underlined) / *ROYAL ACADEMY EXHIBITION OF WORKS BY THE OLD MASTERS, 188.,* in pen and brown ink, *91. /* printed in black, *Name of Artist,* in pen and brown ink, *F. J. Cosens /* printed in black, *Title of Work,* in pen and brown ink, *Landscape /* printed in black, *(Please correct if not properly given.) /* printed in black, *Name and Address / of Owner. /* in pen and brown ink, *Sir Bradford Leslie K.C.I.E. / F* [*T* ?] *arrangower . . .* [illegible] *on*[*u*?] *desbury*

Provenance: John Constable, R. A.; Charles Robert Leslie; his sale, Foster's, London, 25–28 April 1860, lot 402; Evans (10.10.0 pounds); Sir Bradford Leslie, K.C.I.E. (Charles Robert Leslie's son, died 1926); Miss Lydia Spence (Charles Robert Leslie's granddaughter, died 1957); A. L. Gordon (Charles Robert Leslie's great-great-grandson), 1974; Leger Galleries, London, 1974; purchased from the Leger Galleries, London, 1976

Literature: Bell and Girtin 1935, no. 205 (III); Oppé 1952, 159 n. 1; Fenwick 1966, 24; Manchester 1971, 7, 23, under no. 43; Sotheby's 1973, 16, under lot 1 (vol. 1, folio 12); Milroy 1977, 6, fig. 9

Exhibitions: London 1891, no. 23; London 1922–1923, no. 35; London 1974a, no. 2 (repr. on cover); Toronto 1987a, 142, pl. 153, no. 164

Acc. no. 18741

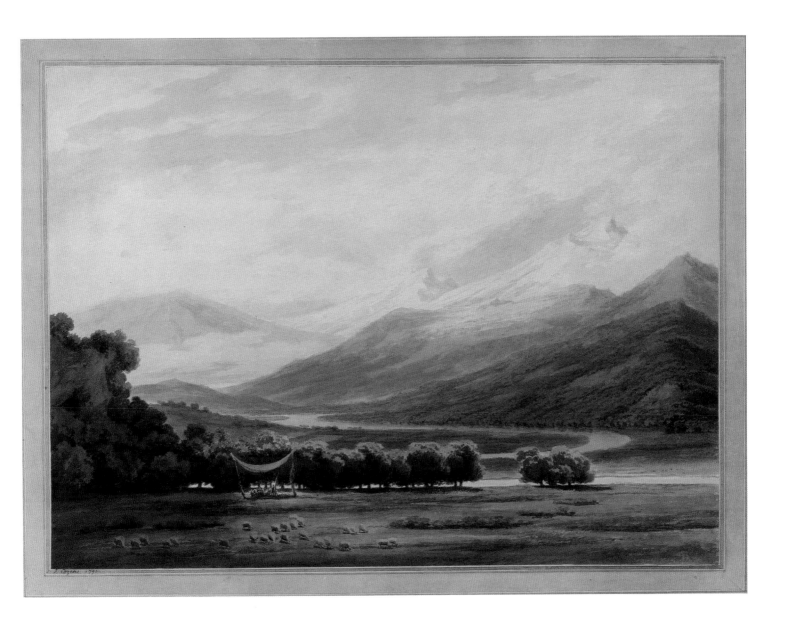

The extensive inscriptions on the verso of the original mount of this watercolor have caused a great deal of confusion about its provenance. It has often been thought that the inscription meant the watercolor was originally owned by Sir George Beaumont, Bt. (1753–1827), who had been a pupil of John Robert Cozens' father, Alexander Cozens (1717–1786), at Eaton College. Beaumont and John Robert Cozens often sketched and visited together while they were in Italy in 1782, and Beaumont helped to organize a fund to support Cozens after he became ill in 1794. Beaumont owned several watercolors and oils by Cozens, but only three can now be identified with certainty and they do not include this view in the Tyrol.[1] It is still possible, however, that the present watercolor was originally commissioned by Beaumont, since it is not known when it came into the possession of John Constable (see cat. 83) and since Constable could not possibly have been its first owner after it was painted in 1791.

It was probably Beaumont who introduced Constable to Cozens' work. From 1799 Constable had known and copied from Beaumont's London collection,

near Brixen — June 7

Fig. 1. John Robert Cozens, *Near Brixen in the Tyrol,* page 12 of the first Beckford sketchbook, 1782, Whitworth Art Gallery, University of Manchester (Courtesy of Tom Girtin, London)

which undoubtedly included works by Cozens. Constable's admiration for Cozens' work was also evident in his correspondence with Archdeacon Fisher, for whom Constable purchased a Cozens in 1819, writing "could pictures choose their possessors, you would have had many like it long ago."[2] In Hampstead two years later, Constable wrote to Fisher that he had borrowed two Cozens drawings from a neighbor to copy, and concluded, "Cozens was all poetry, and your drawing is a lovely specimen."[3]

That Constable's admiration for Cozens was lifelong is evident from the often-quoted passage from a letter from Constable to a friend while preparing his Hampstead lectures in 1835: "I want to know when the younger Cozens was born; his name was John, and he was the greatest genius that ever touched landscape."[4] The artist Charles Robert Leslie (1794–1859), who owned the present drawing after Constable's death, was Constable's great friend and biographer;

thus we need not doubt that it was once one of Constable's most treasured possessions. His ownership of this watercolor by Cozens was, therefore, very important for Constable's own work, and its original commission is thus of some significance.

An album of drawings by Cozens that was once in Sir George Beaumont's collection helps to clarify the meaning of the inscription on the verso that it was *from a sketch in the large collection of sketches (very slight) in the possession of Sir. G. Beaumont Bt.* The album, now in the Yale Center for British Art, New Haven, is labeled on its cover "Sketches in Italy by Cozens" and contains 215 tracings and drawings on oiled or varnished paper, now very fragile.[5] Nearly half of these are tracings in Cozens' own hand from the seven sketchbooks he had filled on his second European tour (1782–1784) in the entourage of William Beckford (1760–1844).[6] This wealthy young man was at that time writing his Gothic novel, *Vathek,* and he

was famous later as the builder of Fonthill Abbey, but he was also a pupil and friend of John Robert's father, Alexander. Cozens used the sketches from this trip as the basis for nearly a hundred finished watercolors for Beckford, but he also used them as the basis for watercolors for other patrons. He eventually had to give the seven sketchbooks to Beckford, since they were passed on through the latter's family, but the tracings now in the Beaumont album at Yale, made from the sketchbooks, indicate that Cozens made tracings for his own use before giving the books to Beckford.[7]

The tracing in the Beaumont album on which the Ottawa watercolor is based (1977.14.4576) is inscribed *Near Brixen— June 7* and is marked off along the bottom, left to center, for squaring up. It is traced from the original drawing on page 12 of the first Beckford sketchbook (fig. 1). At least seven finished watercolors[8] were made from this sketch and/or the tracing of it, of which the one in the National Gallery of Canada is the largest and possibly best preserved. The others vary not only in size but also in the placement of the sheep and shepherds or the addition of goats under the clump of trees on the right and the location and shape of the shepherds' shelter. None of this foreground staffage appears in the original sketch or the tracing after it. In addition to adding the dramatic clouds that sweep across the sky and tops of the mountains, Cozens also altered the shapes of the mountains in the final watercolors, making them more peaked and rugged than the fairly rolling ones of the original sketch.

William Beckford was a capricious and demanding patron, and his tour through the Alps to Italy in June 1782 was a swift one. When he set out he was looking forward to reaching the "wild rocks of the Tirol [sic]" where he would "enjoy many a deep reverie amongst their solitudes" and "the Forests of Pine which cover the Mountains."[9] When the entourage reached Augsburg on 2 June, he wrote to John Robert's father, Alexander, "your Son is well and grows every day in my esteem [but] the Weather is gloomy and every Mountain still crowned with snow."[10] In his journal two days later, at the entrance to the Tyrol, he recorded the first of Cozens' drawings in the sketchbooks: "I ran delighted into the world of

Fig. 2. John Robert Cozens, *View in the Tyrol near Brixen,* Collection of Tom Girtin, Esq., London (Courtesy Photo Archive, Paul Mellon Centre for Studies in British Art, London)

boughs, while Cozens sat down to draw the huts which are scattered about for the shelter of herds and discover themselves amongst the groves in a picturesque manner.''[11] There are no letters or journal entries for 7 June, the day Cozens drew several sketches of the valley of the River Isarco (also called Eisak), just beyond Sterzing (Vipiteno) and Brixen (Bressanone), which included the sketch for the National Gallery of Canada watercolor. However, the speed of their journey and the stormy weather that drove them on is evident in the fact that Cozens only managed to make one or two sketches each day.

The watercolor Cozens worked up for Beckford of the valley near Brixen, now in a private collection (fig. 2),[12] shows the valley not cold and cloudy, as it actually was and how Cozens depicted it in the other six versions, but as Beckford had imagined and wanted it to be—a sunny, leafy vale with goatherds emerging from a leafy forest into a picturesque valley en-

closed by rolling, tree-covered hills. Instead of this cozy image that existed only in Beckford's exuberant imagination, when Cozens executed finished versions for other patrons, he was able to convey the majestic, sweeping, even sublime scene he himself had recorded and remembered.

KS

1. Leicester 1975, 45.
2. Leslie 1843, 74.
3. Leslie 1843, 82.
4. Leslie 1843, 241.
5. The album was purchased from Beaumont's descendants in 1977 by the Yale Center for British Art, New Haven; see Bell and Girtin 1935, 6–8, and New Haven 1980, 43–48, nos. 97–128.
6. These sketchbooks are now in the Whitworth Art Gallery, University of Manchester; see Sotheby's 1973 and Toronto 1987a, 139–150, 155–157.
7. These tracings must have come into Beaumont's hands at the sale of Cozens' effects held at Greenwood's in London in 1794, when Cozens became too ill to continue working and was put in the care of Dr. Thomas Monro. The tracings were mounted in the album in that year or shortly after since the album paper is watermarked 1794.
8. Sotheby's 1973, 16, lot 1 (vol. 1, folio 12, repr.).
9. Melville 1910, 150 (letter from Brussels, 19 May 1782).
10. Melville 1910, 151 (letter to Alexander Cozens, Augsburg, 2 June 1782).
11. Bell and Girtin 1935, 17.
12. Bell and Girtin 1935, 52, no. 205.1, pl. 18(a).

## 79

## *The Lock Up,* 1790

**Thomas Rowlandson**
London 1756–1827 London

Pen and gray and brown ink with gray and brown wash and watercolor over graphite on wove paper

327 x 311 (12⁷/₈ x 12¹/₄)

Inscribed by the artist, lower left, in pen and brown ink, *T. Rowlandson. 1790.*

Provenance: Anonymous sale, Sotheby's, London, 12–13 March 1924, lot 237; purchased from Walter T. Spencer, London, 1925, on the recommendation of Charles Ricketts

Literature: Hayes 1972, 46, 140, no. 76 (as "formerly London, Walter T. Spencer"); Godfrey 1985, cover, 2, 5

Exhibition: London 1984a (shown only at Ottawa, *hors catalogue*)

Acc. no. 3232

The title of one of Thomas Rowlandson's later illustrated books, *The Dance of Life* (1817), might with justice be appropriated to describe his entire, astonishingly prolific output of prints and drawings. Part of a pan-European graphic tradition that included Giandomenico Tiepolo in Italy (see cat. 20), Francisco Goya in Spain (see cats. 59, 60), Gabriel de Saint-Aubin (1724–1780) in France, and above all, William Hogarth in England (see cat. 72), Rowlandson used his pen to mock the follies of contemporary life. And since mankind's follies are apparently infinite, so too are Rowlandson's comic exposures of them. Under his spirited baton, which never lashes but merely tickles, we jig through all ranks of late Georgian society, from the aristocracy at the gambling table to the low-life prisoners in the present drawing.[1]

By 1790, the date of this watercolor,[2] Rowlandson had established his reputation with two pairs of works that he exhibited at the Royal Academy: *Vauxhall Gardens* and *Skaters on the Serpentine* in 1784 and *The English Review* and *The French Review* in 1786, the latter set purchased for the Royal Collection.[3] In view of the disreputable subject matter of *The*

*Lock Up,* it may well be relevant to note that the year before, in April 1789, the artist had inherited the considerable sum of approximately two thousand pounds from his aunt.[4] The thirty-three-year-old heir promptly proceeded to dissipate his fortune in an orgy of gambling, drinking, and whoring that no doubt brought him into intimate contact with the sort of sordid company depicted in this picture. Far from being a dispassionate onlooker, Rowlandson participated vigorously in the life he caricatured, with the result that his moral stance is rarely highly critical, but usually comical and indulgent. When his fortune was exhausted, Rowlandson had to fall back on his true inheritance, his reed pen, which supported him for the rest of his life.[5]

Paulson is undoubtedly correct in stating that "Rowlandson's works never assume a causal sequence," as do Hogarth's, where a whole moral history of past, present, and future is revealed in one highly charged incident.[6] Hogarth was, however, a fundamental influence on Rowlandson, who owned the former's complete engraved works and even re-etched five of the earlier master's small *Hudibras* illustrations, including a

Fig. 1. Thomas Rowlandson, *The Night Watchman*, 1798, The Fine Arts Museums of San Francisco, Achenbach Foundation for Graphic Arts (Copyright The Fine Arts Museums of San Francisco)

Fig. 2. Thomas Rowlandson, *A Woman Arrested*, Henry E. Huntington Library and Art Gallery, San Marino, California

*Sidrophel,* for an 1809 edition (see cat. 72, fig. 2).[7] *The Lock Up* reveals Rowlandson's debt to Hogarth in his ability to evoke both the past and the future within the present moment. Two fashionably dressed prostitutes, still exerting their considerable charms on the world outside their barred window, find themselves sharing a cell with a blowsy old bawd or alewife who, deep in her cups, continues to carouse with a drunken soldier. An important detail, but one apt to be overlooked by a twentieth-century viewer, is the night watchman's coat, lantern, and rattle hanging on the wall behind the soldier.[8] To an eighteenth-century observer, the immediate past becomes instantly clear. On his rounds the night before, the watchman had picked up this motley crew in the street, an incident that the artist illustrated in a 1798 watercolor, where the watchman is shown with the coat, lantern, and rattle included in the present work (fig. 1).[9] So encyclopedic is Rowlandson's subject matter that the next episode in this almost cinematic history is seen in another drawing. The watchman has arrested the prostitute and leads her into the Watch

House (fig. 2),[10] no doubt the setting of the present work, where the prisoners are awaiting their fate. A second telling detail on the wall above the fat woman makes it clear what that fate will be: a corpse swinging from a gibbet.[11] In *The Lock Up,* past, present, and future are therefore suggested in a simplified, though nevertheless thoroughly Hogarthian way, by means of carefully chosen symbolic details.

In the amusing standing woman on the left with her extravagantly beplumed and beribboned hat and her rather bedraggled train, Rowlandson pays comic tribute to Henry Fuseli, whose work contains numerous erotic back views of women sporting grotesque and absurd fashions (see cat. 77).[12] The rear view exaggerating the fantastic styles then current was, moreover, a staple of fashion caricatures.[13] Beside Rowlandson's drooping peacock à la Fuseli we see a charming beauty who, if extracted from the unfortunate situation in which she finds herself, might pass for one of the more wholesome young ladies that Rowlandson derived from the work of his fellow artists Francis Wheatley and

John Downman.[14] To an unusual degree, *The Lock Up* encapsulates many of the artistic influences that Rowlandson assimilated but did not usually reveal.

The composition of *The Lock Up* is structured according to the classic system of Rowlandsonian contrasts.[15] The standing prostitute viewed from the rear is placed beside the beautiful seated woman in profile, who in turn is compared to the grotesquely ugly woman depicted in full-face. In the latter's bestial features we recall Rowlandson's interest in the comparative physiognomy of men and animals and also his debt to Leonardo, whose grotesque faces lie behind Rowlandson's, as does the brutal juxtaposition of beauty and ugliness.[16] The major contrast of the picture, however, is between the fat, toothless crone seen full-face and her companion, a skeletally thin soldier whose face is depicted in profile.[17] Here the artist has reversed his usual procedure of comparing a fresh young maid with a disgustingly grotesque, satyrlike old man in a Beauty-and-the-Beast confrontation. Rowlandson usually reserved the present male/female reversal for his treatment of

handsome young soldiers wooing hideously repulsive, but rich, old women.[18]

Rowlandson stands at the very center of the early English watercolor tradition inherited from such artists as Paul Sandby (see cat. 73).[19] Delicate pastel tints of watercolor, rising in a vivid crescendo to the red of the soldier's jacket, have been applied over a pen and ink drawing that has been washed with monochrome gray and brown to establish tonal contrasts of light and shade. This was the standard practice of the topographers in the last quarter of the eighteenth century, but by the 1790s it was regarded as old-fashioned compared with the revolution in watercolor technique achieved by John Robert Cozens (see cat. 78), among others. Rowlandson's pen line here is elegant and flowing, becoming more animated in the focal point of the composition, the juxtaposition of the bawd's and soldier's heads, which are surrounded by a swirl of calligraphic fireworks. The fact that Rowlandson is so funny often obscures his very real talents as a draftsman.

This watercolor, together with seven others by Rowlandson, was recommended for purchase in 1925 by Charles Ricketts, the English artist and aesthete, who in the mid-1920s was under contract to the National Gallery of Canada. A note from the dealer Walter T. Spencer to the first director of the National Gallery, Eric Brown, who had made the preliminary selection of the drawings, states that ''Mr Ricketts and Mr Shannon came yesterday to look at your Rowlandson's and thought them a very fine lot.''[20] The two connoisseurs purchased six Rowlandson watercolors that same year for their own distinguished collection, which was bequeathed to the Fitzwilliam Museum in Cambridge on Shannon's death in 1937.[21]

DES

1. Prison scenes are encountered with some frequency in Rowlandson's work; see, for example, Wark 1966, nos. 18, 63, 73, 88, 99; Wark 1975, no. 200; Grego 1880, 2:37, 430.

2. The dating of Rowlandson's work is notoriously difficult and complicated by the fact that many genuine inscriptions include incorrect dates. The present signature and date appear to be both authentic and correct, judging by the fashions represented. See Baum 1938.

3. Hayes 1972, 17–18, 45, fig. 22, pls. 16–17, 48–51.

4. Falk 1949, 71–72.

5. See obituary in *The Gentleman's Magazine,* June 1827, reprinted in Falk 1949, 25–26.

6. Paulson 1972, 13.

7. Grego 1880, 2:174. The prison scene is also a thoroughly Hogarthian subject; see, for example, Hogarth's early painting of a scene from *The Beggar's Opera.*

8. Hayes 1972, 140, identified the detail but did not go on to interpret its meaning.

9. See also Wark 1975, 104, no. 384, and Hayes 1972, 187, no. 123.

10. Wark 1975, 105, no. 393.

11. Scenes of execution are also found in Rowlandson's work; see, for example, Oppé 1923, pl. 86.

12. Hayes 1972, 140.

13. For example, James Gillray's *A Spencer & a Thread-paper* (1792; Hill 1976, no. 26), or his *Parasols for 1795* (Wright and Evans 1851, 421, no. 405).

14. For example, his *Duchess of Devonshire and Lady Duncannon* (1790, Yale Center for British Art; New Haven 1977b, 17, no. 23, pl. 17). See also Baskett and Snelgrove 1977, 53–54, nos. 204–207.

15. See Paulson 1972, 20–30, 74.

16. Paulson 1972, 33–34, 46, 66–70.

17. For a similar juxtaposition of soldier and barebosomed crone, see Rowlandson's *Light Horse Refreshing at an Inn* (London 1933, 39, no. 39, pl. 40).

18. For example, his 1809 etching *Oh! You're a Devil. Get Along, Do!* (Grego 1880, 2:134–135).

19. Hardie 1966–1968, 1:207.

20. National Gallery of Canada, curatorial file, note dated 7 May 1925.

21. Cambridge 1979, 72, under no. 178. I have not been able to ascertain if Ricketts purchased his Rowlandsons from Spencer.

80

*Jeune Lorette*, c. 1800

**George Heriot**

Haddington, Scotland 1759–1839 London

Watercolor over graphite on laid paper

252 x 376 (9¹⁵/₁₆ x 14³/₄)

Provenance: English collection (?); W. D. Lighthall, Montreal, through unnamed Canadian dealer, 1913; purchased from W. D. Lighthall, Montreal, 1937

Literature: National Gallery of Canada 1948, 176; Finley 1979, 32; Finley 1983, no. 77

Exhibitions: Vancouver 1966, no. 23; Windsor 1967, no. 1; Kingston 1978–1979, no. 84

Acc. no. 4300

Located on the Saint-Charles River near the city of Quebec, Jeune Lorette was an Indian community established following the displacement of the Hurons from the shores of the Great Lakes by the Iroquois in 1649. George Heriot said of the village:

Jeune Lorette is situated nine miles to the north-west of Quebec, upon a tract of land which rises towards the mountains. It commands, by its elevated position, an extensive

view of the river Saint Lawrence, of Quebec, of the immediate country, of the southern coast, and of the mountains which separate Canada from the United States. The village, which contains upwards of two hundred inhabitants, consists of about fifty houses, constructed of wood and stone, which have a decent appearance. . . . The chapel is small but neat . . . [which] the Indians attend, with scrupulous attention, to the performance of their devotions. . . . They live together in a state of almost uninterrupted harmony and tranquility.[1]

For the well-heeled inhabitants of Quebec City, Jeune Lorette was a popular spot for an interesting day's excursion into the countryside. For Heriot, Jeune Lorette held a particular interest.

Born into an old and notable Scottish family, George Heriot received a classical education in Edinburgh. In 1781 Heriot enrolled in the Royal Military Academy at Woolwich, not to gain an officer's commission but for the opportunity to study with the drawing master Paul Sandby (see cat. 73). Under Sandby's tutelage, Heriot rapidly developed as an artist, absorbing his master's style and the picturesque tradition. Upon leaving Woolwich Heriot took up a civilian position in the army's Ordnance department. It was this occupation that brought him to Canada from 1792 to 1796 and again from 1797 to 1816. (During his second posting he was appointed Deputy Postmaster General for British North America.) While in Canada, Heriot never ceased to pursue his interest in art, history, and writing. He wrote two books about Canada, a general history in 1804 and an illustrated travelogue in 1807.[2]

Jeune Lorette as depicted here is seen through the culturally biased eyes of this sophisticated British gentleman. At first glance it could be mistaken for any peaceful English village. Its rendering faithfully adheres to all the essential qualities of a truly picturesque landscape.

The only feature that places the subject in its proper locale is the scattering of a few Indians in the foreground. Yet even they suffer from Heriot's preconceptions. Heriot found the customs of the Hurons at Jeune Lorette of particular interest, even though he recognized that much of their culture had been undermined by long and close contact with Europeans. He made several watercolors of their traditional dances and devoted a chapter in his Canadian travel book to the American Indian. Although he found aspects of their culture "uniformly rude and disgusting,"[3] intellectually and artistically he modified reality with an overlay of the European concept of the Noble Savage while also borrowing from old texts and engravings to achieve historic authenticity. In this watercolor Heriot therefore abandons accuracy for stereotype. One naked Indian fulfills the role of the Noble Savage while the others appear in a variety of costumes to represent all Indians but in particular the Hurons of Jeune Lorette.

The closeness of this watercolor to Heriot's description of Jeune Lorette suggests that it was intended for his illustrated *Travels through the Canadas* (1807). Instead Heriot selected for translation into colored aquatint another view of Jeune Lorette seen from the bottom of the cataract.

RLT

1. Heriot 1807, 80–81.
2. Heriot 1804; Heriot 1807.
3. Heriot 1807, 82.

81

*A View near Lyme Regis, 1797–1798*

**Thomas Girtin**

Southwark 1775–1802 London

Watercolor over graphite on laid paper laid down on heavy wove paper

240 x 549 (9⁷/₁₆ x 21⁵/₈)

Inscribed in an unknown hand, verso center, in graphite, *18075*

Provenance: Edward Cohen (son of Girtin's wife by her second marriage); Edward Poulter; Victor Reinacker; Miss Winnifred M. Church; her sale, Sotheby's, London, 4 May 1949, lot 2; purchased from Thomas Agnew & Sons, London, 1950, through Paul Oppé

Literature: Girtin and Loshak 1954, 166, no. 239 (as *Above Lyme Regis, Dorset (a)*; Fenwick 1966, 24; New Haven 1986, 17

Acc. no. 5065

From the titles of the watercolors Thomas Girtin exhibited at the Royal Academy in the spring of 1798, it is evident that he had spent the previous summer touring the southwestern counties of England. The area around Lyme Regis on the Dor- set coast seems to have been particularly attractive to him, since there are at least four finished watercolors of the coast and rolling hills above the town.[1] Three of these, including the present watercolor, were apparently painted in the winter in London from sketches made on the spot in the summer of 1797.[2]

In this practice he was very much like his friend and contemporary J. M. W. Turner (cat. 82) and other artists working in watercolor at the time whose work Girtin and Turner knew well and had even copied, including Edward Dayes, Thomas Malton, Michael Angelo Rooker, and, particularly, John Robert Cozens (cat. 78). From 1794 to 1797 Turner and Girtin had worked for the collector Dr. Thomas Monro at his evening "Acad- emy" in Adelphi Terrace, where they copied Cozens' sketches from his tours

Fig. 1. Thomas Girtin, *Above Lyme Regis*, formerly Collection of Major Stephen Courtauld, present location unknown (Courtesy of Tom Girtin, London)

through the Alps and Italy.[3] The influence of Cozens on both these artists' work was profound and immediately apparent in the new way they began to look at nature. Turner used his imagination to rearrange and recombine elements of the landscapes drawn in his sketchbooks into watercolors with stronger dramatic and visual impact. Unfortunately, unlike Turner, few of Girtin's pencil sketches done on his summer tours survive. Enough remain, however, to establish that he was faithful to his first vision of the landscape, following his sketches closely for his finished watercolors.

Before he began to attend Dr. Monro's "Academy," Girtin's watercolors were characterized by a straightforward topographical approach, colored in the traditional tinted drawing technique. After his exposure to the rolling landscape of the north of England on his summer tour of 1796 and to the sketches and finished watercolors of John Robert Cozens, the architectural features that had been central to Girtin's earlier watercolors began to become integral features of the landscape, which in turn was often now depicted as a panorama into which he managed to instill a sense of atmosphere and some of his own feelings for the landscape.

By the time he painted the Ottawa *View near Lyme Regis*, Girtin was becoming a master of panoramic views, competent at capturing the spirit of the place. He was also by then adept at Cozens' watercolor technique, which relied strongly on di-

rectly applied local color. Instead of using his characteristic pencil drawing with its hooks and dashes to give an underlying unity to his composition, as in earlier watercolors, in this work Girtin uses watercolor like oil paint, building up forms with successive layers and touches of local color. This technique, pioneered by Cozens, gave watercolors the solidity and presence that allowed them to compete with oils on the walls of the Royal Academy and of patrons' houses. Girtin added his own refinements to this technique; in this work he uses a very fine brush for the final details, so that the hooks and dashes of orange, brown, red, and pale and bright blues play over the surface of the painting. However, the strongest unifying effect comes from the texture and tone of the "cartridge" paper Girtin favored, with its mixed fibers and heavy wire lines.[4]

Girtin had spent some of the previous two years studying the work of old masters like Claude Lorrain and copying works by Piranesi, Marco Ricci, and such English Claudeans as Richard Wilson. His use here of the slanting rays of the sun is one of the classical devices Girtin favored and adapted to his own use, while at the same time he rejected others that had become rather hackneyed, like *repoussoir* trees or strong, dark foregrounds. He also copied Dutch prints, which obviously influenced the way he treated panoramic landscapes.[5]

Although the National Gallery of Canada's watercolor was not exhibited at the

Royal Academy, its size indicates that it was intended to have been framed and hung rather than placed in a portfolio. A similar work, entitled *Above Lyme Regis* (fig. 1), of almost identical dimensions and depicting a view looking in the opposite direction, toward the sea, reinforces this conclusion since they appear to have been intended as a pair,[6] possibly commissioned by a private patron to depict the views from his house.

The sky in *Above Lyme Regis* appears to be rather badly faded, unlike the powerful blue-gray clouds and rays of sunlight that alternately lighten and darken the hills and fields of the Ottawa drawing. Girtin's particular skill, so clearly illustrated here, was in uniting the earth and the sky and thus lending his watercolors a strong sense of atmosphere and place. This and his talent for self-expression in his panoramic landscapes were Girtin's unique contribution to the beginnings of romanticism in English watercolors,[7] and they elevate this *View near Lyme Regis* from a topographical bird's-eye view to a panorama that evokes a late summer afternoon in the English countryside.

K S

1. Girtin and Loshak 1954, no. 209, *Lyme Regis, Dorset* (location not known at that time, now Yale Center for British Art, New Haven); no. 198, *Coast of Dorset with the Town of Lyme* (present location unknown); no. 239, as *Above Lyme Regis, Dorset (a)* (National Gallery of Canada, Ottawa); and no. 240, *Above Lyme Regis (b)* (ex coll. Major Stephen Courtauld, present location unknown).
2. The fourth, the one now at the Yale Center for British Art, New Haven, may have been executed as late as 1801; see New Haven 1986, 17, 46, no. 86 (repr.).
3. For the most recent discussion of Girtin's work for Dr. Monro, see New Haven 1986, 12–14.
4. For the identification of this paper, which Girtin was the first to use consistently, see London 1987b, 84–86.
5. See New Haven 1986, 15–17.
6. I am grateful to Susan Morris for her suggestion that these two watercolors were executed as a pair.
7. See Hardie 1966–1968, 2:19.

## Joseph Mallord William Turner
London 1775–1851 London

**after James Hakewill** 1778–1843

# 82
# *Forum Romanum*, 1818

Watercolor over traces of graphite on wove paper laid down on wove paper

140 x 216 (5¹/₂ x 8¹/₂)

Inscribed by the artist, lower right, in pen and brown watercolor, *J M W Turner 1818*

Provenance: A trust estate (John Dillon?) sale, Christie's, London, 29 April 1869, lot 142; Vokins; Lord Justice Giffard; his sale, Christie's, London, 23 March 1889, lot 76; Vokins; T. Maclean, 1889; gift of Frederick John Nettlefold, Nutley, Sussex, 1948

Literature: Hakewill 1820, pl. 21 (engraving by G. Hollis and J. Mitan); Roscoe 1831, pl. 5 (engraving by J. Henshall, 1830); Roscoe 1832 (?), opp. 272 (repr., engraving by J. Henshall, 1830); Redford 1888, 2:179; Armstrong 1902, 274; Thornbury 1904, 161, 577 (wrongly described as engraved by J. Le Keux); Rawlinson 1908, 1:81, 2:192; Rawlinson and Finberg 1909, 15, 18; Graves 1921, 3:226, 241; Anonymous 1928, 241 (repr.), 258; Grundy and Roe 1933–1938, 4:26, 27 (repr.); Finberg 1939, 253, 491, no. 363; Anonymous 1948, lix; Anonymous 1949, 434 (repr.); Bury 1950, 84, 85 (repr.); Hubbard 1959a, 159 (repr.); *Encyclopedia of Art* 1970, 21:4370 (repr.), 4371; Wilton 1979b, 382, no. 705; Powell 1982, 418–419, 423 n. 41; Powell 1987, 18, 56, 201; Gage 1987, 58, fig. 82

Exhibitions: Liverpool 1831, no. 222;[1] London 1899;[2] Montreal 1953, no. 251; Kingston 1965, no. 17; Florence 1969, 57, no. 45, fig. 44; London 1969, no. 75 (repr.); Paris 1969–1970, 72–73, no. 76, pl. 36

Acc. no. 4920

A visit to Italy had been one of Turner's greatest ambitions for over twenty years, from his earliest days as a student at the Royal Academy until long after his own appointment there as professor of perspective. The dictate of Reynolds and the general belief of all British Royal Academicians was that it was not possible to become a great artist without spending time in Italy, and especially in Rome, studying from life, the antique, and the work of the old masters. Turner's attempts to go there were frustrated at first by the Napoleonic Wars (during the brief respite in 1802 he managed to visit France and the Swiss Alps) and, once the war with France was over, by pressure of business. In 1818, however, Turner re-

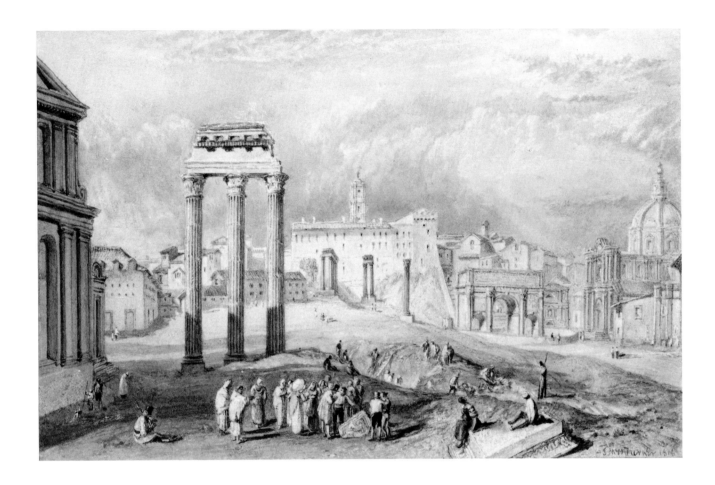

ceived a commission that revived his determination to visit Italy. The following year, when the project was finished, at the mature age of forty-four, Turner made his first long study tour of Italy (August 1819–February 1820), and his work was transformed immeasurably by it.

Turner's commission of 1818 was to convert the detailed topographical pencil drawings of Italy by the architect James Hakewill (1778–1843) into atmospheric watercolors that could be engraved as plates for the architect's book, *A Picturesque Tour of Italy*. The publication was to follow the currently popular format for armchair travelers. It was to be released from 1818 to 1819 in fifteen parts, each with five engravings and a brief descriptive text written by John Thomas James (1786–1828) and based on the respected guidebooks of Joseph Addison, John Eustace, and Joseph Forsyth.[3] Several artists and engravers were involved, but the publisher, John Murray, was inclined to approve only those watercolors produced by Turner, who therefore got the lion's share of the commission—twenty watercolors in all.[4]

Turner was not unaccustomed to transforming drawings taken on the spot into finished watercolors for patrons or engravers, but always before it was of an area he had himself visited. In order to do justice to the present project, he had lengthy conversations with Hakewill, who eventually supplied Turner with a suggested route for his own tour of Italy and recommended several guidebooks, which Turner obviously studied carefully while working on the watercolors for this commission.[5] It was not, however, the study of these sources alone that enabled Turner to transform Hakewill's rather pedantic, detailed views, taken with the aid

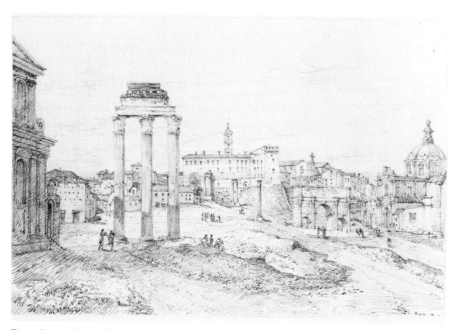

Fig. 1. James Hakewill, *Forum Romanum,* Collection of Stuart B. Schimmel, Greenwich, Connecticut, and London (Courtesy of Cyril Fry, London)

of a *camera lucida,* into watercolors with the appropriate color, light, atmosphere, and staffage. Turner's knowledge of these aspects of Italy had also been gleaned through his study of the Italian masters in British collections and the Italian paintings he had seen in the Louvre on his brief visit to France, as well as his extensive study of the classics, the history of ancient Italy, and the relevant work of contemporary authors and poets, particularly James Thomson and Lord Byron.[6]

The present watercolor of the *Forum Romanum* provides an excellent example of how Turner transformed Hakewill's objective drawing (fig. 1) into a striking image that brings to life the past and present of one of the most revered sites of ancient and modern Rome. According to Eustace, the Forum "presented one of the richest exhibitions that eyes could behold, or human ingenuity invent," and "its name was coeval with the city . . . connected with all the glories of the Republic . . . the seat or rather the throne of Roman power."[7] Eustace went on, how-

ever, to remind the reader that although it was once great, the Republic and the Forum "are now fled for ever; its temples are fallen, its sanctuaries have crumbled into dust, its colonades encumber its pavements now buried under the remains."[8]

John James, the author of the letterpress description published alongside the engraving of Turner's view (fig. 2), provided a historical description of the buildings that had once occupied the site and proposed identifications of the ruins that remained. He also commented on current archaeological excavations in the Forum, in particular the circular wall, funded by the French government, around the Arch of Septimius Severus in the distance and those undertaken at the expense of the papal government in front of the three columns in the foreground.

Hakewill's original drawing was an accurate delineation of the sites that remained, as dry as James' antiquarian description, with tiny contemporary figures dotted about and no sense of atmosphere or the "glory that was once Rome."

Turner's meticulously painted clouds are a beautiful shade of blue, which is a bit too cool for the warm Mediterranean light Turner had not yet seen himself. Nevertheless, they form a striking backdrop to the warm earth tones of the Forum and cast flickering pools of light and shade that highlight the more ancient ruins whose strong vertical statements convey something of Eustace's veneration and the greatness of the site, once the seat of the ancient Republic of Rome. At the same time, the modern city and its particular greatness and power are not forgotten—the light catches the crosses and rounded baroque beauty of the facades and dome of more modern "temples." Turner reminds us of the present inhabitants' connection with and reverence for antiquity, which was the main theme of James' accompanying text, by adding the large groups of figures watching and discussing the excavations in the foreground.[9]

While Turner's work for Hakewill revived his desire to visit Italy, the commission continued to influence Turner once

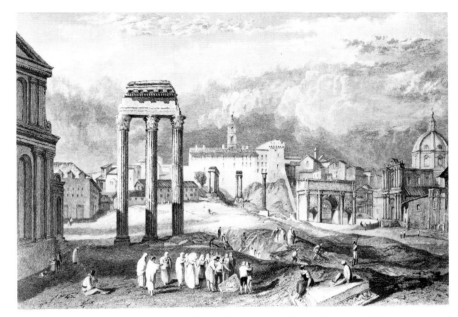

Fig. 2. George Hollis, after Joseph Mallord William Turner, *Forum Romanum*, Collection of Stuart B. Schimmel, Greenwich, Connecticut, and London (Courtesy of Cyril Fry, London)

he arrived in Rome, since he often stood on the same spot as had Hakewill to sketch. In the years following his visit, Turner continued to dwell on the theme of ancient and modern Rome; in 1826 he produced an oil of the *Forum Romanum* for Sir John Soane's Museum, London, and in 1839 two large important oils further elucidated this theme, which had first been expressed in works like the Ottawa watercolor of the *Forum Romanum*.[10]

K S

1. Bell 1901, 169.

2. Graves 1914, 3:1354, no. 110.

3. Powell 1982, 411 n. 16 and n. 20. See this article and the same author's book of 1987 for the most recent and thorough discussion of Hakewill's book and Turner's involvement with the project.

4. Turner was paid twenty guineas for each watercolor, but all the planned parts were not published, and two of Turner's watercolors were not used when the book appeared as a whole in 1820; see Powell 1982, 413–414.

5. See Powell 1987, 13–14, and Gage 1987, 46–48.

6. The fourth canto of Byron's *Childe Harold's Pilgrimage* appeared in the spring of 1818 and strongly influenced Turner's vision in several of the watercolors; see Powell 1982, 415.

7. Eustace 1813–1819, 1:216; 2:88.

8. Eustace 1813–1819, 1:217.

9. Gage 1987, 58, states that in his later oil *Modern Rome* (see note 10, below), Turner added an inscription to the large fragment in the foreground, *PONT* [IFEX] *MAX*[IMUS], a reference to the papal government's funding of the excavation.

10. The paintings of 1839 were titled *Ancient Rome—Agrippina Landing with the Ashes of Germanicus* and *Modern Rome—Campo Vaccino*. For a discussion of these three oils and their intended meanings, see Powell 1987, 121–126, 182–188, and Gage 1987, 56–58.

## 83
### *Saint Martin's Church, Salisbury, 1820*

**John Constable**
East Bergholt 1776–1837 London

Graphite on wove paper removed from a sketchbook (sewing holes and torn edges on left side)

115 x 184 (4¹/₂ x 7¹/₄)

Inscribed in an unknown hand, verso center, in graphite, *9460 | John Constable R. A.;* in an unknown hand, lower left in graphite, *M. L. C-;* in an unknown hand, lower right, in pen and brown ink, *R. Thompson Esq. from Isabel Constable;* in an unknown hand, upper right, in graphite, *38*

Provenance: The artist's eldest daughter, Maria Louisa Constable; the artist's second daughter, Isabel Constable; given by her to R. A. Thompson; his great-niece, Mrs. Bell Duckett; her sale, Morrison, McChlery and Co., Glasgow, 18 March 1960, lot 102; purchased from Frank T. Sabin, London, 1960

Literature: Reynolds 1984, 58, no. 20.57 (as private collection), pl. 178

Exhibition: Kingston 1962, no. 64

Acc. no. 9086

Maria Louisa Constable, John Constable's second child, was one year old when her family spent the summer of 1820 at the home of her godfather, Archdeacon John Fisher, in the close of Salisbury Cathedral. It was the pencil and oil sketches that Constable made on this visit, including the oil sketch now also in the National Gallery of Canada, that inspired the bishop of Salisbury to commission the large well-known painting of the cathedral now in the Victoria & Albert Museum, London.[1]

During that summer Constable used two sketchbooks the size of the present drawing, and there can be no doubt that this drawing of Saint Martin's Church is

from one of them; not only is the size the same, but the style of the drawing is very close to that of other dated drawings from the two sketchbooks of July and August 1820. At this time Constable was beginning to pay special attention to achieving what he described as an overall "effect" in his works, mainly by attempting to unite the sky with the landscape so that the one reflected the other. Here the oncoming, darkening clouds, which cast deep shadows in the churchyard, are blown across the sky by the same wind that bends the trees and even the grass beneath them. Constable emphasizes the sense of movement by the use of diagonal scratches in the heavier areas of pencil shading, a technique also found in other drawings from that summer.[2]

In addition to making several studies of Salisbury Cathedral and details of its architecture and surrounding grounds, in the summer of 1820 Constable also visited and drew Gillingham Church (one of the archdeacon's parishes) and the churchyard of Downton, near the New Forest, which he visited with Fisher. This connection with Fisher provides obvious reasons why Constable should have made drawings of those churches in particular, but not for why he would visit and draw Saint Martin's, a flint structure dating from the thirteenth century, which had been given an ashlar facing on the tower and west wall in 1791. The avenue of limes visible in Constable's drawing, which had been planted in 1792, lead to a turnstile in the southeast corner of the churchyard.[3] The church contained notable fifteenth-century corbels, which Constable, who showed an interest in such architectural details around this time,[4] may have wished to study.

There may have been, however, another reason why Constable chose to draw this particular churchyard. Views of his local parish church at East Bergholt occur frequently in his oeuvre, and include his first known exhibited oil, of 1811, and a drawing of 1818 that focuses on the tombs of his parents in the churchyard. Throughout his life Constable seems to have taken every opportunity to make drawings of churchyards similar to this view of Saint Martin's.[5] The reason is possibly that they visualized for him the setting of Thomas Gray's well-known *Elegy Written in a Country Churchyard.* It is known that his

1811 oil of *The Church Porch, East Bergholt* was painted with Gray's poem in mind, and there is evidence that in 1833 Constable based his illustrations for Gray's poem on various churchyards he had drawn throughout his career.[6] He was familiar with and admired the work of a large number of English eighteenth-century poets, whose vision of England played an important role in his own attempts to convey his native land on canvas.

In the text that accompanied Constable's view of Stoke Church near Neyland, Suffolk, in his *Various Subjects of Landscape Characteristic of English Scenery . . .*, 1830–1832, he described many similar

noble Gothic churches . . . [which], seen . . . in solitary and imposing grandeur in neglected and almost deserted spots, imparts a peculiar sentiment and gives a solemn air to even the country itself and they cannot fail to impress the mind of the stranger with the mingled emotions of melancholy and admiration. . . . The venerable grandeur of these religious edifices, with the charm the mellowing hand of time hath cast over them, gives them an aspect of extreme solemnity and pathos.[7]

Although in this instance he was referring to the churches of his native county, this passage underlines the fact that Constable had a particular penchant for gothic parish churches that had been mellowed by time. It is not surprising then that, when Maria Louisa Constable came to choose which drawings from her father's sketchbooks she would like to keep for herself,[8] she included this drawing, which was not just a depiction of a church in the city that had such happy memories for her family, but was also an evocative reminder of her father's poetic feeling for such scenes.

K S

1. This painting was exhibited at the Royal Academy in 1823; see London 1976a, 131, no. 216 (repr.).
2. See Reynolds 1984, no. 20.21, pl. 148 (also once belonged to Maria Louisa Constable); no. 20.46, pl. 168; and Reynolds 1973, 134, no. 205, pl. 152.
3. Crittall 1962, 144–147.
4. Reynolds 1984, no. 20.47, pl. 169; no. 20.73, pl. 194.
5. For discussion and reproductions of his drawings of churchyards, see London 1976a, nos. 10, 17, 36, 99, 101, 162.
6. London 1976a, nos. 298–302. For Constable's views on eighteenth-century poetry and in particular Gray's *Elegy*, see Rosenthal 1983, 48–51.
7. Wilton 1979a, 38.
8. For the breaking up of the sketchbooks while they were still in Constable's family's hands, see Reynolds 1973, 5.

84

*View on the River Wye, near Chepstow, 1844*

**John Martin**

Haydon Bridge, Northumberland
1789–1854 Douglas, Isle of Man

Watercolor, gouache, and touches of oil paint (?) over graphite with scraping out, heightened with varnish and/or gum arabic, on wove paper

299 x 718 (11¾ x 28¼)

Inscribed by the artist, lower right, in brush point and brown paint, *J. Martin. 1844*

Provenance: John Baskett; purchased from Hazlitt, Gooden & Fox, London, 1981

Literature: Feaver 1975, 168, 178, 232 n. 49, pl. VI

Exhibition: London 1975b, no. 45, pl. 46

Acc. no. 26820

As befits an artist who was born on a farm named East Landends and whose family contained more than its share of madness, John Martin spent most of his career in either heaven or hell, creating such apocalyptic visions of Edenic bliss or Satanic destruction as *The Fall of Babylon* (1819), *Belshazzar's Feast* (1820), *Adam and Eve Entertaining the Angel Raphael* (1823), *The Deluge* (1826), and his final sublime Last Judgment trilogy (1852–1853).[1] Now and then, however, perhaps more

frequently than his contemporaries realized, Martin came down to earth to paint landscapes in watercolor, which he often approached in the same visionary vein as his great thundering machines. Such a watercolor is the present *View on the River Wye, near Chepstow*, created in 1844 during the last decade of the artist's life.

Having grown up in the Tyne River Valley in Northumberland, Martin showed a distinct preference for dramatic river valley landscapes throughout his career.[2] On his arrival in London in 1806, he sold topographical drawings to the publisher Rudolph Ackermann (1764–1834) and among his first exhibits at the British Institution were views of Hampstead, Carisbrooke Castle, and Kensington Gardens.[3] With his reputation established in the 1820s, Martin became more and more preoccupied during the following decade with grandiose engineering projects to bring pure water to London, to control pollution and flooding, to com-

Fig. 1. John Martin, *The Wye Valley*, 1844, Whitworth Art Gallery, University of Manchester

plete the Thames embankment, and to recycle sewage. On the verge of bankruptcy in 1838, the artist reestablished his reputation with *The Coronation of Queen Victoria* (1839).[4] Judging by his exhibited pictures, from this time on Martin made increasing numbers of watercolor landscapes, which apparently found more ready purchasers than his enormous canvases depicting Divine urban renewal.

Two of his huge pictures, in what Morton D. Paley describes as Martin's "apocalyptic beautiful" mode,[5] look forward to the Wye landscapes of the mid-1840s: *The Eve of the Deluge* (1840), commissioned by Prince Albert, and *The Celestial City and River of Bliss* (1841), based on Milton.[6] Both show vast river valley landscapes receding into an infinity of pure dazzling light and prefigure Martin's definitive statement of paradisiacal joy in *The Plains of Heaven* (1853).

Although Martin was essentially an urban man, he made frequent excursions into the countryside surrounding London, returning with sketches of Richmond Park, the valley of the Wandle, Hangar Hill, and Twickenham.[7] From time to time he seems to have struck out farther afield to Sussex, the Isle of Wight, and Monmouthshire in southeast Wales along the English border. There he was especially captivated by the view from the Wyndcliff of the River Wye as it winds its way past Chepstow to the mouth of the Severn on the horizon.[8] In 1845 Martin exhibited *View on the River Wye, Looking towards Chepstow* at the Royal Academy, following it with *View of the Wynn* [sic] *Cliff on the Wye* two years later, and *View from the Wyndcliff* and

*View, Looking towards the Wyndcliff* in 1850.[9] In 1848 he showed three watercolors at the Society of British Artists, all entitled *View from the Wyndcliff*.[10] It seems quite likely that the impressive Ottawa landscape was one of these exhibited works, but positive identification remains difficult because of the numerous replicas Martin made of favorite compositions. Just as his greatest hit, *Belshazzar's Feast*, exists in at least four autograph versions,[11] so the present Wye Valley view is repeated in another almost identical version now in the Whitworth Art Gallery, University of Manchester (fig. 1), also dated 1844, as well as in an oil copy.[12]

It would appear that not all of these Wye landscapes were sold during the various exhibitions, or perhaps Martin made duplicates of his favorite subjects for himself,[13] for after his death many works bearing the same titles as the exhibited views were included in a sale of fifty-nine of his watercolors at Christie's, London, in May 1854.[14] The reviewer of *The Athenaeum* was surprised to encounter so many of Martin's landscapes, indicating that the artist's great apocalyptic canvases had eclipsed his more intimate watercolors in the public mind:

These works, beautiful in execution, finished with all the dainty minuteness of even a woman's hand, and deep and bright in colour, presented us with a new view of the artist's character. He who revelled in vastness and sublimity . . . could go out and watch, it seems, with a poet's love . . . rivers winding "at their own sweet will" calm and child-like under the benediction of the sun. . . . The best of the whole collection for finish and tone were the views from the 'Wynd Cliff,' the au-

tumnal foliage being composed of a depth of transparent and glowing colours we never saw so richly heaped together, or so finely contrasted with the faint purple of the retreating distance, with the cliffs of Chepstow and the waves of the Severn white in the horizon.[15]

If the Ottawa watercolor was not among these works singled out for special praise, it is a close variant of them. Surprisingly, yet another watercolor entitled *The Wynd Cliff* appeared in the artist's house sale in July 1854.[16]

In the Ottawa watercolor Martin has applied gouache and even perhaps touches of oil paint, all heightened with liberal applications of varnish or gum arabic, to produce the highly saturated hues of an "exhibition" watercolor, which in scale and finish sought to rival an oil painting.[17] Martin chose a dramatic bird's-eye view over the magnificent S-curve of the river, a broad panorama in the tradition of Bruegel's world landscapes. The spatial sweep is enhanced by the long narrow format that Martin often favored for his landscapes, perhaps influenced by the similarly shaped Petworth canvases by Turner.[18] Although Martin had published seven etchings in *Characters of Trees* (London, 1817), each delineating a specific type,[19] in his Wye landscape his foliage resembles the pointillistic, jewellike confections of the china painter, a trade that Martin had in fact practiced in his youth.[20] The dark vertical banks of trees at either side act as theatrical flats to set off the luminous backdrop, where transparent glazes produce the glowing effect of painted glass, another art form that Martin had mastered during his early years. The melodramatic contrasts of chiaroscuro were learned from the mezzotint process, for Martin was one of the few artists who used the medium for original, as opposed to reproductive, prints.[21] Tiny, antlike figures—a couple enjoying the view, a man on horseback, and a small boat on the curve of the river—define by their very minuteness the vast scale of the view and derive from such sublime precedents as John Robert Cozens' watercolors (see cat. 78).[22]

Comparing the Manchester (fig. 1) and Ottawa versions, we notice that in the latter Martin has darkened and enlarged the *repoussoir* trees and added, very effectively, the two ravens in the left middle ground, not only to define the space and provide a focal point for the eye, but also

to instill a note of foreboding. The birds of ill omen have in fact flown into the Wye Valley from Martin's *The Eve of the Deluge,* where they prefigure the coming destruction.[23] The improvements in the Ottawa composition, together with its broader handling, may indicate that it is the later of the two.

Martin had an unexpected influence on the course of American painting. In 1829 Thomas Cole met Martin in London and soon after planned *The Course of Empire,* a cycle of four grandiose pictures very much in the Martin vein.[24] When they painted the New World landscape, Cole and his followers, especially Frederick Church, saw their subjects as the unspoiled Eden that Martin had depicted so evocatively in such works as *View on the River Wye, near Chepstow.*

DES

1. Feaver 1975, pls. 26, III, 38, IV (1834 version), 147, VII, and 155, respectively.
2. Feaver 1975, 178, suggests that the Wye landscape reminded the artist of childhood scenes.
3. Feaver 1975, 12; Graves 1875, 370 (Martin's exhibits in 1816, nos. 49, 74, 145, 147, 178); and London 1975b, nos. 7–8.
4. Feaver 1975, pl. 119.
5. Paley 1986, 153.
6. Feaver 1975, pls. 121, 125.
7. Balston 1947, 280–281.
8. Artists had been going to Wales for picturesque prospects ever since the Reverend William Gilpin and Paul Sandby made their first visits there in 1770. The ruins of Tintern Abbey, a short distance upstream from Martin s view, became an especially popular romantic subject for countless painters.
9. Graves 1905–1906, 5:205 (Martin's exhibits in 1845, no. 707; 1847, no. 977; 1850, nos. 954, 976). What was apparently the 1845 exhibit, signed and dated 1844, was sold at Christie's, London, 1 March 1977, lot 176, the property of the late Mrs. R. Frank. I am indebted to Francis W. Hawcroft of the Whitworth Art Gallery, University of Manchester, for bringing this work to my attention.
10. London 1975b, 43, under no. 45.
11. Paley 1986, 189–190.
12. Feaver 1975, 232 n. 49.
13. Suggested by Balston 1947, 254.
14. *Catalogue of the Entire Collection of Exquisite Drawings in Water-Colours, By that Distinguished and Highly Poetical Artist, John Martin . . .,* Christie's, London, 22 May 1854; *The Wynd Cliff* (lot 10), *The Double View on the Wye* (lot 51), *A View of the Wynd Cliff* (lot 52), and *The Wynd Cliff* (lot 53).
15. Anonymous 1854, 657. Slightly different edited versions are given in Pendered 1923, 112–113, and Balston 1947, 254–255.
16. *Catalogue of Capital Modern Furniture and Collection of Works of Art, Of that Distinguished Artist, John Martin . . .,* Christie's, London, 4–5 July 1854, at Lindsey House, Battersea Bridge (Martin's home), lot 223.
17. See New Haven 1981, 15–24.
18. Turner was a major influence on Martin, his *Snowstorm: Hannibal Crossing the Alps* (1812) being an important prototype for Martin's cataclysmic subjects. Turner had included a plate entitled *Junction of Severn and Wye* in his *Liber Studiorum* (Finberg 1924, no. 28), and his many panoramic views of river valleys, such as *The Vale of Ashburnham* (1816; London 1975d, 92–93, no. 45), provide precedents for Martin's Wye landscapes. An example of Turner's elongated format is the *Petworth Park, Tillington Church in the Distance* (c. 1828; London 1974b, no. 325).
19. Williamstown 1986–1987, no. 2; Johnstone 1974, 54–55.
20. In the workshop of William Collins in the Strand, where Martin also learned glass painting (Feaver 1975, 13–15).
21. See Williamstown 1986–1987.
22. "It is interesting to note that, even in his landscapes, man remained for Martin a diminutive figure, and that the trees are unduly large in proportion to those under them" (Todd 1946, 111).
23. Feaver 1975, 161.
24. Feaver 1975, 107–110; Baigell 1981, 40, 42, figs. 4–6, pl. 15.

85

*Oak Trees, Lullingstone Park,* 1828

**Samuel Palmer**
London 1805–1881 Reigate

Pen and brown (iron gall) ink and wash, graphite, watercolor, gouache, and opaque white, with gum arabic and scraping out, on gray wove paper

295 x 468 (11⅝ x 18⁷⁄₁₆)

Inscribed by the artist, lower right, in pen and brown ink, *S. Palmer*; in another hand (Linnell's?), verso lower right, in pen and brown ink, *Shoreham / By Samuel Palmer*

Provenance: John Linnell; his grandson, Herbert Linnell; purchased from Walker's Galleries, London, 1937, through Paul Oppé

Literature: Walker's Galleries (London) 1937a, 3; Walker's Galleries (London) 1937b, 1; Grigson 1937, 10, opp. 16 (repr.); Oppé 1941, 56, pl. E; Howard 1946, 13; Grigson 1947, 89, 170, no. 62; Boase 1959, 64, pl. 26b; Fenwick 1964, 2; Popham and Fenwick 1965, ix; Fenwick 1966, 24; Peacock 1968, 134, monochrome pl. 3; Boggs 1969, 152; London 1969, 8; Florence 1969, 10; Paris 1969–1970, 10; Boggs 1971, 33, 182, pl. 182; Sellars 1974, 52, 58, 145, pl. 46; New Haven 1977a, 120, under no. 217; London 1982a, 62, under no. 32; Lister 1985, 52–53, 56, no. 13; Lister 1988, no. 88

Exhibitions: London 1937, 10, opp. 10 (repr.), no. 88; New York 1949, no. 7; Montreal 1953, no. 256; London 1957, 14, no. 17; Victoria 1965, 81, no. 23; Detroit 1968, 260–262, no. 180

Acc. no. 4357

Fig. 1. Samuel Palmer, *Ancient Trees, Lullingstone Park*, c. 1828, Yale Center for British Art, New Haven, Paul Mellon Collection

While genius can never be fully explained, a certain number of identifiable factors contributed to Samuel Palmer's extraordinary early blossoming: his profoundly religious temperament, intensified by a saturation in literature, especially the Bible, Milton, and Bunyan; his crucial meeting with the painter John Linnell (1792–1882), who introduced him to the work of Albrecht Dürer and more importantly to William Blake; and his exquisite sensitivity to nature, which found its most passionate response in the idyllic Kentish countryside around Shoreham, where he lived from 1827 to 1832. The present landscape, created at the height of the Shoreham period, documents the aesthetic crisis that racked Palmer at this time: the claims of naturalism and the close study of nature versus the demands of a spiritual, transcendental, and imaginative art. It is this particular tension between observed fact and visionary essence that accounts for the extreme power and individuality of this watercolor.

Trees were a major theme in Palmer's work from the very beginning of his ca-

reer. As early as c. 1819, the artist revealed his close observation of trunks in an inscription on the verso of a drawing: ''. . . This pollard willow was enriched with a great variety of tints some of rich olive green and others where the mosses had not prevailed of a silvery grey. . . .''[1] Such an interest in the color and texture of tree trunks indicates that Palmer's art was indeed based, as his son, A. H. Palmer, stated, on a ''careful analysis of Nature's detail (especially of trees),''[2] an analysis that would reach a climax in the Lullingstone Park tree studies.

In 1822 Palmer met John Linnell, thirteen years his senior, who immediately became his ''good angel'' and rescued him ''from the pit of modern art'' by showing him the work of Dürer, Lucas van Leyden, and the early Italian and Northern primitives.[3] Two years later Linnell introduced his protégé to William Blake whose visionary art, especially his little wood-engraved landscapes for Dr. Robert Thornton's edition of *The Pastorals of Virgil* (1821), had a major influence on Palmer's work (see cat. 86, fig. 1).[4] Soon Palmer became one of the central figures

in a group of young artist-disciples around Blake who called themselves ''The Ancients.''[5]

Having discovered a vocabulary to express his imaginative ideas, Palmer began a sketchbook in 1824, which must be considered one of the most astonishing creations of his career. Among the wild ecstatic landscapes and religious visions in this book, there are a great many studies of trees that are very carefully observed and yet stylized in the manner of Lucas van Leyden.[6] A similar delicate balance between natural observation and archaic stylization is also apparent in the six remarkable gum and sepia drawings of 1825, three of which feature forest scenes with a variety of contrasting textured trunks.[7]

Although Linnell was obviously supportive of Palmer's visionary art, as he was of Blake's, he had a much more pragmatic approach to his artistic career, becoming as a result a wealthy and successful Victorian artist. When he visited Palmer at Shoreham for the first time in 1828, the older artist evidently felt that his protégé's work was becoming too di-

vorced from reality; he was equally concerned with the fact that Palmer's visionary pictures were not saleable. Linnell therefore recommended a return to nature study and for this purpose commissioned a series of landscapes in and around Shoreham. A sequence of letters from Palmer to Linnell and to his fellow Ancient, George Richmond (1809–1896), document the ensuing artistic crisis that Palmer experienced in the fall of 1828.

The chronology of the Lullingstone Park treescapes, and indeed of Palmer's whole stay in Shoreham, has been confused by a letter from Palmer to Linnell that Raymond Lister published as dated "Shoreham Kent/Wednesday Septemb'. 1824."[8] A close reading of this letter, containing Palmer's announcement that he has "begun two studies for you on grey paper at Lullingstone" (one of which was possibly the present drawing), indicates quite clearly that it was written in September 1828, not 1824. It fits perfectly into the sequence of letters following Linnell's first visits to Shoreham (20–24 August and 2–6 September 1828) and his commission of studies from nature.[9]

In the same letter, Palmer went on to report how his project was progressing: "Have I not been a good boy? I may safely boast that I have not entertain'd a single imaginative thought these six weeks; while I am drawing from Nature, vision seems foolishness to me—the arms of an old rotten tree trunk more curious than the arms of Buonaroti's Moses."[10]

In his journal Linnell recorded a visit with Palmer in early September 1828 to Lullingstone Park, the seat of the Hart Dyke family, about two miles north of Shoreham.[11] The park was famous for its ancient trees, especially oaks, some of which still exist.[12] The name of the River Darent, which wends its way from Shoreham to Lullingstone, comes from the Celtic word *derva* (an oak tree), and means "a river where oaks are common."[13] It is quite possible that Palmer was aware of this meaning when he decided to draw a series of old oaks at Lullingstone.

Palmer reported details of Linnell's visits in a long letter to his friend George Richmond, confessing quite frankly that he was not about to sell his soul to Linnell's naturalism: "By God's help, I will not sell away His gift of art for money; no, not for fame neither, which is far bet-

ter. Mr. Linnell tells me that by making studies of the Shoreham scenery I could get a thousand a year directly. Tho' I am making studies for Mr. Linnell, I will, God help me, never be a naturalist by profession."[14]

The last letter of the year to Linnell, dated 20 November but not mailed until 21 December, is the most remarkable of all, a rhapsodic summation of Palmer's artistic credo and the definitive statement of the claims of vision over naturalism. He refers specifically to his forest studies at Lullingstone: "Milton, by one epithet, draws an oak of the largest girth I ever saw: 'Pine and *Monumental* Oak' [from *Il Penseroso*]. I have just been trying to draw one in Lullingstone, but the Poet's tree is huger than any in the park. There, the moss, and rifts, and barky furrows, and the mouldering grey, tho' that adds majesty to the lord of forests, mostly catch the eye before the grasp and grapple of the roots, the muscular belly and shoulders, the twisted sinews."[15] Palmer's visualization of nature through the words of Milton is entirely typical, as is his anthropomorphic description of the tree, the anatomy of which he succeeded magnificently in delineating in the present drawing.[16]

In his November/December letter to his mentor, Palmer made an overwhelming case for visionary art as superior to naturalistic representation—"Nature does yet leave a space for the soul to climb above her steepest summits"—but finally concluded, "After all, I doubt not but there must be the study of this creation, as well as art and vision."[17] Attempting to reassure Linnell, he added in a postscript, "I am desperately resolved to try what can be got by drawing from nature."[18]

In all, Palmer appears to have produced at least five nature studies for Linnell, the present sheet and another closely related Lullingstone Park forest scene, as well as three less highly finished Shoreham landscapes with houses, sheds, and barns.[19] He also made for himself a graphite drawing of Lullingstone oaks, similar in composition to the Ottawa watercolor but focusing more closely on two central trunks, in which he attempted to render the colors and textures primarily by linear means (fig. 1).[20]

While Palmer obviously felt he was betraying his visionary gift by producing

watercolors from nature, compared with the contemporary work of John Varley, David Cox, or Linnell himself, Palmer's forest scenes represent a completely different level of reality. Despite Palmer's close attention to the texture and color of the main trunk in the Ottawa sheet, the pen and ink drawing that defines the bulk and sinews of the tree is quite stylized and reminiscent of his earlier archaizing style. Palmer's color and technique, moreover, is entirely personal; glazes of blazing gold built up like enamels over thick blobs of opaque white contrast with the warm green watercolor washes and nutty brown ink lines.[21] The result is jewellike, surreal, and totally original. The graphic freedom in the treatment of the trees in the right and left background and the pattern of the spidery branches of the center tree are also particularly distinctive. If the Ottawa drawing is in part a factual representation of trees in Lullingstone Park, it is equally an Edenic vision, a distillation of the earthly paradise and a hymn to autumnal ripeness. Palmer's inner vision could not be suppressed even when he was attempting a literal transcription of natural fact.[22]

In view of the fact that Linnell had commissioned the nature studies specifically to promote the young artist's career, especially in the economic sense, it is highly ironic that they were all rejected by the Royal Academy for its 1829 exhibition, while two of Palmer's imaginative religious compositions were accepted, a *Ruth* and a *Deluge*.[23] It seems probable that the Ottawa watercolor, because of its monumental scale, high finish, and prominent signature, was one of the nature studies submitted to the Hanging Committee. Linnell must have been quite mystified when even the Royal Academy rejected Palmer's efforts at "naturalism" and endorsed his most extravagant visionary work.

DES

1. Grigson 1947, 152, no. 2.

2. London 1926, 3. A. H. Palmer goes on to quote Edgar Allan Poe: "The truly imaginative are never otherwise than analytic."

3. Palmer 1892, 14.

4. For Palmer's famous description of his first awestruck visit to Blake at Fountain Court, see Palmer 1892, 9.

5. The most recent study of this circle is Cambridge 1984.

6. A facsimile of Palmer's sketchbook was published by Butlin 1962, 1:33, 36, 42, 64–65, 87, 93–94, 103, 123, 130, 156, 172, 177.

7. London 1982, 33–40, nos. 5–10.

8. Palmer 1974, 1:7–9, no. 1824(1). The letter was first published by Malins 1968, 7, who also gives the year as 1824. Evidently such a year does appear on the letter, perhaps added later or by mistake. In Palmer 1974, Lister transcribed from a photostat. I have not been able to consult the original in the Linnell Trust, but according to the evidence presented in note 9 below, the letter should be dated 1828.

9. Payne 1982, 135. The following topics from the so-called 1824(1) letter are discussed, sometimes using the very same words, in a group of letters dated from 13 August 1828 to 20 November–21 December 1828— "hopping": Palmer 1974, 1:31, no. 1828(8); "two studies for you on grey paper at Lullingstone": Palmer 1974, 1:36, 45, 47–48, nos. 1828(9), 1828(10), 1828(11); "a head on grey paper life size and tinted": Palmer 1974, 1:38, no. 1828(9); whole argument of studies after nature versus imaginative art: Palmer 1974, 1:36, 45–50, 52, nos. 1828(9), 1828(10); Michelangelo's *Night*: Palmer 1974, 1:48–49, no. 1828(11); "Kemsing Sow": Palmer 1974, 1:37, no. 1828(9); and finally and most conclusively, "I am glad Clary does well . . . for a bad servant is a home nuisance": in a letter of 7 August 1828, Linnell wrote to Palmer to see if one of Mr. Tooth's daughters at Shoreham would be available to look after his children; A. H. Palmer, the artist's son, noted on the letter that "Clara Tooth was ultimately engaged"; Palmer 1974, 1:25 n. 1. On 13 August 1828, Palmer wrote back to Linnell that "Clary" and her father wanted more information about the position before they agreed; Palmer 1974, 1:26–27, no. 1828(5). It seems quite obvious that no. 1824(1) was written immediately after no. 1828(8), which Lister dates "Tues. September [17 1828]," when Clary Tooth had begun working for Linnell; no. 1824(1), dated "Wednesday," may even be the following day.

10. Palmer 1974, 1:8, no. 1824(1). (In this and following quotes, I have slightly changed the punctuation and spelling for the sake of clarity.) Palmer recanted at the end of the letter by announcing that Michelangelo's *Night* was more fascinating to him than the "clover and beans and parsley . . . and the innumerable etceteras of a foreground." Palmer 1974, 1:9, no. 1824(1).

11. Payne 1982, 135.

12. For modern photographs of the Lullingstone trees, see Sellars 1974, 52, 56, figs. 47–48, 52.

13. Lister and Astbury 1980, 17.

14. Palmer 1974, 1:36, no. 1828(9).

15. Palmer 1974, 1:47–48, no. 1828(11).

16. That Palmer habitually thought of trees in human terms is further indicated on a page of his 1824 sketchbook: "These leaves were a gothic window but sometimes trees are seen as men. I saw one a princess walking stately with a majestic train" (Butlin 1962, 1:5). Even more remarkable is Palmer's proposed transformation of a human limb into a tree: "Let any one who can draw, copy exactly in pen and ink some boldly-shadowed limb of Bonasoni's [Italian engraver Giulio Bonasone (active 1531–1574), whose archaisms were much admired by the young Palmer], and afterwards turn it into a tree-trunk by vigorous line work expressing the textures of the bark, and he will then see texture in its proper function, and shadow in its poetic sleep" (Palmer 1974, 2:862, no. 1872[20]). Grigson 1947, 147 n. 11, specifically connects the Lullingstone Park tree drawings with Bonasone's prints and this 1872 letter.

17. Palmer 1974, 1:50, no. 1828(11).

18. Palmer 1974, 1:52, no. 1828(11).

19. All five were acquired from John Linnell's grandson, Herbert Linnell, and sold by Walker's Galleries (London 1937, nos. 84–88; Grigson 1947, nos. 60, 62–65). The second Lullingstone Park scene closely related to the Ottawa example was recently discussed by Lister in Cambridge 1984, 14, no. 16, fig. 16.

20. This work was apparently never owned by Linnell but passed from the artist to his son, A. H. Palmer. See New Haven 1977a, 120, no. 217.

21. His idiosyncratic use of gouache and opaque white has caused cracking and flaking in many of his Shoreham works, including the present example.

22. Several works by Linnell have been linked to his visit to Lullingstone with Palmer: a study of beech trees, which only emphasizes more clearly the gulf between the "naturalism" of Linnell and the "naturalism" of Palmer (Payne 1982, 135, fig. 9, and Cambridge 1982–1983, 23, no. 62, but London 1973, no. 38, pl. 14, prefers an earlier date of c. 1816–1820 for Linnell's drawing) and a more interesting, stippled gouache of a leaning tree, which glows with Palmer's golds and greens and appears to have been strongly influenced by the latter's 1828 watercolors (New Haven 1977a, 111, no. 198, pl. 36). One of Palmer's nature studies for Linnell, *Ivy Cottage, Shoreham*, bears on its verso a drawing by Linnell entitled *Ploughing at Shoreham* (Yale Center for British Art, New Haven).

23. Palmer 1974, 1:53–54, no. 1829(3). *Ruth* is now in the Victoria & Albert Museum, London; the *Deluge* is untraced.

86

*Moeris and Galatea: A Design for Virgil's Ninth Eclogue,*
c. 1872–1876

**Samuel Palmer**
London 1805–1881 Reigate

Pen and brush and black and gray ink with black chalk (or charcoal?) and graphite, partially squared in graphite for transfer, on Bristol board

174 x 256 (6⅞ x 10¹/₁₆), sheet; 101 x 152 (4 x 6), image

Inscribed with record of biting (by the artist?)[1] verso center, in graphite, *9 / Mar 3 1876 —(bad silk) - [4 crossed out?] Mordant 4 to 1—1 hour / Mar 6— —Mord. 4 to 1—1¹/₂ hour / Mar——1 hour / [in A. H. Palmer's hand] March 16 1876. (bad silk) Mor 4 to 1.——1 hour / March 24. 1876 do. ditto 1 hour / March 31 1876 do ditto 30 min⁵. / April 1 1876 do——4 to 1 ——1 hour / April 26 1876. do.——4 to 1.——1 hour;* added in left margin opposite fourth line, in graphite, *Wed;* in left margin, with bracket to last five lines, in graphite, *AHPs / handwriting-;* in right margin opposite second line, referring to mordant, in graphite, *[of course by / weight];* in right margin opposite third line, in graphite, *xx;* in an unidentified hand, verso lower left, in graphite, *9.ᵗʰ Ecl. The cream-bowl set etc;* in an unindentified hand, verso lower left, in graphite, written sideways, *10523;* verso lower right, in graphite, *[checkmark?]*

Provenance: The artist's son, A. H. Palmer; The Cotswold Gallery, London, by 1927; purchased from The Cotswold Gallery, London, 1930

Literature: Alexander 1937, 53; Lister 1974, 267 n.; Sellars 1974, 132, 150, fig. 139; London 1982a, 73, under no. 53; Lister 1988, no. V21

Exhibitions: London 1926, no. 147; London 1927, no. 19; London 1978–1979, no. XIII(c)

Acc. no. 3947

In 1863, the middle-aged Samuel Palmer was obliged to sit for the Bond Street photographer Cundall, who was taking portraits of all the members of the Old Water-Colour Society.[2] Although it is impossible to deduce the title of the book from the finished photograph, the artist insisted on posing with his treasured copy of Virgil's *Eclogues*, which his fellow Ancient Edward Calvert had given him years before. Palmer forwarded a copy of the photograph to Calvert with instructions to cut out the book and ''throw the old man who holds it into the fire,'' explaining that the Virgil was his constant companion: ''I have been . . . in the deepest distress of mind, employed for many months in endeavouring to sift the *Eclogues* thoroughly, to the last exactness of meaning and expression.''[3]

Ever since Palmer had learned Latin at his father's knee, Virgil's pastoral poems had been among his favorite books and a major inspiration for his landscape art. The artist therefore persisted with his translation project until 1872, when he wrote to his friend and fellow artist Philip Gilbert Hamerton (1834–1894), requesting advice on how to publish his maiden literary effort. Since William Blake's enchanting little wood engravings for Dr. Robert Thornton's edition of *The Pastorals of Virgil* (fig. 1) had been an important influence on Palmer's Shoreham landscapes forty years earlier,[4] the artist lamented that ''if Blake were alive and I could afford it, I would ask him to make a head-piece to each bucolic.''[5]

Not surprisingly, Hamerton suggested that Palmer illustrate his translation with his own designs, in order to make the volume more attractive to a publisher. Although the artist at first ''loathed the thought,''[6] he was finally persuaded to undertake ten drawings, one for each eclogue, which would be reproduced photomechanically by the autotype process in his projected publication.[7] In June 1872 he retreated to Margate to produce his pastorals, returning home with ten pen and India ink designs on Bristol board in various stages of completion. His son, Alfred Herbert Palmer, who was intimately involved with the Virgil project, stated that to meet the requirements of the photomechanical process, Palmer tried ''to use pen and ink in a manner which was unnatural to him . . . endeavouring to keep each line and touch separated from its neighbours.''[8] It seems probable that the present pen and ink design, *Moeris and Galatea* for the Ninth Eclogue, was one of the ten begun in 1872 specifically for the autotype process.[9] Because the reproductions proved disappointing in tests (''smudge pure and simple''),[10] Hamerton, who was an authority on etching and had published on the subject, urged Palmer to etch his Virgil illustrations.

In 1850 Palmer had joined the Old Etching Club, whose members regarded the medium primarily as a means of illustrating literature and favored highly labored, complex prints.[11] Describing the process as ''an elegant mixture of the manual, chemical and calculative'' and as ''quite alone among the complete arts in its compatibility with authorship,''[12] Palmer evolved a laborious, perfectionist technique in which dense webs of line revealed countless sparkles of white paper—''those thousand little luminous eyes which peer through a finished linear etching.''[13] He found this quality above all in Claude Lorrain's prints, which became the dominant inspiration of his later work.

Since he was not interested in the sort of spontaneity that James McNeill Whistler would champion as an etcher, Palmer made many preliminary drawings before beginning a plate: ''In etching at home I don't think a line should be scratched before . . . a little sketch is made, showing the general effect (I care not how smudgy), in which the masses and trains of dark are right, and the emphatic lights and darks in their proper places. . . . The little effect sketch for the proposed etching may be done best with charcoal.''[14]

A black chalk and charcoal sketch for the Ninth Eclogue now in Princeton (fig. 2) appears to fit the above description perfectly and may have been done after the pen and ink design in Ottawa, rather than before it, specifically as a preparation for the general tonal effects of the etching.[15] In connection with another Virgil pen and ink design, Palmer's son recalled that the charcoal was added at a later date, only after the photomechanical process had been abandoned in favor of etching.[16] It appears likely that the Ottawa drawing was similarly reworked in chalk or charcoal in preparation for the print.

An inscription on the verso of the present sheet indicates that the etching was bitten eight times during March and April 1876, the same months that the plates for the Fifth and Eighth Eclogues were also underway.[17] By 1879 Palmer reported to Hamerton that ''four of the poor little Vs [Virgils] have been bitten and proved,'' including the *Moeris and Galatea,* and that another design for the Eighth Eclogue, *Opening the Fold,* was ready to be transferred to the plate.[18] As it turned out, the latter was the only Virgil etching completely finished by Palmer before his death. At the same time as the Virgil project, the artist had also begun another series of etchings based on a set of watercolors illustrating John Milton's *L'Allegro* and *Il Penseroso.* Two of these etchings, *The Bellman* and *The Lonely Tower,* were brought to completion and are now considered, along with *Opening the Fold,* to be Palmer's print masterpieces.

Because his Virgil designs were very close to his heart—''my ten poor little Vs, more deeply thought out than anything else I have done''[19]—Palmer on his deathbed made his son promise that he would publish the translation together

Fig. 1. William Blake, *Colinet Resting By Night,* 1821, The Tate Gallery, London

## 87

### *Edith Holman Hunt, 1876*

**William Holman Hunt**
London 1827–1910 London

Red and black chalk with stumping on heavy wove paper

543 x 374 (21⅜ x 14¾)

Inscribed by the artist, lower left, in red chalk, *18 Whh* [in monogram] *76 / April / Jerusalem*

Watermark: Along bottom edge, *AN 1875 B* (probably Whatman)

Provenance: The artist's widow, Edith Holman Hunt; her daughter, Gladys Holman Hunt; her adopted daughter, Mrs. Elizabeth Burt; her sale, Sotheby's, London, 10 October 1985, lot 63; purchased from P. & D. Colnaghi, London, 1986

Literature: Hunt 1913, 2:265; Holman-Hunt 1969, repr. between 272–273; Anonymous 1973, 14; New Haven 1984, under no. 18

Exhibitions: London 1906, no. 50?; Manchester 1906–1907, no. 77?; Liverpool 1907, no. 88; Glasgow 1907, no. 42; extended loan to Wightwick Manor, Staffordshire, 1961–1985[1]

Acc. no. 29578

The importance of portraiture in Pre-Raphaelite art has long been recognized.[2] Not only did William Holman Hunt, John Everett Millais (cat. 90), and Dante Gabriel Rossetti (cat. 88) cast their friends and relatives in leading roles in their subject pictures,[3] but they also made many portraits for their own sakes. In the case of Holman Hunt, large-scale portrait drawings, usually in colored chalks and startlingly lifelike, became the norm to record the faces of his circle of friends and relatives.[4]

The present drawing of Hunt's second wife, Edith, is a particularly intimate work of art, created on their honeymoon in Jerusalem in April 1876 and only recently released from the family collection. Like much of his work, the portrait of Edith is an enigmatic one with private and hidden meanings. Why the image is far from that of the conventional happy bride may be explained by the truly traumatic circumstances surrounding their marriage some five months before.

In 1861 Hunt met Fanny Waugh, one of

eight daughters of the chemist Dr. George Waugh, who was druggist to Queen Victoria.[5] When Hunt was visiting the Waugh household to court Fanny, her youngest sister, Edith (1846–1931), fell hopelessly in love with him. Fanny and Holman were married in 1865 and later set out for Palestine, where the artist had first gone ten years earlier to paint biblical pictures. On their way they were detained in Florence by a cholera epidemic. Here Fanny gave birth to a son, Cyril, but died some weeks after of puerperal fever. During his stay in Florence, Hunt had commenced a portrait of his wife in which her pregnancy is modestly concealed behind an armchair (Toledo Museum of Art).[6]

Back in London in September 1867, Hunt began an oil portrait of his sister-in-law, Edith, to commemorate her twenty-first birthday (fig. 1). The picture was intended to be a companion to Fanny's, and both were completed with identical frames designed by the artist. In Edith's portrait, entitled *The Birthday,* she is

that recaptures at least some of the radiance of his earlier Shoreham visions. Traces of his interest in stylized trees remain in the two exquisitely balanced umbrella pines silhouetted against the sea and sky.

In 1909 Palmer's son, Alfred Herbert, immigrated to Vancouver, bringing with him much of his father's work, including the present drawing.[27] Descendants of Samuel Palmer apparently continue to live in Vancouver to this day.

<div align="right">DES</div>

1. The author of the last five lines of this record of biting is identified by a later inscription as the artist's son, A. H. Palmer; at the time of the acquisition of this drawing, it was thought that possibly A. J. Finberg of the Cotswold Gallery had made this notation. The implication is that the artist himself wrote the first three lines. It is possible, however, that the entire inscription was made by Palmer's son, the handwriting being quite similar throughout; this would be consistent with his son's claim that in helping his father with the Virgil plates he "laid all the grounds; . . . bit the plates in; did NOT touch the stopping out; proved the plates; and finally 'finished' them" (London 1978–1979, under no. III). Lister considers the entire inscription to be in the artist's hand (London 1978–1979, no. XIII[c]).

2. The photograph is reproduced in Cecil 1969, fig. 6, and in Peacock 1968, monochrome pl. 21.

3. Palmer 1974, 2:684–685, no. 1863(10).

4. For Palmer's famous rhapsodic reaction to Blake's Virgil prints, see Palmer 1892, 15–16.

5. Palmer 1974, 2:835, no. 1872(1).

6. Palmer 1974, 2:868, no. 1872(21).

7. Palmer worked with T. Lace Cayley of the Autotype Fine Art Co. See Palmer 1974, 2:852, no. 1872(12). Apparently other photomechanical processes were also considered.

8. Palmer 1892, 156–157.

9. Other surviving designs that may have been begun as early as 1872 may be tentatively identified by their similarity of technique, format, and paper; for example, Cambridge 1984, nos. 67–69, 72–74, 76–77.

10. Palmer 1892, 157. There was apparently a "voluminous correspondence with Mr. Hamerton" concerning the "dreary technicalities" of the photomechanical process, which A. H. Palmer did not quote in his book and which has subsequently been lost.

11. Pressly 1970, 8.

12. Palmer 1974, 2:865, no. 1872(21).

13. Palmer 1974, 2:932, no. 1876(5).

14. Palmer 1974, 2:864–865, no. 1872(21).

15. Pressly 1969, 35–36, who was not aware of the Ottawa drawing, speculated that another, more finished drawing might intervene between the Princeton sheet and the completed etching.

16. London 1926, no. 145.

17. The Fifth plate was bitten between February and April 1876 and the Eighth between February and March 1876 (Cambridge 1984, no. 73, and Pressly 1970, 40, no. 8).

18. Palmer 1974, 2:963, no. 1879(4).

19. Palmer 1974, 2:964, no. 1879(4).

20. The small paper edition was published in 1884.

21. Alexander 1937, 31, who also thought A. H. Palmer worked on the cattle.

22. London 1978–1979, under no. III.

23. For example, "The design for Eclogue IX is superficially attractive, but on examination it is rather thinly and feebly executed" (Mather 1937, 259), or "'Moeris and Galatea' is the least successful of the group; it is a muddled composition in which the various elements fail to cohere" (Lister 1969, 91).

24. Graham Reynolds has connected *The Woman and Tambourine* and *The Temple of Minerva Medica* from Turner's *Liber Studiorum* with Palmer's Virgil illustrations (in London 1978–1979, 44).

25. Palmer 1883, 88. A. H. Palmer described his father's translation as "a 'paraphrase,'" but perhaps more correctly, it has been compared in musical phrase to 'a meditation upon Virgil's air'" (Palmer 1883, xiv).

26. In 1837 Palmer had married John Linnell's daughter, Hannah; see Malins 1968.

27. Lister gives 1909 as the year of the move (Palmer 1974, 1:xiii), Butlin gives 1910 (Butlin 1962, 2:1). Unfortunately, before he left England, Herbert Palmer burned a large number of his father's early drawings, including some sketchbooks; if the latter were anything like the 1824 one that survives in the British Museum, London, this holocaust was a truly disastrous calamity for British art.

with those plates that he had brought near to completion. In 1883 A. H. Palmer dutifully published the large paper edition of *An English Version of the Eclogues of Virgil* with the one finished etching, the four incomplete ones that he himself finished, and photoengraved reproductions of preliminary drawings to illustrate the remaining poems.[20] There has been considerable debate concerning A. H. Palmer's contribution to the four unfinished plates. With regard to the *Moeris and Galatea* etching (fig. 3), he later described in private correspondence what he had done: "The state of the plate illustrating the 9th Eclogue (*Moeris and Galatea*) in so far as the sky and sea were concerned, was precisely the same as in the original design. There was a pretty problem for a raw recruit to face!"[21] This suggests that he completed the sea and sky, since this area in the Ottawa design is indeed unfinished. A. H. Palmer also claimed that his additions to the Virgil plates were "done chiefly with the graver."[22]

The *Moeris and Galatea* etching has not found great favor with the critics, especially compared with the delicate beauty of the original drawing.[23] Of all the Virgil designs, it is the most dependent on Claude, with also strong echoes of J. M. W. Turner in his most Claudean vein.[24] It illustrates a poem within the poem, in which the shepherd Moeris attempts to seduce the sea nymph Galatea to leave the waves for a life of pastoral bliss with him on shore. In Palmer's version, which in this passage is so free as to be hardly related to Virgil's Latin, the lines are as follows:

Then, to our goats at milking-time return
O'er breezy heather-bells and slopes of vine;
The cream-bowl set and in our cave recline,
(Its brows with poplar shaded, watch the
    West),
And timely, with the sun, together rest.[25]

In the cave Moeris is sitting on the right, gazing at the sea nymph who lounges provocatively before him, a mildly erotic motif from the prudish Palmer that recalls the more overt sensualism of Edward Calvert's famous wood engraving, *The Chamber Idyll* (1831). Outside the shadowy cave all nature is bathed in the glow of the setting sun. Drawing on his recollections of Italy, which he had visited on his honeymoon in 1837–1839,[26] Palmer produced in this design an evocation of Arcadian serenity

Fig. 2. Samuel Palmer, *Moeris and Galatea*, c. 1872–1876, The Art Museum, Princeton University, Gift of Frank Jewett Mather, Jr. (Copyright 1987 Trustees of Princeton University)

Fig. 3. Samuel Palmer and A. H. Palmer, *Moeris and Galatea*, 1883, Yale Center for British Art, New Haven, Paul Mellon Collection

Fig. 1. William Holman Hunt, *The Birthday*, Royal Academy 1869, private collection (Courtesy Witt Library, London)

wearing Fanny's cameo brooch, which Hunt had given her. Whether the artist realized it or not we do not know, but Edith was longing to supplant her dead sister as his wife. Hunt's portrait reveals a remarkably unhappy twenty-one year old. Conceding that the picture had "amazing power," the critic of the *Art-Journal* made the following comment when it appeared in the 1869 Royal Academy exhibition: "The lady bears in her hands birthday-presents mournfully, as if under the burden of dark misgivings: thus, as usual, the artist is suggestive of some hidden meaning; and the spectator stands aghast in wonder—scarcely in admiration."[7] Considering that the reviewer had apparently no idea of the complex feelings behind this prophetic portrait of Edith in the shoes, as it were, of Fanny, it is a very perceptive observation. The melancholic Edith of *The Birthday* is, therefore, a definite prefiguration in mood of her honeymoon portrait in Jerusalem of eight years later.

Although Edith gradually won Hunt's affections, marriage, it seemed, was out of the question. What stood in their way was the Table of Affinities, proscribing a union between a man and his deceased wife's sister.[8] Having become the leading

religious painter of the Victorian period, Hunt was painfully aware of his impossible position.[9] Edith was, however, a very determined woman, and she finally proposed marriage to Hunt. When the couple confronted the Waughs and the Hunts with their decision, their families turned savagely against them. With a wonderful irony, which could not have escaped the protagonists, Edith at this time was posing as the Virgin Mary for preliminary work on *The Triumph of the Innocents* (1876–1887), and Hunt complained to his friend the art critic Frederic George Stephens (1828–1907) that "no effort of mine is capable of making her smile from morning till night."[10]

In November 1875 the lovers left London for Neuchâtel, Edith with a chaperone and Hunt traveling separately. There they were married legally under Swiss law, the bride radiant in white. They were to prove an ideal couple. Edith adored her husband and bore him two children, a son and a daughter, Hilary and Gladys.[11]

The newlyweds moved on to Jerusalem, where Hunt drew this portrait of his pensive wife, the first known drawing of her after their marriage.[12] In view of what they had both endured, it can be understood why Edith appears not only so soulful, a typical Pre-Raphaelite emotional stance, but also so subdued in her happiness. If Edith's head is bent, it does not, however, droop like that of many another Victorian woman in distress. Her powerful jaw indicates the strength of character that saw her through a terrible ordeal.

Edith was, in fact, not typical of the sort of beauty, or "stunner," who normally attracted the Pre-Raphaelites. Tom Taylor, the art critic for *Punch*, described her as "repulsively ugly" when he reviewed *The Birthday*.[13] There is some evidence that Edith herself was dissatisfied with the uncompromising plainness of that painted image.[14] Although Edith had the large, melting eyes of a true stunner, she lacked the full, sensuous lips and abundant, cascading hair for which Rossetti and Frederick Sandys, in particular, had an apparent fetish (see cats. 88 and 89). Instead, Edith's straight brown hair, severely arranged in a knot at the back of her head, denotes the prim, correct background from which she came and contrasts with the overt sexuality of the stun-

ners with their unfettered locks and lifestyles.

In many of Hunt's large chalk portraits, the heads are presented in what can only be described as close-up.[15] So insistent is the focus on the head that clothing is barely suggested and the background remains blank. Hunt almost invariably favored a combination of red and black chalks used coloristically in an amazingly realistic manner, echoing the rather florid tones of his painting. Called by John Ruskin the greatest draftsman since Albrecht Dürer,[16] Hunt was a virtuoso technician. His portrait of Edith reveals his astonishing technical control, a bravura performance that encompasses infinite gradations of red and black blended flawlessly together to produce a head so palpably real that it becomes surreal. It is this paradox that informs most of his art and accounts for its particular power.

Hunt usually preferred a full frontal view of the face, which was more consistent with his confrontational brand of uncompromising and unflattering realism. In both major portraits of Edith, *The Birthday* and the Jerusalem drawing, however, he chose what was for him a particularly poetic profile pose. The sad inclination of the head in the drawing balances the beautiful curl of hair that escapes from the bun at the nape of the neck, providing a grace note in an otherwise severe and rigorous composition.[17]

DES

1. The literature and exhibitions listings are based on those compiled by Judith Bronkhurst, who is preparing a catalogue raisonné of Holman Hunt's work. I should like to thank Dr. Bronkhurst for her kind help.

2. See Rose 1981, 4–16.

3. Sometimes the typecasting was uncannily prophetic, such as Millais' decision to use the doomed Elizabeth Siddal as his *Ophelia* (1852, Tate Gallery, London).

4. Rose 1981, 52, 54–55, 57–59, 63.

5. Most of the information concerning Fanny, Edith, and Hunt comes from Holman-Hunt 1969, 231–291. The writer Evelyn Waugh was a descendant of the same family.

6. Rose 1981, 60.

7. Landow 1979, 163.

8. The Deceased Wife's Sister's Marriage Act, which apparently legalized such unions, was not given Royal assent until 1907. According to Judith Bronkhurst, Hunt was an active member of the Marriage Law Reform Association (communication of 24 November 1986, National Gallery of Canada, curatorial file). See also Holman-Hunt 1960, 124.

9. He had just completed *The Shadow of Death* (City of Manchester Art Galleries) and received a commission from the Queen herself for a small replica of the head of Christ.

10. Holman-Hunt 1969, 283.

11. For a wonderful reminiscence of Edith in her old age, when she had become something of a gorgon, see Holman-Hunt 1960.

12. A silverpoint, inscribed *Edith / July 1877 Jerusalem*, is in the Edmund J. and Suzanne McCormick Collection (New Haven 1984, no. 18). It was this drawing that the artist chose to illustrate in the first edition of his *Pre-Raphaelitism and the Pre-Raphaelite Brotherhood* (Hunt 1905–1906, 2:317). Edith added the Ottawa portrait of herself to the illustrations of the second edition.

13. Rose 1981, 61.

14. Gladys Holman Hunt revealed that her mother had asked Hunt's studio assistant Edward Hughes (1851–1914) to darken the eyebrows, redden the lips, and take in the waist of her *Birthday* portrait, when Hunt was too blind to know what she was doing (Holman-Hunt 1960, 100). Some retouching of the face and the nipping in of the waist may be clearly seen in recent photographs of the painting (fig. 1).

15. There may be a connection between Hunt's portraits and Julia Margaret Cameron's photographs. In the latter's numerous studies of her niece, Julia Jackson, the sitter looks with her round eyes, straight hair, and profile pose startlingly like Edith in Hunt's drawing (Ford 1975, 113, pl. 90). Hunt had, in fact, courted Julia Jackson in 1862–1863, but she had declined his proposal of marriage (Marsh 1985, 228). Since Cameron's photographs of Julia Jackson precede Hunt's portrait of Edith, it may be that in this instance the artist was influenced by the photographer's work, which he undoubtedly knew well, although he rejected Cameron's out-of-focus chiaroscuro for sharp-focus realism, an article of Pre-Raphaelite faith. It is also possible that Hunt's large chalk heads, which he produced as early as 1853 (for example, Sotheby's, London, 10 October 1985, lot 18), may have initially inspired Cameron in her choice of the extreme close-up for her photographs.

16. According to Edith in Holman-Hunt 1960, 39. The exact quotation in Ruskin has not been identified, although he frequently compared the Pre-Raphaelites to Dürer (for example, Ruskin 1903–1912, 12:323, 355).

17. A recent acquisition, the drawing of Edith joins Hunt's oil portrait of *Henry Wentworth Monk* (1858) in the collection of the National Gallery of Canada, which was, in fact, purchased by the Gallery in 1911 from Edith, then recently widowed. Hubbard 1959a, 86–87.

## 88

## *The Roseleaf,* 1870

**Dante Gabriel Rossetti**

London 1828–1882 Birchington-on-Sea

Two types of graphite on wove paper

390 x 352 (15⁵/₁₆ x 13⁷/₈)

Inscribed by the artist, center left, in graphite, *DGR* [in monogram, in a circle] / *1870*

Provenance: Estate of the artist; Rossetti sale, Christie's, London, 12 May 1883, lot 189; McLean; purchased from P. & D. Colnaghi, London, 1925

Literature: Knight 1887, bibliography xix, no. 59;[1] Marillier 1899, 157, 158 (repr.), 250, no. 227; Marillier 1901, 116, 160, no. 287; Marillier 1904, opp. 108 (repr.), 111, 167, no. 287; Wood c. 1910?, pl. 10; Waugh 1928, 189; Surtees 1971, 1:122, no. 215, 2: pl. 309; Ovenden 1972, 33, no. 15; Hubbard 1976, 5; London 1983, 40 (repr.), under no. 53; Benedetti 1984, 123, 287, pl. 51, no. 363; London 1984c, under no. 246; Ovenden 1984, 27; Bartram 1985, 135–139, fig. 132; Marsh 1987, 10–11, pl. 5

Exhibitions: Winnipeg 1956, no. 92; Indianapolis 1964, no. 68; Ottawa 1965, no. 119

Acc. no. 3202

In the summer of 1857 the second phase of Pre-Raphaelitism commenced with Dante Gabriel Rossetti's arrival in Oxford to paint Arthurian murals on the walls of the Union Society Debating Hall, an enterprise he shared with a group of eager young disciples, notably Edward Burne-Jones (1833–1898) and William Morris (1834–1896). During a visit to the theater, Rossetti spotted a striking dark-haired girl and immediately resolved to ask her to pose for his pictures. The "stunner" he had discovered was Jane Burden (1839–1914),[2] the daughter of an Oxford groom. She first posed for Rossetti as the adulterous Guinevere—one of those uncanny Pre-Raphaelite typecastings that was to prove startlingly prophetic. Her entry into the lives of Rossetti and Morris had far greater importance than the Oxford Union murals, which were soon fading and peeling from the walls because of the artists' technical incompetence. *The Roseleaf* is one of Rossetti's most poignant portraits of the woman who came to dominate his art and life for the last two decades of his career.

There is reason to believe that Rossetti and Jane Burden fell in love almost immediately, but because Rossetti was morally committed to Elizabeth Siddal (1834–1862) there was no possibility of a relationship. If we are to believe Rossetti's later prose tale entitled *The Cup of Cold Water* (c. 1873; first published 1886), the wooing was straight out of Malory's chivalric romances: The King (Rossetti), having fallen in love with the Forester's daughter (Jane Burden), encouraged his best friend, a young Knight (Morris), to marry her, because he was already betrothed to the Princess (Elizabeth Siddal)—and so Jane Burden and Morris were married in 1859.[3] For the newlyweds Rossetti painted *The Salutation of Beatrice* on two cabinet doors of a large settle for the Red House, the Morrises' celebrated new home in Bexley Heath, Kent, designed by Philip Webb. In these panels, which are now in the National Gallery of Canada,[4] Rossetti cast Jane Morris as Beatrice, the beloved of Dante, the artist's namesake.

Rossetti married Elizabeth Siddal in

Fig. 1. John R. Parsons, *Jane Morris*, 1865, Victoria & Albert Museum, London (Courtesy of the Board of Trustees of the Victoria & Albert Museum)

1860 and seems to have drifted away from the Morrises for a time, especially after his wife's death in 1862. In 1865, however, when the Morrises were forced for financial reasons to abandon their home in Kent and return to London, Rossetti began drawing Jane again and in July posed her for a series of extraordinary photographs taken in his Chelsea garden by the photographer John R. Parsons.[5] *The Roseleaf* is one of several works based directly on these photographs (fig. 1). By 1868 Jane had begun to sit regularly for Rossetti, and her marriage to William Morris had reached a breakdown. Rossetti's pictures of her during this period, such as *La Pia de' Tolomei, Aurea Catena, Mariana,* and *Pandora,* all contain obvious references to her entrapment in a loveless marriage, a meaning that became even more evident in Rossetti's many later versions of *Proserpine.*[6]

The year of this drawing, 1870, marked a turning point in the relationship between the artist and his model. Two of Rossetti's love letters of that year are the most passionate demonstrations of his devotion to Jane that survive.[7] The volume of his *Poems* published that year contains fifty newly written sonnets celebrating his love, and for the first time the two lovers were alone together at a cottage at Scalands, during April and May.

The experiment of a country retreat, ostensibly for the benefit of their health, was so successful that it led the following year to the joint tenancy of Kelmscott Manor in Oxfordshire by Rossetti and William Morris, who suffered great pain by his wife's defection, but felt that she had a right to seek personal happiness away from her legal mate.

Although Mrs. Morris was considered a great beauty by Pre-Raphaelite standards, her looks were decidedly strange for the uninitiated. Henry James' famous description of her to his sister in March 1869 forms a verbal complement to Rossetti's drawing and Parsons' photograph:

It's hard to say whether she's a grand synthesis of all the pre-Raphaelite pictures ever made—or they a 'keen analysis' of her—whether she's an original or a copy. In either case she is a wonder. Imagine a tall lean woman in a long dress of some dead purple stuff, guiltless of hoops (or of anything else, I should say,) with a mass of crisp black hair heaped into great wavy projections on each of her temples, a thin pale face, a pair of strange sad, deep, dark Swinburnian eyes, with great thick black oblique brows . . . [and] a long neck, without any collar.[8]

Because Mrs. Morris' health had deteriorated—she evidently took refuge in an undiagnosable invalidism as a way of

coping with her predicament—she was frequently away from London for cures and rests and so unable to pose for Rossetti. It appears that during these absences he relied on the 1865 photographs to continue his work. The telling differences between the Jane of the posed photographs, which is not necessarily the "real" Jane,[9] and Rossetti's ideal woman of his art may be seen in a comparison of the present drawing and its source photograph (fig. 1). While retaining the basic pose and the Pre-Raphaelite dress for which Jane was celebrated,[10] Rossetti has prettified her features, ennobled her brow, regularized her bushy eyebrows, tamed her wild and wirey hair, monumentalized her back and shoulder toward the Amazonian proportions of his later *Astarte Syriaca,*[11] and significantly added the hands that raise a spray of roseleaves to her lips.

*The Roseleaf* is one of a group of related drawings of Mrs. Morris including *Silence, La Donna della Fiamma,* and *La Donna della Finestra,*[12] which Rossetti turned into subject pictures by adding specific attributes. All of these drawings refer in some way to his relationship with his model. It appears certain that Rossetti used flowers in his pictures with the specific meanings attributed to them in the Victorian language-of-flowers manuals.[13] According to John Ingram's *Flora Symbolica* a roseleaf signifies "You may hope," the development of the rose from leaf to bud to full bloom symbolizing the course of true love.[14] For Rossetti, the rose was above all the flower of physical passion,[15] which he frequently used in such celebrations of carnal love as *Lady Lilith* and *Venus Verticordia.*[16] The meaning of the attribute in *The Roseleaf* is, therefore, highly appropriate to the lovers' situation in 1870. In the drawing the roseleaf is also associated with Jane's fingers and hands, the implication being that her majestic head is the rose upon its graceful neck/stem.[17] The portrait, exquisitely executed in a cool, silvery graphite, exudes a gentle melancholy, a mood of vulnerability and alienation that is enhanced by the turn of the back toward the spectator. The pale rectangle of light falling on the wall to the right of the head emphasizes the feeling of imprisonment and looks forward to the reuse of the same motif in *Proserpine.*

In adding the hand with the leaves to

Fig. 2. Frederick Sandys, *Love's Shadow*, 1867, Collection of A. C. W. Crane, Esq., Bath

the over-the-shoulder profile in *The Rose-leaf*, Rossetti was returning to a motif that he had used as early as 1865.[18] Frederick Sandys, who is known to have plundered Rossetti's designs in the late 1860s, used the same composition in *Love's Shadow* (1867), where a sultry young woman holds a nosegay to her lips (fig. 2).[19] The latter drawing evolved into Sandys' *Proud Maisie* (1868; for a later version see cat. 89), which is even closer in pose to Rossetti's *The Roseleaf* but with the leaves changed into a strand of hair. As drawings of their respective mistresses, Rossetti's *The Roseleaf* and Sandys' *Proud Maisie* form a fascinating pair of almost mirror images and indicate the complex interrelationships between the work of these two artists.[20]

During his tryst with Mrs. Morris at Scalands in April 1870, Rossetti wrote to his friend Barbara Bodichon, who owned the cottage they were occupying: "I am making a very careful drawing of Mrs. Morris which will be worth money if I choose to sell it, only I like to keep my best studies."[21] Although this drawing cannot be precisely identified, we know that Rossetti kept *The Roseleaf* for himself, for it was first sold in the artist's sale after his death. It, therefore, had a particular significance for him and now fulfills the prophecy that the artist inscribed in Latin

on his 1868 oil portrait of Jane: "Famed by her poet husband and surpassingly famous for her beauty, may my picture add to her fame."[22]

DES

1. Knight indicates that *The Roseleaf* was published as a photograph in the "Perlascura Series."
2. For recent biographies of Jane Burden, see Marsh 1985, 117–130, 168–171, 188–197, 241–265, 285, 290–298, 318; Marsh 1986.
3. Doughty 1960, 369; the tale is quoted in Marsh 1986, 124–125.
4. Hubbard 1959a, 132.
5. Surtees 1971, 1: nos. 366–370; 2: pl. 409; sixteen of Parsons' photographs are reproduced in Ovenden 1972, frontispiece, nos. 2–3, 6–9, 11–12, 14, 16–19, 22, 24. Bartram 1985, 135, gives the reasons for identifying Parsons as the photographer.
6. Surtees 1971, 1: nos. 207, 209, 213, 224, 233; 2: pls. 300, 297, 303, 318, 331, respectively.
7. "For the last 2 years I have felt distinctly the clearing away of the chilling numbness that surrounds me in the utter want of you" (30 January 1870) and "You are the noblest and dearest thing that the world has had to show me" (4 February 1870); in Bryson and Troxell 1976, 33–34, nos. 15–16.
8. James 1920, 1:17–18.
9. Bartram 1985, 135–139, perhaps overestimates the importance of the Parsons photographs in interpreting the "real" character of Jane; it seems probable that in these posed photographs, which demanded long exposures, the model could have been playing a role as much as in one of Rossetti's paintings or drawings.
10. Christina Rossetti, Elizabeth Siddal, and Jane Morris were all pioneers in dress reform, wearing un-conventional clothes that not only expressed Pre-Raphaelite aesthetics, but that offered much greater freedom of movement than the tightly laced fashionable dress of the period. See Newton 1974, 30–33, fig. 8.
11. Surtees 1971, 1: no. 249; 2: pl. 371.
12. Surtees 1971, 1: nos. 214, 216, 255A–D; 2: pls. 306, 308, 384, 385.
13. Smith 1979, 142–145.
14. Ingram 1869, 43, 360. Smith 1979, 145 n. 28, states that Ingram was on the fringes of the Rossetti circle and corresponded with Rossetti in the 1870s. In the game "the Floral Oracle," if a woman chose a rose from a bouquet, it signified that she would marry an artist (Ingram 1869, 330).
15. Sonstroem 1970, 129.
16. Surtees 1971, 1: nos. 205, 173; 2: pls. 293, 248.
17. In Burne-Jones' illustration for the Kelmscott Chaucer's *The Romaunt of the Rose* (called *The Pilgrim in the Garden* or *The Heart of the Rose*), the lover worships his lady's face ensconced in the center of a fully opened rose blossom (Chaucer 1896, 312; see Parry 1983, 117–118, for a later tapestry based on the design).
18. Surtees 1971, 1: no. 714; 2: pl. 492.
19. Brighton 1974, no. 140.
20. The National Gallery of Canada acquired the two Pre-Raphaelite sirens together in 1925. They have recently been joined by the very unsirenlike *Edith Holman Hunt* (cat. 87).
21. Rossetti 1965–1967, 2:853–854, no. 997 (dated 24 April). The artist expressed a similar view to Charles Eliot Norton earlier that year (Rossetti 1965–1967, 2:784, no. 915 [dated 22 January 1870]).
22. Surtees 1971, 1: no. 372; 2: pl. 408.

## 89
## *Proud Maisie,* 1902

**Frederick Sandys**
Norwich 1829–1904 London

Two kinds of black chalk on wove paper, laid down on cardboard[1]

302 x 334 (15⁷/₁₆ x 13¹/₈)

Inscribed by the artist, upper right, in black chalk, *Proud Maisie. 1902. | F Sondys.* [sic]

Provenance: Purchased from P. & D. Colnaghi, London, 1925

Literature: London 1985, under no. 6; Schoenherr 1988, 313–314, fig. 4

Exhibition: Brighton 1974, no. 158, pl. 117

Acc. no. 3203

Although he produced a number of significant oil paintings in the Pre-Raphaelite mode,[2] Frederick Sandys achieved fame primarily as a draftsman, in Dante Gabriel Rossetti's opinion "the greatest of living draughtsmen."[3] He is now remembered for his superb designs for wood-engraved book illustrations of the 1860s,[4] and especially for his large portrait drawings and ideal heads executed in a bravura technique. The present *Proud Maisie* is one of a number of versions of his single most celebrated subject, a tour de force of extraordinary elaboration and obsession.

Born in Norwich to a journeyman dyer who had moved up in the world to become a drawing master and artist, the precocious Sandys exhibited a drawing of Minerva at the Norwich Art Union at the age of ten.[5] Sandys had moved to London by 1851, when he showed his first work at the Royal Academy, a crayon portrait of Lord Henry Loftus. Sometime after 1855 he added a "y" to his last name—"Sands" becoming "Sandys" but retaining the former pronunciation—in order to link himself at least orthographically with a more distinguished, aristocratic family.

In 1857 the still unknown artist suddenly catapulted to public attention with a caricature of John Everett Millais' *Sir Isumbras at the Ford,* which was attracting a lot of attention at that year's Royal Academy exhibition. Sandys' print, entitled *A Nightmare,* was an effective parody of the Pre-Raphaelite movement, burlesquing not only Millais, but also Rossetti, Holman Hunt, and John Ruskin.[6] Rossetti evidently enjoyed the spoof and became a close friend of Sandys for the next decade.

The Ottawa *Proud Maisie,* dated 1902, seems a quintessential fin-de-siècle image, so closely related to the innumerable gorgons, sphinxes, and femmes fatales of that deliciously decadent epoque that it comes as something of a shock to discover that Sandys first treated the subject some thirty-four years earlier. In 1868 Sandys exhibited at the Royal Academy a *Study of a Head* (no. 735), which was praised by two important champions of the Pre-Raphaelite movement, William Michael Rossetti and Algernon Charles Swinburne. Rossetti described the drawing as "an excellent study of a wilful, tameless-spirited beauty, who bites her hair in her gathering mood."[7] Swinburne commented at greater length: ". . . the other [drawing], a woman's face, is one of his most solid and splendid designs; a woman of rich, ripe, angry beauty, she draws one warm long lock of curling hair through her full and moulded lips, biting it with bared bright teeth, which add something of a tiger's charm to the

Fig. 1. Frederick Sandys, *Proud Maisie*, c. 1868, Victoria & Albert Museum, London (Courtesy of the Board of Trustees of the Victoria & Albert Museum)

Fig. 2. Dante Gabriel Rossetti, *Study for Delia in The Return of Tibullus*, Fitzwilliam Museum, Cambridge (Copyright Fitzwilliam Museum)

sleepy and couching passion of her fair face."[8] It seems probable that this 1868 crayon drawing was Sandys' original *Proud Maisie*, modeled on the seventeen-year-old actress Mary Clive (Mary Jones, daughter of Justice Jones of Hull), who met the artist around this time and became his common-law wife and the mother of his nine children. A colored chalk drawing in the Victoria & Albert Museum, London, is no doubt similar to the work shown in the 1868 exhibition (fig. 1).

It is significant that Sandys' drawing was not exhibited under the title of *Proud Maisie*. Apparently at some later date the artist decided to turn his work into a subject or ideal head by attaching the title *Proud Maisie*, derived from a celebrated poem by Sir Walter Scott.[9] Sandys may have found his portrait of his mistress more commercially viable with the literary allusions of a new title, although aside from depicting a proud, disdainful beauty the drawing does not really illustrate the death-and-the-maiden theme of Scott's poem.

*Proud Maisie* became Sandys' greatest hit, and to the end of his life the artist was content to produce replica after replica, some of inferior quality. The earlier

versions are usually executed in colored chalks and feature a Rossetti-like rose ornament in the model's hair and medievalizing decorative flaps on the upper sleeve.[10] The later versions, such as the Ottawa drawing, have no hair ornament, a different sleeve with no shoulder flaps, and a cuff introduced below the wrist.[11] The amazing proto-art nouveau rhythms of the hair vary considerably from version to version. The style of the drawings also changes from the coloristic warmth and spirit of the Victoria & Albert sheet to the cold, glittering hardness of the Ottawa drawing, a glacial rendering that effectively enhances the chilly hauteur of the subject. *Proud Maisie* obviously found renewed favor at the turn of the century among the Decadents, whose mood Sandys had anticipated three decades earlier.

The derivation of Sandys' *Proud Maisie* from precedents in Dante Gabriel Rossetti's work illustrates the uneasy alliance between the two artists in the 1860s. While Sandys was technically one of the finest graphic artists of his age, he evidently lacked powers of invention. He not only repeated many of his compositions, but also based many of his motifs on those of his friend Rossetti, whose

vivid visual imagination amply compensated for his undeniable weaknesses in technique. Their friendship was at its closest during 1866, when Sandys lived with Rossetti at 16 Cheyne Walk in London. In 1869, however, a crisis in the relationship occurred when Rossetti pointed out the similarity of many of Sandys' designs to his own.[12] Sandys reacted violently to the charges of plagiarism, perhaps because they were largely true, and broke off the friendship, to Rossetti's regret. Although *Proud Maisie* was not one of the works specifically mentioned by Rossetti, it belongs generically to a long line of enticing sirens that Rossetti had depicted in head-and-shoulders poses with great emphasis on their luxuriant hair, beginning with *Bocca Baciata* (1859) and continuing with such works as *Helen of Troy* (1863), *Fazio's Mistress* (1863), *Woman Combing Her Hair* (1864), and *The Blue Bower* (1865), to name only a few.[13] Rossetti's portrait of Mrs. Morris called *The Roseleaf* (cat. 88) continues this tradition, providing an interesting mirror-image pendant to *Proud Maisie*.

The principal motif of Sandys' drawing derives from Rossetti's many studies of Elizabeth Siddal for the figure of Delia (fig. 2) in *The Return of Tibullus to Delia*

Fig. 3. Frederick Sandys, *If*, 1866, City Museum and Art Gallery, Birmingham

(1851–1853), a theme that Rossetti had returned to in the later 1860s, when he and Sandys were in close contact.[14] Sandys was evidently most impressed with Rossetti's deeply sensual image of a young woman drawing a strand of hair through her teeth, for he first used it in an 1866 book illustration for Christina Rossetti's poem *If* (fig. 3), where the action symbolizes the intense sexual longing of the heroine, as it does in Rossetti's *Tibullus*.[15] Sandys repeated the motif soon afterward in another 1866 book illustration, *Helen and Cassandra*, which shows Helen in a sulk, drawing a strand of hair through her teeth.[16] This illustration also spawned Sandys' painting of *Helen of Troy* (c. 1867), in which the artist isolated the figure in a head-and-shoulders composition.[17] It seems clear, therefore, that Sandys' *Proud Maisie* was inspired by one of Rossetti's more provocative motifs and was the sort of borrowing that Rossetti complained about in 1869, although Sandys has treated the motif in his own inimitable way.

The importance of women's hair to the Pre-Raphaelites and to Rossetti in particular is well known. It is perhaps not entirely coincidental that at the same time Sandys was producing his first *Proud Maisie*, Rossetti was completing his oil

painting *Lady Lilith* (1868), showing the woman considered to be Adam's first wife according to Rabbinical tradition, combing her luxuriant locks before a mirror.[18] Sandys had no doubt been attracted to Mary Jones because of her stupendous locks. One of his first depictions of her is a portrait entitled *Love's Shadow* (1867; see cat. 88, fig. 2), in which the over-the-shoulder profile pose and the abundant cascading hair obviously look forward directly to the *Proud Maisie* of the following year.[19] At Mary's death in 1920, Gordon Bottomley remembered her hair and Sandys' obsession with it in an obituary poem:

Now she is deathless by her lover's hand,
To move our hearts and those of men not
   born,
With famous ladies by her living hair—
Helen and Rosamund and Mary Sandys.[20]

It is not surprising that *Proud Maisie*'s locks were soon transformed by Sandys into *Medusa* (c. 1875),[21] an almost inevitable progression from Pre-Raphaelite femme fatale to symbolist gorgon.

DES

1. The remains of tack-over edges on the top, right, and bottom of the primary support indicate that it was once mounted on a wooden strainer or panel.
2. Notably *Mary Magdalene* (c. 1859–1860, Bancroft Collection, Delaware Art Museum, Wilmington), *Autumn* (c. 1861–1862, City of Norwich Museums), *Morgan Le Fay* (1862–1863, City Museum and Art Gallery, Birmingham), and *Medea* (1868, City Museum and Art Gallery, Birmingham). Brighton 1974, nos. 46, 52, 58, 72, pls. 20, 24, 29, 43, respectively.
3. Quoted in Brighton 1974, 17.
4. The National Gallery of Canada has recently acquired Sandys' superb design for Christina Rossetti's poem *Amor Mundi*, published in the *Shilling Magazine* in 1865 (London 1986, no. 13). See Schoenherr 1988.
5. His earliest patron was the Reverend James Bulwer (1793–1879), a naturalist, antiquarian, and amateur artist, who became with his son a personal friend of Sandys. Members of the Bulwer family eventually moved to Vancouver and presented an oil *Portrait of the Reverend Bulwer* (1863) by Sandys to the National Gallery of Canada in 1961 (Brighton 1974, no. 86, pl. 57). The Bulwer family also presented the diary that Sandys kept while working on the portrait; the National Gallery of Canada purchased from the Bulwer family in 1983 a colored chalk portrait of Dorothea Bulwer by Sandys (Ottawa 1965, no. 131).
6. Brighton 1974, no. 42, pl. 18.
7. Rossetti and Swinburne 1868, 25.
8. Rossetti and Swinburne 1868, 43.
9. Mad Madge Wildfire sings the song as she expires at the conclusion of chapter 40 in *The Heart of Midlothian* (1818). In the poem, Proud Maisie asks a robin on a bush when she shall marry; the bird replies that her bridal bed will be her grave. Sandys may have been attracted to the poem by his taste for the maca-

bre, which is very evident in his book illustrations. The poem was frequently anthologized and became a favorite lyric for songwriters, one of Sandys' *Proud Maisie* drawings (Collection Lord Battersea, now Victoria & Albert Museum, London) being used on one occasion as an illustration for a music book (MacLeod and Boulton, frontispiece).
10. Six drawings of this type are known: two in the Victoria & Albert Museum, London (fig. 1; Brighton 1974, nos. 142–143, pls. 102–103); Sotheby's, Belgravia, 25 March 1975, lot 21 (apparently c. 1870); Sotheby's, Belgravia, 18 April 1978, lot 44 (dated 1893 on label on verso); National Gallery of Victoria, Melbourne (Lindsay 1937, 51); and London 1985, no. 6. A drawing from the collection of Dr. Todhunter, possibly one of the above, was reproduced in Wood 1896, 9. The artist also began an oil painting of *Proud Maisie* (c. 1868), but only completed the background of apple blossoms and a blossom in the hair (Brighton 1974, no. 69, pl. 40).
11. Only two other drawings of this type are known besides the Ottawa one: Sotheby's, Belgravia, 1 October 1979, lot 16 (dated 1903) and a very late version (dated 1904) in a private collection in Melbourne in 1972 (photograph in National Gallery of Canada curatorial file).
12. Rossetti 1965–1967, 2:697–699, nos. 828–829; Rossetti 1903, 393–396, under 27 May, 4 June, and 5 June 1869.
13. Surtees 1971, 1: nos. 114, 163–164, 174, 178; 2: pls. 186, 232, 234, 252, 259, respectively.
14. Surtees 1971, 1: nos. 62, 62A, 62B, 62D, 62E, R.1; 2: pls. 56–58, 60–61.
15. Brighton 1974, nos. 275–276, pl. 167.
16. Brighton 1974, nos. 270–271, pl. 166.
17. Brighton 1974, under no. 67.
18. Surtees 1971, 1: no. 205; 2: pl. 293. On a label on the back of a watercolor version of *Lady Lilith* (1867), Rossetti inscribed four lines from Shelley's translation of Goethe's *Faust, Part I*, indicating an interesting early romantic source for Pre-Raphaelite hair fetishism:

Beware of her hair, for she excels
All women in the magic of her locks
And when she twines them round a young man's neck
She will not ever set him free again.

   (Surtees 1971, 1: no. 205 R.1.)
19. Brighton 1974, nos. 140–141, pls. 100–101.
20. Brighton 1974, 15.
21. Brighton 1974, no. 152, pl. 111.

## 90

## *The Return of the Dove to the Ark, 1851*

**John Everett Millais**

Southampton 1829–1896 London

Brush and pen with black and gray ink over traces of graphite, with scraping out, on wove paper with gold paint border[1]

234 x 129 (9³/₁₆ x 5¹/₁₀), trimmed to arch at top

Inscribed by the artist, lower right, in brush point and black ink, *1851 JM* [in monogram]

Provenance: Juliet Pritchett; her sale, Sotheby's, London, 15 July 1964, lot 35; purchased from J. S. Maas & Co., London, 1964

Literature: Betcherman 1965, 336; Rosenblum 1965–1966, 140, 142, fig. 8; Boggs 1969, 155; Maas 1969, 126; Boggs 1971, 58, pl. 183; New York 1975b, under no. 32; Bolton 1979, under no. 48; Grieve 1984, 36, 40–41, fig. 15; Maas 1984, 227; London 1984c, under no. 34

Exhibitions: Ottawa 1965, 17 (repr.), no. 91; London 1967, no. 270, under no. 32; Toronto 1968, no. 55 (repr.); London 1969, 9, 81, no. 76; Florence 1969, 11, no. 44, fig. 46; Paris 1969–1970, 11, no. 78; Peoria 1971, no. 50; Baden-Baden 1973–1974, no. 61

Acc. no. 14661

John Everett Millais was one of the great child prodigies of art, entering the Royal Academy Schools at the age of eleven and showing his first picture at a Royal Academy exhibition at the age of sixteen. In the fall of 1848 he joined William Holman Hunt (cat. 87) and Dante Gabriel Rossetti (cat. 88) to found the Pre-Raphaelite Brotherhood, whose principal aims were to study nature intensely and to produce pictures with the same directness and conviction as those created before Raphael. When the three young artists first publicly exhibited paintings inscribed with the initials *P.R.B.* in 1849, they were on the whole well received. In the following year, however, the critical press began their savage onslaught, provoked particularly by Millais' *Christ in the House of His Parents* (exhibited at the Royal Academy in 1850), which drew the wrath of Charles Dickens because of its uncompromising realism applied to a cherished sacred subject.

Undeterred by this public hostility, Mil-lais prepared three pictures for the 1851 Royal Academy exhibition: *The Woodman's Daughter, Mariana,* and *The Return of the Dove to the Ark.* The progress of the latter, which was the last to be painted, may be followed in a series of letters to the superintendent of the Clarendon Press at Oxford, Thomas Combe, and his wife, close friends and ardent supporters of the artist. Millais originally intended to paint an elaborate Deluge picture, reporting in early December 1850 that he had settled his composition and would commence it that week.[2] Shortly thereafter Rossetti saw the completed design, probably the superb drawing *The Eve of the Deluge* now in the British Museum, London, which he described as "immeasurably the best thing" Millais had done.[3] In mid-January 1851 Millais was still hoping to begin the painting, but by the end of the month he had realized that he could not possibly complete so ambitious a composition in time to submit it to the Royal Academy in early April.[4] He there-

Fig. 1. Charles Landseer, *The Return of the Dove to the Ark,* The FORBES Magazine Collection, New York (Photograph Otto E. Nelson)

fore wrote to Combe that he had given up the Flood for this year and substituted a smaller picture:

> The subject is quite new and, I think, fortunate; it is the dove returning to the Ark with the olive-branch. I shall have three figures—Noah praying, with the olive-branch in his hand, and the dove in the breast of a young girl who is looking at Noah. The other figure will be kissing the bird's breast. The background will be very novel, as I shall paint several birds and animals one of which now forms the prey to the other.[5]

Millais was perhaps exaggerating the novelty of his proposed picture, for it seems likely that it was inspired by Charles Landseer's *The Return of the Dove to the Ark* (fig. 1), exhibited at the Royal Academy in 1844, when Millais was attending the Royal Academy Schools.[6] In the center of Landseer's picture is a seated young woman pressing the dove to her breast. To the left stands Noah, his hands clasped in prayer. The background contains just the sort of Peaceable Kingdom menagerie that Millais suggested for his much smaller and more intimate work. A sketch for Millais' composition with Noah is at the City Museum and Art Gallery, Birmingham.[7]

On 10 February 1851 Millais wrote to Mrs. Combe that he was hoping to commence the Noah picture that week.[8] Sometime between then and the first of April when the Combes had purchased the still unfinished picture, Millais eliminated the figure of Noah and the animals in the background, focusing exclusively on the two young girls who have been described as the daughters of Noah or the wives of the sons of Noah.[9] He reported to his Oxford friends that the picture was considered the best of his three Royal Academy entries by all of his fellow artists.[10]

Although he had used the arched compositional format previously for his *Ferdinand Lured by Ariel* (Royal Academy, 1850), Millais may have wished to present his Dove picture as a pendant to the similarly arched *Convent Thoughts* by Charles Allston Collins, also shown in the 1851 exhibition and subsequently bought by the Combes.[11] He may also have chosen the curved top for his Dove composition to evoke the rainbow that appeared at the end of the Flood.[12]

At the same time that Millais was working on the Ottawa drawing, his final design for the Dove picture, he was com-

pleting a small and intense portrait entitled *The Bridesmaid* (1851; fig. 2), not intended for the coming exhibition. It seems quite probable that the same model, a Miss McDowall,[13] was used for both the bridesmaid and the girl on the left in the Ottawa sheet, because of the striking similarity of features, particularly the abundant cascading hair. Millais was evidently dissatisfied with this figure in his drawing, for he chose an entirely different, much homelier model for the finished picture (fig. 3), thus incurring the displeasure of the critics who were sensitive to female beauty as a prerequisite of art.[14]

Millais' motif of one woman embracing another resembles a Visitation,[15] but the cast of characters with the added dove points more strongly to an Annunciation. The return of the dove to the ark could, in fact, be interpreted as a typological prefiguration of the Annunciation, the theme of hope and salvation being central to both events.[16] That Millais was thinking of an Annunciation subtext for his *Return of the Dove to the Ark* is suggested by the change in the costume of the girl on the right. In the Ottawa drawing both figures wear loose, vaguely me-

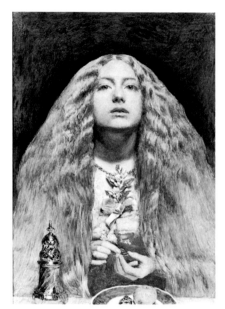

Fig. 2. John Everett Millais, *The Bridesmaid*, 1851, Fitzwilliam Museum, Cambridge (Copyright Fitzwilliam Museum)

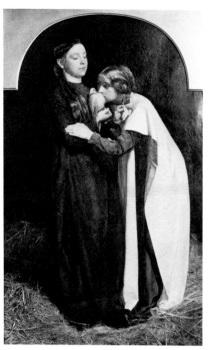

Fig. 3. John Everett Millais, *The Return of the Dove to the Ark*, 1851, Ashmolean Museum, Oxford (Copyright Ashmolean Museum)

the Royal Academy are already seen in his Dove picture: the two embracing figures became almost a formula in such future triumphs as *A Huguenot* (Royal Academy, 1852) and *The Black Brunswicker* (Royal Academy, 1860). The motif seems to have lingered as late as *The Princes in the Tower* (Royal Academy, 1878), when Millais had become a wealthy and successful academician, producing popular subjects and portraits in a broad painterly style far removed from his youthful Pre-Raphaelite work.[24]

<div align="right">D E S</div>

1. Since this drawing is often referred to as being executed in pen and ink, it is worth noting that microscopic examination has revealed that it was done almost exclusively with a brush.
2. Millais 1899, 1:91.
3. Fredeman 1975, 86, under 10 December 1850, 241 n. 10.1.
4. Millais 1899, 1:94. As late as 1854 Millais was still hoping to begin the Flood picture, but he never did so (Bolton 1979, no. 47).
5. Millais 1899, 1:97.
6. New York 1975b, no. 32.
7. London 1984c, 89, under no. 34.
8. Millais 1899, 1:99.
9. Millais 1899, 1:98.
10. Millais 1899, 1:100.
11. London 1984c, 88–89.
12. The artist was certainly in the habit of endowing every detail of his pictures with complex symbolic meanings; a sweeping semicircular table, evidently intended to symbolize the rainbow, had already appeared in his earlier design for *The Eve of the Deluge*.
13. Fredeman 1975, 89, under 9 February 1851, 243 n. 9.15.
14. Harding 1977, 70. Ruskin was particularly severe: "No defense can, however, be offered for the choice of features in the left-hand figure of Mr. Millais' 'Dove returning to the Ark.' I cannot understand how a painter so sensible of the utmost refinement of beauty in other objects should deliberately choose for his model a type far inferior to that of average humanity, and unredeemed by any expression save that of dull self-complacency" (Ruskin 1903–1912, 12:325).
15. Noted in Baden-Baden 1973–1974, no. 61.
16. Scriptural typology or the method of finding anticipations of Christ in Old Testament persons and events was a fundamental device of Victorian literature and art, particularly of the Pre-Raphaelites. See Landow 1979, Landow 1980, and Sussman 1979. The rainbow after the Flood was interpreted as a type of Christ, notably by Ruskin (Landow 1980, 112–113), but Millais' prefiguration of the Annunciation in *The Return of the Dove to the Ark* appears to be a unique interpretation of this event (see Sussman 1979, 58–60).
17. The first Pre-Raphaelite picture that Burne-Jones and his college friend William Morris had seen, in a shop window in Oxford in 1854, was Millais' *Return of the Dove to the Ark*, a major epiphany in their artistic education (Burne-Jones 1906, 1:99). Burne-Jones' watercolor *The Annunciation*, begun in 1859 and finished in 1861 (City Museum and Art Gallery, Birmingham), shows the Virgin pressing the dove to her breast and the angel Gabriel in an ecclesiastical vestment. The

dieval garments reminiscent of smocks or nightdresses; in the Oxford oil the girl kissing the dove wears a white ecclesiastical surplice, like a nun's scapular, which Millais quite obviously borrowed from the Angel Gabriel in Rossetti's celebrated Annunciation picture, *Ecce Ancilla Domini!* (1849–1850, Tate Gallery, London). If the figure on the right has links with the Angel Gabriel, the principal figure on the left, holding the dove to her breast, suggests the Virgin Annunciate. That other contemporary viewers understood the Annunciation imagery in Millais' Dove picture is confirmed by an early watercolor and a stained-glass design of the Annunciation by Edward Burne-Jones based on Millais' *Return of the Dove to the Ark*.[17]

It was Millais' habit in his early Pre-Raphaelite days to make many preparatory drawings for his pictures. For the Dove there remains a sketch of the two girls (Vanderbilt Art Gallery, Nashville), the present finished *modello*, and a nude study, unique in Millais' oeuvre, which may have served as a cartoon (Royal Academy of Arts, London).[18] The Ottawa sheet is executed in an exquisite, highly finished style typical of P.R.B. drawings of c. 1848–1850.[19] The draperies in particular have been stylized to suggest Gothic statuary in their simplified planes and sharp angles. The heads, bird, and straw, as well as the delicate hatching of the draperies, rival Dürer in their perfection of technique and finish.[20] Millais' prominent monogram in the lower right reinforces the Düreresque flavor of the drawing.

*The Return of the Dove to the Ark*, which Millais himself described as "universally acknowledged to be my best work, parts of which I feel incapable of surpassing,"[21] has always been admired by the public and connoisseurs alike. The Victorian exhibition-goer could enjoy it for its anecdotal charm, which was only one step away from the sentimental "Good Night, Pet" variety of genre;[22] Ruskin appreciated the beauty of the execution and coloring, as well as the tenderness of the motif.[23]

The seeds of Millais' future successes at

motif of the clasped dove, which quite obviously derives from Millais' picture, was repeated in Burne-Jones' highly original Annunciation design (c. 1860) for the left lancet of a triple-light window commissioned for Saint Columba's, Topcliffe, Yorkshire, by the architect William Butterfield. This unorthodox and sensual gesture so offended Butterfield that when Burne-Jones refused to change it, the remaining windows were taken away from him and awarded to Michael Frederick Halliday. For the Topcliffe window, which was executed by the stained-glass firm of Lavers and Barraud, see Sewter 1974–1975, 1:13–14, color pl. 2, 2:3; Harrison and Waters 1973, 31–32, color pl. 3; Fitzgerald 1975, 33. For Burne-Jones' cartoon, see London 1975–1976, no. 61.

18. Bolton 1979, 12–13, 28, under no. 48.

19. See Grieve 1984, 23–43.

20. See Dürer, cat. 28, *Nude Woman with a Staff*, where a hatched pen-and-ink figure is similarly silhouetted against a dark wash background.

21. Millais 1899, 1:105.

22. Grieve 1984, 41. Millais went on to paint such pictures as *The Dove* (1862; Indianapolis 1964, no. 52), which may derive from Walter Howell Deverell's *A Pet* (1853; London 1984c, no. 54).

23. Indeed Ruskin tried to purchase the picture from the 1851 exhibition, but it had been already sold to the Combes (Millais 1899, 1:101; Fredeman 1975, 92, under 8–10 May 1851). To balance the general abuse in the press, Ruskin came to the Brotherhood's defense in two letters to the *Times*, dated 9 May and 26 May and published on 13 May and 30 May 1851, respectively (Ruskin 1903–1912, 12:319–327). Ruskin's support produced a decisive change in the public fortunes of the Pre-Raphaelites and marked the beginning of the strange and eventful relationship between Millais and the critic; their friendship ended with the artist marrying Ruskin's wife, Effie, in one of the most delicious scandals in nineteenth-century British art (Lutyens 1967).

24. The National Gallery of Canada owns a fine example of Millais' late painting *Portrait of the Marquis of Lorne* (1884), which the artist presented at the suggestion of the sitter, who had founded the National Gallery in 1880 (Hubbard 1959a, 108).

# Bibliography  *Books and Articles*

Adriani 1983
Adriani, Götz. *Cézanne Watercolors*. New York, 1983.

Alcaide 1965
Alcaide, Victor Manuel Nieto. *Dibujos de la Real Academia de San Fernando: Carlo Maratti, cuarenta y tres dibujos de tema religioso*. Madrid, 1965.

Alexander 1937
Alexander, R. G. *A Catalogue of the Etchings of Samuel Palmer*. The Print Collectors' Club Publication, no. 16. London, 1937.

Allen 1984
Allen, Virginia M. " 'One Strangling Golden Hair': Dante Gabriel Rossetti's *Lady Lilith*." *The Art Bulletin* 66 (June 1984), 285–294.

Ames-Lewis 1981
Ames-Lewis, F. *Drawing in Early Renaissance Italy*. New Haven, 1981.

Ananoff 1961–1970
Ananoff, Alexandre. *L'Oeuvre dessinée de Jean-Honoré Fragonard, 1732–1806: Catalogue raisonné*. 4 vols. Paris, 1961–1970.

Ananoff 1976
Ananoff, Alexandre. *François Boucher*. 2 vols. Lausanne and Paris, 1976.

Andrews 1964
Andrews, Keith. *The Nazarenes: A Brotherhood of German Painters in Rome*. Oxford, 1964.

Anonymous 1854
Anonymous. "Fine-Art Gossip." *The Athenaeum*, no. 1387 (27 May 1854), 657.

Anonymous 1928
Anonymous. "Current Art Notes." *Connoisseur* 81 (August 1928), 258.

Anonymous 1948
Anonymous. "List of Pictures Presented by Mr. F. J. Nettlefold to Various Public Galleries, etc." *Connoisseur* 122 (December 1948), lix.

Anonymous 1949
Anonymous. "Noble Landscapes Recently Acquired by the National Gallery of Canada." *Illustrated London News*. 17 September 1949, 434–435.

Anonymous 1973
Anonymous. *Wightwick Manor, Staffordshire (The National Trust)*. London (?), 1973.

Anonymous 1987
Anonymous. "Review of *Gustave Moreau: The Watercolours* by Pierre-Louis Mathieu." *Drawing* 9, no. 2 (July-August 1987), 39–41.

Antal 1956
Antal, Frederick. *Fuseli Studies*. London, 1956.

Antal 1962
Antal, Frederick. *Hogarth and His Place in European Art*. London and New York, 1962.

Armstrong 1902
Armstrong, Walter. *Turner*. London, 1902.

Arslan 1960
Arslan, E. *I Bassano*. Milan, 1960.

Askew 1969
Askew, Pamela. "The Angelic Consolation of St. Francis of Assisi in Post-Tridentine Italian Painting." *Journal of the Warburg and Courtauld Institutes* 32 (1969), 280–306.

Baigell 1981
Baigell, Matthew. *Thomas Cole*. New York, 1981.

Ballarin 1969
Ballarin, Alessandro. "Introduzione ad un catalogo dei disegni di Jacopo Bassano—I." *Arte Veneta* 23 (1969), 85–114.

Ballarin 1973
Ballarin, Alessandro. "Introduzione a un catalogo di Jacopo Bassano—III." *Arte Veneta* 27 (1973), 91–123.

Balston 1947
Balston, Thomas. *John Martin 1789–1854: His Life and Works*. London, 1947.

Bartram 1985
Bartram, Michael. *The Pre-Raphaelite Camera*. Boston, 1985.

Bartsch
Strauss, Walter (general editor). *The Illustrated Bartsch*. New York, continuing.

Baskett and Snelgrove 1977
Baskett, John, and Dudley Snelgrove. *The Drawings of Thomas Rowlandson in the Paul Mellon Collection*. London, 1977.

Baudouin 1977
Baudouin, Frans. *Pietro Paolo Rubens*. New York, 1977.

Baum 1938
Baum, Richard M. "A Rowlandson Chronology." *The Art Bulletin* 20 (September 1938), 237–250.

Bean 1976
Bean, Jacob. "Johann Liss (and Paolo Pagani)." *Master Drawings* 14, no. 1 (Spring 1976), 64–66.

Bean 1979
Bean, Jacob. *Seventeenth-Century Italian Drawings in the Metropolitan Museum of Art*. New York, 1979.

Bean and Turčić 1982
Bean, Jacob, and Lawrence Turčić. *15th and*

*16th Century Italian Drawings in the Metropolitan Museum of Art*. New York, 1982.

Bell 1901
Bell, C. F. *The Exhibited Works of Turner*. London, 1901.

Bell and Girtin 1935
Bell, C. F., and Thomas Girtin. "The Drawings and Sketches of John Robert Cozens." Special issue of *The Walpole Society* 23 (1934–1935). Reprint 1969.

Bellori 1672
Bellori, Giovanni Pietro. *Le vite de pittori, scultori e architetti moderni*. Rome, 1672. Reprint. Turin, 1976.

Benedetti 1984
Benedetti, Maria Teresa. *Dante Gabriel Rossetti*. Florence, 1984.

Benesch 1935
Benesch, Otto. *Rembrandt Werk und Forschung*. Vienna, 1935.

Benesch 1957
Benesch, Otto. *The Drawings of Rembrandt*. 6 vols. London, 1957. Rev. ed. London, 1973.

Benesch 1962
Benesch, Otto, ed. *Great Drawings of All Time*. 2 vols. New York, 1962.

Benesch 1964
Benesch, Otto. *Meisterzeichnungen der Albertina: Europäische Schulen von der Gotik bis zum Klassismus*. Salzburg, 1964.

Bénézit
Bénézit, E. *Dictionnaire des peintres, sculpteurs, dessinateurs, et graveurs*, 10 vols. Rev. ed. Paris, 1976.

Berenson 1938
Berenson, Bernard. *Drawings of the Florentine Painters*. 3 vols. Chicago, 1938. 3d ed. Chicago, 1961.

Van den Berg 1942
Van den Berg, H. M. "Willem Schellinks en Lambert Doomer in Frankrijk." *Oudheidkundig Jaarboek* 2 (1942), 1–31.

Bernt 1958
Bernt, Walter. *Die Niederländischen Zeichner des 17 Jahrhunderts*. Munich, 1958.

Bertelà and Ferrara 1973
Bertelà, Giovanna, and Stefano Ferrara. *Incisori bolognesi ed emiliani del secolo XVII*. Bologna, 1973.

Betcherman 1965
Betcherman, Lita-Rose. "Victorian Painting at Ottawa." *The Burlington Magazine* 107 (June 1965), 336.

Binion 1983
Binion, Alice. *I disegni di Giambattista Pittoni*. Florence, 1983.

Blake 1980
Blake, William. *The Letters of William Blake with Related Documents*. 3d ed. Edited by Geoffrey Keynes. Oxford, 1980.

Blanc 1865
Blanc, Charles. *Histoire des peintres de toutes les écoles: Ecole française*. 3 vols. Paris, 1865.

Boase 1959
Boase, T. S. R. *English Art, 1800–1870*. Oxford History of English Art, no. 10. Oxford, 1959.

Bocher 1875
Bocher, Emmanuel. *Les Gravures françaises du XVIIIe siècle, II: Pierre-Antoine Baudouin*. Paris, 1875.

Bocher 1876
Bocher, Emmanuel. *Les Gravures françaises du XVIIIe siècle, III: Jean-Baptiste Siméon Chardin*. Paris, 1876.

Bodmer 1939
Bodmer, Heinrich. *Ludovico Carracci*. Burg.b. Main, 1939.

Boggs 1969
Boggs, Jean Sutherland. "European Drawings from the National Gallery of Canada." *Apollo* 90 (August 1969), 152–155.

Boggs 1971
Boggs, Jean Sutherland. *The National Gallery of Canada*. Toronto, 1971.

Boggs 1975
Boggs, Jean Sutherland. *Prints by Goya: The Changing Image. National Gallery of Canada Journal* 5 (February 1975), 1–8.

Bohn 1984
Bohn, Babette. "The Chalk Drawings of Ludovico Carracci." *Master Drawings* 22, no. 4 (Winter 1984), 405–425.

Boime 1980
Boime, Albert. *Thomas Couture and the Eclectic Vision*. New Haven and London, 1980.

Boon 1961
Boon, K. G. "Roelandt Savery te Praag." *Bulletin van het Rijksmuseum* 9, no. 4 (1961), 145–148.

Boon 1978
Boon, K. G. *Catalogue of the Dutch and Flemish Drawings in the Rijksmuseum*. Vol. 2. *Netherlandish Drawings of the Fifteenth and Sixteenth Centuries*. The Hague, 1978.

Borenius and Wittkower
Borenius, Tancred, and Rudolf Wittkower. *Catalogue of the Collection of Drawings by the Old Masters Formed by Sir Robert Mond*. London, n.d.

Bortolatti 1974
Bortolatti, Luigina Rossi. *L'opera completa di Francesco Guardi*. Milan, 1974.

Bottari and Ticozzi 1822–1825
Bottari, Giovanni Gaetano, and Stefano Ticozzi. *Raccolta di lettere sulla pittura, scultura ed architettura. . . .* 8 vols. Milan, 1822–1825.

Boucher 1979
Boucher, Marie-Christine. *Catalogue des beaux-arts de la ville de Paris*. Paris, 1979.

Bourin 1910
Bourin, H. "Le Chevalier de Lespinasse." *Bulletin de Société d'iconographie parisienne*, 1910, 25–32.

Boyer 1949
Boyer, Ferdinand. "Catalogue raisonné de l'oeuvre de Charles Natoire, peintre du Roi (1700–1777)." *Archives de l'art français* 21 (1949), 31–106.

Brejon de Lavergnée 1986
Brejon de Lavergnée, Barbara. "New Attributions around Simon Vouet." *Master Drawings* 23–24, no. 3 (Autumn 1986), 347–351.

Briganti 1970
Briganti, Giuliano. *The View Painters of Europe*. Translated by Pamela Waley. Oxford, 1970.

Briganti 1977
Briganti, Giuliano. *I pittori dell'immaginario: Arte e rivoluzione psicologica*. Milan, 1977.

Briquet
Briquet, Charles Moïse. *Les filigranes. Dictionnaire historique des marques du papier*. 4 vols. Paris, 1907, 2d ed. Leipzig, 1923.

Brockhaus 1885
Brockhaus, Heinrich. *Gesammelte Studien zur Kunstgeschichte . . . für Anton Springer*. Leipzig, 1885.

Brown 1905
Brown, G. Baldwin. *William Hogarth*. London and New York, 1905.

Brussels 1984
Musées Royaux des Beaux-Arts de Belgique. *Catalogue inventaire de la peinture ancienne*. Brussels, 1984.

Bruyn 1982
Bruyn, Joos. "The Documentary Value of Early Graphic Reproductions." In Rembrandt Research Project, *A Corpus of Rembrandt Paintings* 1. 35–52. The Hague, 1982.

Bryson and Troxell 1976
Bryson, John, and Janet Camp Troxell, eds. *Dante Gabriel Rossetti and Jane Morris: Their Correspondence*. Oxford, 1976.

Burchard and d'Hulst 1963
Burchard, Ludwig, and R.-A. d'Hulst. *Rubens Drawings*. Brussels, 1963.

Burne-Jones 1906
[Burne-Jones, Georgiana]. *Memorials of Edward Burne-Jones*. 2 vols. in 1. New York and London, 1906.

Burri 1982
Burri, Silva. "Paolo Pagani." *Saggi e memorie* 13 (1982), 47–72.

Bury 1950
Bury, Adrian. *Two Centuries of British Watercolour Painting*. London, 1950.

Butlin 1962
Butlin, Martin. *Samuel Palmer's Sketch-book, 1824*. 2 vols. [London and Paris], 1962.

Butlin and Joll 1984
Butlin, Martin, and Evelyn Joll. *The Paintings of J. M. W. Turner*. Rev. ed. 2 vols. New Haven and London, 1984.

Byam Shaw 1962
Byam Shaw, James. *The Drawings of Domenico Tiepolo*. London, 1962.

Byam Shaw 1967
Byam Shaw, James. *Paintings by Old Masters at Christ Church*. Oxford, 1967.

Byam Shaw and Knox 1987
Byam Shaw, James, and George Knox. *The Robert Lehman Collection at the Metropolitan Museum of Art: Italian Eighteenth-Century Drawings*. Princeton, 1987.

Carlisle 1813
Carlisle, Nicholas. *A Topographical Dictionary of Scotland*. Vol. 1. London, 1813.

Carman 1985
Carman, W. Y. *Richard Simkin's Uniforms of the British Army*. Exeter, 1985.

Casgrain 1903
Casgrain, P. Baby. *La Maison d'Arnoux où Montcalm est mort*. Bulletin des recherches historiques. Lévis, 1903.

Castiglione 1971
Castiglione, Giovanni Benedetto. *Lettere e altri documenti intorno alla storia della pittura: Giovanni Benedetto Castiglione detto il Grechetto . . .* Genoa, 1971.

Cazort 1975
Cazort, Mimi Taylor. "The Van Dyck drawing, *Expulsion from Paradise*." Typescript of a memorandum, National Gallery of Canada, 12 August 1975.

Cecil 1969
Cecil, David. *Visionary and Dreamer, Two Poetic Painters: Samuel Palmer and Edward Burne-Jones*. Bollingen Series 35, 15. Princeton, 1969.

Chapais 1911
Chapais, Thomas. *Le Marquis de Montcalm*. Quebec, 1911.

Chapman 1986
Chapman, H. Parry. "A *Hollandse Pittura*: Observations on the Title Page of Philips Angel's Lof der schilder-konst." *Simiolus* 16, no. 4 (1986), 233–248.

Chappuis 1973
Chappuis, Adrien. *The Drawings of Paul Cézanne: A Catalogue Raisonné*. 2 vols. London, 1973.

Chaucer 1896
Chaucer, Geoffrey. *The Works of Geoffrey Chaucer Now Newly Imprinted*. Kelmscott Press. London, 1896.

Chesneau 1866
Chesneau, Ernest. "Salon de 1866." *Le Constitutionnel* 8 May 1866.

Churchill 1935
Churchill, W. A. *Watermarks in Paper in Holland, England, France, etc. in the XVII and XVIII Centuries and Their Interconnection*. Amsterdam, 1935.

Ciselet and Delcourt 1943
Ciselet, Paule, and Marie Delcourt, eds. *Belgique 1567 par Messire Lodovico Guicciardini*. Brussels, 1943.

Clark 1956
Clark, Kenneth. *The Nude: A Study in Ideal Form*. New York, 1956.

De Claussin 1824–1828
Claussin, Ignace-Joseph de. *Catalogue raisonné de toutes les estampes de Rembrandt*. Paris, 1824. (*Supplément*, 1828).

Cohn 1977
Cohn, Marjorie B. *Wash and Gouache: A Study of the Development of the Materials of Watercolor*. Cambridge, Mass., 1977.

Colnaghi 1960
*Colnaghi's 1760–1960*. London, 1960.

Crittall 1962
Crittall, Elizabeth, ed. *The Victorian History of the Counties of England: A History of Wiltshire*, Vol. 6. London, 1962.

Cummings 1974
Cummings, Frederick. "La Peinture sous Louis XVI." In *De David à Delacroix: La Peinture française de 1774 à 1830*, 31–44. Paris, 1974.

Dacier and Vuaflart 1929
Dacier, Emile, and Albert Vuaflart. *Jean de Jullienne et les graveurs de Watteau au XVIIIe siècle*. 4 vols. Paris, 1929.

Daniels 1975
Daniels, Jeffery. "Sado-Mannerism." *Art & Artists* 9 (February 1975), 22–29.

Davies and Gould 1970
Davies, Martin, and Cecil Gould. *National Gallery Catalogues: French School*. London, 1970.

Dayot and Vaillat 1907
Dayot, Armand, and Léandre Vaillat. *L'Oeuvre de J.-B. S. Chardin et de J.-H. Fragonard*. Paris, 1907.

Defoer 1977
Defoer, H. L. M. "Rembrandt van Rijn, De Doop van de Kamerling." *Oud Holland* 91, no. 1/2 (1977), 2–26.

Degenhart and Schmitt 1968
Degenhart, Bernhard, and Annegrit Schmitt. *Corpus der italienischen Zeichnungen 1300–1450*. I:4 vols. Berlin, 1968.

Degenhart and Schmitt 1980
Degenhart, Bernhard, and Annegrit Schmitt. *Corpus der italienischen Zeichnungen 1300–1450*. II:4 vols. *Venedig*. Berlin, 1980.

Delacroix 1950
Delacroix, Eugène. *Correspondance générale d'Eugène Delacroix*. Edited by André Joubin. 5 vols. Paris, 1950.

Delen 1938
Delen, A. J. J. *Cabinet des estampes de la ville d'Anvers, Catalogue des dessins anciens: Ecoles flamande et hollandaise*. Brussels, 1938.

Delignères 1865
Delignères, Emile. *Catalogue raisonné de l'oeuvre gravé de Jean-Charles Le Vasseur d'Abbeville*. Abbeville, 1865.

Delteil
Deltiel, Loys. *Le Peintre-graveur illustre, XIX et XX siècles*. 31 vols. Paris, 1906–1930.

d'Hulst 1969
d'Hulst, Roger-A. "Review of *Jacob Jordaens*." *The Art Bulletin* 51 (December 1969), 378–388.

d'Hulst 1974
d'Hulst, Roger-A. *Jordaens Drawings*. 4 vols. London, 1974.

D.I.A.L. 1958–
Rijksbureau voor Kunsthistorische Documentatie. *Decimal Index of the Art of the Low Countries*. The Hague, 1958–continuing.

Diderot 1957–1967
Seznec, Jean, and Jean Adhémar, eds. *Diderot: Salons*. 4 vols. Oxford, 1957–1967.

Dieterich 1972
Dieterich, Anton. *Goya Zeichnungen*. Cologne, 1972.

Dodgson 1934
Dodgson, C. "Ein Miniaturwerk Jörg Breus d.J." *Münchener Jahrbuch der bildenden Kunst*, n.s. 11 (1934), 191–210.

Doughty 1901
Doughty, Arthur G. *The Siege of Quebec and the Battles of the Plains of Abraham*. 6 vols. Quebec, 1901.

Doughty 1960
Doughty, Oswald. *A Victorian Romantic: Dante Gabriel Rossetti*. London, 1960.

Durand 1974
Durand, Ariane. "Odilon Redon et l'Orient 1840–1916." Ph.D. diss., Université de Nancy, 1974.

Edwards 1979
Edwards, B. *Drawing on the Right Side of the Brain*. Los Angeles, 1979.

Eineder 1960
Eineder, Georg. *The Ancient Paper Mills of the Former Austro-Hungarian Empire and Their Watermarks*. Hilversum, 1960.

Eitner 1983
Eitner, Lorenz. *Géricault: His Life and Work*. London, 1983.

Eitner 1986
Eitner, Lorenz. "Master Drawings by Géricault." *The Burlington Magazine* 128, no. 994 (January 1986), 55–59.

Ekkart 1979
Ekkart, Rudolf E. O. "Lievens als Zeichner." In *Jan Lievens*, 27–32. Braunschweig, 1979.

Emiliani 1985
Emiliani, Andrea. *Federico Barocci*. 2 vols. Bologna, 1985.

Emory 1965
Emory, T. "The Nude in Art." *Canadian Art* 22, no. 1 (January-February 1965), 39–47.

Encyclopedia of Art 1970
*The New International Illustrated Encyclopedia of Art*. Vol. 21. New York, 1970.

Enggass 1964
Enggass, Robert. *The Painting of Baciccio*. University Park, Pa., 1964.

Von Erffa and Staley 1986
Von Erffa, Helmut, and Allen Staley. *The Paintings of Benjamin West*. New Haven and London, 1986.

Ettesvold 1980
Ettesvold, Paul. "De Watteau à Watteau de Lille: Dessins français du XVIIIe siècle." In *La Donation Baderou au musée de Rouen*. Etudes de la Revue du Louvre et des Musées de France, no. 1. Paris, 1980.

Eustace 1813–1819
Eustace, John Chetwode. *A Tour through Italy, Exhibiting a View of Its Scenery, Its Antiquities, and Its Monuments*. 2 vols. London, 1813–1819.

Evans 1968
Evans, Grose. *Van Gogh*. Toronto, 1968.

Faille 1928
Faille, J.-B. de la. *L'Oeuvre de Vincent van Gogh: catalogue raisonné*. 4 vols. Paris and Brussels, 1928.

Faille 1970
Faille, J.-B. de la. *The Works of Vincent van Gogh: His Paintings and Drawings*. Amsterdam, 1970.

Falk 1949
Falk, Bernard. *Thomas Rowlandson: His Life and Art*. London [1949].

Feaver 1975
Feaver, William. *The Art of John Martin*. Oxford, 1975.

Feilchenfeldt 1973
Feilchenfeldt, Marianne. *25 Jahre Feilchenfeldt in Zürich*. Zurich, 1973.

Fenwick 1956
Fenwick, Kathleen M. "A Gift of a Notable Dürer." *Canadian Art* 13, no 4 (Summer 1956), 331.

Fenwick 1964
Fenwick, Kathleen M. "The Collection of Drawings." *The National Gallery of Canada Bulletin* 4 (1964), 1–13.

Fenwick 1966
Fenwick, Kathleen M. "The National Gallery of Canada, The Collection of Drawings." *Museum News* 44 (January 1966), 21–26.

Fenwick and Stacey 1956
Fenwick, Kathleen M., and Charles P. Stacey. "Thomas Davies—Soldier and Painter of Eighteenth-Century Canada," and "Officer of Rank and Talent." *Canadian Art* 13, no. 3 (Spring 1956), 271–276, 300.

Finberg 1924
Finberg, Alexander J. *The History of Turner's Liber Studiorum*. London, 1924.

Finberg 1939
Finberg, Alexander J. *The Life of J. M. W. Turner, R. A.* Oxford, 1939. 2d ed. Oxford, 1961.

Finley 1979
Finley, Gerald. *George Heriot: 1759–1839*. Edited by Dennis Reid. Canadian Artists Series, National Gallery of Canada. Ottawa, 1979.

Finley 1983
Finley, Gerald. *George Heriot: Postmaster-Painter of the Canadas*. Toronto, 1983.

Fiocco 1935
Fiocco, Giuseppe. "I Giganti di Paolo Uccello." *Rivista d'arte* 17 (1935), 385–404.

Fitzgerald 1975
Fitzgerald, Penelope. *Edward Burne-Jones: A Biography*. London, 1975.

Flechsig 1931
Flechsig, E. *Albrecht Dürer*. 2 vols. Berlin, 1931.

Focillon 1918
Focillon, Henri. *Giovanni Battista Piranesi: Essai de catalogue raisonné de son oeuvre*. Paris, 1918. Reprint. Mayenne, 1964.

Ford 1975
Ford, Colin. *The Cameron Collection*. London, 1975.

Franz 1965
Franz, Heinrich Gerhard. "Hans Bol als Landschaftszeichner." *Jahrbuch des Kunsthistorischen Institutes der Universität Graz* 1 (1965), 21–67.

Franz 1969
Franz, Heinrich Gerhard. *Niederländische Landschaftsmalerei im Zeitalter des Manierismus*. Graz, 1969.

Fredeman 1975
Fredeman, William E., ed. *The P. R. B. Journal: William Michael Rossetti's Diary of the Pre-Raphaelite Brotherhood, 1849–1853*. Oxford, 1975.

Frieländer 1917
Frieländer, Max J. "Der Niederländische Glasmaler Aerdt Ortkens." *Amtliche Berichte aus den Königl. Kunstsammlungen* 38, no. 6 (1917), cols. 161–167.

Friedländer 1971
Friedländer, Max J. *Early Netherlandish Painting*. Edited by N. Veronee-Verhaegen and translated by H. Norden. 14 vols. Leyden and Brussels, 1971.

Fuciková 1986
Fuciková, Eliska. *Die Rudolfinische Zeichnung*. Prague, 1986.

Gage 1987
Gage, John. *J. M. W. Turner: 'A Wonderful Range of Mind.'* New Haven and London, 1987.

Galt 1820
Galt, John. *The Life, Studies and Works of Benjamin West, Esq., President of the Royal Academy of London*. London, 1820.

Ganz 1966
Ganz, P. L. *Die Basler Glasmaler der Spätrenaissance und der Barockzeit*. Basel, 1966.

Garboli and Baccheschi 1971
Garboli, Cesare, and Edi Baccheschi. *L'opera completa di Guido Reni*. Milan, 1971.

Gassier 1973
Gassier, Pierre. *Les Dessins de Goya*. Paris, 1973.

Gassier and Wilson 1970
Gassier, Pierre, and Juliet Wilson. *Vie et oeuvre de Francisco Goya*. Fribourg, 1970.

Gaston-Dreyfus 1923
Gaston-Dreyfus, Philippe. *Catalogue raisonné de l'oeuvre peint et dessiné de Nicolas-Bernard Lépicié, 1735-1784*. Paris, 1923.

Gathorne-Hardy 1902
*Descriptive Catalogue of drawings . . . in the Collection of the Hon. A. E. Gathorne-Hardy*. London, 1902.

Gealt 1986
Gealt, Adelheid. *Domenico Tiepolo: The Punchinello Drawings*. New York, 1986.

Geisberg 1930
Geisberg, M. *Bilder-Katalog, Der Deutsche Einblatt-Holzschnitt in der ersten Hälfte des XVI. Jahrhunderts*. Munich, 1930.

Gerdts 1954
Gerdts, William H. "The Sword of Sorrow." *Art Quarterly* 17 (1954), 212–229.

Gere 1966
Gere, John A. "Two of Taddeo Zuccaro's Last Commissions, Completed by Federico Zuccaro. I: The Pucci Chapel in S. Trinità dei Monti." *The Burlington Magazine* 108 (August 1966), 284–293.

Gere 1969
Gere, John A. *Taddeo Zuccaro: His Development Studied in His Drawings*. London, 1969.

Gernsheim
Gernsheim, W. *The Gernsheim Corpus Photographicum*. London and Florence, continuing.

Gerson 1936
Gerson, Horst. *Philips Koninck*. Berlin, 1936. Rev. ed. Berlin, 1980.

Gerson 1968
Gerson, Horst. *Rembrandt: Paintings*. Amsterdam, 1968.

Gerstenberg and Rave 1934
Gerstenberg, K., and P. Rave. *Die Wandgemälde der deutschen Romantiker im Casino Massimo zu Rom (Jahresgabe des deutschen Vereins für Kunstwissenschaft 1934)*. Berlin, 1934.

Gerszi 1977
Gerszi, Terez. "Le Problème de l'influence réciproque des paysagistes rodolphiniens." *Bulletin du Musée National Hongrois des Beaux-Arts* 48-49 (1977), 105–128.

Gibbons 1967
Gibbons, Felton. "Notes on Princeton Drawings 1: A Sheet of Figures by Perino del Vaga." *Record of the Art Museum, Princeton University* 26, no. 1 (1967), 13–18.

Gibbons 1977
Gibbons, Felton. *Catalogue of Italian Drawings in the Art Museum, Princeton University*. 2 vols. Princeton, 1977.

Gilpin 1789
Gilpin, William. *Observations, Relative Chiefly to Picturesque Beauty, Made in the Year 1776, on Several Parts of Great Britain: Particularly the High-Lands of Scotland*. London, 1789. Reprint. Richmond, 1973.

Girtin and Loshak 1954
Girtin, Thomas, and David Loshak. *The Art of Thomas Girtin*. London, 1954.

Glück 1931
Glück, Gustav. *Van Dyck*. 2d ed. Stuttgart, 1931.

Godfrey 1985
Godfrey, Richard. "English Caricatures 1620 to the Present." *National Gallery of Canada Journal* 48 (March 1985), 1–8.

Van Gogh 1959
*The Complete Letters of Vincent van Gogh*. Edited by V. W. van Gogh. 3 vols. 2 ed. Greenwich, Conn., 1959.

Graf 1976
Graf, Dieter. *Die Handzeichnungen von Guglielmo Cortese und Giovanni Battista Gaulli*. 2 vols. Düsseldorf, 1976.

Grasselli 1986
Grasselli, Margaret Morgan. "Eleven New Drawings by Nicolas Lancret." *Master Drawings* 23-24, no. 3 (Autumn 1986), 377–389.

Grassi 1956
Grassi, Luigi. *Il disegno italiano dal trecento al seicento*. Rome, 1956.

Graves 1875
Graves, Algernon. *The British Institution 1806-1867*. n.p., 1875. Reprint. Bath, 1969.

Graves 1905–1906
Graves, Algernon. *The Royal Academy of Arts: A Complete Dictionary of Contributors . . .* 8 vols. London, 1905-1906. Reprinted in 4 vols., 1970.

Graves 1914
Graves, Algernon. *A Century of Loan Exhibitions*. 5 vols. London, 1914.

Graves 1921
Graves, Algernon. *Art Sales from Early in the Eighteenth Century to Early in the Twentieth Century*. 3 vols. London, 1921.

Grebarowicz and Tietze 1929
Grebarowicz, M., and H. Tietze. *Albrecht Dürers Zeichnungen im Lubomirksi Museum zu Lemberg*. Vienna, 1929.

Grego 1880
Grego, Joseph. *Rowlandson the Caricaturist*. 2 vols. London, 1880.

Grieve 1984
Grieve, Alastair. "Style and Content in Pre-Raphaelite Drawings 1848–50." In *Pre-Raphaelite Papers*, 23–43. London, 1984.

Grigson 1937
Grigson, Geoffrey. "Samuel Palmer at Shoreham." *Signature* 7 (November 1937), 1–16.

Grigson 1947
Grigson, Geoffrey. *Samuel Palmer: The Visionary Years*. London, 1947.

Grinnell-Mill 1963
Grinnell-Mill, Duncan. *Mad, Is He? The Character and Achievement of James Wolfe*. London, 1963.

Grundy and Roe 1933–1938
Grundy, C. Reginald, and F. Gordon Roe. *A Catalogue of the Pictures and Drawings in the Collection of Frederick John Nettlefold*. 4 vols. London, 1933–1938.

Hahlbrock 1976
Hahlbrock, Peter. *Gustave Moreau oder Das Unbehagen in der Natur*. Berlin, 1976.

Hakewill 1820
Hakewill, James. *A Picturesque Tour of Italy 1816–1817*. London, 1820.

Hamilton 1954
Hamilton, George Heard. *The Art and Architecture of Russia*. Harmondsworth, 1954.

Hardie 1966–1968
Hardie, Martin. *Water-colour Painting in Britain*. 3 vols. London, 1966–1968.

Harding 1977
Harding, James. *The Pre-Raphaelites*. London, 1977.

Harper 1966
Harper, J. Russell. *Painting in Canada*. Toronto, 1966.

Harris and Schaar 1967
Harris, Ann Sutherland, and Eckhard Schaar. *Die Handzeichnungen von Andrea Sacchi und Carlo Maratta*. Düsseldorf, 1967.

Harrison and Waters 1973
Harrison, Martin, and Bill Waters. *Burne-Jones*. New York, 1973.

Haskell and Penny 1981
Haskell, Francis, and Nicholas Penny. *Taste and the Antique*. New Haven, 1981.

Van Hasselt 1957
Van Hasselt, Carlos. "Three Drawings by Francisco Goya (1746–1828) from the Fitzwilliam Museum, Cambridge." *Apollo* 65 (March 1957), 87–89.

Haverkamp-Begemann 1959
Haverkamp-Begemann, Egbert. *Willem Buytewech*. Amsterdam, 1959.

Haverkamp-Begemann and Logan 1970
Haverkamp-Begemann, Egbert, and Anne Marie S. Logan. *European Drawings and Watercolors in the Yale University Art Gallery 1500–1900*. 2 vols. New Haven and London, 1970.

Hayes 1972
Hayes, John. *Rowlandson Watercolours and Drawings*. London, 1972.

Heawood
Heawood, Edward. *Watermarks, Mainly of the 17th and 18th Centuries*. Hilversum, 1950.

Held 1959
Held, Julius S. *Rubens: Selected Drawings*. 2 vols. London, 1959.

Held 1964
Held, Julius S. "Review of *Die Zeichnungen Anton Van Dycks* by Horst Vey." *The Art Bulletin* 46 (December 1964), 560, 565–568.

Heriot 1804
Heriot, George. *The History of Canada from Its First Discovery*. Vol. 1. London, 1804.

Heriot 1807
Heriot, George. *Travels through the Canadas*. London, 1807.

Hérold 1931
Hérold, Jacques. *Gravure en manière de crayon: Jean-Charles François, 1717–1769, Catalogue de l'oeuvre gravé*. Paris, 1931.

Herrmann 1965
Herrmann, Luke. "Paul Sandby in Scotland: A Sketch-book." *The Burlington Magazine* 107 (September 1965), 467–468.

Heywood 1874
Heywood, Thomas. *The Dramatic Works . . . in Six Volumes*. London, 1874.

Hibbard 1972
Hibbard, Howard. "*Ut picturae sermones*: The First Painted Decorations of the Gesù." In *Baroque Art: The Jesuit Contribution*, ed. Rudolf Wittkower and Irma B. Jaffé, 29–49. New York, 1972.

Hill 1976
Hill, Draper. *The Satirical Etchings of James Gillray*. New York, 1976.

Hind 1923
Hind, Arthur M. *Catalogue of Drawings by Dutch and Flemish Artists Preserved in the Department of Prints and Drawings in the British Museum*. Vol. 2, *Drawings by Rubens, Van Dyck and Other Artists of the Flemish School of the XVII Century*. London, 1923.

Hoff 1937–1938
Hoff, Ursula. "Meditations in Solitude." *Journal of the Warburg Institute* 1 (1937–1938), 292–294.

Hollstein
Hollstein, F. W. H. *Dutch and Flemish Etchings, Engravings and Woodcuts, ca. 1450–1700*. Amsterdam, continuing.

Holman-Hunt 1960
Holman-Hunt, Diana. *My Grandmothers and I*. London, 1960.

Holman-Hunt 1969
Holman-Hunt, Diana. *My Grandfather, His Wives and Loves*. New York, 1969.

Howard 1946
Howard, Alexander L. *Trees in Britain*. London, 1946.

Hubbard 1959a
Hubbard, R. H. *The National Gallery of Canada Catalogue of Paintings and Sculpture*. Vol. 2, *Modern European Schools*. [Toronto], 1959.

Hubbard 1959b
Hubbard, R. H. "The Discovery of Early Canadian Painting." *Art in America* 47, no. 3 (Autumn 1959), 40–47.

Hubbard 1972
Hubbard, R. H. *Thomas Davies in Early Canada*. Ottawa, 1972.

Hubbard 1976
Hubbard, R. H. "Penny Plain, Twopenny Coloured: Vicissitudes in the Collecting of British Art by the National Gallery of Canada." *National Gallery of Canada Journal* 21 (19 November 1976), 1–8.

Huisman 1969
Huisman, Philippe. *French Watercolours of the Eighteenth Century*. Translated by Diana Imber. London, 1969.

Hulsker 1977
Hulsker, Jan. *Van Gogh en zijn weg*. Amsterdam, 1977.

Hulsker 1980
Hulsker, Jan. *The Complete Van Gogh: Paintings, Drawings, Sketches*. New York, 1980.

Hunt 1905–1906
Hunt, William Holman. *Pre-Raphaelitism and the Pre-Raphaelite Brotherhood*. 2 vols. New York and London, 1905–1906.

Hunt 1913
Hunt, William Holman. *Pre-Raphaelitism and the Pre-Raphaelite Brotherhood*. 2 vols. 2d ed. London, 1913.

Ingram 1869
Ingram, John Henry. *Flora Symbolica*. New York and London, 1869.

Inventaire-XVIIe siècle
Bibliothèque Nationale. Département des Estampes. *Inventaire du fonds français. Graveurs du XVIIe siècle*. Paris, 1939–.

Inventaire-XVIIIe siècle
Bibliothèque Nationale. Département des Estampes. *Inventaire du fonds français. Graveurs du XVIIIe siècle*. Paris, 1930–.

Ireland 1799
Ireland, Samuel. *Graphic Illustrations of Hogarth*. 2 vols. London, 1799.

Isreal 1982
Isreal, Jonathan I. *The Dutch Republic and the Hispanic World 1606–1661*. Oxford, 1982.

Jacob 1979
Jacob, Sabine. "Zur Entwicklung der Landschaftsmalerei von Jan Lievens." In *Jan Lievens*, 21–26. Braunschweig, 1979.

Jaffé 1969
Jaffé, Michael. "Reflections on the Jordaens Exhibition." *National Gallery of Canada Bulletin* 13 (1969), 1–40.

Jaffé 1970
Jaffé, Michael. "Rubens and Jove's Eagle." *Paragone* 21, no. 245 (1970), 19–26.

James 1920
James, Henry. *The Letters of Henry James*. Edited by Percy Lubbok. 2 vols. New York, 1920.

Jean-Richard 1978
Jean-Richard, Pierrette. *L'oeuvre gravé de François Boucher dans la Collection Edmond Rothschild*. Paris, 1978.

Joachim and McCullagh 1979
Joachim, Harold, and Suzanne Folds McCullagh. *Italian Drawings in the Art Institute of Chicago*. Chicago and London, 1979.

Johnson 1956
Johnson, Lee. "The Early Drawings of Delacroix." *The Burlington Magazine* 98 ( January 1956), 22–24.

Johnson 1958
Johnson, Lee. "The Formal Sources of Delacroix's *Barque de Dante*." *The Burlington Magazine* 100 ( July 1958), 228–232.

Johnson 1981
Johnson, Lee. *The Paintings of Eugène Delacroix: A Critical Catalogue, 1816–1831*. Vol. 1. Oxford, 1981.

Johnston 1979
Johnston, Catherine. *Maestri emiliani dei sei- e settecento*. Florence, 1979.

Johnstone 1974
Johnstone, Christopher. *John Martin*. London, 1974.

Jones 1963
Jones, Henri. "Delacroix en Amérique." *Vie des Arts*, no. 32 (Autumn 1963), 18–23.

Jouin 1889
Jouin, Henri. *Charles Le Brun et les arts sous Louis XIV. Le premier peintre, sa vie, son oeuvre, ses écrits, ses contemporains, son influence, d'après le manuscrit de Nivelon et de nombreuses pièces inédites*. Paris, 1889.

Joyner 1983
Joyner, Paul. "Some Sandby Drawings of Scotland." *The Journal of the National Library of Wales* 23 (1983), 1–16.

Kaplan 1982
Kaplan, Julius. *The Art of Gustave Moreau: Theory, Style, and Content*. Ann Arbor, 1982.

Kirschbaum 1972
Kirschbaum, E., ed. "Schmerzen Mariens." In *Lexikon der christlichen Ikonographie*, Vol. 4. Rome, 1972.

Knight 1887
Knight, Joseph. *Life of Dante Gabriel Rossetti*. Great Writers Series. London, 1887.

Knipping 1974
Knipping, John B. *Iconography of the Counter Reformation in the Netherlands*. 2 vols. Nieuwkoop, 1974.

Knowles 1831
Knowles, John. *The Life and Writings of Henry Fuseli, Esq. M.A. R.A.* 3 vols. London, 1831.

Knox 1960
Knox, George. *Catalogue of the Tiepolo Drawings in the Victoria and Albert Museum*. London, 1960.

Knox 1970
Knox, George. *Domenico Tiepolo: Raccolta di teste*. Milan, 1970.

Knox 1974
Knox, George. *Un quaderno di vedute di Giambattista Tiepolo e Domenico figlio*. Venice, 1974.

Knox 1975
Knox, George. " 'Philosopher Portraits' by Giambattista, Domenico and Lorenzo Tiepolo." *The Burlington Magazine* 117 (March 1975), 147–155.

Knox 1976
Knox, George. "Francesco Guardi as an apprentice in the studio of Giambattista Tiepolo." *Studies in Eighteenth Century Culture* 5 (1976), 29–39.

Knox 1980
Knox, George. "The Sala dei Banchetti of the Ducal Palace: The Original Decorations and Francesco Guardi's 'veduta ideata.' " *Arte Veneta* 34 (1980), 201–205.

Knox 1983
Knox, George. "Domenico Tiepolo's Punchinello Drawings: Satire, or Labour of Love." In *Satire in the Eighteenth Century*, 124–146. New York, 1983.

Knox 1984
Knox, George. "The Punchinello Drawings of Giambattista Tiepolo." In *Interpretazioni Veneziane: studi di storia dell'arte in onore di Michelangelo Muraro, a cura di David Rosand*. Venice, 1984.

Komelova 1968
Komelova, Galina. *Views of St. Petersburg and Surroundings in the Middle of the Eighteenth Century*. Leningrad, 1968.

Kraus 1985
Kraus, H. P. *Illuminated Manuscripts*. New York, 1985.

Laclotte 1967
Laclotte, Michel. "Rencontres franco-italiennes au milieu du XVe siècle." *Acta Historiae Artium, Academiae Scientiarum Hungaricae* 13, nos. 1–3 (1967), 33–41.

Landow 1979
Landow, George P. *William Holman Hunt and Typological Symbolism*. New Haven and London, 1979.

Landow 1980
Landow, George P. *Victorian Types, Victorian Shadows: Biblical Typology in Victorian Literature, Art, and Thought*. Boston, London, and Henley, 1980.

Laran and Deshairs 1913
Laran, Jean, and Léon Deshairs. *Gustave Moreau*. Paris, 1913.

Larsen 1980
Larsen, Erik. *L'opera completa di Van Dyck*. 2 vols. Milan, 1980.

Laskin and Pantazzi 1987
Laskin, Myron, Jr., and Michael Pantazzi (eds.) *European and American Painting, Sculpture and Decorative Arts in the National Gallery of Canada*. Vol. 1, 1300–1800 (part 1: text, part 2: plates). Ottawa, 1987.

Leslie 1843
Leslie, Charles Robert. *Memoirs of the Life of John Constable Composed Chiefly of His Letters*. London, 1843. 2d ed. London, 1845. Rev. ed., edited by Jonathan Mayne. London, 1951.

Levey 1964
Levey, Michael. *The Later Italian Pictures in the Collection of H.M. the Queen*. London, 1964.

Lewis 1846
Lewis, Samuel. *A Topographical Dictionary of Scotland*. Vol. 1. London, 1846.

Lindeman 1929
Lindeman, C.M.A.A. *Joachim Anthonisz. Wtewael*. Utrecht, 1929.

Lindsay 1937
Lindsay, Lionel. "Drawing and Drawings in Australia." *Art in Australia*, 3d ser. 68 (16 August 1937), 18–124.

Lippmann 1929
Lippmann, F. *Zeichnungen von Albrecht Dürer in Nachbildungen*. Edited by F. Winkler. Berlin, 1929.

Lister 1969
Lister, Raymond. *Samuel Palmer and His Etchings*. London, 1969.

Lister 1974
Lister, Raymond. *Samuel Palmer: A Biography*. London, 1974.

Lister 1985
Lister, Raymond. *The Paintings of Samuel Palmer*. Cambridge, London, New York, New Rochelle, Melbourne and Sydney, 1985.

Lister 1988
Lister, Raymond. *A Catalogue Raisonné of the Works of Samuel Palmer*. Cambridge, 1988. Forthcoming.

Lister and Astbury 1980
Lister, Raymond, and A. K. Astbury. *Samuel Palmer in Palmer Country*. East Bergholt, 1980.

Litta 1819–1911
Litta, Pompeo. *Famiglie Celebri Italiane*. 12 vols. Milan, 1819–1911.

Livan 1942
Livan, L. *Notizie d'arte tratte dei Notatori e dagli Annali di Pietro Gradenigo*. Padua, 1942.

Lochnan 1980
Lochnan, Katharine. "National Gallery Circulates Master Drawings." *The Gallery* (Art Gallery of Ontario) 2, no. 6 ( July–August 1980), 2.

Lochnan 1986
Lochnan, Katharine. "Les Lithographies de Delacroix pour *Faust* et le théâtre anglais des années 1820." *Nouvelles de l'estampe* 87 (1986), 6–13.

Locquin 1912
Locquin, Jean. *La Peinture d'histoire en France de 1747 à 1785*. Paris, 1912. 2d ed. Paris, 1978.

Lombardi 1973
Lombardi, Sandro. *Jean Fouquet*. Florence, 1973.

Longhi 1952
Longhi, Roberto. "Ancora sulla cultura del Fouquet." *Paragone* 27 (1952), 56–57. Reprint. *Arte Italiana e Arte Tedesca*, by Roberto Longhi, 39–40. Florence, 1979.

López-Rey 1956
López-Rey, José. *A Cycle of Goya Drawings*. New York, 1956.

Lossky 1962
Lossky, Boris. *Tours, Musée des Beaux-Arts: Peintures du XVIIIe siècle*. Paris, 1962.

Lowenthal 1986
Lowenthal, Anne W. *Joachim Wtewael and Dutch Mannerism*. Doornspijk, 1986.

Lugt
Lugt, Frits. *Les Marques de collections de dessins et d'estampes*. Amsterdam, 1921. Supplément. The Hague, 1956.

Lugt-Répertoire des ventes
Lugt, Frits. *Répertoire des catalogues des ventes publiques . . .* 3 vols. Paris, 1938–1964.

Lugt 1949
Lugt, Frits. *Musée du Louvre: Inventaire général des dessins des écoles du nord . . . Ecole flamande.* 2 vols. Paris, 1949.

Lutyens 1967
Lutyens, Mary. *Millais and the Ruskins.* New York, 1967.

Maas 1969
Maas, Jeremy. *Victorian Painters.* London, 1969.

Maas 1984
Maas, Jeremy. "The Pre-Raphaelites: A Personal View." In *Pre-Raphaelite Papers,* 226–234. London, 1984.

Macandrew 1980
Macandrew, Hugh. *Ashmolean Museum, Oxford, Catalogue of the Collection of Drawings.* Vol. 3, *Italian Schools: Supplement.* Oxford, 1980.

MacLeod and Boulton
MacLeod, A. C., and Harold Boulton. *Songs of the North, Gathered Together from the Highlands and Lowlands of Scotland.* 2d ed. London and New York, n.d.

Malafarina 1976
Malafarina, Gianfranco. *L'Opera completa di Annibale Carracci.* Milan, 1976.

Mâle 1951
Mâle, Emile. *L'Art religieux de la fin du XVIe siècle, du XVIIe siècle et du XVIIIe siècle: Etude sur l'iconographie après le Concile de Trente.* Paris, 1951.

Malins 1968
Malins, Edward. *Samuel Palmer's Italian Honeymoon.* London, 1968.

Mancigotti 1975
Mancigotti, Mario. *Simone Cantarini il Pesarese.* Pesaro, 1975.

Mariette 1851–1860
Mariette, Pierre-Jean. *Abecedario.* Edited by P. de Chennevières and A. de Montaiglon. 6 vols. Archives de l'art français. Paris, 1851–1860.

Marillier 1899
Marillier, H. C. *Dante Gabriel Rossetti: An Illustrated Memorial of His Art and Life.* London, 1899.

Marillier 1901
Marillier, H. C. *Dante Gabriel Rossetti: An Illustrated Memorial of His Art and Life.* 2d ed. London, 1901.

Marillier 1904
Marillier, H. C. *Dante Gabriel Rossetti: An Illustrated Memorial of His Art and Life.* 3d ed. London, 1904.

Mariuz 1971
Mariuz, Adriano. *Giandomenico Tiepolo.* Venice, 1971.

Marsh 1985
Marsh, Jan. *Pre-Raphaelite Sisterhood.* London, Melbourne, and New York, 1985.

Marsh 1986
Marsh, Jan. *Jane and May Morris: A Biographical Story 1839–1938.* London and New York, 1986.

Marsh 1987
Marsh, Jan. *Pre-Raphaelite Women: Images of Femininity in Pre-Raphaelite Art.* London, 1987.

Martin 1867
Martin, F. *De Montcalm en Canada ou les dernières années de la colonie française (1756–1760).* Tournai, 1867.

Martin 1968
Martin, John Rupert. *The Ceiling Paintings for the Jesuit Church in Antwerp.* London, 1968.

Martin 1971
Martin, John Rupert. "Rubens's *Jupiter and Cupid:* An Exhibition at Princeton." *Apollo* 94 (October 1971), 277–278.

Martin 1972
Martin, John Rupert, ed. *Rubens before 1620.* Princeton, 1972.

Martin 1988
Martin, Denis. *Portraits de héros de la Nouvelle-France.* 1988. Forthcoming.

Mather 1937
Mather, Frank Jewett, Jr. "Samuel Palmer's Virgil Etchings." *The Print Collector's Quarterly* 24 (October 1937), 253–264.

Mathieu 1972
Mathieu, Pierre-Louis. "Gustave Moreau." In *Encyclopaedia Universalis.* Vol. 11, 321–323. Paris, 1972.

Mathieu 1976
Mathieu, Pierre-Louis. *Gustave Moreau with a Catalogue of the Finished Paintings, Watercolors and Drawings.* Boston, 1976.

Mathieu 1984
Mathieu, Pierre-Louis. *Gustave Moreau Aquarelles.* Fribourg, 1984.

McGrath 1975
McGrath, Elizabeth. "A Netherlandish History by Joachim Wtewael." *Journal of the Warburg and Courtauld Institutes* 38 (1975), 182–217.

Meder 1922–1925
Meder, Joseph, ed. *Handzeichnungen alter Meister aus der Albertina und aus Privat besitz.* 2 vols. Rev. ed. Vienna, 1922–1925.

Mellerio 1913
Mellerio, André. *L'Oeuvre graphique complet d'Odilon Redon.* Paris, 1913.

Melville 1910
Melville, Lewis. *The Life and Letters of William Beckford of Fonthill.* London, 1910.

Mercure de France 1755a
"Arts agréables. Peinture." *Mercure de France* (March 1755), 145–146.

Mercure de France 1755b
"Gravûre. Lettre à l'Auteur du Mercure." *Mercure de France* (May 1755), 131–133.

Mesley 1983
Mesley, Roger J. "The Theme of Mystic Quest in the Art of Odilon Redon." Ph.D. diss., University of Toronto, 1983.

Mettra 1972
Mettra, Claude. *L'Univers de van Gogh.* Paris, 1972.

Mezzetti 1955
Mezzetti, Amalia. "Contributi a Carlo Maratti." *Rivista dell'Istituto Nazionale d'Archeologia e Storia dell'Arte,* n.s. 4 (1955), 253–254.

Millais 1899
Millais, John Guille. *The Life and Letters of Sir John Everett Millais.* 2 vols. London, 1899.

Millar 1963
Millar, Oliver. *The Tudor, Stuart, and Early Georgian Pictures in the Collection of Her Majesty The Queen.* 2 vols. London, 1963.

Milroy 1977
Milroy, Elizabeth. "The Evolution of Landscape in Prints and Drawings 1500–1900." *National Gallery of Canada Journal* 23 (15 July 1977), 1–8.

Mode 1972
Mode, Robert L. "Masolino, Uccello and the Orsini 'Uomini Famosi.'" *The Burlington Magazine* 114 (June 1972), 369–378.

Moinet 1986
Moinet, E. "Le départ du braconnier par Lépicié." *Revue du Louvre et des Musées de France* 36, nos. 4–5 (1986), 296–297.

Mongan 1949
Mongan, Agnes. *One Hundred Master Drawings.* Cambridge, Mass., 1949.

Mongan and Sachs 1940
Mongan, Agnes, and Paul J. Sachs. *Drawings in the Fogg Museum of Art.* 3 vols. Cambridge, Mass., 1940.

Morassi 1937
Morassi, Antonio. *Disegni antichi della collezione Rasini in Milano.* Milan, 1937.

Morassi 1958
Morassi, Antonio. *Dessins vénitiens du XVIIIe siècle de la collection du duc de Talleyrand.* Paris, 1958.

Morassi 1973
Morassi, Antonio. *Guardi: Antonio e Francesco.* Venice, 1973.

Morassi 1975
Morassi, Antonio. *Guardi: Tutti i disegni.* Venice, 1975.

Müller Hofstede 1966
Müller Hofstede, Justus. "Review of *Rubens Drawings* by Ludwig Burchard and R.-A. d'Hulst." *Master Drawings* 4, no. 4 (Winter 1966), 435.

Muller 1863–1881
Muller, Frederik. *De Nederlandsche Geschiedenis in Platen, Beredeneerde Beschrijving van Nederlandsche Historieplaten, Zinneprenten en historische Kaarten.* 4 vols. Amsterdam, 1863–1881.

Muraro 1952
Muraro, Michelangelo. "Gli affreschi di Jacopo e Francesco da Ponte a Cartigliano." *Arte Veneta* 6 (1952), 42–62.

Muraro 1957
Muraro, Michelangelo. "The Jacopo Bassano Exhibition." *The Burlington Magazine* 99 (September 1957), 291–299.

Musper 1952
Musper, H. T. *Albrecht Dürer, der gegenwärtige Stand der Forschung.* Stuttgart, 1952.

National Gallery of Canada 1948
National Gallery of Canada. *Catalogue of Paintings.* Ottawa, 1948.

Nearing 1944
Nearing, Alice Jones. *Cupid and Psyche, by Shakerly Marmion: A Critical Edition with an Account of Marmion's Life and Works.* Philadelphia, 1944.

Newton 1974
Newton, Stella Mary. *Health, Art & Reason: Dress Reformers of the 19th Century.* London, 1974.

Nichols 1785
[Nichols, John, et al.] *Biographical Anecdotes of William Hogarth.* 3d ed. London, 1785. Facsimile reprint. London, 1971.

Nichols 1833
[Nichols, John Bowyer.] *Anecdotes of William Hogarth.* London, 1833. Facsimile reprint. London, 1970.

Nicolson 1974
Nicolson, Benedict. "Current and Forthcoming Exhibitions." *The Burlington Magazine* 116 (September 1974), 52–53.

Oppé 1923
Oppé, A. Paul. *Thomas Rowlandson: His Drawings and Water-colours.* London, 1923.

Oppé 1941
Oppé, A. Paul. "Drawings at the National Gallery of Canada." *The Burlington Magazine* 79 (August 1941), 50–56.

Oppé 1948
Oppé, A. Paul. *The Drawings of William Hogarth.* London, 1948.

Oppé 1952
Oppé, A. Paul. *Alexander and John Robert Cozens.* London, 1952.

Orgel and Strong 1973
Orgel, Stephen, and Roy Strong. *Inigo Jones: The Theatre of the Stuart Court.* 2 vols. London, 1973.

Orlandi 1719
Orlandi, Pellegrino Antonio. *Abecedario pittorico.* Bologna, 1719.

Osler 1968
Osler, Pamela G. "Gustave Moreau: Some Drawings from the Italian Sojourn." *The National Gallery of Canada Bulletin* 11 (1968), 20–28.

Ovenden 1972
Ovenden, Graham. *Pre-Raphaelite Photography.* London and New York, 1972.

Ovenden 1984
Ovenden, Graham. *Pre-Raphaelite Photograpy.* 2d ed. London and New York, 1984.

Paladilhe and Pierre 1972
Paladilhe, Jean, and José Pierre. *Gustave Moreau.* New York, 1972.

Paley 1986
Paley, Morton D. *The Apocalyptic Sublime.* New Haven and London, 1986.

Pallucchini 1945
Pallucchini, Rodolfo. *I disegni di G. B. Pittoni.* Padua, 1945.

Pallucchini 1982
Pallucchini, Rodolfo. *Bassano.* Bologna, 1982.

Palmer 1883
Palmer, Samuel. *An English Version of the Eclogues of Virgil.* London, 1883.

Palmer 1892
Palmer, A. H. *The Life and Letters of Samuel Palmer.* London, 1892.

Palmer 1974
Palmer, Samuel. *The Letters of Samuel Palmer.*

Edited by Raymond Lister. 2 vols. Oxford, 1974.

Panofsky 1915
Panofsky, E. *Dürers Kunsttheorie vornehmlich in ihrem Verhältnis zur Kunsttheorie der Italiener.* Berlin, 1915.

Panofsky 1945
Panofsky, E. *Albrecht Dürer.* 2 vols. Princeton, 1945.

Pantazzi 1985
Pantazzi, Michael. "A Preliminary Study for Benjamin West's 'Death of General Wolfe.'" *Drawing* 7, no. 1 (May–June 1985), 1–4.

Parker 1938
Parker, Karl. *Catalogue of the Collection of Drawings in the Ashmolean Museum.* Vol. 1, *Netherlandish, German, French and Spanish Schools.* Oxford, 1938.

Parker 1956
Parker, Karl. *Catalogue of the Collection of Drawings in the Ashmolean Museum.* Vol. 2, *Italian Schools.* Oxford, 1956.

Parker and Mathey 1957
Parker, Karl, and François Mathey. *Antoine Watteau: Catalogue complet de son oeuvre dessiné.* 2 vols. Paris, 1957.

Parma Armani 1986
Parma Armani, Elena. *Perin del Vaga: L'anello mancante.* Genoa, 1986.

Parris, Shields, and Fleming-Williams 1975
Parris, Leslie, Conal Shields, and Ian Fleming-Williams, eds. *John Constable: Further Documents and Correspondence.* London, 1975.

Parry 1983
Parry, Linda. *William Morris Textiles.* New York, 1983.

Paulson 1970
Paulson, Ronald. *Hogarth's Graphic Works.* Rev. ed. 2 vols. New Haven and London, 1970.

Paulson 1971
Paulson, Ronald. *Hogarth: His Life, Art, and Times.* 2 vols. New Haven and London, 1971.

Paulson 1972
Paulson, Ronald. *Rowlandson: A New Interpretation.* London, 1972.

Payne 1982
Payne, Christiana. "John Linnell and Samuel Palmer in the 1820s." *The Burlington Magazine* 124 (March 1982), 131–136.

Peacock 1968
Peacock, Carlos. *Samuel Palmer: Shoreham and After.* London, 1968.

Pendered 1923
Pendered, Mary L. *John Martin, Painter: His Life and Times.* London, 1923.

Pignatti 1960
Pignatti, Terisio. *Il Museo Correr di Venezia.* Venice, 1960.

Pilo 1961
Pilo, Giuseppe Maria. *Carpioni.* Venice, 1961.

Pilo 1964
Pilo, Giuseppe Maria. *Marco Ricci.* Venice, 1964.

Pollock 1972
Pollock, Griselda F. S. "Vincent van Gogh and

The Hague School." M.A. report, Courtauld Institute of Art, University of London, 1972.

Poncheville 1928
Poncheville, André M. *Louis et François Watteau dits Watteau de Lille.* Paris, 1928.

Popham 1936
Popham, Arthur E. "Sebastiano Resta and his Collections." *Old Master Drawings* 11, no. 1 (June 1936), 1–15.

Popham 1938
Popham, Arthur E. "Seventeenth-Century Art in Europe at Burlington House: Drawings." *The Burlington Magazine* 72 (January 1938), 13–20.

Popham and Fenwick 1965
Popham, Arthur E., and Kathleen M. Fenwick. *European Drawings (and Two Asian Drawings) in the Collection of the National Gallery of Canada.* [Toronto], 1965.

Portalis 1889
Portalis, Roger. *Honoré Fragonard: Sa vie et son oeuvre.* Paris, 1889.

Posner 1971
Posner, Donald. *Annibale Carracci: A Study in the Reform of Italian Painting around 1590.* London, 1971.

Powell 1951
Powell, Nicolas. *The Drawings of Henry Fuseli.* London, 1951.

Powell 1973
Powell, Nicolas. *Fuseli: The Nightmare.* Art in Context. London, 1973.

Powell 1982
Powell, Cecilia. "Topography, Imagination and Travel: Turner's Relationship with James Hakewill." *Art History* 5, no. 4 (December 1982), 408–425.

Powell 1987
Powell, Cecilia. *Turner in the South: Rome, Naples, Florence.* New Haven and London, 1987.

Pressly 1969
Pressly, William L., Jr. "Samuel Palmer and the Pastoral Convention." *Record of the Art Museum, Princeton University* 28, no. 2 (1969), 22–37.

Pressly 1970
Pressly, William L., Jr. "Samuel Palmer: The Etching Dream." *Record of the Art Museum, Princeton University* 29, no. 2 (1970), 7–44.

Procès-verbaux
Anatole de Montaiglon, ed. *Procès-verbaux de l'Académie royale de peinture et de sculpture, 1648–1792.* 10 vols. and table. Paris, 1875–1909.

Ragghianti 1937
Ragghianti, Carlo. "Casa Vitaliani." *Critica d'arte* 2 (September–December 1937), 236–250.

Raupp 1985
Raupp, Hans Joachim. "Bemerkungen zu den Genrebildern Roelant Saverys." In *Roelant Savery in seiner Zeit (1576–1639),* 39–45. Cologne, 1985.

Rawlinson 1908
Rawlinson, W. G. *The Engravings of J.M.W. Turner, R.A.* 2 vols. London, 1908.

Rawlinson and Finberg 1909
Rawlinson, W.G., and Alexander J. Finberg.

*The Water-colours of J.M.W. Turner.* London, 1909.

Rearick 1962
Rearick, W. R. "Jacopo Bassano: 1568–69." *The Burlington Magazine* 104 (December 1962), 524–533.

Réau 1922
Réau, Louis. "Un Type d'art Pompadour: 'L'Offrande du coeur.'" *Gazette des Beaux-Arts* 5 (April 1922), 213–218.

Redford 1888
Redford, George. *Art Sales.* 2 vols. London, 1888.

Reed 1969
Reed, Susan. "Types of Paper Used by Rembrandt." In *Rembrandt Experimental Etcher,* 178–180. Boston, 1969.

Van Regteren Altena 1959
Van Regteren Altena, J. Q. "Een bladzijde uit een Italiaanse Codex van omstreeks 1445." *Bulletin van het Rijksmuseum* 7, nos. 2-3 (1959), 82–83.

Reitlinger 1927
Reitlinger, H. S. "An Unknown Collection of Dürer Drawings." *The Burlington Magazine* 50, no. 288 (March 1927), 153–159.

Rembrandt Research Project 1982
Rembrandt Research Project. *A Corpus of Rembrandt Paintings 1.* The Hague, 1982.

Rewald 1983
Rewald, John. *Paul Cézanne: The Watercolors.* Boston, 1983.

Rey 1969
Rey, Jean-Dominique. "A Paris: Dessins de la Galerie nationale du Canada." *Jardin des arts* 181 (December 1969), 10–11.

Reynolds 1973
Reynolds, Graham. *Victoria and Albert Museum: Catalogue of the Constable Collection.* 2d ed. London, 1973.

Reynolds 1984
Reynolds, Graham. *The Later Paintings and Drawings of John Constable.* 2 vols. New Haven and London, 1984.

Ribeiro 1983
Ribeiro, Aileen. *A Visual History of Costume: The Eighteenth Century.* London and New York, 1983.

Richardson 1979
Richardson, John. *The Collection of Germain Seligman: Paintings, Drawings, and Works of Art.* New York, Luxembourg, and London, 1979.

Roberts 1969
Roberts, Keith. "Current and Forthcoming Exhibitions." *The Burlington Magazine* 111 (July 1969), 467–468.

Robison 1977
Robison, Andrew. *Paper in Prints.* Washington, D.C., 1977.

Robison 1986
Robison, Andrew. *Piranesi: Early Architectural Fantasies.* Washington, D.C., 1986.

Robitaille 1936
Robitaille, Georges. *Montcalm et ses historiens.* Montreal, 1936.

Roethlisberger 1968
Roethlisberger, Marcel. *Claude Lorrain: The Drawings.* 2 vols. Berkeley and Los Angeles, 1968.

Roli 1960
Roli, Renato. "Qualche appunto per Aureliano Milani." *Arte antica e moderna* (1960), 189–192, pls. 61a–61d.

Roli 1977
Roli, Renato. *Pittura bolognese 1650-1800. Dal Cignani ai Gandolfi.* Bologna, 1977.

Romani 1982
Romani, Vittoria. "Lelio Orsi e Roma; fra maniera raffaellesca e maniera michelangiolesca." *Prospettiva* 29 (1982), 41–61.

Romani 1984
Romani, Vittoria. *Lelio Orsi.* Modena, 1984.

Romney 1830
Romney, John. *Memoirs of the Life and Works of George Romney.* London, 1830.

Roscoe 1831
Roscoe, Thomas, ed. *The Remembrance.* London, 1831.

Roscoe 1832(?)
Roscoe, Thomas, ed. *The Talisman, or English Keepsake.* London, 1832(?).

Rose 1981
Rose, Andrea. *Pre-Raphaelite Portraits.* Yeovil, 1981.

Rosenblum 1965–1966
Rosenblum, Robert. "Victorian Art in Ottawa." *Art Journal* 25, no. 2 (Winter 1965–1966), 138–142.

Rosenblum 1974
Rosenblum, Robert. *Transformations in Late Eighteenth Century Art.* 3d ed. Princeton, 1974.

Rosenthal 1983
Rosenthal, Michael. *Constable: The Painter and His Landscape.* New Haven and London, 1983.

Ross 1986
Ross, Alexander M. *Imprint of the Picturesque on Nineteenth-Century British Fiction.* Waterloo, Ont., 1986.

Rossetti 1903
Rossetti, William Michael. *Rossetti Papers 1862 to 1870.* London, 1903. Reprint. New York, 1970.

Rossetti 1965–1967
Rossetti, Dante Gabriel. *Letters of Dante Gabriel Rossetti.* Edited by Oswald Doughty and John Robert Wahl. 4 vols. Oxford, 1965–1967.

Rossetti and Swinburne 1868
Rossetti, William Michael, and Algernon C. Swinburne. *Notes on the Royal Academy Exhibition, 1868.* London, 1868. Reprint. New York, 1976.

Rotermund 1963
Rotermund, Hans-Martin. *Rembrandts Handzeichnungen und Radierungen zur Bibel.* Stuttgart, 1963.

Rupprich 1966
Rupprich, H. *Dürers Schriftlicher Nachlass.* 3 vols. Berlin, 1966.

Ruskin 1903–1912
Ruskin, John. *The Works of John Ruskin.* Edited by E. T. Cook and Alexander Wedderburn. 39 vols. London, 1903–1912.

Salvagnini 1837
Salvagnini, Francesco Alberto. *I Pittori Borgognoni Cortese (Courtois) e la loro casa in Piazza di Spagna.* Rome, 1837.

Sandby 1892
Sandby, William. *Thomas and Paul Sandby, Royal Academicians: Some Account of Their Lives and Works.* London, 1892.

Saxl and Meier 1953
Saxl, F., and H. Meier. *Verzeichnis astrologischer und mythologischer illustrierter Handschriften des lateinischen Mittelalters.* Vol. 3, *Handschriften in englischen Bibliotheken.* London, 1953.

Sayre 1966
Sayre, Eleanor A. "Goya's Bordeaux Miniatures." *Boston Museum of Fine Arts Bulletin* 64, no. 327 (1966), 84–123.

Scarpa 1987
Scarpa, Pietro. "A Venetian Seventeenth-Century Collection of Old Master Drawings." In *Drawings Defined.* Walter Strauss and Tracie Felker, eds. New York, 1987.

Schatborn 1977
Schatborn, Peter. "Review of *Lambert Doomer, Sämtliche Zeichnungen* by Wolfgang Schulz." *Simiolus* 9, no. 1 (1977), 48–55.

Schatborn 1985
Schatborn, Peter. *Catalogue van de Nederlandse Tekeningen in het Rijksprentenkabinet, Rijksmuseum, Amsterdam.* Vol. 4, *Tekeningen van Rembrandt, zijn onbekende leerlingen en navolgers.* 's-Gravenhage, 1985.

Scheller 1962
Scheller, R. W. "Uomini Famosi." *Bulletin van het Rijksmuseum* 10, nos. 2-3 (1962), 56–67.

Scheller 1963
Scheller, R. W. *A Survey of Medieval Model Books.* Haarlem, 1963.

Schiff 1973
Schiff, Gert. *Johann Heinrich Füssli 1741-1825.* Oeuvrekataloge Schweizer Künstler, 2 vols. Zurich and Munich, 1973.

Schiller 1971
Schiller, Gertrud. *Iconography of Christian Art.* New York, 1971.

Schilling and Blunt 1971 (?)
Schilling, Edmund, and Anthony Blunt. *The German Drawings at Windsor Castle and Supplements to the Catalogues of Italian and French Drawings.* London, 1971 (?).

Schnackenburg 1981
Schnackenburg, Bernhard. *Adriaen van Ostade, Isack van Ostade: Zeichnungen und Aquarelle.* 2 vols. Hamburg, 1981.

Schneider 1932
Schneider, H. *Jan Lievens: Sein Leben und seine Werke.* Haarlem, 1932. Rev. ed. with supplement by R. E. O. Ekkart. Amsterdam, 1973.

Schnorr 1886
Schnorr von Carolsfeld, J. *Briefe aus Italien.* Gotha, 1886.

Schoenherr 1988
Schoenherr, Douglas. "Frederick Sandys's *Amor Mundi.*" *Apollo* 127, no. 314 (May 1988), 311–318.

Schulz 1972
Schulz, Wolfgang. "Lambert Doomer, 1624–

1700: Leben und Werke.'' Ph.D. diss., Freie Universität, Berlin, 1972.

Schulz 1974
Schulz, Wolfgang. *Lambert Doomer: Sämtliche Zeichnungen.* Berlin, 1974.

Schwager 1977
Schwager, Klaus. ''Die 'Dantebarke'—Zur Ausernandersetzung Eugène Delacroix mit einen literarischen Vorwurf.'' In *Word und Bild.* Munich, 1977.

Schwartz 1985
Schwartz, Gary. *Rembrandt: His Life, His Paintings.* Harmondsworth, 1985.

Sciolla 1974
Sciolla, G. C. *I disegni di maestri stranieri della Biblioteca reale di Torino.* Turin, 1974.

Seilern 1959
Seilern, Antoine. *Italian Paintings and Drawings at 56, Princes Gate.* London, 1959.

Sellars 1974
Sellars, James. *Samuel Palmer.* London, 1974.

Selz 1979
Selz, Jean. *Gustave Moreau.* New York, 1979.

Sewter 1974–1975
Sewter, A. Charles. *The Stained Glass of William Morris and His Circle.* 2 vols. New Haven and London, 1974–1975.

Simon 1958
Simon, M. ''Claes Jansz. Visscher.'' Ph.D. diss., Albert Ludwig Universität, Freiburg, 1958.

Simpson 1966
Simpson, W. A. ''Cardinal Giordano Orsini (†1438) as a Prince of the Church and a Patron of the Arts.'' *Journal of the Warburg and Courtauld Institutes* 29 (1966), 135–159.

Smith 1970
Smith, Graham. ''A Drawing for the Interior Decoration of the Casino of Pius IV.'' *The Burlington Magazine* 112 (February 1970), 108–110.

Smith 1973
Smith, Graham. ''Two Drawings by Federico Barocci.'' *Bulletin of the Detroit Institute of Arts* 52, nos. 2–3 (1973), 83–91.

Smith 1977
Smith, Graham. *The Casino of Pius IV.* Princeton, 1977.

Smith 1978
Smith, Graham. ''Federico Barocci at Cleveland and New Haven.'' *The Burlington Magazine* 120 (May 1978), 330–333.

Smith 1979
Smith, Sarah Phelps. ''Dante Gabriel Rossetti's 'Lady Lilith' and the 'Language of Flowers.' '' *Arts Magazine* 53 (January 1979), 142–145.

Sonkes 1969
Sonkes, M. *Dessins du XVe siècle: Groupe van der Weyden. Les Primitifs flamands.* Vol. 3, *Contributions à l'étude des primitifs flamands 5.* Brussels, 1969.

Sonstroem 1970
Sonstroem, David. *Rossetti and the Fair Lady.* Middletown, Conn., 1970.

Sotheby's 1973
*Catalogue of Seven Sketch-books by John Robert Cozens (Formerly in the Collection of William Beckford) Sold by Order of His Grace the Duke of Hamilton.* Introduction by Anthony Blunt. Sotheby's, London, 29 November 1973.

Spendlove 1958
Spendlove, F. St. George. *The Face of Early Canada, Pictures of Canada Which Have Helped to Make History.* Toronto, 1958.

Spicer 1970
Spicer, Joaneath. ''The *naer het leven* Peasant Studies, by Pieter Bruegel or Roelandt Savery?'' *Master Drawings* 8, no. 2 (Spring 1970), 3–30.

Spicer 1979
Spicer, Joaneath. ''The Drawings of Roelandt Savery.'' Ph.D. diss., Yale University, 1979.

Spicer 1982
Spicer, Joaneath. ''*The Defense of Prague 15 February 1611* by Roelandt Savery.'' *Umeni* 30, no. 5 (1982), 454–462.

Spicer 1985
Spicer, Joaneath. ''Review of *Six Subjects of Reformation Art: A Preface to Rembrandt* by E. H. Halewood.'' *RACAR* 12, no. 1 (1985), 75–78.

Stacey 1959
Stacey, Charles P. *Quebec, 1759, The Siege and the Battle.* Toronto, 1959.

Stacey 1966
Stacey, Charles P. ''Benjamin West and *The Death of Wolfe.*'' *The National Gallery of Canada Bulletin* 7 (1966), 1–5.

Stacey 1974
Stacey, Charles P. ''Wolfe, James.'' *Dictionary of Canadian Biography.* Vol. 3. 666–674. Quebec, 1974.

Standring 1982
Standring, Timothy James. ''Benedicti Castiglionis Ianven: The Paintings of Giovanni Benedetto Castiglione (1609–1663/65).'' Ph.D. diss., University of Chicago, 1982.

Stewart 1979
Stewart, John Douglas. ''Review of *Van Dyck as Religious Artist.*'' *The Burlington Magazine* 121 (July 1979), 466–468.

Stix and Spitzmuller 1941
Stix, Alfred, and Anna Spitzmuller. *Beschreibender katalog der handzeichnungen.* Vol. 6. *Die Schulen von Ferrara, Bologna, Parma etc.* Vienna, 1941.

Strauss 1974
Strauss, Walter L. *The Complete Drawings of Albrecht Dürer.* 6 vols. New York, 1974.

Strauss 1977
Strauss, Walter L. *Hendrick Goltzius, Master Engraver.* New York, 1977.

Sumowski 1961
Sumowski, Werner. *Bemerkungen zu Otto Beneschs Corpus der Rembrandtzeichnungen.* Bad Pyrmont, 1961.

Sumowski 1979–
Sumowski, Werner. *Drawings of the Rembrandt School,* 7 vols. New York, 1979–continuing.

Sumowski 1980
Sumowski, Werner. ''Observations on Jan Lievens Landscape Drawings.'' *Master Drawings* 18, no. 4 (Winter 1980), 370–373.

Surtees 1971
Surtees, Virginia. *The Paintings and Drawings of Dante Gabriel Rossetti (1828–1882): A Catalogue Raisonné.* 2 vols. Oxford, 1971.

Sussman 1979
Sussman, Herbert L. *Fact into Figure: Typology in Carlyle, Ruskin, and the Pre-Raphaelite Brotherhood.* Columbus, 1979.

Swarzenski and Schilling 1914
Swarzenski, G., and E. Schilling. *Handzeichnungen alter Meister aus Deutschen Privatbesitz.* Frankfurt, 1914.

Symmons 1984
Symmons, Sarah. *Flaxman and Europe: The Outline Illustrations and Their Influence.* New York, 1984.

Szabo 1981
Szabo, George. *Eighteenth-Century Italian Drawings from the Robert Lehman Collection.* New York, 1981.

Tate Gallery 1964
Tate Gallery. *The Tate Gallery Report 1963–64.* London, 1964.

Thieme-Becker
Thieme, U., and F. Becker. *Allgemeines Lexikon der bildenden Künstler von der Antike bis zur Gegenwart.* 37 vols. Vienna and Leipzig, 1907–1950.

Thièry 1953
Thièry, Yvonne. *Le Paysage flamand au XVIIe siècle.* Brussels, 1953.

Thomas 1954
Thomas, Hylton. *The Drawings of Giovanni Battista Piranesi.* London, 1954. 2d ed. New York, 1955.

Thomas 1957
Thomas, Hylton. ''De Tekeningen van Piranesi in het Museum Boymans.'' *Bulletin Museum Boymans* 8 (1977), 10–20.

Thornbury 1904
Thornbury, Walter. *The Life of J.M.W. Turner, R.A.* 2d ed. London, 1904.

Tietze and Tietze-Conrat 1937
Tietze, Hans, and Erica Tietze-Conrat. *Kritisches Verzeichnis der Werke Albrecht Dürers.* 2 vols. Basel and Leipzig, 1937.

Tietze and Tietze-Conrat 1944
Tietze, Hans, and Erica Tietze-Conrat. *The Drawings of the Venetian Painters of the 15th and 16th Centuries.* New York, 1944.

Todd 1946
Todd, Ruthven. ''The Imagination of John Martin.'' In *Tracks in the Snow.* London, 1946.

Toesca 1952
Toesca, Ilaria. ''Gli 'Uomini Famosi' della Biblioteca Cockerell.'' *Paragone* 3, no. 25 (1952), 16–20.

Toesca 1970
Toesca, Ilaria. ''Di nuovo sulla' Cronaca Cockerell.''' *Paragone* 21, no. 239 (1970), 62–66.

Tomory 1967
Tomory, Peter. *A Collection of Drawings by Henry Fuseli, R.A.* Auckland, 1967.

Tomory 1972
Tomory, Peter. *The Life and Art of Henry Fuseli.* New York and London, 1972.

Touwaide 1979
Touwaide, R. H. "Lodovico Guicciardini." In *Nationaal Biographisch Woordenboek.* Brussels, 1979.

Trapp 1971
Trapp, Frank Anderson. *The Attainment of Delacroix.* Baltimore and London, 1971.

Tümpel 1969
Tümpel, Christian. "Studien zur Ikonographie der Historien Rembrandts." *Nederlands Kunsthistorisch Jaarboek* 20 (1969), 107–198.

Tümpel 1970
Tümpel, Christian. *Rembrandt legt die Bibel aus.* Berlin-Dahlem, 1970.

Turner 1985
Turner, Nicholas. "Two paintings attributed to Ludovico Carracci." *The Burlington Magazine* 127 (November 1985), 795–796.

Valentiner 1934
Valentiner, W. R. *Rembrandt: Handzeichnungen.* Berlin, 1934.

Vandenbroeck 1985
Vandenbroeck, Paul. *Koninklijk Museum voor Schone Kunsten Antwerpen: Catalogus Schilderijen 14e en 15e Eeuw.* Antwerp, 1985.

Vasari 1878–1885
Vasari, Giorgio. *Le vite de' più eccellenti pittori, scultori ed architettori.* Edited by Gaetano Milanesi. 9 vols. Florence, 1878–1885.

Venturi 1936
Venturi, Lionello. *Cézanne: Son Art, Son Oeuvre.* 2 vols. Paris, 1936.

Venturi 1951
Venturi, Lionello. "Giunte a Cézanne." *Commentari* 2, no. 1 (January–March 1951), 48.

Vertova 1965
Vertova, Luisa. *I Cenacoli fiorentini.* Turin, 1965.

Vertova 1969
Vertova, Luisa. "L'arte disegnativa europea nella Galleria Nazionale del Canada." *Antichità Viva* 3, no. 4 (1969), 42–48.

Vey 1962
Vey, Horst. *Die Handzeichnungen Anton van Dycks.* 2 vols. Brussels, 1962.

Vey and Kesting 1967
Vey, Horst, and Annamaria Kesting. *Katalog der Niederländischen Gemälde von 1550 bis 1800 im Wallraf-Richartz–Museum und im Öffentlichen Besitz der Stadt Köln.* Cologne, 1967.

Vignau-Wilberg 1982
Vignau-Wilberg, T. *Christoph Murer und die "XL. Emblemata Miscella Nova."* Berne, 1982.

Villani 1955
Villani, M. R. "Un gruppo di disegni inediti di Lelio Orsi." *Emporium* 61, no. 730 (1955), 169–176.

Virch 1962
Virch, Claus. *Master Drawings in the Collection of Walter C. Baker.* New York, 1962.

Vitzthum 1964
Vitzthum, Walter. "Review of the *Catalogue of the Drawings of the Italian Schools of the 17th and 18th Centuries at the Hermitage.*" *Master Drawings* 2, no. 2 (Spring 1964), 174.

Vitzthum 1969
Vitzthum, Walter. "Dessins d'Ottawa." *L'Oeil* 179 (1969), 10–17.

Voorn
Voorn, H. *De papiermolens in de provincie Noord-Holland.* Haarlem, 1960.

Voss 1920
Voss, Hermann. *Die Malerie der Spätrenaissance in Rom und Florenz.* Berlin, 1920.

Van de Waal 1952
Van de Waal, H. *Die Eeuwen Vaderlandsche Geschied-Uitbeelding 1500–1800.* 's-Gravenhage, 1952.

Walker's Galleries (London) 1937a
Walker's Galleries (London). "Early English Water-colours." *Walker's Monthly* 114 (June 1937), 3–4.

Walker's Galleries (London) 1937b
Walker's Galleries (London). "Early English Water-colours." *Walker's Monthly* 115 (July 1937), 1–3.

Wark 1966
Wark, Robert R. *Rowlandson's Drawings for the English Dance of Death.* San Marino, Calif., 1966.

Wark 1975
Wark, Robert R. *Drawings by Thomas Rowlandson in the Huntington Collection.* San Marino, Calif., 1975.

Waterhouse 1978
Waterhouse, Ellis. *Painting in Britain 1530 to 1790.* 4th ed. Harmondsworth, 1978.

Waugh 1928
Waugh, Evelyn. *Rossetti: His Life and Works.* London, 1928.

Wayment 1967
Wayment, Hilary G. "A Rediscovered Master: Adrian van den Houte of Malines (c. 1459–1521) and the Malines/Brussels School: I, A Solution to the 'Ortkens' Problem." *Oud Holland* 82 (1967), 172–202.

Wayment 1969a
Wayment, Hilary G. "Bernard van Orley and Malines: The *Dido and Aeneas* Tapestries at Hampton Court." *The Antiquaries Journal* 49 (1969), 267–376.

Wayment 1969b
Wayment, Hilary G. "A Rediscovered Master: Adrian van den Houte of Malines (c. 1459–1521) and the Malines-Brussels School: III, Adrian's Development and His Relation with Bernard van Orley." *Oud Holland* 84 (1969), 257–269.

Webster 1927
Webster, John Clarence. *Wolfiana: A Potpourri of Facts and Fantasies, Culled from Literature Relating to the Life of James Wolfe.* n.p., 1927.

Webster 1930
Webster, John Clarence. *Wolfe and the Artists: A Study of His Portraiture.* Toronto, 1930.

Wegner 1973
Wegner, Wolfgang. *Kataloge der Staatliche Graphischen Sammlungen München: Die Niederländischen Handzeichnungen des 15.–18. Jahrhunderts.* Berlin, 1973.

Wegner and Pée 1980
Wegner, Wolfgang, and H. Pée. "Die Zeichnungen des David Vinckboons." *Münchener Jahrbuch der bildenden Kunst* 31 (1980), 35–128.

Wender 1984
Wender, Dorothea. *Hesiod and Theognis.* Harmondsworth, 1984.

Whitbread 1971
Whitbread, Leslie George. *Fulgentius the Mythographer: Translated from the Latin.* Columbus, 1971.

White 1969
White, Christopher. *Rembrandt as an Etcher; a Study of the Artist at Work.* 2 vols. London, 1969.

Wildenstein 1963
Wildenstein, Daniel. "Les Oeuvres de Charles Le Brun d'après les gravures de son temps." *Gazette des Beaux-Arts* 66 (July–August 1965). 1–58.

Williams 1970
Williams, Iolo A. *Early English Watercolours.* Bath, 1970.

Wilton 1979a
Wilton, Andrew. *Constable's 'English Landscape Scenery.'* London, 1979.

Wilton 1979b
Wilton, Andrew. *The Life and Work of J.M.W. Turner.* London, 1979.

Wilton-Ely 1978
Wilton-Ely, John. *The Mind and Art of Giovanni Battista Piranesi.* London, 1978.

Winchester 1967
Winchester, Alice. "Canadian Chronology in Brief 1605–1867." *Antiques* 92, no. 1 (July 1967), cover and 62.

Winkler 1936–1939
Winkler, F. *Dürers Zeichnungen.* 4 vols. Berlin, 1936–1939.

Wittkower 1952
Wittkower, Rudolf. *Drawings by the Carracci in the Collection of Her Majesty The Queen at Windsor Castle.* London, 1952.

Wood 1896
Wood, Esther. *A Consideration of the Art of Frederick Sandys.* Special Winter Number of *The Artist.* London, 1896.

Wood c. 1910(?)
Wood, T. Martin. *Drawings of Rossetti.* London and New York, c. 1910(?).

Wright and Evans 1851
Wright, Thomas, and R. H. Evans. *Historical and Descriptive Account of the Caricatures of James Gillray.* London, 1851.

Yalouris 1975
Yalouris, N. *Pegasus: The Art of the Legend.* New York, 1975.

Zampetti 1958
Zampetti, Pietro. *Jacopo Bassano.* Rome, 1958.

Zampetti 1964
Zampetti, Pietro. *I Maestri del colore: Bassano.* Milan, 1964.

Zanotti 1739
Zanotti, Giampiero. *Storia dell'Accademia Clementina.* 2 vols. Bologna, 1739.

Zanotti 1925
Zanotti, Augusto (ed.) "Brevi cennidella vita

di Mauro Gandolfi bolognese: pittore, disegnatore ed incisore a taglio reale.'' *Commune di Bologna* 2, no. 2 (1925), 73–81; no. 4 (1925), 145–153, no. 6 (1925) 388–393.

Zapperi, Roberto. ''Le cardinal Odoardo et les 'Fastes' Farnèse.'' *Revue de L'Art* 77 (1987), 62–65.

Zava Bocazzi 1979
Zava Bocazzi, Franca. *Pittoni.* Venice, 1979.

Zorzi 1961
Zorzi, Giangiorgio. ''Il testamento del pittore Giulio Carpioni. . . .'' *Arte Veneta* 15 (1961), 219–222.

Zwager 1968
Zwager, H. H. *Lodovico Guicciardini en zijn ''Beschrijvinghe van alle de Nederlanden.''* Amsterdam, 1968.

Zweite 1980
Zweite, Armin. *Marten de Vos als Maler.* Berlin, 1980.

## Exhibition Catalogues

Amsterdam 1913
*Catalogue d'une vente importante de dessins anciens provenant des collections J. P. Heseltine et Dr. Paul Richter de Londres.* Frederick Muller, 27–28, May 1913.

Amsterdam 1938
*Fransche Meesters uit de XIXe Eeuw.* Paul Cassirer, 1938.

Amsterdam 1946
*Fransche Meesters 1800–1900.* Stedelijk Museum, 1946.

Amsterdam 1974
*Anthon van Rappard: Companion and Correspondent of Vincent van Gogh: His Life and All His Works.* Rijksmuseum Vincent van Gogh, 1974.

Amsterdam 1981a
*Italiaanse Tekeningen II, de 15$^{de}$ en 16$^{de}$ Eeuw.* Exh. cat. by L. C. J. Frerichs. Rijksprentenkabinet, Rijksmuseum, 1981.

Amsterdam 1981b
*Vincent van Gogh in zijn Hollandse jaren.* Rijksmuseum Vincent van Gogh, 1981.

Ann Arbor 1965
*French Water Colors, 1760–1860.* University of Michigan Museum of Art, 1965.

Antwerp 1966
*Tekeningen van Jacob Jordaens.* Rubenshuis, Antwerp, 1966; Museum Boymans-van Beuningen, Rotterdam, 1967.

Antwerp 1977
*P. P. Rubens: Paintings–Oilsketches–Drawings.* Koninklijk Museum voor Schone Kunsten, 1977.

Augsburg 1980
*Welt im Umbruch: Augsburg zwischen Renaissance und Barock.* Städtische Kunstsammlungen, 1980.

Baden-Baden 1973–1974
*Präraffaeliten.* Staatliche Kunsthalle, 1973–1974.

Basel 1984
*Spätrenaissance am Oberrhein: Tobias Stimmer 1539–1584.* Kunstmuseum, 1984.

Berlin 1973
*Vom späten Mittelalter bis zu Jacques Louis David.* Staatliche Museen Preussischer Kulturbesitz, 1973.

Berlin 1974
*Julius Schnorr von Carolsfeld: Aus dem ziechnerischen Werk, Blätter aus Berlin, Dresden, Leipzig und Weimar.* Staatliche Museen, Kupferstichkabinett und Sammlung der Zeichnungen, 1964.

Berne 1963
*Eugène Delacroix.* Musée des Beaux-Arts, 1963.

Berne 1979
*Niklaus Manuel Deutsch: Maler Dichter Staatsmann.* Kunstmuseum, 1979.

Bloomington 1968
*The Academic Tradition: An Exhibition of 19th-Century French Drawings.* Exh. cat. by Sarah Whitfield. Indiana University Art Museum, 1968.

Bloomington 1979
*Domenico Tiepolo's Punchinello Drawings.* Exh. cat. by Marcia E. Vetrocq. Indiana University Art Museum, 1979.

Bologna 1956
*Mostra dei Carracci: I disegni.* Exh. cat. by Denis Mahon. Palazzo dell'Archiginnasio, 1956. 2d ed. Bologna, 1963.

Bologna 1959
*Maestri della pittura del seicento emiliano.* Palazzo dell'Archiginnasio, 1959.

Bologna 1968
*Il Guercino: Catalogo critico dei dipinti.* Exh. cat. by Denis Mahon. Palazzo dell'Archiginnasio, 1968.

Bolton 1979
*The Drawings of John Everett Millais.* Exh. cat. by Malcolm Warner. Bolton Museum and Art Gallery; Brighton Museum and Art Gallery; Mappin Art Gallery, Sheffield; Fitzwilliam Museum, Cambridge; National Museum of Wales, Cardiff; 1979.

Bordeaux 1951
*Goya 1746–1828.* Musée des Beaux-Arts, 1951.

Bordeaux 1963
*Delacroix, ses maîtres, ses amis, ses élèves.* Exh. cat. by Gilberte Martin-Méry. Musée des Beaux-Arts, 1963.

Boston 1974–1975
*The Changing Image: Prints by Francisco Goya.* Exh. cat. by Eleanor Sayre. Museum of Fine Arts, Boston; National Gallery of Canada, Ottawa; 1974–1975.

Braunschweig 1979
*Jan Lievens.* Herzog Anton Ulrich-Museum, 1979.

Bremen 1964
*Eugène Delacroix.* Kunsthalle, 1964.

Brighton 1974
*Frederick Sandys 1829–1904.* Exh. cat. by Betty O'Looney. Brighton Museum and Art Gallery; Mappin Art Gallery, Sheffield; 1974.

Brussels 1968–1969
*Dessins de paysagistes hollandais du XVII$^e$ siècle.* Exh. cat. by Carlos van Hasselt. Bibliothèque Albert I$^{er}$; Musée Boymans-van Beuningen,

Rotterdam; Institut Néerlandais, Paris; Musée des Beaux-Arts, Berne; 1968–1969.

Budapest 1967
*Bruegeltöl Rembrandtig.* Exh. cat. by T. Gerszi. Szépmüvészeti Múzeum, 1967.

Cambridge 1959
*Exhibition of Seventeenth-Century Italian Drawings.* Exh. cat. by Carlos van Hasselt. Fitzwilliam Museum, 1959.

Cambridge 1967
*Ingres, Centennial Exhibition 1867–1967: Drawings, Watercolors and Oil Sketches from American Collections.* Exh. cat. by Agnes Mongan and Hans Naef. Fogg Art Museum, 1967.

Cambridge 1977
*Drawings by George Romney.* Exh. cat. by Patricia Jaffé. Fitzwilliam Museum, 1977.

Cambridge 1979
*All for Art: The Ricketts and Shannon Collection.* Exh. cat. by Joseph Darracott. Fitzwilliam Museum, 1979.

Cambridge 1982–1983
*John Linnell: A Centennial Exhibition.* Exh. cat. by Katherine Crouan. Fitzwilliam Museum, Cambridge; Yale Center for British Art, New Haven; 1982–1983.

Cambridge 1984
*Samuel Palmer and 'The Ancients.'* Exh. cat. by Raymond Lister. Fitzwilliam Museum, 1984.

Cleveland 1978
*The Graphic Art of Federico Barocci: Selected Drawings and Prints.* Exh. cat. by Edmund P. Pillsbury and Louise S. Richards. Cleveland Museum of Art; Yale University Art Gallery, New Haven; 1978.

Cologne 1922
*Alte Malerei aus Köln.* Kunstverein, 1922.

Detroit 1968
*Romantic Art in Britain: Paintings and Drawings 1760–1860.* Exh. cat. by Frederick Cummings and Allen Staley. Detroit Institute of Arts; Philadelphia Museum of Art; 1968.

Downsview 1981
*Nineteenth-Century German Drawings and Prints.* York University Art Gallery, 1981.

Düsseldorf 1976
*Ausgewählte Graphik und Zeichnungen aus sechs Jahrhunderten (Neue Lagerliste Nr. 67),* C. G. Boerner Gallery, 1976.

Edmonton 1982
*Leader of My Angels: William Hayley and His Circle.* Exh. cat. by Victor Chan. Edmonton Art Gallery, 1982.

Florence 1966
*Disegni di Perino del Vaga e la sua Cerchia.* Exh. cat. by Bernice F. Davidson. Gabinetto Disegni e Stampe, Uffizi, 1966.

Florence 1968
*Mostra di disegni francesci da Callot a Ingres.* Gabinetto Disegni e Stampe, Uffizi, 1968.

Florence 1969
*Da Dürer a Picasso: Mostra di disegni della Galleria Nazionale del Canada.* Gabinetto Disegni e Stampe, Uffizi, 1969.

Florence 1976
*Tiziano e il disegno veneziano del suo tempo.* Exh.

cat. by W. R. Rearick. Gabinetto Disegni e Stampe, Uffizi, 1976.

Florence 1980
*Designi di Bernardino Poccetti.* Exh. cat. by Paul Hamilton. Gabinetto Disegni e Stampe, Uffizi, 1980.

Ghent 1954
*Roelandt Savery.* Exh. cat. by P. Eeckhout. Museum voor Schöne Kunsten, 1954.

Glasgow 1907
*Exhibition of Pictures and Drawings by W. Holman Hunt, O.M., D.C.L.* Kelvingrove Art Gallery, 1907.

Halifax 1976
*Gleams of a Remoter World.* Dalhousie Art Gallery, 1976.

Hamilton 1982
*Thanatopis: Images of Death in the Graphic Arts.* McMaster University Art Gallery, 1982.

Hartford 1976–1977
*Jean-Baptiste Greuze, 1725–1805.* Exh. cat. by Edgar Munhall. Wadsworth Athenaeum, Hartford; California Palace of the Legion of Honor, San Francisco; Musée des Beaux-Arts, Dijon; 1976–1977.

Heidelberg 1986
*Die Renaissance in deutschen Südwesten.* Badisches Landesmuseum, Karlsruhe, in Heidelberger Schloss, 1986.

Indianapolis 1954
*Pontormo to Greco: The Age of Mannerism.* John Herron Art Museum, 1954.

Indianapolis 1964
*The Pre-Raphaelites.* Herron Museum of Art, Indianapolis; Gallery of Modern Art, New York; 1964.

Kansas City 1965
*Drawings: Collection of Milton McGreevy.* William Rockhill Nelson Gallery of Art and Mary Atkins Museum of Fine Arts, 1965.

Karlsruhe 1978–1979
*Heilige, Adlige, Bauern: Entwürfe zu ''Kabinettscheiben'' aus der Schweiz und vom Oberrhein.* Staatliche Kunsthalle, 1978–1979.

Kingston 1962
*Constable to Bacon: An Exhibition of Nineteenth and Twentieth Century British Art.* Agnes Etherington Art Centre, Queen's University, 1962.

Kingston 1965
*Romanticism: Exhibition and Seminar.* Agnes Etherington Art Centre, Queen's University, 1965.

Kingston 1978–1979
*George Heriot: Painter of the Canadas.* Exh. cat. by Gerald Finley. Agnes Etherington Art Centre, Queen's University, Kingston; National Gallery of Canada, Ottawa; McCond Museum, Montreal; Art Gallery of Windsor; Royal Ontario Museum, Toronto; 1978–1979.

Kitchener-Waterloo 1985–1986
*George Romney in Canada.* Exh. cat. by Jennifer C. Watson. Kitchener-Waterloo Art Gallery; Art Gallery of Windsor; Edmonton Art Gallery; 1985–1986.

Leicester 1954
*The Ellesmere Collection of Old Master Drawings.*

Exh. cat. by P. A. Tomory, Leicester Museums and Art Gallery, 1954.

Leicester 1975
*Sir George Beaumont of Coleorton, Leicestershire.* Exh. cat. by Luke Herrmann and Felicity Owen. Leicester Museums and Art Gallery, 1975.

Liverpool 1831
Liverpool Academy, 1831.

Liverpool 1907
*Collective Exhibition of the Art of W. Holman Hunt, O.M., D.C.L.* Walker Art Gallery, 1907.

London 1836
*The Lawrence Gallery: A Catalogue of One Hundred Original Drawings by Lodovico, Agostino and Annibale Carracci Collected by Sir Thomas Lawrence, Late President of the Royal Academy.* Woodburn's Gallery, 1836.

London 1891
*Exhibition of Old Masters and Watercolours.* Royal Academy of Arts, 1891.

London 1896
Society of Antiquaries, 1896.

London 1898
*Catalogue of the Ellesmere Collection of Drawings at Bridgewater House.* Bridgewater House, 1898.

London 1899
*Loan Exhibition.* Guildhall, 1899.

London 1906
*An Exhibition of the Collected Works of W. Holman Hunt, O.M., D.C.L.* Leicester Galleries, 1906.

London 1922–1923
*Catalogue of a Collection of Drawings by John Robert Cozens.* Exh. cat. by C. F. Bell. Burlington Fine Arts Club, 1922–1923.

London 1926
*Catalogue of an Exhibition of Drawings, Etchings & Woodcuts by Samuel Palmer and Other Disciples of William Blake.* Exh. cat. by A. H. Palmer. Victoria & Albert Museum, 1926.

London 1927
*Catalogue of a Small Exhibition of Water-colours, Drawings and Etchings by Samuel Palmer.* Cotswold Gallery, 1927.

London 1928
*Tiepolo Exhibition.* Savile Gallery, 1928.

London 1933
*A Catalogue of Watercolour Drawings by Thomas Rowlandson (1756–1827).* Frank T. Sabin, 1933.

London 1937
*The 33rd Annual Exhibition of Early English Water-colours.* Walker's Galleries, 1937.

London 1938
*Seventeenth-Century Art in Europe: The Drawings.* Royal Academy of Arts, 1938.

London 1949
*Old Master Drawings.* P. & D. Colnaghi, 1949.

London 1952
*Old Master Drawings.* P. & D. Colnaghi, 1952.

London 1953
*Drawings by Old Masters.* Royal Academy of Arts, 1953.

London 1953–1954
*Flemish Art.* Royal Academy of Arts, 1953–1954.

London 1955a
*A Loan Exhibition of Drawings by the Carracci and Other Masters from the Collection of the Earl of Ellesmere.* Exh. cat. by James Byam Shaw. P. & D. Colnaghi, 1955.

London 1955b
*Old Master Drawings.* P. & D. Colnaghi, 1955.

London 1957
*Samuel Palmer & His Circle: The Shoreham Period.* Exh. cat. by John Commander. Arts Council of Great Britain, 1957.

London 1958
*Catalogue of the Well-known Collection of Old Master Drawings Principally of the Italian School Formed in the 18th Century by John Skippe.* Christie's, 20–21 November 1958.

London 1959
*Drawings by Old Masters from the Collection of Dr. and Mrs. Springell.* P. & D. Colnaghi, 1959.

London 1961
*Old Master Drawings.* P. & D. Colnaghi, 1961.

London 1962
*Old Master Drawings from the Collection of Mr. C. R. Rudolf.* Arts Council of Great Britain, 1962.

London 1963a
*Exhibition of Drawings by George Romney 1734–1802.* Exh. cat. by Patricia Milne Henderson (Patricia Jaffé). The Folio Society, Collectors' Corner, 1963.

London 1963b
*Exhibition of Old Master Drawings.* W. R. Jeudwine, 1963.

London 1963–1964
*Goya and His Times.* Royal Academy of Arts, 1963–1964.

London 1967
*PRB Millais PRA.* Exh. cat. by Mary Bennett. Royal Academy of Arts, London; Walker Art Gallery, Liverpool; 1967.

London 1969
*European Drawings from the National Gallery of Canada, Ottawa.* P. & D. Colnaghi, 1969.

London 1971
*Loan Exhibition.* P. & D. Colnaghi, 1971.

London 1972
*Flemish Drawings of the Seventeenth Century from the Collection of Frits Lugt, Institut Néerlandais, Paris.* Exh. cat. by Carlos van Hasselt. Victoria & Albert Museum, London; Institut Néerlandais, Paris; Kunstmuseum, Berne; Royal Library of Belgium, Brussels; 1972.

London 1973a
*Exhibition of Drawings.* Baskett and Day, 1973.

London 1973b
*A Loan Exhibition of Drawings, Watercolours, and Paintings by John Linnell and His Circle.* P. & D. Colnaghi, 1973.

London 1974a
*Early English Watercolours.* Leger Galleries, 1974.

London 1974b
*Turner 1775–1851.* Tate Gallery, 1974.

London 1975a
*Henry Fuseli 1741–1825.* Exh. cat. by Gert Schiff. Tate Gallery, 1975.

London 1975b
*John Martin 1789–1854 Loan Exhibition: Oil Paintings, Watercolours, Prints.* Hazlitt, Gooden & Fox, 1975.

London 1975c
*Old Master Drawings and French Drawings of the 19th Century.* Yvonne Tan Bunzl, 1975.

London 1975d
*Turner in the British Museum: Drawings and Watercolours.* Exh. cat. by Andrew Wilton. British Museum, 1975.

London 1975–1976
*Burne-Jones: The Paintings, Graphic and Decorative Work of Sir Edward Burne-Jones 1833–98.* Exh. cat. by John Christian. Hayward Gallery, London; Southampton Art Gallery; City Museum and Art Gallery, Birmingham; 1975–1976.

London 1976a
*Constable: Paintings, Watercolours and Drawings.* Exh. cat. by Leslie Parris, Ian Fleming-Williams, and Conal Shields. 2d ed. Tate Gallery, 1976.

London 1976b
*William Roy 1726–1790: Pioneer of Ordnance Survey.* Exh. cat. by Yolande O'Donoghue. Map Library, British Museum, 1976.

London 1977
*French Landscape Drawings and Sketches: Catalogue of a Loan Exhibition from the Louvre and Other French Museums.* British Museum, 1977.

London, 1978
*Nineteenth-Century French Drawings.* Hazlitt, Gooden & Fox, 1978.

London 1978–1979
*Samuel Palmer, A Vision Recaptured: The Complete Etchings and the Paintings for Milton and for Virgil.* Victoria & Albert Museum, 1978.

London 1980
*100 of the Finest Drawings from Polish Collections.* Heim Gallery, 1980.

London 1981
*Old Master Drawings.* Lorna Lowe, 1981.

London 1982a
*Samuel Palmer 1805–1881: Loan Exhibition from the Ashmolean Museum, Oxford.* Exh. cat. by David Blayney Brown. Hazlitt, Gooden & Fox, London; National Gallery of Scotland, Edinburgh; 1982.

London 1982b
*Van Dyck in England.* Exh. cat. by Oliver Millar. National Portrait Gallery, 1982.

London 1983
*Pre-Raphaelite Photography.* Exh. cat. by Michael Bartram. The British Council, 1983.

London 1984a
*English Caricature: 1620 to the Present.* Exh. cat. by Richard Godfrey. Yale Center for British Art, New Haven; Library of Congress, Washington, D.C.; National Gallery of Canada, Ottawa; Victoria & Albert Museum, London; 1984.

London 1984b
*English Watercolours.* Leger Galleries, 1984.

London 1984c.
*The Pre-Raphaelites.* Tate Gallery, 1984.

London 1985
*Master Drawings of the Nineteenth and Twentieth Centuries.* Exh. cat. by Christopher Newall. Peter Nahum, 1985.

London 1986
*A Selection of Drawings and Oil Studies.* Julian Hartnoll, 1986.

London 1987a
*Drawing in England from Hilliard to Hogarth.* Exh. cat. by Lindsay Stainton and Christopher White. The British Museum, London; Yale Center for British Art, New Haven; 1987.

London 1987b
*English Artists' Paper.* Exh. cat. by John Krill. Victoria & Albert Museum, 1987.

London 1987c
*English Drawings & Watercolours.* P. & D. Colnaghi, 1987.

London 1987d
*Master Drawings: The Woodner Collection.* Royal Academy of Arts, 1987.

Louisville 1983–1984
*In Pursuit of Perfection: The Art of J.-A.-D. Ingres.* Exh. cat. by Patricia Condon, Marjorie B. Cohn, and Agnes Mongan. J. B. Speed Art Museum, Louisville; Kimbell Art Museum, Fort Worth; 1983–1984.

Madrid 1986
*Dibujos de los siglos XIV al XX: Colección Woodner.* Museo del Prado, 1986.

Malibu 1983
*Master Drawings from the Woodner Collection.* Exh. cat. by George Goldner. J. Paul Getty Museum, Malibu; Kimbell Art Museum, Fort Worth; National Gallery of Art, Washington, D.C.; Fogg Art Museum, Cambridge; 1983.

Manchester 1906–1907
*The Collected Works of W. Holman Hunt, O.M., D.C.L.* Manchester City Art Gallery, 1906–1907.

Manchester 1971
*Watercolours by John Robert Cozens.* Exh. cat. by Francis Hawcroft. Whitworth Art Gallery, Manchester; Victoria & Albert Museum, London; 1971.

Milan 1958
*Arte Lombarda dai Visconti Agli Sforza.* Palazzo Reale, 1958.

Milan 1959
*Mostra di disegni: dei seicento emiliano nella Pinacoteca di Brera.* Exh. cat. by Andrea Emiliani. Palazzo di Brera, 1959.

Montreal 1950
*The Eighteenth Century: Art of France and England.* Montreal Museum of Fine Arts, 1950.

Montreal 1953
*Five Centuries of Drawings.* Exh. cat. by Regina Shoolman. Montreal Museum of Fine Arts, 1953.

Munich 1986
*Meisterzeichnungen aus Sechs Jahrhunderten: Die Sammlung Ian Woodner.* Haus der Kunst, 1986.

Neuss 1965
*Meine Schwarzen Bilder; Kohlezeichnungen und Lithographien von Odilon Redon.* Clemens-Sels-Museum, 1965.

Newcastle upon Tyne 1961
*The Carracci: Drawings and Paintings.* Exh. cat. by Ralph Holland. King's College, 1961.

Newcastle upon Tyne 1973
*Watercolour and Pencil Drawings by Cézanne.* Laing Art Gallery, Newcastle upon Tyne; Hayward Gallery, London; 1973.

New Haven 1977a
*English Landscape 1630–1850: Drawings, Prints & Books from the Paul Mellon Collection.* Exh. cat. by Christopher White. Yale Center for British Art, 1977.

New Haven 1977b
*Rowlandson Drawings from the Paul Mellon Collection.* Exh. cat. by John Riely. Yale Center for British Art, New Haven; Royal Academy of Arts, London; 1977.

New Haven 1979
*The Fuseli Circle in Rome: Early Romantic Art of the 1770s.* Exh. cat. by Nancy L. Pressly. Yale Center for British Art, 1979.

New Haven 1980
*The Art of Alexander and John Robert Cozens.* Exh. cat. by Andrew Wilton. Yale Center for British Art, 1980.

New Haven 1981
*Works of Splendor and Imagination: The Exhibition Watercolor, 1770–1870.* Exh. cat. by Jane Bayard. Yale Center for British Art, 1981.

New Haven 1984
*The Edmund J. and Suzanne McCormick Collection.* Exh. cat. by Susan P. Casteras. Yale Center for British Art, 1984.

New Haven 1985
*The Art of Paul Sandby.* Exh. cat. by Bruce Robertson. Yale Center for British Art, 1985.

New Haven 1986
*Thomas Girtin 1775–1802.* Exh. cat. by Susan Morris. Yale Center for British Art, 1986.

New York (n.d.)
*Master Drawings.* Charles Slatkin Galleries, (n.d.)

New York 1949
*The Work of Samuel Palmer.* Durlacher Bros., 1949.

New York 1950
*Goya: A Loan Exhibition.* Wildenstein, 1950.

New York 1955
*Vincent van Gogh Loan Exhibition.* Wildenstein, 1955.

New York 1961
*Bassano Drawings.* Seiferheld Master Drawings, 1961.

New York 1966a
*Exhibition of Old Master Drawings.* Shickman Gallery, 1966.

New York 1966b
*Master Drawings.* Charles Slatkin Galleries, 1966.

New York 1968
*Medieval Art from Private Collections.* Exh. cat. by Carmen Gómez-Moreno. The Cloisters, Metropolitan Museum of Art, 1968.

New York 1975a
*Drawings Recently Acquired 1972–1975.* Exh. cat. by Jacob Bean. Metropolitan Museum of Art, 1975.

New York 1975b
*The Royal Academy (1837–1901) Revisited: Victorian Paintings from the FORBES Magazine Collection.* Exh. cat. by Christopher Forbes. Metropolitan Museum of Art, New York; Art Museum, Princeton University; 1975.

New York 1977–1978
*Rembrandt and His Century: Dutch Drawings of the Seventeenth Century from the Collection of Frits Lugt.* Exh. cat. by Carlos van Hasselt. Pierpont Morgan Library, New York; Institut Néerlandais, Paris; 1977–1978

New York 1985
*Master Drawings by Gericault.* Exh. cat. by Philippe Grunchec. Pierpont Morgan Library, New York; San Diego Fine Arts Gallery; Museum of Fine Arts, Houston; 1985.

New York 1985–1986
*The First Painters of the King. French Royal Taste from Louis XIV to the Revolution.* Stair Sainty Matthiesen, New York; New Orleans Museum of Art; Columbia Museum of Art; 1985–1986.

New York 1986
*The Northern Landscape: Flemish, Dutch and British Drawings from the Courtauld Collections.* Exh. cat. by Dennis Farr and William Bradford. The Drawing Center, New York; Courtauld Institute Galleries, London; 1986.

New York 1986–1987
*François Boucher, 1703–1770.* Exh. cat. by Alastair Lang, J. Patrice Marandel and Pierre Rosenberg. Metropolitan Museum of Art, New York; Detroit Institute of Arts; Grand Palais, Paris; 1986–1987.

Northampton 1978
*Antiquity in the Renaissance.* Exh. cat. by Wendy Stedman Sheard. Smith College Museum of Art, 1978.

Ottawa 1965
*An Exhibition of Paintings and Drawings by Victorian Artists in England.* Exh. cat. by R. H. Hubbard. National Gallery of Canada, 1965.

Ottawa 1967–1968
*Three Hundred Years of Canadian Art.* Exh. cat. by R. H. Hubbard and J.-R. Ostiguy. National Gallery of Canada, Ottawa; Art Gallery of Toronto; 1967–1968.

Ottawa 1968–1969
*Jacob Jordaens, 1593–1678.* Exh. cat. by Michael Jaffé. National Gallery of Canada, 1968–1969.

Ottawa 1972
*Thomas Davies.* Exh. cat. by R. H. Hubbard. National Gallery of Canada, 1972.

Ottawa 1974
*The Bronfman Gift of Drawings.* Exh. cat. by Mary Cazort Taylor. National Gallery of Canada, 1974.

Ottawa 1976
*European Drawings from Canadian Collections, 1500–1900.* Exh. cat. by Mary Cazort Taylor. National Gallery of Canada, 1976.

Ottawa 1976–1977
*Puvis de Chavannes.* Exh. cat. by Louis D'Argencourt, Marie-Christine Boucher, Douglas Druik, and Jacques Foucart. Grand Palais, Paris; National Gallery of Canada, Ottawa; 1976–1977.

Ottawa 1980
*The Young van Dyck.* Exh. cat. by Alan McNairn. National Gallery of Canada, 1980.

Ottawa 1982
*Bolognese Drawings in North American Collections 1500–1800.* Exh. cat. by Mimi Cazort and Catherine Johnston. National Gallery of Canada, 1982.

Paris 1866
*Salon de 1866.* Palais des Champs-Elysées, 1866.

Paris 1907
*Chardin-Fragonard.* Galerie Georges Petit, 1907.

Paris 1930
*Centenaire du romantisme: Exposition E. Delacroix.* Musée du Louvre, 1930.

Paris 1963
*Memorial de l'exposition Eugène Delacroix.* Exh. cat. by Maurice Sérullaz. Musées Nationaux, 1963.

Paris 1964a
*Le Dessin français dans les collections hollandaises.* Institut Néerlandais, Paris; Rijksmuseum, Amsterdam; 1964.

Paris 1964b
*Le Surréalisme: Sources, histoire, affinités.* Galerie Charpentier, 1964.

Paris 1967
*Le dessin à Naples du XVIe siècle au XVIIIe siècle.* Exh. cat. by Catherine Monbeig-Goguel and Walter Vitzthum. Cabinet des Dessins, Musée du Louvre, 1967.

Paris 1969–1970
*De Raphaël à Picasso: Dessins de la Galerie nationale du Canada (Ottawa).* Cabinet des Dessins, Musée du Louvre, 1969–1970.

Paris 1974
*Dessins flamands et hollandais du dix-septième siècle.* Exh. cat. by Carlos van Hasselt. Institut Néerlandais, 1974.

Paris 1974–1975
*French Painting 1774–1830: The Age of Revolution.* Exh. cat. by Frederick J. Cummings, Pierre Rosenberg and Robert Rosenblum. Grand Palais, Paris; Detroit Institute of Arts; Metropolitan Museum of Art, New York; 1974–1975.

Paris 1975
*Willem Buytewech, 1591–1624.* Institut Néerlandais, 1975.

Paris 1977
*Le Cabinet d'un amateur.* Institut Néerlandais, 1977.

Paris 1979
*Goya: 1746–1828, Peinture, dessins, gravures.* Exh. cat. by Eleanor Sayre et al. Centre culturel du Marais, 1979.

Paris 1979–1980
*Rubens and Rembrandt in Their Century: Flemish and Dutch Drawings from the Pierpont Morgan Library.* Exh. cat. by Felice Stampfle. Institut Néerlandais, Paris; Koninklijk Museum voor Schone Kunsten, Antwerp; British Museum, London; Pierpont Morgan Library, New York; 1979–1980.

Paris 1983a
*Autour de Raphael.* Exh. cat. by Roseline Bacou. Cabinet des Dessins, Musée du Louvre, 1983.

Paris 1983b
*The Hague School: Dutch Masters of the 19th Century.* Exh. cat. by John Sillevis, Ronald de Leeuw and Charles Dumas. Grand Palais, Paris; Royal Academy of Arts, London; Haags Gemeentemuseum, The Hague; 1983.

Paris 1984
*Acquisitions du Cabinet des Dessins 1973–1983.* Cabinet des Dessins, Musée du Louvre, 1984.

Paris 1984–1985
*Diderot et l'art de Boucher à David: Les Salons, 1759–1781.* Hôtel de la Monnaie, 1984–1985.

Paris 1985
*Renaissance et Maniérisme dans les Ecoles du Nord: Dessins des collections de l'Ecole des Beaux-Arts.* Exh. cat. by Emmanuelle Brugerolles. Ecole nationale supérieure des Beaux-Arts, 1985.

Paris 1987–1988
*Fragonard.* Exh. cat. by Pierre Rosenberg. Grand Palais, Paris; Metropolitan Museum of Art, New York; 1987–1988.

Peoria 1971
*The Victorian Rebellion.* Exh. cat. by Vilma Kinney. Lakeview Center for the Arts and Sciences, 1971.

Philadelphia 1971
*Giovanni Benedetto Castiglione: Master Draughtsman of the Italian Baroque.* Exh. cat. by Ann Percy. Philadelphia Museum of Art, 1971.

Philadelphia 1978–1979
*The Second Empire 1852–1870: Art in France under Napoleon III.* Philadelphia Museum of Art; Detroit Institute of Arts; Grand Palais, Paris; 1978–1979.

Prague 1978
*Rudolfinská kresba.* Národni Galerie, 1978.

Princeton 1979
*Van Dyck as Religious Artist.* Exh. cat. by John Rupert Martin and Gail Feigenbaum. Art Museum, Princeton University, 1979.

Princeton 1982
*Drawings of the Holy Roman Empire, 1540–1680.* Exh. cat. by Thomas Kaufmann. Art Museum, Princeton University, 1982.

Providence 1973
*Drawings and Prints of the First Maniera, 1515–1535.* Rhode Island School of Design, 1973.

Rome 1979–1980
*Disegni di Guglielmo Cortese (Guillaume Courtois) detto Il Borgognone nelle collezioni del Gabinetto Nazionale delle Stampe.* Exh. cat. by S. Prosperi Valenti Rodinò. Villa Farnesina, 1979–1980.

Rotterdam 1903
*Vincent van Gogh.* Kunstzalen Oldenzeel, 1903.

Rotterdam 1904
*Vincent van Gogh.* Kunstzalen Oldenzeel, 1904.

Stockholm 1953
*Dutch and Flemish Drawings.* Nationalmuseum, 1953.

Stuttgart 1979–1980
*Zeichnung in Deutschland: Deutsche Zeichner 1540–1640.* Graphische Sammlung, Staatsgalerie, 1979–1980.

Toronto 1962–1963
*Eugène Delacroix.* Exh. cat. by Lee Johnson. Art Gallery of Toronto (now Art Gallery of Ontario); National Gallery of Canada, Ottawa; 1962–1963.

Toronto 1968
*Master Drawings from the Collection of the National Gallery of Canada.* Art Gallery of Ontario, 1968.

Toronto 1972–1973
*French Master Drawings of the 17th & 18th Centuries in North American Collections.* Exh. cat. by Pierre Rosenberg. Art Gallery of Ontario, Toronto; National Gallery of Canada, Ottawa; California Palace of the Legion of Honor, San Francisco; New York Cultural Center, New York; 1972–1973.

Toronto 1985–1986
*Italian Drawings from the Collection of Duke Roberto Ferretti.* Exh. cat. by David McTavish. Art Gallery of Ontario, Toronto; Pierpont Morgan Library, New York; 1985–1986.

Toronto 1987a
*Alexander and John Robert Cozens: The Poetry of Landscape.* Exh. cat. by Kim Sloan. Art Gallery of Ontario, 1987.

Toronto 1987b
*Our Old Friend Rolly: Watercolours, Prints, and Book Illustrations by Thomas Rowlandson in the Collection of the Art Gallery of Ontario.* Exh. cat. by Brenda Rix. Art Gallery of Ontario, 1987.

Troyes 1977
*Charles-Joseph Natoire (Nîmes, 1700–Castel Gandolfo, 1777).* Musée des Beaux-Arts, Troyes; Musée des Beaux-Arts, Nîmes; Académie de France, Rome; 1977.

Tübingen 1982
*Paul Cézanne: Aquarelle.* Kunsthalle, Tübingen; Kunsthaus, Zurich; 1982.

Vancouver 1957
*Rembrandt to Van Gogh.* Vancouver Art Gallery, 1957.

Vancouver 1964
*The Nude in Art.* Vancouver Art Gallery, 1964.

Vancouver 1966
*Images for a Canadian Heritage.* Exh. cat. by Doris Shadbolt. Vancouver Art Gallery, 1966.

Venice 1957a
*Jacopo Bassano.* Exh. cat. by Pietro Zampetti. Palazzo Ducale, 1957.

Venice 1957b
*Venetian Drawings from the Collection of Janos Scholz.* Exh. cat. by Michelangelo Muraro. Fondazione Giorgio Cini, 1957.

Venice 1958
*Disegni veneti in Polonia.* Exh. cat. by Maria Mrozinska. Fondazione Giorgio Cini, 1958.

Venice 1966
*Disegni di una collezione veneziana del Settecento.* Exh. cat. by Alessandro Bettagno. Fondazione Giorgio Cini, 1966.

Venice 1978a
*Disegni di Giambattista Piranesi.* Exh. cat. by Alessandro Bettagno. Fondazione Giorgio Cini, 1978.

Venice 1978b
*Piranesi: incisioni, rami, legature, architetture.* Exh. cat. by Alessandro Bettagno. Fondazione Giorgio Cini, 1978.

Venice 1980
*Disegni veneti di collezioni inglesi.* Exh. cat. by Julien Stock. Fondazione Giorgio Cini, 1980.

Victoria 1961
*The Age of Elegance.* Art Gallery of Greater Victoria; Vancouver Art Gallery; 1961.

Victoria 1965
*The World of W. B. Yeats.* University of Victoria, 1965.

Vienna 1986
*Die Sammlung Ian Woodner.* Graphische Sammlung Albertina, 1986.

Washington 1969–1970
*Old Master Drawings from Chatsworth.* National Gallery of Art, Washington, D.C.; and tour; 1969–1970.

Washington 1971a
*Dürer in America.* National Gallery of Art, Washington, D.C., 1971.

Washington 1971b
*William Hogarth: A Selection of Paintings from the Collection of Mr. and Mrs. Paul Mellon.* National Gallery of Art, Washington, D.C., 1971.

Washington 1974
*Venetian Drawings from American Collections.* Exh. cat. by Terisio Pignatti. National Gallery of Art, Washington, D.C.; Kimbell Art Museum, Fort Worth; St. Louis Art Museum; 1974.

Washington 1975–1977
*The European Vision of America.* Exh. cat. by Hugh Honour. National Gallery of Art, Washington, D.C.; Cleveland Museum of Art; Grand Palais, Paris; 1975–1977.

Washington 1978–1979
*Drawings by Fragonard in North American Collections.* Exh. cat. by Eunice Williams. National Gallery of Art, Washington, D.C., 1978–1979.

Washington 1982–1983
*Claude Lorrain, 1600–1682.* Exh. cat. by H. Diane Russell. National Gallery of Art, Washington, D.C.; Grand Palais, Paris; 1982–1983.

Washington 1984
*Correggio and His Legacy: Sixteenth-Century Emilian Drawings.* Exh. cat. by Diane De Grazia. National Gallery of Art, Washington, D.C., 1984.

Washington 1984–1985
*Watteau, 1684–1721.* Exh. cat. by Margaret Morgan Grasselli and Pierre Rosenberg. National Gallery of Art, Washington, D.C.; Grand Palais, Paris; Schloss Charlottenburg, Berlin; 1984–1985.

Washington 1986–1987
*The Age of Bruegel: Netherlandish Drawings in the Sixteenth Century.* Exh. cat. by John Oliver Hand, J. Richard Judson, William W. Robinson, and Martha Wolff. National Gallery of Art, Washington, D.C.; Pierpont Morgan Library, New York; 1986–1987.

Williamstown 1986–1987
*"Darkness Visible": The Prints of John Martin.* Exh. cat. by J. Dustin Wees. Sterling and Fran-

cine Clark Art Institute, Williamstown; Helen
Foresman Spencer Museum of Art, University
of Kansas, Lawrence; Allen Memorial Art Mu-
seum, Oberlin College; 1986–1987.

Windsor 1967
*George Heriot (1766–1844).* Willistead Art Gal-
lery, 1967.

Winnipeg 1954
*French Pre-Impressionist Painters of the Nine-
teenth Century.* Winnipeg Art Gallery, 1954.

Winnipeg 1955
*El Greco to Goya.* Winnipeg Art Gallery, 1955.

Winnipeg 1956
*Portraits: Mirror of Man.* Exh. cat. by Ferdinand
Eckhardt. Winnipeg Art Gallery, 1956.

Zurich 1967
*Vincent van Gogh: Zeichnungen und Aquarelle.*
Kunsthaus, 1967.

Zurich 1986
*Gustave Moreau Symboliste.* Kunsthaus, 1986.

## Index of artists

by catalogue number

Barbieri, Giovanni Francesco (called Il Guercino)  10
Barocci, Federico  5
Bassano, Jacopo (Jacopo da Ponte)  4
Baudouin, Pierre-Antoine  54
Bigari, Vittorio Maria  19
Bol, Hans  31a, 31b
Boucher, François  53
Breu, Jörg (the Younger)  30
Cantarini, Simone  13
Carpioni, Giulio  12
Carracci, Annibale  9
Carracci, Ludovico  8
Castiglione, Giovanni Benedetto  11
Cézanne, Paul  70
Claude Gellée (called Claude Lorrain)  47
Constable, John  83
Courtois, Guillaume (Guglielmo Cortese, called Il Borgognone)  15
Couture, Thomas  67
Cozens, John Robert  78
Davies, Thomas  75
Delacroix, Ferdinand-Victor-Eugène  66
Doomer, Lambert  44
Dürer, Albrecht  28
Dyck, Anthony van  39
Fragonard, Jean-Honoré  56
Fuseli, Henry  77
Gandolfi, Mauro  26
Géricault, Théodore  65
Gillot, Claude  49
Girodet (Anne-Louis de Roucy-Trioson)  62
Girtin, Thomas  81
Gogh, Vincent van  46
Goya y Lucientes, Francisco  59, 60
Greuze, Jean-Baptiste  55
Guardi, Francesco  22
Guercino (Giovanni Francesco Barbieri)  10
Heriot, George  80
Hogarth, William  72
Hunt, William Holman  87
Ingres, Jean-Auguste-Dominique  63, 64
Jordaens, Jacob  38
Kern, Anton (after Giovanni Battista Pittoni)  21
Koninck, Philips  42
Le Brun, Charles  48

Lépicié, Nicolas-Bernard  58
Lespinasse, Louis-Nicolas de  57
Lievens, Jan  41
Maratta, Carlo  14
Martin, John  84
Memling, Hans (after)  27
Milani, Aureliano  17
Millais, John Everett  90
Moreau, Gustave  69
Murer, Christoph  32
Natoire, Charles-Joseph  52
Neyts, Gillis  43
Orsi, Lelio  3a, 3b
Ortkens, Aert (pseudo)  29
Pagani, Paolo  16
Palmer, Samuel  85, 86
Parrocel, Charles  51
Perino del Vaga  2
Piranesi, Giovanni Battista  23, 24
Pittoni, Giovanni Battista (after)  21
Poccetti, Bernardino (attributed to)  7
Puvis de Chavannes, Pierre C.  68
Redon, Odilon  71
Rembrandt van Rijn  40
Ricci, Marco  18
Romney, George  74
Rossetti, Dante Gabriel  88
Rowlandson, Thomas  79
Rubens, Peter Paul  37
Sandby, Paul  73
Sandys, Frederick  89
Savery, Roelandt  36
Schnorr von Carolsfeld, Julius  45
Tiepolo, Giovanni Battista  20
Tiepolo, Giovanni Domenico  25
Turner, Joseph Mallord William  82
Unknown Italian or French  1
Unknown Netherlandish (after Hans Memling)  27
Vinckeboons, David  35
Watteau, Jean-Antoine  50
Watteau, François-Louis-Joseph (attributed to)  61
West, Benjamin  76
Wtewael, Joachim  33
Wtewael, Joachim (attributed to)  34
Zuccaro, Federico  6